IL 60

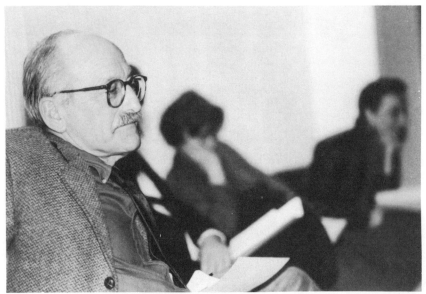

IL at IL60. (SL in background.)

IL 60

ESSAYS HONORING
IRVING LAVIN
ON HIS SIXTIETH BIRTHDAY

*

EDITED BY

MARILYN ARONBERG LAVIN

ITALICA PRESS
NEW YORK
1990

ITALICA PRESS, INC.
595 Main Street
New York, New York 10044

Library of Congress Cataloging-in-Publication Data

IL 60 : essays honoring Irving Lavin on his sixtieth birthday / edited by Marilyn Aronberg Lavin.
 p. cm,
 "Bibliography of the works of Irving Lavin": p.
 Contents: The coordination of wall, floor, and ceiling decoration in the houses of Roman Italy, 100BCE-235CE / John R. Clarke -- Pegasos and the seasons in a pavement from Caesarea Maritima / Marie Spiro -- The Madonna del Coazzone and the Cult of the Virgin Immaculate in Milan and Pavia / Edith W. Kirsch -- Donatello and the high altar in the Santo, Padua / Sarah Blake McHam -- Medici patronage and the festival of 1589 / Arthur Blumenthal -- The Vatican tower of the winds and the architectural legacy of the Counter Reformation / Nicola Courtright -- Drawing and collaboration in the Carracci Academy / Gail Feigenbaum -- Clement VIII, the Lateran and Christian concord / Jack Freiberg -- Lelio Pasqualini, a late sixteenth-century antiquarian / Alexandra Herz -- The Bentvueghels / David Levine -- The king, the poet, and the nation / Michael Mezzatesta -- Marble revetment in the late sixteenth-century Roman chapels / Steven Ostrow.
 ISBN 0-934977-18-6 $45.00
 1. Art, Roman. 2. Art, Italian. 3. Art, Medieval--Italy. 4. Art, Modern--Italy. 5. Relief (Sculpture), French. 6. Lavin,
 Irving, 1927- . I. Lavin, Irving, 1927- . II. Lavin, Marilyn Aronberg. III. Title: IL sixty.
N6911.I34 1990
709'.45--dc20 89-85336

Printed in the United States of America
5 4 3 2 1

CONTENTS

CONTENTS

PREFACE

The concept that brings the twelve articles of this volume together, aside from the celebration of Irving Lavin's sixtieth birthday, is the continuity between generations of art historians. The papers are the fruits of a colloquium called *IL60*, held at the Institute for Advanced Study, Princeton, New Jersey, in December 1987, in which all the participants were either IL's students or his teachers.

The speakers had written or were writing their Ph.D. dissertations under his supervision. The younger discussants had his counsel as a second reader. The senior discussants, three in number and representing three different fields of art history, were the models for IL's own scholarly career. The four "presenters" were current disciples. One was a student by choice, in the midst of her graduate career at Princeton University; two were students by blood: an architectural historian who happened to be his daughter, and another daughter who passed beyond art history to become an artist; she acted as the colloquium's photographer. And the last was IL's student by mistake: his wife and colleague who organized this intellectual surprise party. I confess, incidentally, it was I who introduced IL to the history of art and even graded his freshman survey course final exam. When I married him for love, however, I had not anticipated the years of probing questions that would always make my own work go another step forward. Each and every word I have published includes my thanks for the wondrous things he taught me.

The format of the colloquium was drawn from IL's "Wednesday Lunches" at the Institute. At these informal meetings, visiting members present brief descriptions of the projects on which they will be working during the tenure of

ix

their grants. A discussion follows in which other members and visitors, who may be in widely divergent fields of art history, bring their special knowledge and scholarly experience to bear on the subject at hand. The effort is exacting, yet supportive and productive. It was precisely this atmosphere of intellectual cooperation that *IL60* aimed to recreate in a slightly more structured manner.

The colloquium was organized into three sessions representing the areas of IL's personal research: Late Antique, fifteenth-century Italian, sixteenth-century and the Baroque. The speakers were requested to prepare twenty-minute presentations of "work in progress." They were told to define their problems, display research, indicate the focus of their analysis, but leave their papers open-ended in terms of conclusions. They were advised that their material would receive public scrutiny with the objective of providing critical contributions *before* the papers were prepared for publication.

A number of designated discussants received written versions of the talks about four weeks before the colloquium took place. Their task was to question the logic of the approach, bring additional information where relevant, and to point out further *desiderata* for research and consideration. The discussions, which lasted about forty minutes for each topic, followed a set pattern. A moderator first called upon the designated discussants to pose their prepared comments. When they had finished, the questioning was opened to the floor, including speakers from other sessions and the audience. When this structured intercourse was complete Irving, who had not seen the papers beforehand, was finally allowed to add his observations. And add he did, plunging into each new subject with the energy of a terrier and the inspiration of a divining-rod. He called it the ego orgy of his life. Moreover, it was enthusiastically agreed that a positive and mutually beneficial scholarly exchange had been experienced by everyone present.

The speakers were given a year and a half following the colloquium to digest the comments of the public debate and bring their articles to completion. The final versions are presented here to memorialize the occasion. Because the contributions stemming from the discussions were substantial,

the designated participants are identified with gratitude: *Medieval and Renaissance:* Ernst Kitzinger (Harvard University, Emeritus), Dale Kinney (Bryn Mawr College), Martha Levine Dunkelman (University of New York, Buffalo), William Tronzo (The Johns Hopkins University); *Sixteenth and Seventeenth Centuries:* Linda Klinger (Franklin and Marshall College), Jeffrey Muller (Brown University), Craig Hugh Smyth (Harvard University, Emeritus), George Bauer (University of California, Irvine), Michael Conforti (The Minneapolis Institute of the Arts), John Coolidge (Harvard University, Emeritus); Dora Jane Janson representing W. H. Janson and Margaret Meiss representing Millard Meiss. In addition, appreciation is offered to contributing members of the audience who are here thanked collectively.

The colloquium's theme of generational continuity had been generated, at least in part, by sentiment and not a little nostalgia. But in the end it was evident, and this publication will reinforce the observation, that the continuity is genuinely intellectual. For in spite of the broad spectrum of subjects and personalities involved, the papers display a shared point of view: the history of art is a quest to understand the relationship between the way a work of art looks and what it means. To study with Irving Lavin, it would seem, is to find this challenge inescapable.

Two authors were located only in the year following the colloquium: Arthur R. Blumenthal and John R. Clarke. Alexandra Herz was unable to participate at the time because of her father's illness. These three "students" graciously agreed to contribute articles without the benefit of the discussions. It should be added that all the authors have been encouraged to republish their material in places appropriate to their individual fields. Some have elected to publish only here; others will include their material in larger publications.

Finally, I take this occasion to offer deep gratitude to the benefactors of the colloquium, and therefore this book. The events were supported spiritually and materially by Phyllis Lambert and a generous gift from James I. Merrill. The cover of this volume, conceived as a Lavin bookplate, also used as the cover for the colloquium program, was designed by

Michael Graves. Ronald G. Musto and Eileen Gardiner, friends from the 1970s at the American Academy in Rome, joined the *IL60* group with alacrity as editors and publishers. *Mille grazie* to one and all who join in offering renewed *auguri* to IL.

Marilyn Aronberg Lavin
Princeton, New Jersey
June, 1989

Bibliography of the Works of Irving Lavin

1954-1989

DISSERTATION

1955. "The Bozzetti of Gian Lorenzo Bernini." Harvard University.

BOOKS

1968. *Bernini and the Crossing in Saint Peter's.* Monographs on Archeology and the Fine Arts. New York: New York University Press.

1977. Editor, with John Plummer. *Studies in Late Medieval and Renaissance Painting in Honor of Millard Meiss.* New York: New York University Press.

*1980. *Bernini and the Unity of the Visual Arts.* Oxford: Oxford University Press and New York: Pierpont Morgan Library.
Italian translation: *Bernini e l'unità delle arti visive.* Rome: Edizione dell'Elefante.

1981. Editor, et al. *Drawings by Gianlorenzo Bernini from the Museum der bildenden Künste, Leipzig.* Exhibition Catalog. Princeton, NJ: Princeton University Press.

1985. Editor. *Gianlorenzo Bernini: New Aspects of His Art and Thought. A Commemorative Volume.* State College, PA and London: Pennsylvania State University Press.

*Awarded the Premio Daria Borghese, 1981.

1987. Editor, with William Tronzo. *Studies on Art and Archeology in Honor of Ernst Kitzinger on his Seventy-Fifth Birthday.* Dumbarton Oaks Papers, 41. Washington, DC: Dumbarton Oaks.

1989. Editor. *World Art. Themes of Unity in Diversity.* Acts of the Twenty-Sixth International Congress of the History of Art. 3 vols. University Park, PA and London: Pennsylvania State University Press.

ARTICLES, REVIEWS, ETC.

1954. "Cephalus and Procris. Transformations of an Ovidian Myth." *Journal of the Warburg and Courtauld Institutes* 17:260-87.

1954. "Cephalus and Procris. Underground Transformations." *Journal of the Warburg and Courtauld Institutes* 17:366-72.

1956. "Pietro da Cortona and the Frame." *Art Quarterly* 19:55-59.

1956. Review of *Gian Lorenzo Bernini. The Sculptor of the Roman Baroque,* by Rudolf Wittkower. *Art Bulletin* 38:255-60.

1957. "Decorazioni barocche in San Silvestro in Capite a Roma." *Bollettino d'Arte* 42:44-49.

1957. "An Observation on 'Medievalism' in Early Sixteenth-Century Style." *Gazette des Beaux-Art* 50:113-18.

*1959. "The Sources of Donatello's Pulpits in San Lorenzo. Revival and Freedom of Choice in the Early Renaissance." *Art Bulletin* 41:19-38.

1960. With Cyril Mango. Review of *The Great Palace of the Byzantine Emperors,* edited by D. Talbot Rice. *Art Bulletin* 42:67-73.

1961 "Abstraction in Modern Painting. A Comparison (Jackson Pollock's 'Autumn Rhythm')." *The Metropolitan Museum Bulletin* 19:166-71.

*1962. "The House of the Lord. Aspects of the Role of Palace Triclinia in the Architecture of Late Antiquity and the Early Middle Ages." *Art Bulletin* 44:1-27.

*Awarded the Arthur Kingsley Porter Prize, College Art Association of America.

1963. "Die Mosaikfussböden in Arsameia am Nymphaios."
In *Arsameia am Nymphaios. Die Ausgrabungen...von 1953-
56*, edited by F. K. Dorner. *Istanbuler Forschungen* 23:191-
96. Berlin: Gebr. Mann Verlag.

1963. "The Hunting Mosaics of Antioch and Their Sources.
A Study of Compositional Principles in the Development of
Early Mediaeval Style." *Dumbarton Oaks Papers* 17:179-
286.

1964. "Lettres de Parme (1618, 1627-28), et débuts du théâtre
baroque. " In *Le Lieu théâtral à la Renaissance*, edited by J.
Jacquot, 105-58. Paris: Centre National de la Recherche
Scientifique.

1964. Review of *Gian Lorenzo Bernini. Fontana di Trevi,
Commedia inedita*, edited by Cesare D'Onofrio. *Art Bulletin*
46:568-73.

1965. "The Campidoglio and Sixteenth-Century Stage
Design." In *Essays in Honor of Walter Friedlaender*, edited
by Walter Cahn et al. *Marsyas*, Suppl. 2:114-18. Locust
Valley, NY: J. J. Augustin.

1965. Review of *Theatre Festivals of the Medici 1539-1637*, by
A. M. Nagler. *Journal of the Society of Architectural
Historians* 24:327-28.

1965. Review of *Italian High Renaissance and Baroque
Sculpture*, by John Pope-Hennessy. *Art Bulletin* 47:378-83.

1966. "Michelangelo's Saint Peter's Pietà. The Virgin's Left
Hand and Other New Photographs." *Art Bulletin* 48:103-4.

1967. "Bozzetti and Modelli. Notes on Sculptural Procedure
from the Early Renaissance through Bernini." In *Stil und
Uberlieferung in der Kunst des Abendlandes. Akten des 21.
internationalen Kongresses für Kunstgeschichte in Bonn 1964*,
edited by Herbert von Einem, 3:93-104. Berlin: Gebr. Mann
Verlag.

1967. "The Ceiling Frescoes in Trier and Illusionism in
Constantinian Painting." *Dumbarton Oaks Papers* 21:97-113.

1967. "An Ancient Statue of the Empress Helen
Reidentified(?)." *Art Bulletin* 49:58.

*1968. "Five Youthful Sculptures by Gianlorenzo Bernini and a Revised Chronology of his Early Works." *Art Bulletin* 50:223-48.

1970. In collaboration with Marilyn Aronberg Lavin. "Duquesnoy's Nano di Créqui and Two Busts by Francesco Mochi." *Art Bulletin* 52:132-49.

1970. In collaboration with Marilyn Aronberg Lavin. "Pietro da Cortona Documents from the Barberini Archive." *Burlington Magazine* 112:446-51.

1970. "On the Sources and Meaning of the Renaissance Portrait Bust." *Art Quarterly* 33:207-26.

1972. "Bernini's Death." *Art Bulletin* 54:158-86.

1973. "Afterthoughts on 'Bernini's Death.'" *Art Bulletin* 55:429-36.

1973. Letter to the Editor on Review, by Howard Hibbard, of *Bernini and the Crossing of St. Peter's. Art Bulletin* 55:475-76.

1974. "Divine Inspiration in Caravaggio's Two St. Matthews." *Art Bulletin* 56:59-81.

1974. "Addenda to 'Divine Inspiration.'" *Art Bulletin* 56:590-91.

1975. "On Illusion and Allusion in Italian Sixteenth-Century Portrait Busts." *Proceedings of the American Philosophical Society* 119:353-62.

1976. Letter to the Editor, on "Michelangelo's Unfinished Works," by Juergen Schulz. *Art Bulletin* 58:148.

1976. Partial reprint of "Bernini's Death"(1972), in *Bernini in Perspective*, edited by G. C. Bauer, 111-26. Englewood Cliffs, NJ: Prentice Hall.

1977/78. "The Sculptor's 'Last Will and Testament.'" *Allen Memorial Art Museum Bulletin, Oberlin College* 35,1-2:4-39.

1978. "Calculated Spontaneity. Bernini and the Terracotta Sketch." *Apollo* 107 (May): 398-405.

1978. "On the Pedestal of Bernini's Bust of the Savior." *Art Bulletin* 60:547.

1980. "A Further Note on the Ancestry of Caravaggio's First Saint Matthew." *Art Bulletin* 62:113-14.

*Awarded the Arthur Kingsley Porter Prize, College Art Association of America.

1981 Reprint of excerpt from "Duquesnoy's Nano di Créqui and Two Busts by Francesco Mochi" (1970). In *Francesco Mochi, 1580-1654,* edited by Mina Gregori, 17-18. Florence: Centro Di.

1981. "Bernini and the Art of Social Satire." In *Drawings by Gianlorenzo Bernini from the Museum der Bildenden Künste, Leipzig,* 26-54, 336-37, 349-56. Exhibition catalog. Princeton, NJ: Princeton University Press.

1982. Italian translation of "Bernini and the Art of Social Satire" (1981), as "Bernini e l'arte della satira sociale." In *Immagini del Barocco: Bernini e la cultura del seicento,* edited by Marcello Fagiolo and Gianfranco Spagnesi, 93-116. Rome: Enciclopedia Italiana.

1982. "Words in Memory of H. W. Janson." *College Art Association Newsletter* 7 (7, supplement): 3-4.

1982. "When Vatican Art Goes on the Road." Letter to the Editor, *New York Times,* Sunday, Dec.12, 18E.

1983. Reprint of "Bernini and the Art of Social Satire" (1981). *History of European Ideas* 4:365-420.

1983. "Bernini's Memorial Plaque for Carlo Barberini." *Journal of the Society of Architectural Historians* 42:6-10.

1983. "The Art of Art History." *ARTNews* 82, 8:96-101.

1984. "Bernini's Bust of Cardinal Montalto." *Idea* 3:87-95.

1984. "Bernini's Baldachin. Considering a Reconsideration." *Römisches Jahrbuch für Kunstgeschichte* 21:405-14.

1985. Reprint of "Bernini's Bust of Cardinal Montalto" (1984). *Burlington Magazine* 127:32-38.

1985. "Obituary. Howard Hibbard, 1928-84," *Burlington Magazine* 127:305

1985. "Iconography." In *Automatic Processing of Art History Data and Documents. Pisa, Scuola Normale Superiore. September 24-27, 1984. Proceedings,* edited by Laura Corti and Marilyn Schmitt, 321-31. Florence: Regione Toscana.

1985. "Bernini's Cosmic Eagle." In *Gianlorenzo Bernini. New Aspects of his Art and Thought. A Commemorative Volume,* edited by Irving Lavin, 209-14. State College, PA and London: Pennsylvania State University Press.

1987. French translation of "Bernini and the Art of Social Satire" (1981), as *Bernin et l'art de la satire sociale.* Essais et Conférences, 7-71. Paris: Collège de France and Presses Universitaires de France.

1987. "Le Bernin et son Image du Roi-Soleil." In *"Il se rendit en Italie." Études offertes à André Chastel,* edited by J.-P. Babelon et al., 441-78. Rome: Edizione dell' Elefante and Paris: Flammarion.

1989. "Bernini and Antiquity. The Baroque Paradox. A Poetical View." In *Antikenrezeption im Hochbarock,* edited by H. Beck and S. Schulze, 9-36. Berlin: Gebr. Mann Verlag.

1989. "Donatello's Kanzeln in San Lorenzo und das Wieder- aufleben frühchristlicher Gebräuche: ein Nachwort." In *Donatello. Studien. Italienische Forschungen,* ser. 3, 16:155- 69. Munich: Bruckmann.

I

Notes on the Coordination of Wall, Floor, and Ceiling Decoration In the Houses of Roman Italy, 100 BCE-235 CE*

JOHN R. CLARKE

When I first read Irving Lavin's article on the hunting mosaics of Antioch, I wondered if his method of analyzing the composition of mosaic floors in relation to the viewer's perception of them would apply to Roman black-and-white figural mosaics. Both at the dissertation stage and in the book that followed, the many footnotes citing his article reveal just how important his approach was for my research. As "outside" reader of my 1973 dissertation, Professor Lavin gave generously of his time and expertise, and he has never ceased to do so. This little essay, in fact, is a response to another of his suggestions, that I look at the relationships among wall, floor, and ceiling decoration. The research has taken me to the houses of Pompeii, Herculaneum, and Ostia Antica, where I have spent many months studying decorative ensembles. Here I have highlighted some of the more striking cases where one can see how architects, mosaicists, stuccoists, and wall painters collaborated to satisfy their patrons'

* I wish to thank Prof. Baldassare Conticello, Soprintendente agli Scavi di Pompei, and Dr. Anna Gallina Zevi, Soprintendente agli Scavi di Ostia, for granting me permissions to study at the sites and to publish the drawings and photographs reproduced here. I owe a special debt of thanks to Mr. Michael Larvey for overcoming considerable technical obstacles to produce the new photographs illustrating this article.

requirements for a decor that suited the functions of the spaces in their houses.

Evidence for decorative ensembles of the First Style in Roman Italy comes principally from the sites buried by Vesuvius in 79 CE. First-Style ensembles in excavated houses at Pompeii and Herculaneum are the remains of decoration that was already quite old at the time of the eruption. The ancient Romans valued these venerable decorative ensembles and often went to the trouble of restoring them when damaged rather than redecorating in the style in vogue at the time.

Decorative ensembles still extant in the Samnite House in Herculaneum show how the design principles of the First Style were applied in modest spaces. Although the Samnite House is about sixteen times smaller than its more famous First-Style counterpart at Pompeii, the House of the Faun,[1] its decorative scheme is not without elegance and refinement.

As in the House of the Faun, and in the galleried atria in the houses of Delos[2] in this period, the Samnite House's loggiate atrium (fig. 1) made it into a kind of royal hall – but in the private domain – intended to impress the visitor, whether peer or client. The history of Roman interior decoration is filled with examples of over-reaching, sometimes exaggerated schemes intended to associate the owner with the wealth and power he or she never had. The modern visitor who is surprised at the vertical expansion of space and the refinement of the Samnite House's loggia receives a message consciously embedded by the owner who commissioned this grandiose space for a very small house.

Entering the *fauces*, or entryway, the visitor's axial view of the tiny *tablinum* is framed by carefully-orchestrated decoration (fig. 1). Its floor slopes upward toward the atrium, with white tesserae set into the *cocciopesto* in a pattern of outlined fish-scales.[3] At the inner limit of the

1. House of the Faun, c.3050 mm.; Samnite House, c.190 mm; but much of the House of the Faun consists of walled-in gardens rather than covered rooms.
2. Philippe Bruneau, et. al., *L'Ilot de la Maison des Comediens*, Exploration archéologique de Delos 27 (Paris: E. de Boccard, 1970), figs. 2, 29, 30 (Maison des Comédiens); fig. 80 (Maison des Tritons).
3. The *squame delineate* pattern; see Maria Luisa Morricone Matini, "Mosaico," *Enciclopedia dell'Arte Antica: Supplemento* (Rome: Treccani, 1970), p. 506.

fauces, a threshold band in a meander design with alternating swastikas and squares (as well as a step up) announce the atrium.

Accompanying this *opus signinum* pavement in dark red and white is the First-Style decoration of the fauces' walls. The areas where the door's two battens would have rested when open are practically undecorated, articulated in large white vertical panels. Beyond these rise the faux-marble blocks in three registers, the uppermost register consisting of rectangular ashlars skillfully stuccoed and painted to resemble blocks of red, green, white, and speckled marble (that is, porphyry, *verde antico,* alabaster, and *portasanta*).[4] The faux marble blocks support dentil ranges matching the one over the entryway. The combination of these red cement floors with imitation marble walls reflects an economic compromise, since a wealthy patron (like that of the House of the Faun) could afford to pay for cut marble or mosaic pavements decorated with *emblemata* (set-in figural compositions). A similar repertory of designs accompanies the First-Style decoration preserved under *triclinium* (dining room) 18 of the House of the Menander.

Above the faux-marble blocks extend landscapes, best preserved on the north wall. Painted in the period of the Second Style, the landscapes seem to have been an afterthought, since even when in pristine condition they would have been difficult to read. In this passageway a viewer could hardly be able to contemplate their spatial and symbolic complexities. What remains suggests a sacro-idyllic landscape.

Another Second-Style substitution appears in the fauces' ceiling, an illusionistic representation of the actual lacunary or crossed-beamed ceiling that must have originally accompanied the faux-marble revetment of the walls. In its fragmentary, faded condition it fails to convince the viewer of its architectural role, but like the Second-Style ceilings preserved at Oplontis and in the Villa of the Mysteries, it originally must have lent a note of color and variety to the ensemble.

4. Amedeo Maiuri, *Ercolano: I Nuovi Scavi* (Rome: Istituto Poligrafico dello Stato, 1958), p. 200.

The threshold band on the floor and the framing pilasters and capitals of the antae mark the passage from the *fauces* to the atrium. Important passageways framed in this manner signal the end of one space and the beginning of another: similar framing systems occur around major doorways off the atrium, like that of the *tablinum* (principal reception space) or the *alae* (wings). They are essential to the illusion of First- and Second-Style ensembles, since both styles must convince the viewer that fictive architectural members are real. Piers at major entryways would be needed to support the beam over the opening in actual post-and-lintel construction. In the First Style the piers represented in stucco and paint frame openings and close or complete the rows of orthostats and ashlars making up the room's walls.[5]

Although in their present state none of the rooms of the Samnite House has exactly contemporary floor and wall decoration, existing ensembles in the *fauces* and atrium provide an invaluable glimpse of rare First-Style decorative ensembles.

The earliest example of the Second Style of Romano-Campanian wall painting, dating to c.80 BCE, is found in cubiculum II of the House of the Griffins on the Palatine in Rome. Until the removal of its painted wall decoration, one could experience the way in which floor and walls complemented each other in this room.

Rizzo's photograph shows the interior in c.1930.[6] Painted representations of bossed Corinthian columns on individual bases run at regular intervals around the room's walls. Their job is to appear to hold up the architrave, and thus the barrel-vaulted ceiling. Between these "supporting" columns, which seem to project forward from the actual wall plane, appear panels painted in the same design as the *emblema* in *opus sectile* inserted into the black-and-white tessellated pavement: a pattern of cubes in perspective.

5. Daniela Corlaità Scagliarini, "Spazio e decorazione nella pittura pompeiana," *Palladio* 23-25 (1974-1976): 4-7, figs. 1-4; Anne Laidlaw, *The First Style in Pompeii: Painting and Architecture* (Rome: Giorgio Bretschneider, 1985), color reconstruction of the House of Sallust in frontispiece.
6. Giulio E. Rizzo, *Le pitture della 'Casa dei Grifi'*, Monumenti della pittura antica scoperti in Italia, 3, 1 (Rome: Istituto Poligrafico dello Stato, 1936).

By 60 BCE the Second Style had developed illusionary vistas that seemed to open up *behind* the actual wall plane, thus extending the room's space. As in the early Second-Style schemes, the success of the illusion depended on the establishment of a fictive colonnade that seemed to support the ceiling, a colonnade whose framework also vignetted the views opening up behind them. That this transformation was the work of theatrical scene painters, the *pictores scaenarii*, is attested by the tragic, comic, and satyrical scenes noted by Vitruvius and found in Second-Style schemes. A good example is the cubiculum from the Villa at Boscoreale now in the Metropolitan Museum in New York. (The mosaic floor seen today in the installation at the Metropolitan Museum comes from another archaeological site and is of the early first century CE).[7]

In the Villa of the Mysteries at Pompeii and in the Villa of Oplontis at Torre Annunziata one can study Second-Style ensembles of floor, wall, and ceiling decoration that are intact. Cubiculum 16 of the Villa of the Mysteries, together with cubiculum 11 of the Villa of Oplontis, provides a clear picture of how the arts of the wall painter, stuccoist, and mosaicist were coordinated to differentiate areas with separate functions within the same space.[8]

Perhaps because it was inserted into a First-Style room with a particularly tall elevation, Room 16 of the Villa of the Mysteries is by far more elegant and imposing than its contemporary at the Villa of Oplontis. A bedroom with two alcoves, its principal opening through folding doors (still preserved in plaster casts) provided ample light and air from the portico. Entering the second doorway, from the villa's transverse corridor, one is struck both by the room's height

7. Andrew Oliver, Jr., "The Montebello Mosaics," *American Journal of Archaeology* 69 (1965): 268-70.
8. John R. Clarke, "Relationships between Floor, Wall, and Ceiling Decoration at Rome and Ostia Antica: Some Case Studies," *Bulletin de l'Association Internationale pour l'Étude de la Mosaïque Antique* 10 (1985): 94-95; John R. Clarke, "The Non-Alignment of Functional Dividers in Mosaic and Wall Painting at Pompeii," *Bulletin de l'Association Internationale pour l'Étude de la Mosaïque Antique* 12 (1989): 313-21; Alix Barbet, "Quelques rapports entre mosaïques et peintures murales a l'époque romaine," in *Mosaïque: Recueil d'hommages à Henri Stern* (Paris: Éditions Recherche sur les Civilisations, 1983), pp. 43-44; Olga Elia, "I cubicoli nelle case di Pompei," *Historia* 6 (1932): 412-17.

and the dramatic orchestration of wall, floor, and ceiling designs to differentiate and articulate the spaces. A mosaic carpet with a pattern of red and black crosslets defines the circulation space of the anteroom. Two mosaic bands, or *scendiletti*, meet at right angles at the closet separating the two alcoves. Their designs, in colored tesserae, contrast greatly: one is a sober pattern of step triangles, the other an alternation of large diamonds and squares. They coordinate closely with the Second-Style scheme of the wall painting to divide the anteroom from alcove spaces; the porphyry-red and green pilaster folded around the outside corner of the closet meets these two carpet bands on the floor. Similar pilasters and their capitals fold into the inside corners of each alcove. Whereas the walls of the anteroom, regularly divided by these same pilasters, have a coloristically rich but relatively simple scheme of illusionistic faux-marble revetment, the painted architecture of the two alcoves is both daring in conception and impressive in its detail.

In the east alcove, for example, four elegant Corinthian columns carry a triple point-loaded arcade.[9] These fictive architectural members in turn "support" a two-part stucco cornice consisting of a simple low-relief band below with a deeply projecting dentillated molding above. This upper stucco molding projects even farther at the outside corner formed by the closet, in this way marking the intersection of the stucco frames of both alcoves' ceiling. Preserved parts of the east alcove's ceiling suggest that it was a lattice pattern shaded in pink, cinnabar red, and porphyry red, perhaps with light blue trim. Holes at the intersections of the lattice pattern may have held nails supporting, in turn, stucco rosettes;[10] otherwise these holes may have once contained gems.[11]

9. For excellent photographic and graphic documentation of this and the south alcove, see Josef Engemann, *Architekturdarstellungen des frühen zweiten Stils*, *Römische Mitteilungen Ergänzungsheft* 12 (1967): 76-79, pls. 18-19 (east alcove), pls. 20-23 (south alcove).

10. For stucco lattice-work and rosettes of the late Second Style, compare *tepidarium g* of Pompeii I, 6, 2, the House of the Cryptoporticus, illustrated in Harald Mielsch, "Die Römische Stuckreliefs," *Römische Mitteilungen Ergänzungsheft* 21 (1975): 17-18, pls. 1, 2.

11. A practice documented in wall painting of the Second Style and in the Fourth-Style ceilings of Nero's Domus Transitoria in Rome. See Ranuccio

The well-preserved ceiling painting and stucco ornament in the recently excavated Villa of Oplontis add considerably to the corpus of Second-Style decorative ensembles. Unlike the Villa of the Mysteries, whose Second-Style decoration accompanied the remodeling of an earlier building, the Villa of Oplontis was newly constructed around 50 BCE.[12] Although it was considerably enlarged about forty years later, and again around 45 CE, the owner carefully preserved its original Second-Style atrium, *triclinium*, two *oeci* (parlors), and a *cubiculum* (bedroom).

Like cubiculum 16 of the Villa of the Mysteries, cubiculum 11 at Oplontis employs carefully orchestrated ensembles of complementary but contrasting mosaic, painted, and stucco decoration to differentiate the alcoves from the antechamber (fig. 3). Two different patterns in the mosaic *scendiletti* mark the alcoves on the floor.[13] The room's well-preserved stucco moldings and painted barrel vaults over each alcove show how this differentiation of the two spaces on the floor was carried through on the walls and the ceilings. Trompe l'oeil pilasters on the walls of each alcove correspond with the *scendiletto* bands on the floor. They appear to support the heavy stucco architrave and are topped on each side of the alcoves by sections of molding. Supported by consoles, these blocks of molding jut out from the upper cornice of the architrave, like those of *triclinium* 14. Between these jutting sections of molding run the stucco bands that frame the intrados of each barrel vault. Like the *scendiletti* on the floor beneath them, each carries a different design. Whereas dentil ranges and bead-and-reel moldings culminate in alternating squares and diamonds in the north alcove, they end in a band of squares with hollowed-out centers in the east alcove.

The *scendiletti*, pilasters, jutting moldings, and intrados moldings together form a three-dimensional frame defining the entrance to each alcove. As *scendiletto* and intrados bands

Bianchi-Bandinelli, *Rome: Center of Power* (New York: Braziller, 1970), p. 134, fig. 140.
12. Alfonso De Franciscis, "La villa romana di Oplontis," in Helmut Kyrielis and Bernard Andreae, eds., *Neue Forschungen in Pompeji* (Recklinghausen: Bongers, 1975), pp. 9-10; the three successive phases discussed in John R. Clarke, "The Early Third Style at the Villa of Oplontis," *Römische Mitteilungen* 94 (1987): 293-94.
13. Clarke, "Relationships," p. 95 and fig. 4.

differ from one alcove to the other, so do each alcove's wall and ceiling painting. The differences in the wall painting are evident from the photograph.[14]

Cubiculum 11 is unique in preserving the ceilings of both alcoves and the landscape painted in the tympanum of the north alcove. Although both ceilings employ lacunary schemes, they, too, were carefully differentiated. In the north alcove's ceiling two square lacunars appear on the lower part of each side of the vault, followed on each side by two rectangular lacunars of the same width. The illusion of the lacunars' receding planes is carried by shaded stripes ranging in color from light cream to light red to dark red to black. Close observation reveals that these panels were ornately decorated in added gold with tongue and dart moldings.

The ceiling of the east alcove uses the same colors, but in place of the square lacunars on the lower part of each side appear two long rectangular lacunary panels, followed by two sets of three rectangular panels set at right angles to them. The massive paint losses reveal a grid of lines painted in porphyry red that formed laying-out lines for the design.

Although much faded and abraded, the landscape in the north alcove's tympanum reveals another way in which the Second Style employed the new genre of landscape painting. Whereas landscapes appear in the atrium of the Villa of the Mysteries and in the *fauces* of the Samnite House, before the discovery of the Villa of Oplontis they were unknown in *cubicula*. My drawing reconstructs the landscape from both tracings and photomosaics (fig. 4).[15]

In the left half of the picture, eight figures appear in a complex building with columns and architraves situated by a body of water. Scenes of leave-taking to right and left animate the setting. Toward the far right a male standing on a promontory gestures toward the water. At the bottom center a fisherman can be made out, and behind him a figure

14. See also the color plates in De Franciscis, "Oplontis," p. 27, fig. 14; the drawing in Alix Barbet, *La peinture murale romaine: Les styles décoratifs pompéiens* (Paris: Picard, 1985), p. 60, fig. 29, incorrectly reproduces the same stucco pattern for both intrados bands.
15. The drawing in Barbet, *Peinture murale romaine*, p. 60, fig. 29, indicates figures not visible in 1986-88. It is based on a drawing of 1968 by Iorio in the archives of the Soprintendenza Archeologica di Pompei, which I will publish in a forthcoming article.

striding toward the ruined right side of the picture. These few details serve to connect this landscape with the Nilotic tradition; in particular the pavilion by the water compares closely with that of the Barberini mosaic.[16]

Oplontis 11 reveals the richness and variety of detail employed in Second-Style decorative ensembles. The complexity of their architectural illusionism and the competition of mosaic, stucco, and painted patterns, although contrary to modern canons of taste, provided a lively and engaging (but hardly restful) interior decoration. But with Augustus this showy and aggressive decoration would come to an end, to be replaced by a more sober taste. The Third Style was to reaffirm the flatness of the decorated surfaces and to explore further the miniaturism hinted at in Second-Style decorations.

The principal aesthetic premise of early Third-Style painting and mosaics was that the surfaces were once again conceived as flat without, however, reverting to the First Style's literal imitation of marble surfaces in plaster relief. Instead, early Third-Style schemes divided the wall into color fields, typically rectangular panels in black, cinnabar red, or ivory white. Miniaturistic detail abounds, encouraging close viewing.

Oplontis 25, a predominantly white room, occupies the opposite pole of the decorative spectrum from the complexities and bright colors of the villa's Second-Style rooms. Although its walls are badly damaged, room 25's flattened architecture, consisting of gold and light blue pilasters supporting cinnabar red and purple-pink friezes, contrasts strikingly with the boldly illusionistic perspectives of the mature Second-Style rooms. In the mosaic floor, a *scendiletto* design marks the transition from anteroom to the alcove, but without a hint of polychrome shading or illusionism (fig. 5). In fact, the very motif of squares with concave sides and an "L" in their center in this mosaic represents the last vestige of a motif worked out in polychrome mosaics: the shaded lacunar.[17]

16. Giorgio Gullini, *I mosaici di Palestrina, Archeologia Classica,* suppl. vol. 1 (1956), pl. 14.
17. Although Erich Pernice, *Die hellenistische Kunst in Pompeji: Pavimente und figürliche Mosaiken* (Berlin: W. de Gruyter, 1938), p. 143; and Matini, "Mosaico," pp. 511, 514 consider the so-called "L design" to be a novelty

The drawing reveals the reduced architectural scheme of the wall decoration (fig. 6). The dynamics of weight and support, achieved through a regular repetition of supporting columns or pilasters in the Second Style, are gone. Although the architrave is supported by pilasters folded into the north and south corners, with another appearing at the *scendiletto* position, two candelabra occupy the intervals where the other two pilasters should be. Rather than supporting the architrave, they carry fanciful decorations: a floral plaque and an impost block flanked by volutes.

The two whimsical architectural constructions in the upper zone that flank the candelabrum supporting the floral plaque could serve as emblems of the new style: they depict architecture as decoration rather than pretending to be architecture. Although examples of late Second- and early Third-Style paintings with rudimentary architecture in the corners of the upper zone abound,[18] the closest comparison is with the representations of rustic shrines in the sacro-idyllic stuccoes of the villa under the Farnesina, where pavilions like these two appear, self contained, with no attempt made to connect them with the other fictive architecture on the wall. These pavilions in the sacro-idyllic stuccoes have similar partition walls, isolated columns on podia, and silhouetted architraves.[19]

As this modest example demonstrates, the early Third Style of c.15 BCE to c.25 CE reduced architectural members to ribbon thinness and returned the walls to a salutary flatness by avoiding illusionistic architectural perspectives. The only

introduced in the period of the Third Style, M. de Vos has demonstrated its appearance in the period of the Second Style. See Frederic Bastet and Mariette de Vos, *Proposta per una classificazione del Terzo Stile Pompeiano,* *Archeologische Studien van het Nederlands Historisch Instituut te Rome,* vol. 4 (The Hague: Staatsuitgeverij, 1979), pp. 109-10 n. 16.

18. Aula Isiaca, illustrated in Giulio E. Rizzo, *Le pitture dell'Aula Isiaca di Caligola,* Monumenti della pittura antica scoperti in Italia, 3, 2 (Rome: Istituto Poligrafico dello Stato, 1936), fig. 4, pls. II, 1 and 2; Farnesina cubiculum D, right (northeast) wall, illustrated in August Mau, *Monumenti dell'Instituto* 12 (1884), pl. Va; Pompei, Casa V, I, 14-15, illustrated in August Mau, *Die Geschichte der dekorativen Wandmalerei in Pompeji* (Leipzig: W. Engelmann, 1882), pl. VIII.

19. Irene Bragantini and Mariette de Vos, *Le decorazioni della villa romana della Farnesina,* Museo Nazionale Romano 2, 1 *(Le Pitture)* (Rome: De Luca, 1982), p. 193, inv. 1037, pl. 111.

spatial recession occurred when schemes employed illusion-istic landscape pictures framed in aediculae in the center of each wall. The early Third-Style scheme of the well-known paintings from the red cubiculum (no. 16) in the Villa of Agrippa Postumus at Boscotrecase[20] is echoed in room 8 at Oplontis, the *caldarium* of the villa's bath (fig. 6).[21] Both wall painting and mosaic floor are well-preserved, but the painting presents an enigma, since only the socle and median zone are in the early Third Style, whereas the upper zone is painted in the early Fourth of c.45 CE. Since the plaster level is uniform for both styles of painting, the Third-Style areas must be an imitation of the previous decoration,[22] probably executed by the painters of the Fourth-Style decoration found elsewhere in the villa.

Located off a small courtyard, the *caldarium* is paved uniformly with all white tesserae laid at a 45° angle to the long side walls. A geometric mosaic of black triangles marks the threshold of the niche. The side walls and ceiling of the eastern niche are preserved, showing how these surfaces were related by means of a system of rectilinear geometry and stacked aediculae with figures in them. The abundant use of carpet borders for these geometric divisions is charac-teristic of early Fourth-Style decoration. The upper part of the back wall shows a poet with a lyre in a flat aedicula flanked by frontally-represented peacocks. The columns of the poet's aedicula line up with the carpet-border frame around a figure in the ceiling, a Nereid on a marine bull; the framing elements around the peacocks determine the height of the two aediculae in the ceiling, and so on. The width of these lateral ceiling aediculae is determined by that of the aediculae on the walls directly below them.

Such geometric systems of partitioning, encompassing both walls and ceilings, suggest a working practice in which the grid underlying the geometric divisions of the wall was con-

20. Peter H. von Blanckenhagen, *The Paintings from Boscotrecase*, *Römische Mitteilungen Ergänzungsheft* 6 (1962).
21. De Franciscis, "Oplontis," figs. 28-29.
22. Wolfgang Ehrhardt, *Stilgeschichtliche Untersuchungen an römischen Wandmalereien von der späten Republik bis zur Zeit Neros* (Mainz: von Zabern, 1987), p. 34 n. 360; Clarke, "Oplontis," pp. 292-94.

tinued on to the ceiling. Here this grid did not extend to the floor.

This practice of uniting wall and ceiling decoration by means of the same grid is attested in other Fourth-Style rooms of the Villa at Oplontis. For example, the diamond in the center of the ceiling of cubiculum 38, delineated by carpet borders, aligns with the center of the aedicula painted on the wall.[23]

The House of the Stags at Herculaneum, decorated in the late Fourth Style of 62-79 CE, preserves examples of *opus sectile* floors combined with painted walls and ceilings. There metallic-looking bands and carpet borders divide walls and ceilings geometrically. The walls of room 7 employ the dark gray and gold found in the marble floor. The upper zones of the walls are painted the same red as the ceiling.[24] As in the examples at Oplontis, the geometry of the side walls cues that of the ceiling. A helmeted female, perhaps Athena, looks toward the doorway of the cryptoporticus from the center of the ceiling. In room 17 a gray and orange marble floor coordinates with the gray marble wainscotting on the walls and the red-orange painted walls above.

The leap from the mostly single-story, single-family *domus* and *villae* of the Bay of Naples to the brick-faced concrete multi-story and multi-family apartment buildings of Rome and Ostia Antica is a great one. Rational planning, employing forms that were made possible by first-century experiments with vaulted construction in brick-faced concrete, created remarkable new buildings; in the domestic sphere we find multi-family urban apartment dwellings in an astoundingly broad variety of plans. Since Ostia died of simple abandon, unlike the cities of Vesuvius, usually the only protection for painted decoration was in the layers of plaster applied over earlier painting when a wall was repainted. At Ostia, painting of the Antonine or Hadrianic periods is often revealed only when that of a later period, usually of poorer technical quality, peels off.

Located on the northeast corner of the Garden Houses complex, the House of the Muses' carefully orchestrated and generous spaces, decorated with fine mosaics and wall

23. De Franciscis, "Oplontis," fig. 36.
24. Maiuri, *Ercolano*, p. 309, fig. 243; plan p. 303, fig. 240.

12

paintings, tell us that this was a residence for a person of means. Brickstamps date the building to c.128.[25] With each room autonomous in its position around the ample quadriporticus, the house retains many characteristics and special-purpose rooms of the atrium house. It is a measure of the care taken in the planning of the mosaics that their patterns often align with the axes defined by architectural features, such as doorways and windows. Wall painting followed the mosaics, and in several cases it also takes its proportions and geometric divisions from the geometry of the pattern on the floor. These visual harmonies, arising from an acute awareness of how mosaic and painted decoration must complement the architecture of spaces they adorn, reveal the subtlety and sophistication of Hadrianic decorative ensembles.

The first job of pavements is to establish functional hierarchies among the spaces, divided most generally between those of dynamic and static function. The simplest pavements, in all white tesserae, occur in the courtyard and service corridors 14 and 16, followed by the simple all-over pattern in entryway 1. The same design, but used on two different scales, paves both the quadriporticus and 7, a corridor linking 8 and 9 with both *triclinium* 10 and the quadriporticus. Next in the functional hierarchy are all-over mosaics without special features to signal axial divisions: these occur in cubicula 4, 6, and 9, and in room 11, perhaps a service room for *triclinium* 10. Although an all-over pattern without a single center of interest, the mosaic of room 19 has an axial center line that divides the design (and the room) into two parts along its long axis. Someone standing at the doorway would be looking down this center line. Furthermore, the grid of six by seven squares making up this carpet of interlocked meanders fits the room's irregular dimensions so perfectly that one must conclude that the design was tailor-made for the space.

Examination of the compositions of the more complex floors of *tablinum* 15, *triclinium* 10, and the Muses' room 5 make it clear that the mosaicists paid great attention to each

25. Herbert Bloch in Guido Calza, ed., *Scavi di Ostia* I, *Topografia Generale* (Rome: Istituto Poligrafico dello Stato, 1953), p. 223. Bloch assigns this date on the basis of brickstamps of the years 123, 124, and 125 found in the building fabric.

room's proportions and its pattern of doors and windows when designing its mosaic carpet. Room 15's pavement consists of nine squares defined by a grid and emphasized by the same angle-brackets that appear in a mosaics of the "*ospitalia*" of Hadrian's Villa.[26]

There are two possible explanations for the geometric divisions of room 5's mosaic (fig. 8). The fact that the central motifs (six elaborated swastikas) are oriented on the bias obscures the pavement's design around a six-part grid of squares. Whereas two of these swastika squares define the room's short axis, which is also the axis of entry, two bias-laid squares, each with a different design, line up with three eight-part rosettes to define the room's long axis. Since only a window faces the incoming viewer, the long axis, connecting the important central figures in the wall painting, gets the greater emphasis. Recently Carol Watts has offered a second explanation of this pavement, in a discussion of geometrical systems in pavement patterns.[27] Watts proposes that the painters and mosaicists laid out both floor and wall compositions using special geometric proportioning systems.

If Hadrianic classicism stood for the revival of the painting and sculpture of fifth-and fourth-century Greece, the beautiful wall painting of room 5 that gave this house its name is its perfect expression in the realm of interior decoration. In composition, color, and iconographical program the Room of the Muses recalls the distant Greek past while continuing decorative traditions developed from the time of Augustus, proponent of an earlier classicism.

Each wall's tripartite division both horizontally (into socle, median, and upper zones) and vertically (central aedicula with two lateral wings) continues a tradition begun in the late Second Style. The black faux-marble socle highlighted in cream is interrupted by red plinths for the column bases. All

26. Salvatore Aurigemma, *Villa Adriana* (Rome: Istituto Poligrafico dello Stato, 1961), p. 181, fig. 189.
27. Carol Martin Watts, "A Pattern Language for Roman Housing at Pompeii, Herculaneum, and Ostia" (Ph.D. diss., University of Texas at Austin, 1987), pp. 300-306, fig. 211. See also Donald J. Watts and Carol Martin Watts, "A Roman Apartment Complex," *Scientific American* 255, 6 (December 1986): 132-39 for a convincing demonstration of how the "sacred cut" was employed on larger scales, for the plan of a whole house, or on smaller scales, for the proportions of mosaic floors and of the central picture within the design of a whole wall.

14

architectural foreshortening converges at the eye level of the viewer standing in the center of the room, on the central star. Significantly, the system of shading on the architectural members has as its light source this same point in the room's center. As in rooms of the Second Style, bearing elements at regular intervals support the architrave to turn the room into a colonnaded pavilion; here blue pilasters fold into the corners.

Panels of color organize the decorative scheme as much as the architecture. Gold panels with the key figures of Euterpe and Apollo organize the centers of west and east walls, flanked on either side by red panels, each with the figure of a Muse. These red panels turn the corners behind the blue pilasters to frame the other four Muses on north and south walls. Backgrounds for these panels alternate, painted with passages of foreshortened architecture seen through slots, so that gold panels have red grounds and vice-versa. At the same level as the figures of Apollo and the Muses, square blue panels (like those used in room p of the House of the Vettii at Pompeii) interrupt the background architecture. Colors reverse again in the upper zone, with red panels in the center and gold on the sides. The logic and harmony of this system create a stable yet lively structure for the refined images in the centers of each panel.

The Muses, like the architecture, are meant to be seen from the center of the room. Their lighting, however, differs from that of the architecture: with the exception of the Muse of the left panel of the west wall, the figures are always lit from above left. This indicates that different patterns were used for the architecture and the figures and/or that two different artists executed the design.[28]

Paolo Moreno has noted that the order of the Muses, with one exception, follows that of Hesiod's *Theogony*.[29] Since none of the rooms with Muses in Pompeii or Herculaneum follows this order, nor do any have the full complement of nine Muses, this Hesiodic order must have been deliberate.

28. Bianca Maria Felletti Maj and Paolo Moreno, *Le pitture della Casa delle Muse*, Monumenti della pittura antica scoperti in Italia 3, 3 (Rome: Istituto Poligrafico dello Stato, 1967), p. 23.
29. Felletti Maj and Moreno, *Casa delle Muse*, p. 25; Hesiod, *Theogony*, 77-78; the same order followed by the *Anthologia Latina* 684, in J. Wight Duff and Arnold M. Duff, *Minor Latin Poets* (London: W. Heinemann, 1934), p. 634.

That the patron desired this iconographical correctness must have been very impressive to his clients and friends. The room's prominent location, directly across from the *tablinum*, and the clarity of its iconography left no doubt in anyone's mind that this was a room devoted to the Muses and their patron Apollo. This *museion*, more than that of the House of the Menander, proclaimed to all that the owner was a person of high culture, no stranger to the arts of drama, literature, and dance.

Although rigorous analysis reveals formal and iconographic inconsistencies, the Room of the Muses is a precious reminder of the continuities in form, style, and meaning between Romano-Campanian decoration of the first century and Ostian painting of the second century. It communicates better than any extant wall painting the high level of quality maintained in post-Pompeian decoration; and it documents Roman upper middle-class tastes, making the loss of painted decoration from imperial circles, especially that of Hadrian's Villa, all the more lamentable.

Originally built as a modest private residence in the Hadrianic period, the structure known as the Inn of the Peacock was enlarged and redecorated in the Severan period. It remained a private house until c.250 CE, when it was transformed into a tavern (*caupona*) and inn. Although nothing of the Hadrianic decorative program survives, the pavements and wall paintings of the Severan redecoration campaign characterize the structures and aesthetics of decorative ensembles between c.200 and 220.

Aside from their proving the coexistence of two different fashions in the wall painting of the Severan period, these rooms of the Inn of the Peacock also document the pavement designs that coordinated with the wall painting.[30] The finest mosaic, in *tablinum* 8, has the same interchangeability of white and black forms as that of room 10 (fig. 9). The tesserae are smaller than those of the other contemporary

30. Giovanni Becatti, *Scavi di Ostia*, 4, *Mosaici e pavimenti marmorei*, (Rome: Istituto Poligrafico dello Stato, 1961), pp. 176-77 dates all the paintings and mosaics of the Inn of the Peacock to the mid-third century. His dating must be rejected on the basis of Carlo Gasparri, *Le pitture della Caupona del Pavone*. Monumenti della pittura antica scoperti in Italia 3, 4 (Rome: Istituto Poligrafico dello Stato, 1967).

mosaics of the house, ranging from 1.2 to 1.8 cm. Both the black and the white shapes, bold and unusual in form, take up the same amount of space in the design. Whereas the Hadrianic mosaics of the House of the Muses, for instance, were based on *lines* of tesserae that drew the grid-based designs, room 8's pavement uses black and white *shapes* that are completely equivalent. The design spreads outwards from the center, marked by a white square, but immediately the eye has the choice of either seeing the black forms or the white ones as alternatively figure and ground.[31] This reciprocal relationship between white and black shapes destroys the grid with its big, bold, curvilinear and eye-teasing pattern.

It is unfortunate that the wall painting of *tablinum* 8 was discovered in such ruined condition, since what remains suggests that it was a highly refined decoration. Resting on the socle, crudely repainted in the mid-third century to simulate yellow marble, six plinths sustain six columns that divided the room's long east and west walls into seven sections. Three thin black lines topped by a thick one show through the top of the faux-marble socle; they originally defined the lower edge of the podium beneath the columns. Whereas the two pairs of columns to north and south of the center seem to have been doubled by flanking pilasters, a scheme common in the Second Style, the middle pair that frame the central panel are isolated. Surrounded by gold molding and set against a black ground, the porphyry-red central panels on the west, south, and east walls held images of male togate figures. Remains of an architrave rendered in perspective over the central panels may indicate that the columns carried further perspectives in a lost upper zone. Even from the eroded fragments that remain it is clear that room 8's decoration drew upon the full repertory of architectural and figural motifs first explored in the period of the Second Style.

Because room 9 had a higher ceiling than *tablinum* 8 the painter designed a wall decoration with an especially tall

31. The design of the mosaic found in the Domus Aripporum et Ulpiorum Vibiorum in Rome is nearly identical: Marion E. Blake, "Pavements of the Third Century in Italy," *Memoirs of the American Academy in Rome* 17 (1940): 88, pl. 15, figs. 1-4 .

median zone consisting of two orders of panels to compensate for this added height (fig. 10). It is immediately evident that the artist has done away with the columns, pilasters, architraves, and false doors that structured the decoration of *tablinum* 8. Instead, panels of different colors, sizes, and shapes activate the walls like the patches on a quilt. Although the short north and south walls have essentially the same scheme, organized around a white panel below, the big white panels are not centered on the walls, nor do the panels above match each other with the kind of axial symmetry that had governed Roman wall-decorative schemes since the first century BCE. The tendency to dismantle this age-old tradition of axial symmetry, already nascent in the *tablinum* of the House of Jupiter and Ganymede twenty years before, asserts itself stridently in this little room.

The black-speckled gray socle, deliberately flat and neutral, coordinates with the marble floor without representing a podium. Asymmetry, rather than the foursquare division of the wall with the plum-bob and straightedge, rules the size and placement of the panels. The color scheme, like that of late Antonine decoration, is predominantly warm, the panels alternating between porphyry red and gold, some framed in cream white and blue-green. Several panels of the upper level have curved tops, and the panel on the north wall with a male in a white toga is out of square. These asymmetries and misalignments have the effect of detaching the panels from the flat surface of the wall. The greater the irregularities in respect to the imaginary grid of perfect horizontals and verticals, the more animated the panels – and the figures on them – become. Like the eighteenth-and nineteenth-century galleries with pictures stacked vertically from floor to ceiling, the odd sized and shaped panels in room 9 are like tesserae in a mosaic of pictures that covers the walls. Their variety of shapes and occasional misalignments emphasize that they are autonomous, individual units rather than part of a preconceived, flat grid.

As in *tablinum* 8, the figural and decorative motifs come from a variety of sources. The decorative ensembles of the Severan period in the Inn of the Peacock document, like the figurative arts of the time, the coexistence of two different aesthetics. Gasparri's characterization of the master working

18

in room 9 underscores his participation in a new fashion.[32]
The disappearance of architecture is not only a result of the
small size of the space but bears witness to a different taste,
here manifested in a completely coherent fashion. In this style
the convention of the wall conceived as illusionistically open
and articulated by architecture is broken, composing on it
instead panels and pictures as in a piece of fabric or a
multicolored carpet.[33]

This brief survey reveals patterns of both continuity and
innovation in the decorative ensembles of Roman houses.
The principals of using wall, floor, and ceiling decoration to
divide spaces according to function continue into the third
century, and the notion of transforming the room into a
colonnaded pavilion appears as late as 230. The most
decisive break in wall painting occurs in the white-ground
Streifenlinien, or "stripe-line" style of the late Severan period,
best seen in the Villa Piccola under San Sebastiano;[34] it
coincides with the decline of black-and-white mosaic floors.
In the early fourth century a new aesthetic arises; it develops
with the influx of new patronage from the north African and
eastern provinces, spelling an end to the essentially native
Italian traditions in domestic decoration outlined here.

32. Gasparri, *Caupona del Pavone*, p. 32.
33. Ibid.
34. Fritz Wirth, *Römische Wandmalerei vom Untergang Pompejis bis ans Ende des dritten Jahrhunderts* (Berlin: Verlag für Kunstwissenschaft, 1934), p. 166.

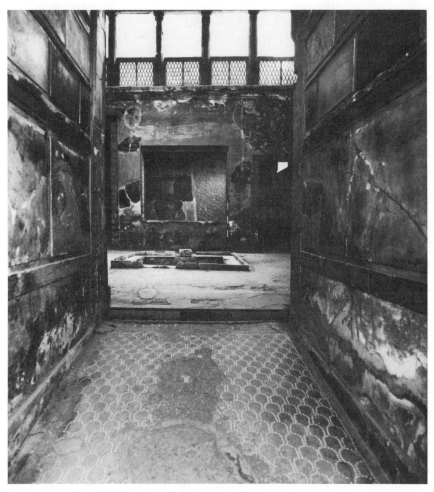

Fig. 1. Herculaneum, Samnite House, west wall of atrium and *fauces*.
(Michael Larvey)

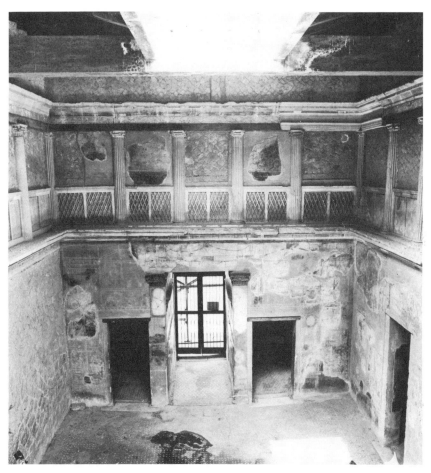
Fig. 2. Herculaneum, Samnite House, *fauces*. (Michael Larvey)

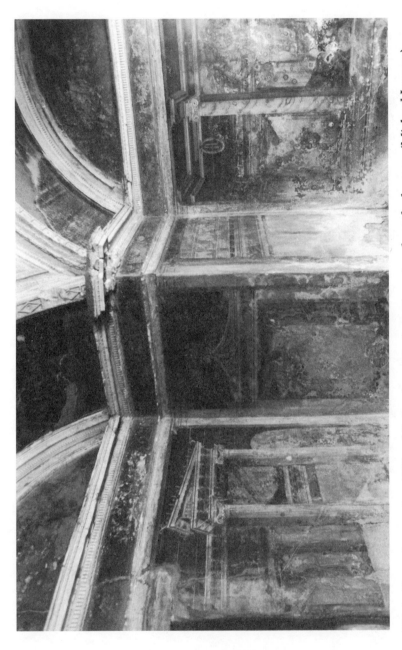

Fig. 3. Torre Annunziata, Villa of Oplontis, cubiculum 11, east and north alcoves. (Michael Larvey)

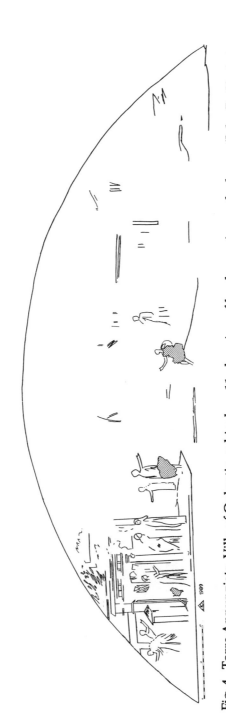

Fig. 4. Torre Annunziata, Villa of Oplontis, cubiculum 11, drawing of landscape in north alcove. (John R. Clarke)

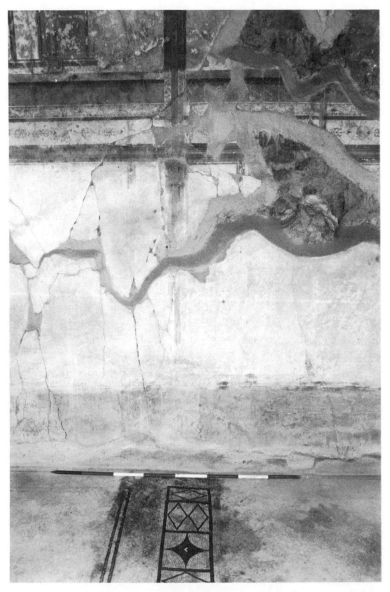

Fig. 5. Torre Annunziata, Villa of Oplontis, cubiculum 25, meeting of mosaic *scendiletto* with painted pilaster. (Michael Larvey)

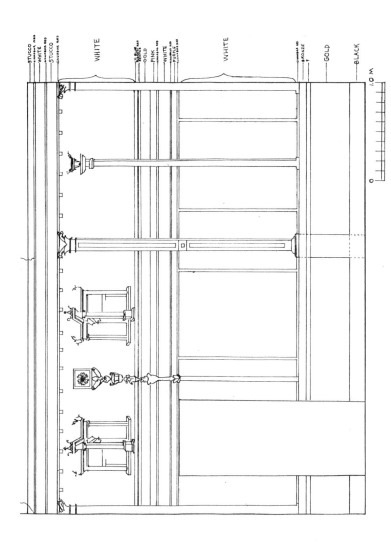

Fig. 6. Torre Annunziata, Villa of Oplontis, cubiculum 25, drawing of west wall. (John R. Clarke)

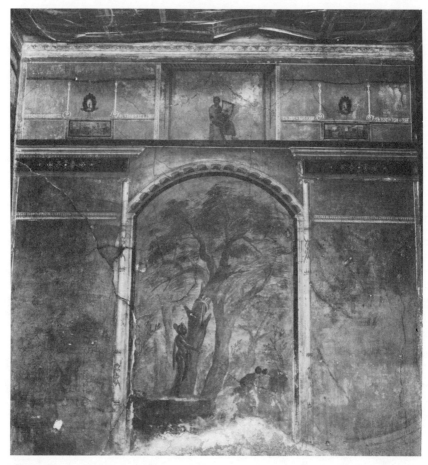

Fig. 7. Torre Annunziata, Villa of Oplontis, caldarium 8, east wall. (Michael Larvey)

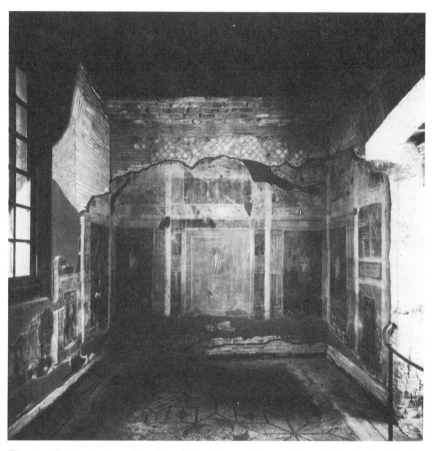

Fig. 8. Ostia Antica, Insula of the Muses, Room 5, eastern half of room. (Istituto Centrale per il catalogo e la Documentazione E-40673)

Fig. 9. Ostia Antica, Inn of the Peacock, room 8, east and south walls. (ICCD E-40937)

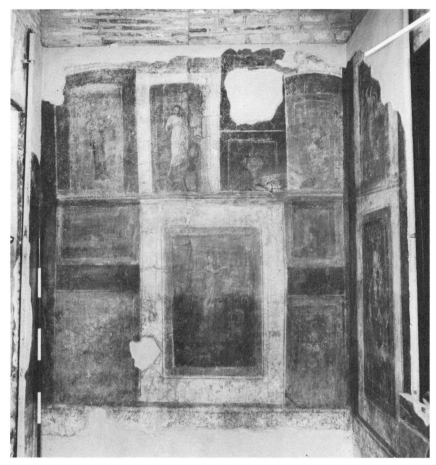

Fig. 10. Ostia Antica, Inn of the Peacock, room 9, north wall. (Michael Larvey)

II

Pegasos and the Seasons
In a Pavement
From Caesarea Maritima*

MARIE SPIRO

During the excavations of the Joint Expedition to Caesarea Maritima in Israel, a damaged mosaic was brought to light in a room belonging to a secular building (fig. 1). The center of the room was destroyed by the installation of a later drain. The pavement contains a field design of five panels and meander swastikas, and a wide border with an oblique grid. In all probability, the border extended around three sides of the field and was absent from the fourth side in front of the main entrance to the room. The panels with their Greek inscriptions were oriented toward this entrance. This project involves an analysis of the iconography, style, and architectural context of the pavement and an examination of its meaning and chronology. My research to date has largely centered on the first three areas.[1]

* The text of this article is unchanged from the presentation at *IL60*. The discussion at that time offered many avenues of research, almost all of which are still under consideration.
1. For background see Salvatore Aurigemma, *L'Italia in Africa: Le scoperte archeologiche. Tripolitania* I. *I monumenti d'arte decorativa,* Parte prima *I mosaici.* (Roma: Instituto Poligrafico dello stato, 1960); Hugo Brandenburg, "Bellerophon christianus? Zur Deutung des Mosaiks von Hinton St. Mary und zum Problem der Mythendarstellungen in der kaiserzeitlichen dekorativen Kunst," *Römische Quartalschrift* 63 (1968): 49-86; Robert L. Bull, "Caesarea Maritima – The Search for Herod's City," *Biblical Archaeology Review* 8 (May/June 1982): 22-40; Jean-Pierre Darmon, *Nymfarum Domus. Les pavements de la maison des Nymphes a Néapolis (Nabeul, Tunisie) et leur lecture* (Leiden: E. J. Brill, 1980); Wladimiro Dorigo, *Late Roman Painting* (London: J. M. Dent,

The iconographic and inscriptional evidence clearly establishes the general theme of bounty and fertility. The four corners of the field originally contained winged female busts of the Seasons of which two are preserved. In the lower right corner of the room, Spring (fig. 2) is shown in three-quarter view wearing white button earrings and a sleeveless blue and green garment that is attached at both shoulders with yellow fibulae. Beside her rests a wicker basket filled with red and pink roses. A wreath of roses also adorned her head, of which parts survive on her right side. Part of an inscription in the right corner of this panel contains traces of an H, A, P, I [] for HAPI[NH]. Although no trace of an inscription is preserved in the second panel (fig. 3), the Season's attribute of millet-like reeds clearly establishes her identity as Winter. Because of the fractured surface on the left part of the panel, it is difficult to determine whether she wore a mantle, another common attribute of this cold and barren Season. There is evidence that Winter, like Spring, was crowned with a wreath and wore button earrings. The panels with Winter and Spring in diagonal corners of the field were accompanied by two other panels. In the upper right corner (fig. 1) there are preserved traces of the last five letters of an inscription: []EPINH. With the addition of a Θ at the beginning, the inscription informs us that ΘEPINH, Summer, occupied this panel. Fall must have been placed in the fourth panel at the lower left corner. The seasonal quartet, therefore, comprised Winter and Summer in the top row and Fall and Spring in the bottom row, an extraordinary arrangement since Seasons are usually arranged concentrically in chronological order. The only other exception to the normal sequence can be found in a pavement from Djebel Oust in

1971); Charles T. Fritsch, ed., *The Joint Expedition to Caesarea Maritima* I. *Studies in the History of Caesarea Maritima* (Missoula, MT: Scholars Press, 1975); Gherardo Ghirardini, "Gli scavi del palazzo di Teodorico a Ravenna," *Monumenti Antiche* 24 (1916): 738-838; George M. A. Hanfmann, *The Season Sarcophagus in Dumbarton Oaks* (Cambridge, MA: Harvard University Press, 1951); Stefan Hiller, *Bellerophon. Ein griechischer Mythos in der römischen Kunst* (Munich: Fink, 1969); Kenneth G. Holum, Robert L. Hohlfelder, Robert J. Bull, and Avner Raban, *King Herod's Dream: Caesarea on the Sea* (New York: W. W. Norton, 1988); Irving Lavin, "The Hunting Mosaics of Antioch and their Sources," *Dumbarton Oaks Papers* 17 (1963): 181-286; Doro Levi, *Antioch Mosaic Pavements* (Princeton: Princeton University Press, 1947); and Nikolas Yialouris, *Pegasus: The Art of the Legend* (Kent: Westerham Press, 1975).

Tunisia where Autumn and Spring are paired in one row and Winter and Summer in the other.

The placement and case of the inscriptions furnish additional information on the specific meaning of the Seasons. In all probability, the inscriptions were situated on the right side of the panel. Since the first letter, H, of Spring and the second letter, Θ, of Summer are both on the right side, it appears that the entire inscription naming the Season was complete on one side of the figure. Furthermore, the adjectival form, INH, is used, not the nominative case, which would have read ΘEPOC or ΘHPOC (Summer), and HAEP or EAP (Spring). Of course, there are late pavements in which an adjective is used in place of the noun; but the combination of location and case of the inscriptions at Caesarea seems to suggest the presence of another word on the left side of the panels. WPH (Season) or TPOПH (Equinox, Solstice) would be quite appropriate in this context. Indeed, a distinction between these two cases is illustrated on a pavement from the Tomb of Mnemosyne at Antioch, where Winter and the Winter Solstice are juxtaposed (fig. 4).

A complete reconstruction of the destroyed central part of the pavement (fig. l) is somewhat tentative at this stage in my research. There are, however, traces of two inscriptions that may well reveal the size and the iconography of this panel. The composition extended the full length of the field, that is up to the ends of the panels with Winter and Spring. Its original width is probably defined by a fragment with an inscription in the lower left corner that reads KAPПO[]. KAPПOI or KAPПOΦOPOI were personifications of the fruit of the earth or figures with similar attributes of a vegetable character. Their presence compliments the cycle and theme of the Seasons in the corners. One wonders if they, as the issues of *Ge*, were accompanied by an image of this popular personification of bounty.

In another inscription toward the center of the room, immediately above the drain lids, the first two letters and the last three letters are preserved: ПH[..]COC. The two very damaged letters between them were probably a Γ and an A. The inscription must have read, therefore, ПH[ΓA]COC, referring to the winged horse of mythology.

There are two scenes associated with the Pegasos story in mosaic pavements. In one, the horse is being groomed and/-or adorned by two or more nymphs. In another, more popular, scene Bellerophon is slaying the Chimera. Because of the shape and length of the panel, it is probable that Pegasos and the Nymphs were represented, with the figures spread across the surface. A mosaic from Leptis Magna (fig. 5) may well reflect the original subject and composition. It is unlikely that a scene with Bellerophon and the Chimera decorated this area because the composition is narrow, usually vertical, and limited to the three figures (fig. 6). Furthermore, the location of the Pegasos inscription so close to the border precludes, in my judgment, a satisfactory position for the rider, Bellerophon, or, for that matter, his inscription.

The iconography of the whole pavement from Caesarea is exceptional. Thus far, I have found no other program that contains this Pegasos story and seasonal images identified by inscription. The absence of this kind of definite statement in other examples of the same scene does not mean that there was no cosmological meaning. Further research and an examination of the attributes of the Nymphs will probably uncover seasonal allusions of a more subtle nature. Furthermore, there is evidence that the Bellerophon and Chimera myth was associated with "the theme of the fertility of nature and the gifts of the Seasons." In a pavement from Lullingstone (fig. 7) and one from the trefoil hall of the so-called Palace of Theodoric at Ravenna, this scene was flanked by the Seasons in the corners. No ΚΑΡΠΟΙ were present, however, unless they are represented by the Erotes who stand between the corner medallions with the Seasons at Ravenna.

The style of the Seasons (figs. 2, 3), which differs for each image, is as exceptional as the iconography. Spring is classical with a rather subtle modeling of the flesh tones and of the texture of her grey and brown left wing. She is a well proportioned, sensuous woman who symbolizes the fertility of the earth at the onset of the warm months. Winter, on the other hand, is a harsh-looking woman with sharply defined features, outlined in grey, and wide, averted eyes that are lifeless in comparison with those of Spring who gazes at us with utmost confidence beneath heavy, seductive lids. Even

Winter's eyebrows have been reduced to checkerboard rows of grey, red, and ochre tesserae, and the color of her preserved wing is a cold blue and grey. Spring's face is alive with color and bright marble highlights. The colors are muted and somber in Winter's face, and the highlights are executed in a dull limestone. Stylistically, only Winter reflects the date of the mosaic which, on secure ceramic evidence, belongs to a period between 450 and 550. She is somewhat closer to the representations of the Seasons from the sixth century (fig. 8) and probably should be dated to that period. Spring, ostensibly, belongs to the past and has no stylistic counterpart among similar personifications from this period.

Archaeological and other evidence confirms that the Seasons were executed in the same period and by the same mosaicist. The foundations of the panels are the same, the material and size of the tesserae are identical, and both images show the same technical excellence. Furthermore, they are similar in their physiognomy, shading, and hair style. The differences, therefore, are intentional. The mosaicist has deliberately tried to represent the physical quality of the climate each personification represents: a harsh, colorless, and abstract image for a cold season; a sensuous, active, and classical one for a season signalling rebirth and fertility. By employing different artistic modes, he intended to communicate the meaning of seasonal change in visual terms. To a far lesser extent, other mosaicists have shown differences among seasonal representations by means of attributes, skin color, and garments, but the style almost always remains the same (fig. 8). There is a pavement from the House of Dionysos on Cyprus in which there is a sharp difference between Winter and the other Seasons. It appears to be a question of different models rather than different modes. (This mosaic has been very little studied.)

The room with our pavement occupies a site overlooking the Mediterranean and is located in a sector of the city that yielded evidence of official and public buildings belonging to various periods. By virtue of its location and vista, and the exceptional iconography, style, and quality of the pavement, the room must have belonged to a very important building, and one probably directly involved with the activities of the governor. The room may have served as a reception hall

35

with benches on three sides for the visitors to sit and view the visual symbols of a beneficent governor, servant of the emperor. Each important participant in this official message is identified by inscription so that the meaning of the pavement was made clear to them. The Seasons and the ΚΑΡΠΟΙ remind the viewer of the bounty and fertility of nature and, therefore, of the happiness and good times brought about by good government. Joining them in this example of artistic propaganda was Pegasos, who, with his wings, may have symbolized in the most general terms the sun or the renewal of life.

DESIDERATA

1. The uses and meaning of Pegasos in official art; an examination of the coinage of the period.

2. The unusual sequence of the Seasons' panels. Is there a reason? Was it determined by the iconography and meaning of the Pegasos scene?

3. The style of Spring. Does it reflect a survival or revival of the the classical style in official art?

4. Can one make a distinction between imperial art and official art in the decoration of civic buildings?

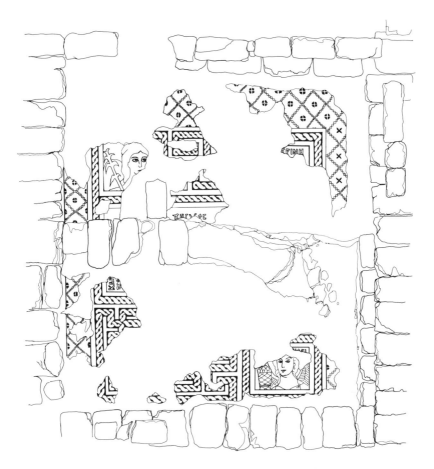

CAESAREA MARITIMA
FIELD C, AREAS 22, 25
Seasons Mosaic 1:20

RBA 1988

Fig. 1. Caesarea Maritima, Governor's Palace? Reception Room, pavement. *Winter and Spring*. Joint Expedition to Caesarea Maritima (JECM). (Roberta Bliss Albert Drawing)

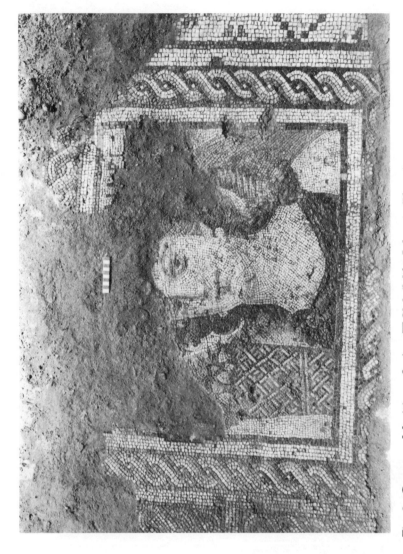

Fig. 2. Caesarea Maritima, *Spring*. JECM. (Mike Johnson Photo)

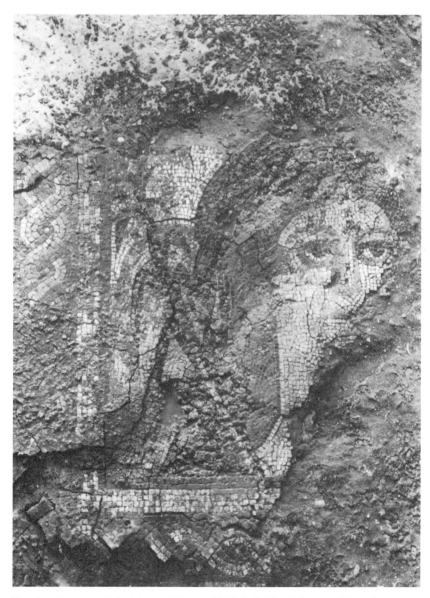

Fig. 3. Caesarea Maritima, *Winter*. JECM. (Mike Johnson Photo)

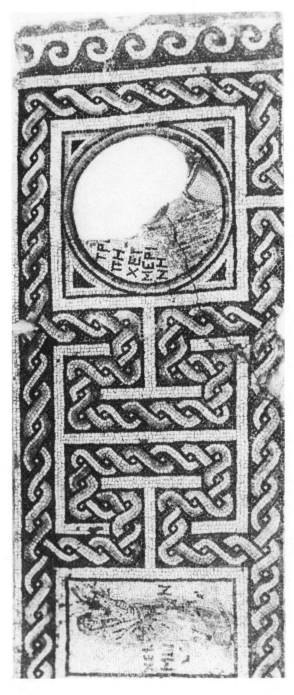

Fig. 4. Antioch, Necropolis of Mnemosyne, *Winter and the Winter Solstice.* (Courtesy Mead Art Building, Amherst College)

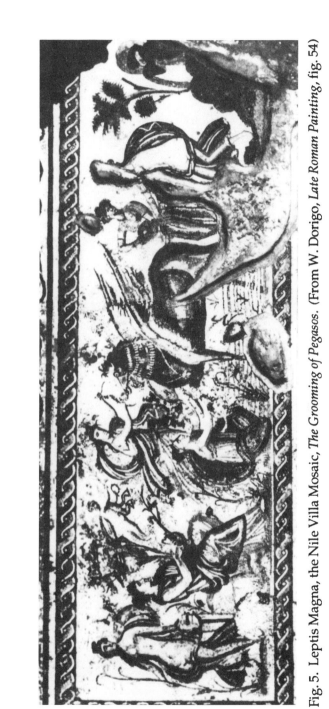

Fig. 5. Leptis Magna, the Nile Villa Mosaic, *The Grooming of Pegasos*. (From W. Dorigo, *Late Roman Painting*, fig. 54)

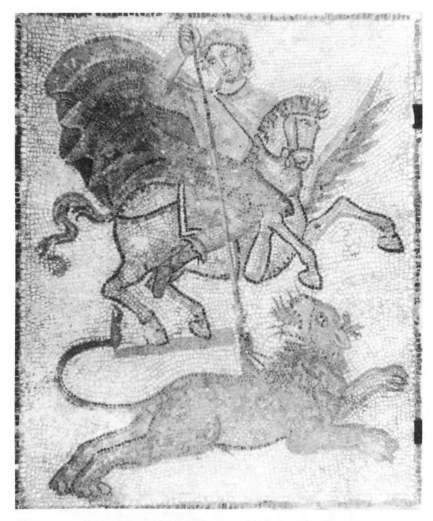

Fig. 6. Pandorf, *Bellerophon Slaying the Chimaera.* (From N. Yialouris, *Pegasus: The Art of the Legend*, fig. 72)

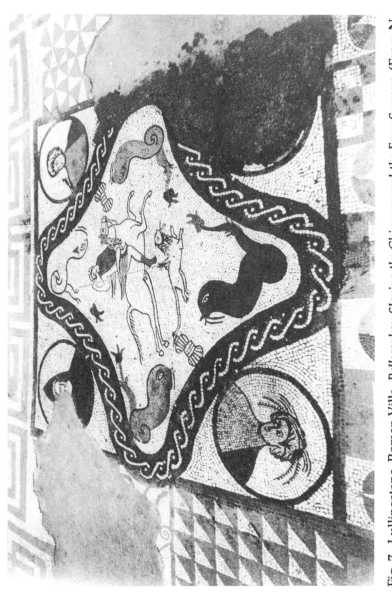

Fig. 7. Lullingstone, Roman Villa, *Bellerophon Slaying the Chimaera and the Four Seasons*. (From N. Yialouris, *Pegasus*, fig. 77)

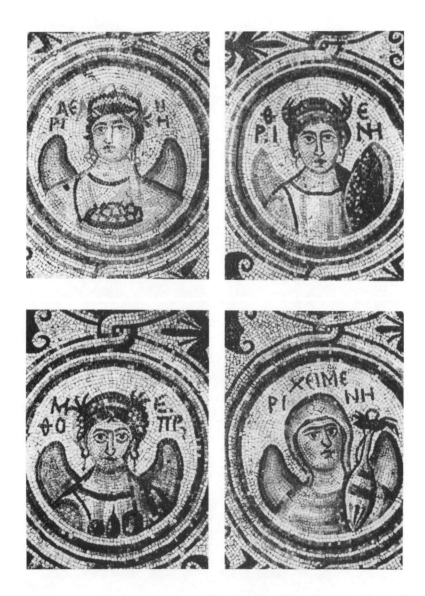

Fig. 8. Kabr Hiram, Christian Church, *The Four Seasons*. (From G. Hanfmann, *The Season Sarcophagus in Dumbarton Oaks*, 2: figs. 117-20)

III

The Madonna del Coazzone And the Cult of the Virgin Immaculate In Milan and Pavia*

EDITH W. KIRSCH

Exhibited in the former ducal chapel of the Castello Sforzesco in Milan is a life-size marble sculpture of a young woman that was deposited in the museum in 1864 by the Fabbrica of the Cathedral of Milan (figs. 1-5).[1] The figure stands in a

* I am indebted to all who commented on this paper at the IL60 Colloquium. As always, many of the most pointed and "door-opening" remarks came from Irving Lavin. For kind assistance, including permission to photograph the Madonna del Coazzone, I thank Dottoressa Maria Teresa Fiorio, Conservatore, Museo del Castello Sforzesco. A Benezet Summer Research Stipend from The Colorado College supported the writing of this paper.

1. Appendix, Doc. 10. All the documents in this appendix are from the *Annali della Fabbrica del Duomo di Milano dall'origine al presente*, 6 vols. and Appendices, 2 vols. (Milan: Fabbrica della Veneranda Fabbrica del Duomo, 1877-1885). Docs. 1-7 are published by Diego Sant'Ambrogio, "Una speciale raffigurazione iconografica di Madonna e la Duchessa Caterina Visconti nella Certosa di Pavia e nel Duomo di Milano," *Rivista di scienze storiche* 1, 1 (1904): 106-22 (documents on 121-22); Docs. 8 and 9 are published by Enrico Cattaneo, "Maria SS. nella storia della spiritualità milanese," *Ambrosius* (1954): 334-85 (350-55 for the Madonna del Coazzone). Doc. 10 has been published previously only in the *Annali*.

Variations in the spelling of *coazzone* in the documents probably reflect the fact that the term seems to be rooted in the word *coaz* (from *coda*, or tail) in Milanese dialect. The term *coazias* occurs in a Milanese sumptuary law of 1396, printed in 1480, prohibiting prostitutes from wearing "*coazias pendentes*." On this see Ettore Verga, "Le leggi suntuarie milanesi: gli statuti del 1396 e del 1498," *Archivio storico lombardo* 25 (1898): 5-79 (40-42 for "*coaz.*") Verga (p. 42) asserts that the Milanese term refers to hair parted in the center, fastened at the nape of the neck, braided, and allowed to flow "*a raggiera*" (in rays) down

rigid, frontal pose, head tilted back as she gazes upward, with her hands joined in prayer. Most of the left arm is missing; the long belt, tight at the waist and extending to the ground, is broken; the hair, extraordinarily long down the back, is also damaged. An iron brace, as well as rough marble at the back of the sculpture, indicates it was once attached to a support. This remarkable figure has received scant attention since 1904, when Diego Sant'Ambrogio identified it, correctly, I believe, with the "figurae marmoris nuncupatae dom. S. Mariae de quazone" for which the *Annali* record payment to the architect and sculptor Pietro Antonio de Solari in 1485.[2] If the identification is correct, and the Castello Sforzesco sculpture is indeed "S. Mariae de quazone," the sculpture takes on importance not only for its beauty but also as an early instance of a life-size, three-dimensional representation of the Virgin without the Christ child and perhaps the earliest instance of a free-standing sculptured altarpiece in the cathedral of Milan.[3] As

the back, a definition that aptly describes the coiffure of the Castello Sforzesco Madonna (fig. 4).

In view of the hypothesis to be developed below that the Castello Sforzesco sculpture represents a particular type of the Virgin Immaculate that emphasizes her role as co-redemptrix with Christ, Professor Marilyn Aronberg Lavin has suggested that the term for a braided hair style from which the sculpture takes its name alludes also to the interweaving of this Virgin's role in salvation with that of Christ. To Marilyn Lavin I am indebted not only for this suggestion but also for many others that helped shape this paper.

2. The fundamental publications on the Madonna del Coazzone are those of Sant'Ambrogio, and of Johann Graus, "S. Maria im Ährenkleid und die Madonna cum cohazono vom Mailänder Dom," *Kirchenschmuck* 35 (1904): 59-95, 101-14; and idem, in the same volume, "Strassengel und St. Maria im Ährenkleide," pp. 1-8. More recently, see Cattaneo, "Maria SS.;" Herbert von Einem, "Die Menschwerdung Christi des Isenheimer Altares," in *Kunstgeschichtliche Studien für Hans Kauffmann*, ed. Wolfgang Braunfels (Berlin: Gebruder Mann, 1956), pp. 152-71; and Albert Walzer, "Noch einmal zur Darstellung der Maria im Ährenkleid," in *Festschrift zum 60. Geburtstag von Werner Fleischauer* (Constance: Thorbecke, 1964), pp. 63-100. See also Alois Thomas, "Ährenkleid Madonna," in *Lexikon der christlichen Ikonographie* 1 (1968): 82-85. For the document of payment to Solari, see Appendix, Doc. 6.

3. There are no other three-dimensional altarpieces of the fifteenth century in the cathedral known to me. The Visconti family seems to have pioneered the commissioning of such free-standing altarpieces. A notable instance is the monumental equestrian sculpture of Bernabò Visconti by Bonino da Campione, now also in the Castello Sforzesco. As early as 1363, it stood in the apse of Bernabò's parish church, San Giovanni in Conca, probably behind the high altar. See Costantino Baroni, *Scultura gotica lombarda* (Milan: E. Bestetti,

interesting as these aspects of the sculpture are, I have chosen to focus here on demonstrating 1) that the Castello Sforzesco Madonna occupies a central position in a widely diffused type of the Virgin Immaculate that seems to have originated in, or at least was focused on, Milan; and 2) that the sculpture embodies salient characteristics of Visconti-Sforza patronage evident also in the Certosa of Pavia.

Pietro Antonio Solari was primarily an architect, active in Milan and elsewhere in Lombardy, though he is best remembered as architect of the Kremlin walls in Moscow, where he went in 1490 and apparently died in 1493.[4] Malaguzzi Valeri attributed to Solari a relief that he identified as part of the tomb of Marco de Capitani (d. 1478), archbishop of Alessandria (fig. 6), for whose tomb Pietro Antonio Solari was paid one hundred gold ducats on March 7, 1484. What remains of this damaged relief sculpture is qualitatively inferior to the sculpture in Milan. On the other hand, the sculptures share certain characteristics. Both the statue and the relief have the exceptionally large hands upon which Malaguzzi Valeri (who was apparently unaware of the Madonna del Coazzone) commented. In addition, both exhibit the stylistic quality that Malaguzzi Valeri characterized as *retardataire*, associating it with the Campionese tradition in Milanese sculpture from which Solari's immediate predecessors and contemporaries, led by Cristoforo Mantegazza, had radically departed.[5]

Both Sant'Ambrogio and Cattaneo have suggested that the Castello Sforzesco Madonna, as well as two other lost

1944), pp. 110-15; Baroni, "Scultura gotica," in *Storia di Milano* 5 (Milan: Fondazione Treccani, 1955), pp. 808-9; and Gian Alberto Dell'Acqua, "I Visconti e le arti," in *I Visconti a Milano* (Milan: Cassa di risparmio delle provincie lombarde, 1977), pp. 161-65.

4. See Francesco Malaguzzi Valeri, "I Solari, architetti e scultori lombardi del xv secolo," *Italienische Forschungen* 1 (1906): 112-32 (131-32 for sculpture). For further bibliography, almost all of it focused on architecture, see Ulrich Thieme and Felix Becker, *Allgemeines Lexikon der bildenden Künstler*, vol. 31 (Leipzig: E.A. Seemann, 1937), p. 231. Malaguzzi Valeri's attribution to Solari of the Alessandria relief discussed here has been accepted but not expanded upon by later scholars.

5. In a most helpful discussion of the two sculptures attributed to Pietro Solari, Professor JoAnne Gitlin Bernstein informed me that she regards this style not so much as a continuation of the Campionese tradition, but rather as a reflection of a renewed interest in fourteenth-century Tuscan sculpture, especially the work of Giovanni di Balduccio, in mid-fifteenth-century Milan.

works with which it is associated in the *Annali*, takes her name from the style of her hair, variously described in the documents by the noun *coazono, cohazono, covazono,* and *quazono*.[6] The coiffure is indeed remarkable. Parted in the center and flat on top, the hair descends in two heavy corkscrew curls (both damaged) framing the Madonna's face, and in a very long central braid that cascades down her youthfully springy back, with three long curls to either side of it (figs. 3, 4). The Madonna's gown is also distinctive, meticulously patterned with sprays of wheat (enclosed in pods on the skirt), stars, rosettes, acanthus scrolls at the wrists, and, at the lower hem, a three-tiered, peacock-feather motif known from classical mosaics.[7] The gown is further adorned by a large collar of undulating rays.

From the *Annali* we learn that the Fabbrica decided in March 1479 to consider *"su quel altare"* (on, or above, which altar) to place, in view of the public, a marble statue that they intended to commission. This new figure would be a replacement for a Madonna *"a quazono"* especially venerated by Germans, at one time affixed to a pilaster in the cathedral, but lost during the rebuilding of the Duomo that began in 1386.[8] A document of 1465 informs us that the old sculpture, which had performed many miracles, was made of silver and gilded with stars.[9] This document, like three others – one of 1464 and two of 1466 – refers to another replacement for the lost Madonna, a panel painting commissioned from Cristoforo de Mottis, active as a painter in both the cathedral of Milan and the Certosa of Pavia.[10] The painting, which was to represent the Madonna with *"cohazono,"* gilded stars, and a diadem, was probably completed in 1466. The fate of

6. See Appendix, Docs. 1-9.
7. On the peacock-feather motif, see Asher Ovadiah, *Geometric and Floral Patterns in Ancient Mosaics* (Rome: "L'Erma" di Bretschneider, 1980), pp. 154-55, where it is identified as imbrication (scale-pattern). Ovadiah accepts the suggestion of earlier scholars that this pattern arises from incised metal-work. As we shall see below, the Madonna del Coazzone probably replaced a lost metal sculpture. For the reference to Ovadiah, I thank Professor Gloria Merker, to whom I am also grateful for knowledge of the work of Torelli cited in note 31 below as well as for discussions of Roman bridal imagery and of the original placement of the Castello Sforzesco sculpture.
8. Appendix, Doc. 5.
9. Appendix, Doc. 2.
10. Appendix, Docs. 1, 3, 4.

Cristoforo's painting is unknown, and we cannot be sure why the Fabbrica decided in 1479 to commission a marble sculpture of the same subject. If, as will be argued below, the Madonna del Coazzone is an image of the Virgin Immaculate, it is possible that the decision of the Fabbrica to dedicate an altar to her and to commission a life-size, three-dimensional sculpture as the altarpiece was related to the earliest papal recognition of the cult of the Virgin Immaculate, the consent to a mass and office of the Immaculate Conception granted by the Franciscan pope, Sixtus IV, in 1476.[11] The *Officium Immaculatae Conceptionis*, composed by another Franciscan, Bernardino de Bustis, received the approval of Sixtus IV in a bull of October 4, 1480, one year after the decision of the Fabbrica.[12]

In any event, Pietro Antonio de Solari was paid in April 1485 for a marble figure of "S. Mariae de quazono," and in April 1487 the brothers Johannes Bernardino and Johannes Stephano de Scotis were paid for gilding this image.[13] Finally, in July 1487 and July 1488, the smith, Joseph de Ferrariis, received payment for gilding a moon at the feet of "S. Mariae de quazono."[14] The altar selected for the Madonna del Coazzone was almost certainly the eighth in the south aisle, just in front of the transept.[15] In 1497 Archbishop Antonio Arcimboldi rededicated this altar to Santa Maria della Neve, and some time between 1560 and 1584

11. *Oxford Dictionary of the Christian Church*, 2d ed. (New York and Oxford: Oxford University Press, 1974), s.v. "Immaculate Conception of the BVM," pp. 692-93.
12. Antonio Alecci, "Bernardino de' Busti," in *Dizionario biografico degli italiani* 15 (1972): 593-95 (595 for the Mass and Office of the Immaculate Conception).
13. Appendix, Docs. 6 and 7.
14. Appendix, Docs. 8 and 9.
15. For the source of this hypothesis, see Giovanni Jacopo Besozzo, *Distinto raguaglio dell'origine e stato presente dell'ottua marauiglia del mondo...volgarmente detta il duomo di Milano* (Milan: Pietro Antonio Frigerio, 1739), pp. 46-48; and *Annali* 2:237 n. 1. The altar is now dedicated to the *Virgo potens*. The present marble relief altarpiece, an enthroned Madonna and Child with angels and Sts. Catherine of Alexandria and Paul, carved in 1396 and formerly in the left nave wall of the cathedral, was moved to its present position in 1894 (Cattaneo, "Maria SS.," p. 354).

49

Archbishop Carlo Borromeo yet again rededicated it to Sts. Victor and Roch.[16]

Assuming that both the painting by Cristoforo de Mottis and the sculpture commissioned from Solari were to be of the same iconographic type as the lost silver image, we may infer from the documents that in all three images the Madonna had a *coazzone*, was crowned, was adorned with gold stars, and had a moon at her feet. The Castello Sforzesco sculpture certainly would seem to have had all three attributes. The presence of a diadem is indicated by a hole in a flattened portion at the back of the figure's head (fig. 4); like the moon that was once at her feet, it may have been made of metal and would likely have included twelve stars that, together with the moon, would have identified this Madonna as the Woman of the Apocalypse.[17] Stars still adorn the Madonna's gown in the sculpture. Contrary to Sant' Ambrogio and Cattaneo, who report no signs of gilding, during a recent examination I discerned bits of gold as well as blue in the lower part of the Madonna's skirt.

A number of the decorative attributes of the marble Madonna not mentioned in the *Annali* (collar, rosettes, acanthus, peacock feathers, belt) were nonetheless probably to be found in all three images. This assumption is supported by the fact that several of these elements, in varying combinations, are present in a large group of a type known as the *Ährenkleid* (wheatdress) Madonna. This group of images is largely Tyrolean and south German, and dates from as early as c.1355, continuing through the fifteenth century and even beyond (fig. 7).[18] In addition to the sprays of wheat for which the representations are named, most include long, unbound hair, a radiant collar, and a long belt; in many instances, stars

16. Besozzo, *Distinto raguaglio*, pp. 46-48. In his account of the various dedications of this altar, Besozzo includes "S. Maria del Covazzone." His is the only early printed guide to the Duomo (or to Milan) that cites this dedication. The others (all of which, like Besozzo's guide, date from after the rededication by Carlo Borromeo), if they mention the altar at all, refer to the dedications to S. Maria della Neve and Sts. Victor and Roch. See also Sant'Ambrogio, "Speciale raffigurazione," p. 119; and Cattaneo, "Maria SS.," p. 354.
17. Revelation 5.
18. Graus, "S. Maria im Ährenkleid," remains the basic study. See also Walzer, "Darstellung;" and Thomas, "Ährenkleid Madonna." The Ährenkleid Madonna occurs primarily in German painting, but the type exists also in woodcuts, sculpture, and stained glass.

are present as well. At least one example, of about 1481, survives from northern France where it formerly graced the altar of a chapel in the abbey of Saint-Bertin dedicated in that year to Notre-Dame de Milan.[19] In fact, many of the Ährenkleid Madonnas bear inscriptions linking them directly to a painting in Milan. These same inscriptions identify the young woman as the youthful Virgin in the Temple. A woodcut of the mid-fifteenth century in Munich, for example, bears the inscription:

All should know that this is a picture of our beloved Lady as she was in the Temple and was married to St. Joseph and was served by angels in the Temple, and thus is she painted in the cathedral of Milan.[20]

An interesting early Christian source for this type was proposed by Sant'Ambrogio and Graus. On the basis of a marble plaque dated to the fifth century, now in Saint-Maximin in Provence, incised with an image of a young woman orant with unbound, flowing hair, and inscribed *"Maria virgo minester de Tempulo gerosalē,"* these authors suggested that an image related to the Ährenkleid Madonna must have existed in the temple built in Jerusalem by Justinian (now the site of the Dome of the Rock), and that pilgrims or Crusaders to the Holy Land brought descriptions or even souvenirs of the image back to Europe. The hypothesis that such reminiscences inspired the type is attractive but difficult to prove.[21] If the Castello Sforzesco Madonna and its

19. O. Bled, "Le tableau de Notre-Dame de Milan autrefois à Saint-Bertin," *Mémoires de la société des antiquaires de la Morinie* 31 (1912-13): 235-51.
20. "Es ist czu wissenn allermanigtlichenn Das das pild ist unnser liebenn frauen pild als Si in dem tempel was e das sy sand joseph vermahelt ward also dyentenn ir die enngell in dem tempel und also ist sy gemalt in dem tum czu maylandt" (Graus, "S. Maria im Ährenkleid," pp. 60-61, where three similar inscriptions are likewise recorded). All the German inscriptions refer to a painting rather than a sculpture in the cathedral of Milan. Perhaps the reference is to the painting by Cristoforo de Mottis.
21. Sant'Ambrogio, "Speciale raffigurazione," pp. 111-12; and Graus, "S. Maria im Ährenkleid," p. 102. Around 1150 the pilgrim John of Würzburg identified the Justinian temple with the site of the Temple in which Mary dwelled, and he recorded an inscription commemorating this fact: "In the Temple of the Lord on the twenty-first of November, it is said that the Blessed Virgin Mary, then three years old, was presented, and these are the verses there written:

German cognates are rooted in early Christian imagery, not surprisingly the basic iconography was enriched in meaning over the centuries. The Milanese sculpture, moreover, contains additional elements that link it specifically to the duchy of Milan, and to the Visconti and Sforza families in power during the fourteenth and fifteenth centuries.

The association with a Milanese Madonna and the identification of the figure as the Virgin before she was married to Joseph are reinforced by the maidenly appearance of the Castello Sforzesco Madonna (figs. 1-4). Small in stature, she stands approximately five feet high; her pose is youthful and her features pure. Her long, unbound hair is characteristic of virgin brides. Thus, the Madonna del Coazzone could very well depict the Virgin at fourteen, the age at which the early apocrypha and, following them, the *Golden Legend* inform us that she was married to Joseph.[22] The attitude of prayer as well as the upward glance are appropriate to accounts of Mary's piety during her sojourn in the Temple; more specifically they may allude to a moment of her response to the angels who are said to have regularly visited the Virgin there, sometimes offering her food.[23] That representations of the moment in which the Virgin is visited by angels in the Temple were current in Lombardy at least from the late fourteenth century is proved by a miniature of this subject of about 1388 in the Psalter-Hours of

The Virgin in her sevenfold company
Of virgins, who, when future times unfold,
Shall be a Handmaid of our God, was here
Presented to the Lord when three years old.

For the passage in John of Würzburg see John Wilkinson, with Joyce Hill and W. F. Ryan, *Jerusalem Pilgrimage 1099-1185* (London: Hakluyt Society, 1988), pp. 246-47; and also pp. 140-41, for the association of the Presentation with this site by the Crusaders. Professor Ernst Kitzinger brought the work of Wilkinson to my attention. For the fifth-century marble, see von Einem, "Die Menschwerdung Christi," fig. 2.

22. Jacobus de Voragine, *The Golden Legend*, trans. Granger Ryan and Helmut Ripperger (New York: Arno Press, 1969), p. 523. For a survey of apocryphal accounts of the life of the Virgin and their reflection in the visual arts, see Jacqueline Lafontaine-Dosogne, *L'Iconographie de l'enfance de la Vierge dans l'Empire Byzantin et en Occident*, 2 vols. (Brussels: Académie Royale de Belgique, 1964-1965), vol. 2 for Western art; and Gertrud Schiller, *Ikonographie der christlichen Kunst*, vol. 4, pt. 2 (Gutersloh: G. Mohn, 1980), pp. 38-54 for Western cycles.

23. Jacobus de Voragine, *Golden Legend*, p. 523.

Giangaleazzo Visconti, where the youthful Virgin's hands are likewise joined in prayer.[24] The sprays of wheat that constitute the principal pattern on the sculpture's gown, especially those on the skirt, enclosed in podlike forms (figs. 1, 2, 5), add another level of meaning. They imply that this young Virgin will soon be the receptacle of the true bread of life, Christ, whose sacrifice was reenacted symbolically at the altar above which the Madonna del Coazzone stood. Furthermore, the grain links this figure to yet another type of the Virgin represented without the infant Christ, at a slightly later moment in her life, the Madonna del Parto (the pregnant Madonna).[25]

The immaculacy of Mary's own conception would have been expressed by the gilded diadem of twelve stars and the moon at her feet. These attributes, both now lost, would have associated her with the woman of Revelation 12 who was inextricably associated with the Virgin Immaculate in the fourteenth and fifteenth centuries.[26] Even without the diadem and moon, however, her sun-like radiant collar, as well as the stars strewn on her gown, also probably originally gilded, would have made the same point. The immaculacy of this Virgin is implied too by the now fragmentary inscription on her long belt (figs. 1, 2): "Ele[cta ut sol pulchra u]t lunna" (beautiful as the moon, bright as the sun), one of the many phrases from the Song of Solomon that describe the spotless beloved widely identified in Christian hermeneutics with the Virgin.[27] The peacock-feather pattern at the hem of the

24. This manuscript is now in Florence, Biblioteca Nazionale, in two volumes: Banco Rari 397 and Landau-Finaly 22. For the Virgin visited by angels in the Temple, see Millard Meiss and Edith W. Kirsch, *The Visconti Hours* (New York: George Braziller, 1972), plate and commentary for BR 76.
25. For a study of the Madonna del Parto as she expresses the concept of the Virgin as co-redemptrix of humanity through her willingness to receive the body of Christ, and of her consequent incorruptibility, see Caroline Feudale, "The Iconography of the Madonna del Parto," *Marsyas* 7 (1957): 8-24. Professor Marilyn Aronberg Lavin brought this article to my attention.
26. Mirella Levi D'Ancona, *The Iconography of the Immaculate Conception in the Middle Ages and Early Renaissance* (New York: College Art Association of America, 1957), pp. 15 et passim. For suggestions earlier than mine that the Castello Sforzesco sculpture represents the Virgin Immaculate, see Cattaneo, "Maria SS.," p. 352; and Walzer, "Darstellung," pp. 76-77.
27. The inscription was read correctly for the first time by Sant'Ambrogio, "Speciale raffigurazione," pp. 107-8. As Cattaneo observed ("Maria SS.," p. 352), the bride in the Song of Songs (5:6) is also characterized by long,

Madonna's skirt likewise expresses her physical incorruptibility, which would have been further underscored by the long belt, emblem not only of her virginity but also of her bodily assumption into heaven, yet another indication of her immaculacy.

The iron strut that projects from the Madonna's right hip (figs. 1, 2) may formerly have supported still another symbol of Mary's immaculacy, a purse.[28] Marian litanies often refer to the Virgin as a vessel suitable, in her purity, to hold the godhead and as a repository and dispenser of God's goodness. Thus, in his *Mariale*, Bernardino de Bustis, author of the office of the Immaculate Conception, invokes the Virgin as the *"scrigno di tutte le ricchezze della sapienza e della scienza di Dio"* (coffret of all the riches of the wisdom and knowledge of God), the *"tesoriera dell'altissimo"* (treasurer of the Highest), and the *"dispensatrice dei doni di Dio"* (dispenser of God's gifts).[29] Citing the custom of leaving votive offerings, including money, at images of the Madonna in two of her principal sanctuaries in Lombardy, Castelseprio and Varese (the cult of the belt was practiced at the latter), Cattaneo suggested that the custom of depositing offerings in a purse attached to the Madonna del Coazzone may have prompted Carlo Borromeo to remove the sculpture from the cathedral, consigning it to several centuries in storage, where it received much of the damage it shows today.[30]

If a purse attached to the Madonna del Coazzone offended Carlo Borromeo, it probably did so in part because of his knowledge of the practice of the wearing of similar containers by Roman brides as symbols of the womb soon to receive the seed of their husbands.[31] Indeed, the most

streaming hair. Walzer ("Darstellung," figs. 46-48) reproduces three German woodcuts of the second half of the fifteenth century (one of them reproduced here as figure 7) in which the Ährenkleid Madonna is identified by garlands as the bride of Christ.

28. The suggestion that the strut supported a purse was offered by Sant'Ambrogio, "Speciale raffigurazione," p. 109. Professor Irving Lavin proposed to me that such an object probably had literary analogs.

29. These invocations occur in Part XII, Sermon 2 of the *Mariale*. See *Bernardino de Bustis e il Mariale* (Busto Arsizio: Convento dei Frati Minori, 1982), pp. 44-45.

30. Cattaneo, "Maria SS.," pp. 352 n. 47 and 354 n. 55.

31. Mario Torelli, *Lavinio e Roma: Riti iniziatici e matrimonio tra archeologia e storia* (Rome: Quazar, 1984), pp. 133-34.

conspicuous surviving attributes of the Castello Sforzesco Madonna – the sprays of wheat on her gown, her long belt, and even the hair from which she apparently takes her name – are likewise rooted in pagan bridal imagery. Wheat, symbol of the earth mother Ceres and of the constellation Virgo, also played a role in Roman forms of marriage, one of which was *farreatio*, the breaking of spelt-bread.[32] As we have seen, inscriptions on the Ährenkleid Madonnas identify this type of image as the Virgin at the time she became the bride of Joseph. After this marriage, she becomes, of course, not only the mother but also the bride of Christ, a belief expressed in the now fragmentary inscription on the sculpture's long belt. Such belts also constituted part of the costume of Roman brides, and though the belt of the Castello Sforzesco Madonna is fastened with a star rather than knotted, the Virgin's belt is conspicuously knotted in a German relief close in date to the Castello Sforzesco sculpture and similar to it in many ways, including the bent knee of the Madonna.[33] Corkscrew curls framed the faces of Roman brides and of vestal virgins on the day of their consecration (figs. 8, 9), in hairdos that included sexpartite division of the hair into curls not unlike those that ripple down the Virgin's back (figs. 3, 4).[34] Widely described as they are in Roman literature, and evident also in at least some surviving Roman works of art, it is likely that any of the pagan forms that lie behind the attributes of the Milanese Madonna would have been known to Carlo Borromeo.[35] Whereas such a fusion of pagan and Christian imagery would surely have displeased the great Milanese sixteenth-century Counter-Reformer, it probably

32. Torelli, *Lavinio e Roma*, pp. 118-19.
33. On the belts of Roman brides see George Wissowa, et al., *Paulys Real-Encyclopädie der classischen Altertumswissenschaft* vol. 17, pt. 1, (Stuttgart: J.B. Metzlersche, 1936), cols. 803-4, 808; Charles Daremberg and Edmond Saglio, *Dictionnaire des antiquités grecques et romaines*, 5 vols. (Paris: Hachette, 1877-1914), 4, 1:88. For the German relief, of c.1495, in the pilgrimage church of Mariatal (near Ravensburg), see Walzer, "Darstellung," fig. 41 and pp. 76-77, where he discusses the knotted belt as a chastity symbol.
34. The example reproduced here is one of a group of terra cotta votive images of the third century BCE, representing either Roman brides or vestal virgins, excavated at Lavinio and published by Torelli, *Lavinio e Roma*, pp. 31-50.
35. See the numerous literary sources cited by Torelli, *Lavinio e Roma*, pp. 31-50 and 131-47.

would have delighted Giangaleazzo Visconti at the end of the fourteenth century. Giangaleazzo's determination to assert both his Christian piety and his heroism and learning *all'antica* led to the creation, during his lifetime, of several extraordinary works of art. The same impetus continued to shape the completion, in the fifteenth century, of the exceptionally grandiose combination of Christian and classical forms that is the Certosa of Pavia.[36]

In fact, because sprays of wheat similar to those that adorn the gown of the Madonna del Coazzone also pattern the clothing of Giangaleazzo's second wife, Caterina, in all the numerous representations of her in the Certosa (established by Giangaleazzo in the 1390s as a mausoleum for himself, his wives, and his direct descendants), Sant'Ambrogio concluded that the Madonna in Milan reflected a lost earlier image of the Virgin in the Certosa.[37] A tradition that dates back at least to the late fifteenth century holds that it was Caterina who encouraged Giangaleazzo to found a Carthusian monastery, in fulfillment of a vow she had made during a pregnancy in 1390.[38] If such an image existed in this foundation, it would have been entirely appropriate for Caterina to be represented there as a votary of the Ährenkleid Madonna (fig. 12). I have discussed elsewhere Giangaleazzo's particular veneration of the Virgin Immaculate.[39] The radiant collar of the Castello Sforzesco figure links her directly to Giangaleazzo, one of whose

36. On the precocious and extraordinary assertion of Christian piety combined with classical heroism in Giangaleazzo's manuscripts see Edith W. Kirsch, *Five Illuminated Manuscripts of Giangaleazzo Visconti* (University Park: Pennsylvania State University Press, in press).
37. "Speciale raffigurazione," p. 114.
38. Luca Beltrami, *Storia documentata della Certosa di Pavia* (Milan: U. Hoepli, 1896), pp. 28-29, 37-38. Beltrami cites as reliable early sources for this vow Bernardino Corio's *Historia di Milano*, published at the end of the fifteenth century, and the biography of Stefano Macone, guiding spirit of the foundation of the Certosa as well as its third prior, by Bartolomeo Sanese, *De vita et moribus beati Stephani Maconi Senensis Carthusiani* (Siena: Herculem de Goris, 1626), bk. 2, chap. 10.
39. "The Visconti Hours: The Patronage of Giangaleazzo Visconti and the Contribution of Giovannino dei Grassi" (Ph.D. diss., Princeton University, 1981), pp. 112-17. This discussion is amplified in my forthcoming monograph on Giangaleazzo's manuscripts, cited in n. 36 above.

principal emblems was a sun with precisely such rays.[40] In this regard, Sant'Ambrogio mentioned that Stefano Macone, called by Giangaleazzo in 1390 from Siena to Milan to become prior of the Certosa of Pontignano as well as confessor to Caterina, in 1398 went as prior to the Carthusian monastery at Seitz in Styria, the region in which some of the earliest Ährenkleid Madonnas appeared.[41]

The very dedication of the Certosa of Pavia to Santa Maria delle Grazie may indicate the existence of a late fourteenth-century image of the Coazzone type in the church. The invocation of the Madonna as *"delle Grazie"* alludes on the one hand to the angelic salutation at the moment of the Incarnation and, on the other, to the gracious protection and gifts of the Virgin expressed most explicitly in the image of the Madonna of Mercy. A German stained-glass window of about 1520, now in the Württembergisches Landesmuseum, Stuttgart, depicts an Ährenkleid Madonna as the Madonna of Mercy.[42] In the Certosa itself, the Madonna carved by Benedetto Briosco between 1492 and 1497 for the tomb of Giangaleazzo Visconti, probably originally intended to stand in the apse of the church, is associated with the Coazzone type by her hair and by the gilded stars on her mantle, although she carries the Christ child.[43]

Strong ties between the Madonna del Coazzone and the first Visconti ducal couple are provided by those elements in the sculpture not found in other representations of the Ährenkleid type. These elements, some of which have been

40. For a fourteenth-century explication of Giangaleazzo's sun device as both a religious and a secular emblem, see Kirsch, "Visconti Hours," p. 74.
41. Sant'Ambrogio, "Speciale raffigurazione," p. 116. On Stefano Macone's role in the establishment of the Certosa of Pavia, see Beltrami, *Certosa di Pavia*, pp. 36-39, 49.
42. Walzer, "Darstellung," fig. 40.
43. On Giangaleazzo's tomb, for which Gian Cristoforo Romano was primarily responsible, see Rosanna Brossaglia, in *La Certosa di Pavia* (Milan: Cassa di Risparmio delle Provincie Lombarde, 1968), pp. 59-60 and fig. 278; and Andrea S. Norris, "The Tomb of Gian Galeazzo Visconti at the Certosa di Pavia" (Ph.D. diss., New York University, 1977). The tomb now stands in the north transept of the Certosa, but in his will of 1397 Giangaleazzo stipulated that it be placed in the apse, behind the high altar. See Luigi Osio, *Documenti diplomatici tratti dagli Archivj* 1 (Milan: G. Bernardoni di Giovanni, 1865), no. 321. Beginning with Azzo Visconti, lord of Milan from 1329 to 1339, each successive lord of Milan established his own burial church, and it seems that each also appropriated the apse as the site of his tomb.

discussed above as derivatives from Roman bridal imagery, are all emblematic devices of Giangaleazzo. Most are found in works of art made for him during his lifetime. Some were later transposed to posthumous fifteenth-century representations of Giangaleazzo and Caterina commissioned for the Certosa of Pavia by Ludovico Sforza as part of an ambitious program to assert his political legitimacy by underscoring his ties with the Viscontis. Of particular interest in this connection are two sculptural projects carried out during the last twenty-five years of the fifteenth century, of imprecisely established authorship, but certainly in part by three of the most active sculptors at the Certosa, Giovanni Antonio Amadeo, Benedetto Briosco, and Gian Cristoforo Romano. These are the door of the old sacristy in the north transept (fig. 10) and the door of the lavabo in the south transept (fig. 12).[44] At the angles of the triangular pediment of the sacristy door are bust portraits of Giangaleazzo Visconti and his sons Giovanni Maria and Filippo Maria, while busts of four Sforza dukes of Milan appear in the frieze above the lunette. The lunette itself is carved with a relief of the Resurrection; the pediment is filled with a very high relief representation of the Temptation of St. Anthony (Giangaleazzo's patron saint) venerated by Carthusians. Visconti devices, angels, and Carthusians also adorn the sides of the portal, along with a conglomeration of classical decorative motifs, to create an ensemble that encapsulates the florid intermingling of classical and Christian pictorial vocabulary characteristic of the Certosa. In the door to the lavabo Caterina Visconti appears at the apex in a roundel formed by Visconti serpents and attired in a gown patterned with grains of wheat (fig. 12). In the lunette below, a Madonna with long, streaming hair adores the infant Christ, together with Joseph and Carthusians, as the Magi approach from the right; framing the lunette are personified virtues, including Faith, who holds a cross, a chalice, and a paten directly above the Christ child.[45] These eucharistic implements underscore the

44. Brossaglia, *La Certosa*, p. 59 and figs. 263-74.
45. Though veiled, the Madonna in the lunette has the conspicuously long, flowing hair of the Madonna del Coazzone. Inasmuch as Carthusians revere Giangaleazzo's patron, St. Anthony, in the lunette of the sacristy door, it seems reasonable to suppose that the Madonna with whom they worship the

sacramental nature of the wheat that patterns Caterina's gown.

Among the decorative devices shared by the Castello Sforzesco Madonna and the Certosa portals are five-petaled rosettes and acanthus. That these motifs are in fact emblematic of Giangaleazzo is apparent from their extensive appearance, in an unequivocally heraldic context, in his manuscripts, especially in the Psalter-Hours now in Florence. In the margins of this book, rosettes and acanthus are often combined and are sometimes represented in the stylized form in which they occur also on the Certosa doors.[46] In some instances, acanthus in the Psalter-Hours terminates in pods resembling those in the broken acanthus form at the left of the pediment in the door to the sacristy;[47] in others, stylized acanthus grows symmetrically out of a calyx, in a manner analogous to the forms that pattern the bust portrait of Giangaleazzo (fig. 11);[48] the same stylized form occurs in the wrist band of the right sleeve of the Madonna del Coazzone (fig. 2). The peacock-feather motif at the hem of the Madonna's skirt (figs. 1, 5) also has a counterpart in the Psalter-Hours, where peacocks are combined with acanthus

infant Christ in the lunette of the door crowned by Caterina would be a Madonna particularly revered by her. In the Lombard Franciscan Breviary of 1447 (Bologna, Biblioteca Universitaria, MS 337, 1, fol. 1r), a conspicuously long-haired Madonna who similarly worships her infant child is identified as the Virgin Immaculate by an inscribed scroll from the Song of Songs that issues from the child's mouth. See Robert Calkins, "The Master of the Franciscan Breviary," *Arte lombarda* 16 (1971): 17-19, fig. 1. In addition to her long hair, two other aspects of the miniature in Bologna connect her to the Madonna del Coazzone: pod-like forms on her gown that resemble those on the Castello Sforzesco Madonna's skirt (forms almost identical to those in the miniature appear also in the German woodcuts of the Ährenkleid Madonna mentioned in note 27 above), and a peacock prominent in the foreground. In the miniature in Bologna, as in the lunette at the Certosa and in other Lombard representations of the fifteenth century, the Madonna del Coazzone worshipping the infant Christ evokes the Brigittine vision of the Nativity. In view of the proximity of Lombardy to northern Europe, where St. Bridget enjoyed special popularity, Brigittine imagery not surprisingly became current around Milan soon after the diffusion of the saint's writings in the late 1370s. On representations of the Brigittine Nativity in Lombardy, see Gary Vikan, ed., *Medieval & Renaissance Miniatures from the National Gallery of Art* (Washington, DC: National Gallery of Art, 1975), no. 18.

46. Meiss and Kirsch, *Visconti Hours,* BR 61r, BR 90r, BR 136r.
47. Ibid., BR 18r, 146v.
48. Ibid., BR 111r, BR 148v.

sprays and other Visconti emblems in the margins of a page devoted to the rarely represented scene of the Virgin's parents giving thanks for her conception.[49] It is not surprising that the Castello Sforzesco Madonna shares heraldic devices with sculptures of the late fifteenth century in the Certosa. Inasmuch as the probable sculptor of the Madonna del Coazzone, Pietro Antonio Solari, as well as other members of his family, worked during the last decades of the fifteenth century both for the Certosa of Pavia and the cathedral of Milan, artistic ideas would have flowed easily through them, and no doubt through other conduits as well, between the two greatest monuments begun by Giangaleazzo Visconti but for the most part actually built during the reign of his Sforza successors.

A final word is in order concerning the original placement of the marble figure under discussion. As noted above, a document informs us that the Madonna del Coazzone was to stand above an altar.[50] Considering the shallowness of the exedra in the Duomo suggested as the "chapel" in which the Castello Sforzesco Madonna served as an altarpiece, and considering also the slender profile of the figure (fig. 4), I cautiously propose that the statue originally stood upon a pedestal within a shallow niche. She was probably fastened to this niche by the iron clamp still visible on the upper part of her back and by a second clamp in the lower part of her skirt. Most likely, the latter was ripped away, together with parts of the marble, when the Madonna was removed from her original position (fig. 3). With the slight tilt of her feet and the correspondingly tilted angle of her head (figs. 1, 4), the youthful Virgin Immaculate, soon to become mother of God, would have been perceived as turning to receive divine nourishment from an angel above an altar upon which the redemptive nourishment of the Eucharist was perpetually offered to those who revered her.

49 Ibid., BR 35v.
50. Appendix, Doc. 5.

APPENDIX

Documents from *Annali della Fabbrica del Duomo di Milano*

1. December 29, 1464 (2:237).

Magister Christoforus de Mottis, pictor...pro mercede manufacturae suae pingendi figuram dominae Sanctae Mariae cum coazono, et pro emendo centen. 4 auri pro ornamento suprascriptae figurae, nec non pro coloribus et auro positis super tabulam unam in ecclesia majori Mediolani, extimatam per magistrum Johannem de Patriarcis pictorem, l. 40.

2. July 28, 1465 (2:243).

Proposuit spectabilis dominus Franciscus de Landriano, alter ex magistris fabricae, quod ex partibus Germaniae figura sacratissimae virginis matris Mariae, in argento sculpta, cum et cohazono et stelis deaureatis, ecclesiae mediolanensi est oblata et requisita ejus effigies seu figura in dicta ecclesia, ob devotionem ipsorum Germanicorum, quae ipsis multa miracula demonstravit; datum fuit eis responsum, in structuris ecclesiae effigiem illam corruisse, unde decerneretur an deberet iterato talis figura seu effigies modo ut praemittitur in tabula in ecclesia praefigenda depingi, an non, in augumentum concursus devotionis Germanicorum seu Theutonicorum ad ipsam effigiem in ecclesia. Qui omnes statuerunt dictam figuram seu effigiem debere devote depingi cum cohazono, stelis deaureatis et diadema aurea in tabella in ecclesia ipsa praefigenda et appehendenda in spectaculum et speculum omnibus devotis beatissimae virginis matris Mariae.

3. May 24, 1466 (2:252).

Magistro Christoforo de Mottis pictori mutuo super ratione picturae et manufacturae suae in pingendo figuram dominae sanctae Mariae cum covazono, pro emendo centenaria 4 auri pro ornamento suprascriptae figurae, l. 12.

4. July 24, 1466 (2:254).

Magistro Christoforo de Mottis pictori super ratione picturae et manufacturae suae, in pingendo et ornando figuram dominae sanctae Mariae de covazono pro emendo aurum, l. 3.

5. March 21, 1479 (2:308).

Intelligentes magnam devotionem, quae per multos Teutonicos et partium longincarum habetur effigie gloriosissimae

virginis Mariae, quae appellatur a quazono, quae solebat esse super quodam pilastro nunc demolito in praedicta ecclesia, ordinaverunt quod videatur super quo altari ipsa effigies potest reponi, quod sit in monstra, et ibi ponatur et dimittatur, donec factum et consecratum fuerit altare ad sui honorem, quod intendunt fieri facere cum effigie marmoris ipsius gloriosissimae virginis.

6. April 19, 1485 (3:26).
Petro Antonio de Solario, filio quondam magistri Guiniforti, pro ejus solutione manufacturae unius figurae marmoris nuncupatae dom. s. Mariae de quazono, per eum factae fabrica[r]e jam sunt duo vel tres anni proxime praeteriti, extimata in summa duc. 18, facientes in summa l. 72.

7. April 16, 1487 (3:36).
Johanni Bernardino et Johanni Stephano fratribus de Scotis pictoribus fabricae, mutuo super ratione adorandi ymaginem marmoream dominae s. Mariae del quazono, l. 16.

8. July 24, 1487 (3:38).
Magistro Joseph de Ferrariis fabro, pro solutione certae quantitatis auri, positi in adorando lunam positam sub pedibus dom. s. Mariae de quazono, et etiam pro solutione manufacturae seu operis per eum facti in adorando ipsam lunam, l. 4.

9. July 28, 1488 (3:43).
Magistro Joseph de Ferrariis fabro, pro ejus solutione reaptandi lunam, quae posita erat sub pedibus dominae s. Mariae de quazono in ecclesia majori Mediolani, l. 2.

10. December 30, 1863 (6:392).
È deliberato di depositare al Museo archeologico di Milano alcuni pezzi antichi della fabbrica, ora fuori d'uso, comechè interessanti la storia dell'arte.[1]
Footnote 1 reads: Furono consegnati il giorno 2 marzo 1864, e sono i sequenti, come dalla ricevuta corrispondente:...Statua di donna in marmo, alta m. 1,60.

Fig. 1. Attributed to Pietro Antonio Solari, c.1482-1485, Madonna del Coazzone. Milan, Castello Sforzesco. (Archivio Fotografico del Castello Sforzesco)

Fig. 2. Madonna, as in Fig. 1, detail. (Saporetti, Milan)

Fig. 3. Madonna, as in Fig. 1, detail. (Saporetti, Milan)

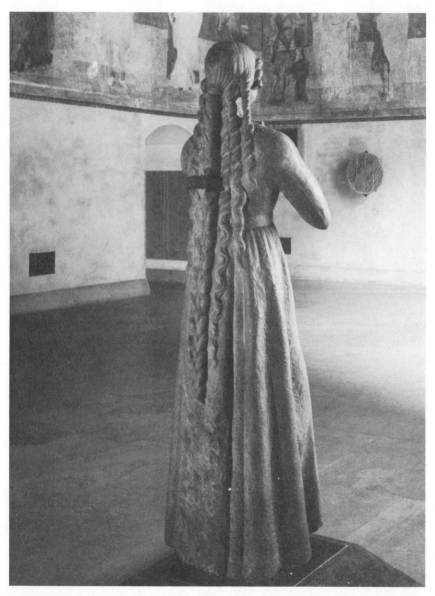

Fig. 4. Madonna, as in Fig. 1, rear view. (Archivio Fotografico del Castello Sforzesco)

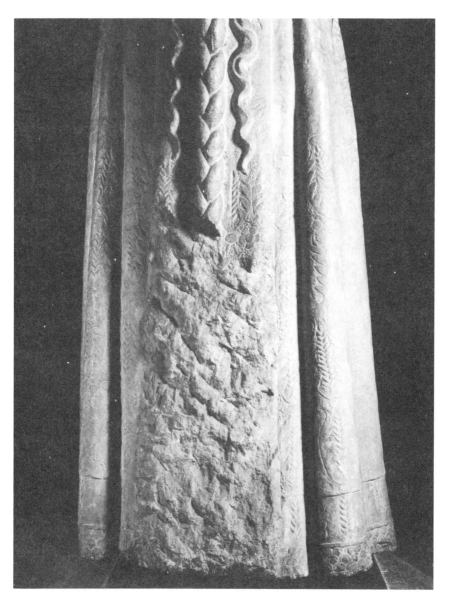

Fig. 5. Madonna, as in Fig. 1, detail. (Saporetti, Milan)

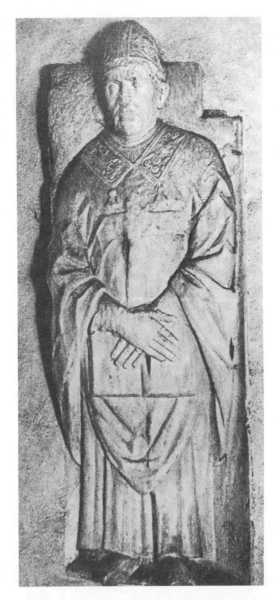

Fig. 6. Attributed to Pietro Antonio Solari,
1484, tomb slab of Archbishop Marco de
Capitani. Alessandria, Cathedral. (Kunsthis-
torisches Institut, Florence)

Fig. 7. Ährenkleid Madonna as Bride of Christ, mid-15th century (woodcut). Zurich, Technischen Hochschule. (Hochschule)

Fig. 9 Side view of Fig 8.

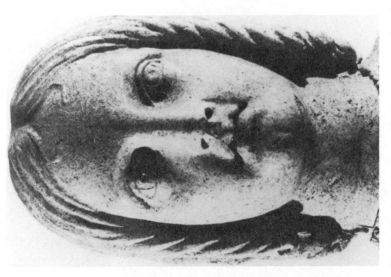

Fig. 8. Roman, 3rd cent. BCE, terra cotta head of a young woman from the Eastern Sanctuary, Lavinio. (Università "La Sapienza," Rome)

Fig. 10. Giovanni Antonio Amadeo and others, begun before 1478, portal of Old Sacristy. Pavia, Certosa. (Brogi 8230)

Fig. 12. Portal of Lavabo, 1490s, detail. Pavia, Certosa. (Archivio Fotografico del Castello Sforzesco)

Fig. 11. Detail of Fig. 10.

Donatello and the High Altar In the Santo, Padua*

SARAH BLAKE MCHAM

Donatello's high altar in the basilica of St. Anthony in Padua, commonly known as the Santo, is by far the grandest altar commissioned in fifteenth-century Italy (figs. 1, 2).[1] It is

* This research forms part of my forthcoming book on the Chapel of the Arca of St. Anthony at the Santo. I would like to acknowledge the financial support of the Research Council of Rutgers University, which has helped make my work possible. I would also like to thank Irving Lavin, Marilyn Aronberg Lavin, and the other respondents at the *IL60* Colloquium for their suggestions that I investigate further issues, such as the early dedication of the high altar and the relationship of the reservation of the Eucharist and the history of the altar.

1. The plan to build this high altar dates back to at least 1366, when Antonio Capodilista donated money for that purpose; see Archivio di Stato, Padua (ASP), Diplomatico, busta 76, MS 8318, published in Giuseppe Fiocco, "L'Altare grande di Donatello al Santo," *Il Santo* 1 (1961): 21-36; and Antonio Sartori, "Documenti riguardanti Donatello e il suo altare di Padova," *Il Santo* 1 (1961): 37-99, at p. 52. Not until 1446 (when Francesco Tergola, one of the Santo's board of governors [the Massari], gave a donation of 1500 lire) was Donatello asked to sculpt the altar; see ASP, Notarile, 678:278; 523:44; 3996:8, published in Sartori, "Donatello e il suo altare," p. 52.

A gap in the documentation preserved in the Archivio dell'Arca at the Santo between July 1445 and June 1446 means that the contract for the altar is not preserved. Otherwise the work on the altar is documented between 1446 and 1449; see H. W. Janson, *The Sculpture of Donatello* (Princeton: Princeton Univ. Press, 1963; reprint 1979), pp. 162-87; and Sartori, "Donatello e il suo altare," pp. 37-99. Two more recent publications of documents compiled by Sartori, both published posthumously, include some new material on Donatello; they are Clemente Fillarini, ed., *Documenti per la storia dell'arte a Padova*, Fonti e studi per la storia del Santo a Padova, Fonti 3 (Vicenza: Neri Pozza, 1976), pp. 87-95; and Giovanni Luisetto, ed., *Archivio Sartori: Documenti*

comprised of seven nearly life-size bronze figures – the
Madonna and Child (fig. 3), flanked by three Franciscan
saints, Francis, Anthony, and Louis of Toulouse, and three
patrons of Padua, Prosdocimus, Giustina (fig. 4), and Daniel.
They stand on a base decorated with five large narratives,
four of them devoted to Anthony – his miracles of the new-
born babe, the reattached leg, the doubting mule, and the
miser's heart (fig. 5). In addition, there is a depiction of the
Entombment of Christ and more than a dozen symbolic reliefs
of Christ as the Man of Sorrows, the evangelists, and music-
making angels.[2]

The paramount importance of Donatello, the unprece-
dented complexity and scale of the altar and its pivotal role
as the prime example of Tuscan Renaissance style in north
Italy, have made it a perennial focus of art-historical

di storia e arte francescana. I. *Basilica e convento del Santo,* (Padua: Biblioteca
Antoniana, 1983), pp. 213-31.
2. The inclusion of Franciscan saints, as well as the patrons of Padua,
reflects the Santo's dual status as a Franciscan church and the "state church"
of Padua. In 1265 the city committed itself to a major annual contribution to
the Santo; see Andrea Gloria, ed., *Statuti del comune di Padova dal secolo XII
all'anno 1285* (Padua: F. Sacchetto, 1873), n. 1156; the legislation is published
also in Giovanni Lorenzoni, ed., *L'Edificio del Santo a Padova,* Fonti e studi per
la storia del Santo a Padova, Studi 3 (Vicenza: Neri Pozza, 1981), p. 202. In
exchange, it was agreed that the three-man board of governors, established at
the same time, should be comprised of two lay officials and one friar, thus
shifting control of the Santo from the Franciscan Order to the city. On the
implications of the Santo as the "state church" of Padua, see Giovanni
Lorenzoni, "Sulla fondazione della basilica del Santo a Padova," *S. Antonio di
Padova fra storia e pietà. Colloquio interdisciplinare su 'il fenomeno antoniano,' Il
Santo* 16 (May-Dec. 1976): 163-64.
The focus of narrative reliefs on the miracles of Anthony reflects his status
as the titular saint of the basilica. The Madonna and Child are the altar's
central figures because of traditional Franciscan devotion to both, but also
because the Santo incorporated into its left transept area the preexisting small
church of S. Maria Mater Domini. According to early sources, Anthony had
been especially attached to the small church and had requested burial there;
this was the major justification for Padua's appropriation of his relics. They
were kept there while the new basilica was being built and in 1350 returned to
the part of the new basilica built over S. Maria Mater Domini; see Cesira
Gasparotto, "S. Maria Mater Domini," *Il Santo* 5 (May-August 1965): 149-56;
and Lionello Puppi, "La Basilica del Santo (con l'Oratorio di S. Giorgio e la
Scoletta del Santo)," in *Padova: Basiliche e chiese,* ed. Claudio Bellinati and
Lionello Puppi (Vicenza: Neri Pozza, 1975), 1:170-72. In the thirteenth century
the church was sometimes even referred to as "S. Maria Mater Domini e S.
Antonio;" see Gasparotto, p. 149.

investigation.[3] Most of this research has been concentrated on the reconstruction of its original appearance: the altar's present arrangement is the result of a misguided nineteenth-century rebuilding intended to correct modifications made to Donatello's design during the intervening centuries. Almost all these reconstructions correct the nineteenth-century version by grouping the statues more closely together and situating them under an architectural canopy.[4] That there was an architectural canopy is indicated by extant documents; the precise arrangement of figures and reliefs is not.[5] Nevertheless, the basic components of Donatello's altar, and certain fundamental features of their arrangement, seem indisputable.[6]

3. The preeminent study of Donatello's career remains Janson, *The Sculpture of Donatello*. The most recent, thorough analysis of the Padua altar is John White, "Donatello," in *Le Sculture del Santo,* ed. Giovanni Lorenzoni, Fonti e studi per la storia del santo a Padova, Studi 4 (Vicenza: Neri Pozza, 1984), pp. 31-94.
4. For a detailed analysis of these reconstructions, see John White, "Donatello's High Altar in the Santo at Padua," *Art Bulletin* 51 (1969): 1-14, 119-41; as well as Janson, *The Sculpture of Donatello,* pp. 162-87. White's more recent essay on the altar reiterates the validity of the reconstruction he first proposed in 1969 and assesses the reconstructions proposed by other historians between 1969 and 1984; see his "Donatello," pp. 76-94.
5. See Archivio dell'Arca, reg. 338, col. 39, right side; published in Sartori, "Donatello e il suo altare," p. 81.
6. The detailed and rigorous analyses of White in "Donatello's High Altar," and "Donatello" supported by documents and early literary descriptions of the Santo, have rebutted alternative reconstructions. At any rate, with two exceptions, all other reconstructions have argued that the bronze statues of the Madonna and Child were flanked by the sculptures of the various saints and positioned above the narrative and decorative reliefs. The first category of exceptions is only a limited exception: various historians have placed two of the statues of saints away from the group around the Madonna and Child. In so doing, they have tried to rationalize Michiel's account of just five statues. See his description in [Marcantonio Michiel], *Der Anonimo Morelliano, Marcantonio Michiel's "Notizia d'opere del disegno,"* ed. Theodor Frimmel, *Quellenschriften für Kunstgeschichte und Kunsttechnik des mittelalters und der Renaissance,* n.s. 1 (1888): 2-3.
Leo Planiscig, *Donatello* (Vienna: Anton Schroll, 1939), set the two bishop saints, Prosdocimus and Louis of Toulouse, on two plinth wings at the altar sides, an option followed by Herzner, who raised the plinths' height; see Volker Herzner, "Donatellos 'pala over ancona' für den Hochaltars des Santo in Padua: ein Rekonstructionversuch," *Zeitschrift für Kunstgeschichte* 33 (1970): 89-126. Fiocco and Sartori positioned two of the statues of saints on the other side of the top of the altar, where they flanked the Eucharist tabernacle; see Fiocco, "L'Altare grande," pp. 21-36; and Sartori, "Donatello e il suo altare," pp. 37-99. Alessandro Parronchi, "Per la ricostruzione dell'altare del Santo,"

Further speculation about the details of the altar's original appearance seems unfruitful because it is unlikely that we shall ever discover much more factual information about it. The archives of the Santo and related Franciscan institutions have been exhaustively studied by Fra Antonio Sartori, who devoted his life to this pursuit. His extensive documentary discoveries were published posthumously in two volumes; they yield little new important information about the altar beyond what he had earlier published in articles jointly written with Fiocco.[7]

The lack of documentary clarification forces a different approach. This paper examines the typology of the generally agreed-upon features of the high altar and, for the first time, relates the altar to the devotional context of the Santo. Historians who have broached the problem acknowledge implicitly that the basic components and arrangement of the altar are known. Several have related the altar, with its seven figures in a unified architectural setting placed on a base decorated with narrative and symbolic reliefs, to contemporary Tuscan paintings of the so-called "sacra conversazione" type.[8] This theme generally depicts a similar grouping of the Madonna and Child flanked by saints above a predella, illustrating the lives of the Virgin and Child or else

Arte antica e moderna 22 (1963): 109-23, obscured two of the saints behind projecting columns at the altar's top sides.

As Michiel's account was crossed out and rewritten, it seems more reasonable that he was writing from memory and was inaccurate; see White's argument on this score in his "Donatello," p. 80. Nevertheless, it should be emphasized that none of the above reconstructions questions the basic premise that the statues of the Madonna and Child and saints were positioned above the narrative and decorative reliefs. The only reconstruction to do that, H. Schroeteler, "Zur Rekonstruction des Donatello-Altars im Santo zu Padua," *Il Santo* 16 (1976): 3-45, arranged the statues of the saints in two vertical tiers within an elaborate architectural frame that formed part of the choir screen. This reconstruction mistakenly used as its point of departure a drawing for the late sixteenth-century altar that replaced the Donatello altar. The drawing's relationship to the later altar, as well as the documentary and literary references that refute its connection to the Donatello altar, are established in White, "Donatello," p. 85.

7. See above, n. 1.
8. Hans Kauffmann, *Donatello; Eine Einführung in sein Bilden und Denken* (Berlin: G. Grote'sche, 1935), pp. 118-21, was the first to set Donatello's Padua altar within this tradition. This relationship has been validated by all subsequent commentators. See Janson, *The Sculpture of Donatello*, p. 180; and White, "Donatello," pp. 93-94.

an arrangement of one predella scene for each holy figure included in the main panel. The latter formula is represented by Domenico Veneziano's St. Lucy Altarpiece (fig. 6).

Comparison with the painted "sacra conversazione" results in a problematic and inadequate explanation of the form of Donatello's altar. There are only a few paintings representing this related iconography that can probably be dated before Donatello's altar.[9] More significantly, Donatello's altar is by far the most elaborate and complicated example of a then embryonic and even now controversial type.[10] Moreover, his altar is sculpture, whereas almost every other example is painted.[11] Finally, there is no compelling reason why this type of painting should have inspired Donatello's altar. The underlying assumption is that Donatello brought this Tuscan iconographic innovation to *retardataire* north Italy, where it was eagerly accepted. This assumption is belied by the fact that Donatello was working for the Massari dell'Arca, the exigent overseers of the Santo, which was and is the major devotional site in north Italy – one with its own deeply entrenched and revered traditions.[12]

9. The development of the "sacra conversazione" type has been generally traced to painters working in Florence between the late 1420s and 1440s, such as Masaccio, Fra Angelico, or Domenico Veneziano. See Johannes Wilde, "Die 'Pala di San Cassiano' von Antonello da Messina," *Jahrbuch der kunsthistorischen Sammlungen in Wien* n. s. 3 (1929): 57-72; G. Pudelko, "Studien über Domenico Veneziano," *Mitteilungen des Kunsthistorischen Institutes in Florenz* 4 (1932-34): 195-97; John Shearman, "Masaccio's Pisa Altarpiece: An Alternative Reconstruction," *Burlington Magazine* 108 (1966): 449-55.

10. Rona Goffen, "*Nostra Conversatio in Caelis Est*: Observations on the *Sacra Conversatio* in the Trecento," *Art Bulletin* 51 (June 1979): 198-222, contended that the term should be extended to include a group of trecento paintings that she collected, an argument contested by Hayden B.J. Maginnis's letter to the editor, *Art Bulletin* 62 (September 1980): 480-81.

11. See, for example, Janson, *The Sculpture of Donatello*, p. 180, who noted, "That its antecedents, as well as its successors, are to be found in painting rather than in sculpture, has been acknowledged by every student of the problem." The one sculpted altar, acknowledged by all historians to relate to Donatello's high altar, is Niccolò Pizzolo's altarpiece in the Ovetari Chapel of the Eremitani in Padua, a single relief panel. See, for example, Janson, *The Sculpture of Donatello*, p. 172. Pizzolo was an assistant of Donatello's at the Santo, and his altarpiece was begun while the Santo high altar was under construction. White, "Donatello," p. 94, suggested that the relationship of the Donatello high altar to the altar in the Chapel of St. Felix should be explored. See description and fig. 10 below.

12. The demanding nature of the governing board of the Santo and their strict control of artistic commissions can be demonstrated through their annotations

While not denying the validity of the association with painted altarpieces of the "sacra conversazione," I would like to suggest that there is a major sculptural tradition, that of saints' tombs, that provided an apposite model for the high altar of the Santo. This tradition was well known to Donatello and his commissioners, and its forms were peculiarly appropriate to the devotional function and history of the Santo.

The earliest Italian example of this type of saint's shrine is the Bolognese Arca of St. Dominic by Nicola Pisano and shop, dating from the mid-thirteenth century (figs. 7, 8).[13] The arca's considerable later alterations mask its original appearance which, as reconstructed by Pope-Hennessy, consisted of a sarcophagus carved with low-relief scenes of Dominic's life and miracles, supported on caryatids.[14]

The Arca of St. Dominic was the model for dozens of later saints' tombs.[15] One notable example is the Arca of St. Peter Martyr in Sant'Eustorgio, Milan, of the late thirteenth century, which is particularly important for our study because it was not altered in later centuries (fig. 9).[16] The features of

in artists' contracts requiring that the latter follow absolutely certain models prescribed by the board, and that the artists not be paid until their results were assessed; see the repeated contractual stipulations in regard to the reliefs in the Chapel of the Arca of St. Anthony as analyzed in Sarah Blake Wilk (McHam), "La decorazione cinquecentesca della cappella dell'Arca di S. Antonio," in Le Sculture del Santo a Padova, ed. Giovanni Lorenzoni, Fonti e studi per la storia del Santo a Padova, Studi 4 (Vicenza: Neri Pozza, 1984), pp. 109-72, esp. 149-51.

13. On this arca, see John Pope-Hennessy, Italian Gothic Sculpture, 3d ed. (New York: Random House, 1985), p. 181.

14. See Pope-Hennessy, "The Arca of St. Dominic: A Hypothesis," Burlington Magazine 93 (1951): 347-51.

15. Its basic components, a sarcophagus carved with small-scale reliefs, usually of the life and miracles of the saint, supported on caryatids, or more often, plain columns, were often repeated. Some examples of arcas in northeast Italy influenced by it include: Arca of the Beato Bertrando, Duomo, Udine, mid-14th century, illustrated in Wolfgang Wolters, La scultura veneziana gotica, 1300-1460 (Venice: Alfieri, 1976), 1:185-86, cat. no. 69 and 2, figs. 266-71; Arca of Beato Odorico da Pordenone, S. Maria del Carmine, Udine, mid-fourteenth century, illustrated in ibid., 1:157-59, cat. no. 22; 2, figs. 61-67; 70-75; Arca of St. Nazzaro, Duomo, Capodistria, early fifteenth century, illus. in ibid., 1:182-83, cat. no. 59, 2, figs. 244-45, 247-49 (this arca originally had an elaborate gilded marble baldacchino).

16. See Pope-Hennessy, Italian Gothic Sculpture, pp. 198-99, 279; a more developed analysis is found in P. Venturino Alice, "La Tomba di S. Pietro Martire e la Cappella Portinari in S. Eustorgio in Milano," Memorie

special note include the figures that stand atop the sarcophagus, that the sarcophagus is decorated with relief scenes of the life of the saint, and that an architectural canopy surmounts the enthroned Madonna and Child atop the whole complex.

This type of saint's shrine was sometimes adapted for the tombs of secular figures.[17] Crucial examples in Padua include the now-destroyed tomb of Raimondino de' Lupi erected in the late fourteenth century and once standing in the Oratorio di S. Giorgio adjacent to the Santo. The oratory's beautiful frescoes by Altichiero still survive; but, unfortunately, the only extant parts of the tomb itself are the sarcophagus and the cuirass of one of the ten over-lifesized figures that originally stood atop it.[18]

Literary accounts indicate that the sarcophagus, surmounted by ten statues under an architectural canopy that nearly touched the ceiling of the oratory, originally stood in the center of the room.[19] Several early chroniclers described the tomb, even specifying that visitors frequently mistook it for that of a saint and kissed its statues in reverence.[20]

In the Santo itself and adjacent to the high altar was another chapel, dedicated to St. James, frescoed by Altichiero for a different branch of the Lupi family.[21] Its altar was surmounted by five standing statues of the Madonna and Child flanked by saints carved by Rinaldino de' Francia in the late fourteenth century (fig. 10).[22] In the late fifteenth century, when the relics of St. Felix were acquired, the chapel's

domenicane 69 (1952): 3-34. In this case, the contract for the Dominican Peter Martyr's arca specifically states that the tomb should be similar in every respect to that of Dominic, the founder of the order.

17. For example, the Tomb of Bernabò Visconti, Museo del Castello Sforzesco, Milan, late fourteenth century, adds an equestrian statue on top of the saint's arca form; see Pope-Hennessy, *Italian Gothic Sculpture*, p. 201.

18. See Mary D. Edwards, "The Tomb of Raimondino de' Lupi and its Setting," *Rutgers Art Review* 3 (1982): 37-50; and idem, "The Tomb of Raimondino de' Lupi, its Form and Meaning," *Konsthistorisk Tidskrift* 52 (1983): 95-105. For a tentative reconstruction of the tomb, see Gian Lorenzo Mellini, *Altichiero e Jacopo Avanzi*, (Milan: Edizione di Comunità, 1965), fig. 157.

19. See Edwards, "The Tomb and its Setting," p. 38 n. 9.

20. Ibid., p. 97.

21. The most thorough publication of documents concerning the Chapel of St. James is Antonio Sartori, "La Cappella di S. Giacomo al Santo di Padova," *Il Santo* 6 (May-December 1966): 267-359.

22. Ibid., pp. 294, 343-44, doc. xii.

dedication was changed to honor that saint, and local Paduan sculptors were commissioned to build an arca. The five fourteenth-century statues were positioned atop it.[23] In fact, the fourteenth-century high altar of the Santo, the one that Donatello's altar replaced, may have looked something like this, judging from the brief mention of it in known documents.[24]

Thus, we can infer from the abundance of saints' arcae, and the tombs of secular figures derived from them – some of them in or near the Santo – that the Massari of the Santo, Donatello's patrons, were well aware of this tradition. Donatello himself must have been as well. Indeed, while he was working on the Santo high altar, he was also designing a saint's tomb, the Shrine of St. Anselm in Mantua.[25]

These saints' shrines, and the secular tombs derived from them, provide a typological model for Donatello's high altar in many ways. They are sculptural complexes often crowned by a group of three-dimensional figures. A comparison of the Arca of St. Peter Martyr with the various reconstructions of Donatello's altar yields the following similarities. The figures are positioned in a unifying regularity; they are sometimes enframed by an architectural canopy. They are placed atop a raised rectangular base that is frequently decorated on the front and back with narrative reliefs of the saint's life. The figures are quite iconic; they are widely spaced and they do not interact, although they may be posed in ways that suggest interaction. The statues of flanking saints, and especially the Madonna from Donatello's altar, are given extremely

23. See Antonio Sartori, "Da San Giacomo a San Felice," *Il Santo* 5 (May-August 1965): 157-73; and Giulio Bresciani Alvarez, "L'Architettura e l'arredo della cappella di S. Giacomo ora detta di S. Felice al Santo," *Il Santo* 5 (May-August 1965): 131-41.
24. The original contract for the altar in the Chapel of S. Felice was made with Andriolo de' Sanctis on Feb. 12, 1372. In it the altarpiece for the Santo's high altar is referred to as a model for the altarpiece in the chapel, "...ancona cominciata suso l'altare grande de la chiesa di santo Antonio...." See Wolters, *La scultura*, 1:209. However, as the framework in which the five sculptures were once set on the altar of the San Felice chapel is neither referred to nor preserved, there is no precise information about the appearance of the original high altar of the Santo.
25. See James G. Lawson, "New Documents on Donatello," *Mitteilungen des Kunsthistorischen Institutes in Florenz* 18 (1974): 357-62; and Volker Herzner, "Regesti donatelliani," *Rivista dell'Istituto nazionale d'archeologia e storia dell'arte* 2 (1979): 169-228, nos. 325-26, 339, 374, 377, 380-83, and 385-87.

restrained characterizations, radically different from the extraordinarily expressive reliefs of St. Anthony and the *Entombment of Christ* below them (figs. 3, 4, 5).[26] Furthermore, Donatello's high altar reflects the tradition of saints' arcae in that the latter are generally contiguous to an altar, either directly above or elevated behind it. In fact, in the Santo there were several examples of arcae that functioned as altars. Mass was celebrated atop the Arca of St. Felix, as it had been atop the fourteenth-century Arca of St. Anthony and is still today atop the sixteenth-century arca that replaced it.[27]

It makes sense that Donatello's high altar should have been derived from the tradition of saints' arcae: the Santo was built to house the bones of St. Anthony; the donations of the faithful who came to pray before those relics paid for its construction.[28] Because of the miracles worked by those relics the faithful came in such throngs that new ways had to be

26. In this regard, the high altar adheres as well to the conventions of painted altarpieces, in which the main panel is typically more iconic than the predella panels. However, the painted "sacre conversazioni" of the late 1420s to 1440s depict saints who stand together relatively close to the Virgin and Child, to whom they seem to respond. The arca tradition provides a different model – one where there is a regular distance between the statues and each is basically self-contained.
Relating Donatello's high altar to the latter introduces the possibility that reconstructions of his altar should pose the saints less closely together and perhaps even in a regular rhythm that does not imply emotional interaction. The tradition of arcae may also partly account for the often noted archaism of Donatello's figures, especially the Madonna and Child. On this point, see especially James H. Beck, "Donatello's Black Madonna," *Mitteilungen des Kunsthistorischen Institutes in Florenz* 14 (1969-70): 456-60; and Volker Herzner, "Donatellos Madonna von Paduaner Hochaltar – eine 'Schwarze Madonna'?" *Mitteilungen des Kunsthistorischen Institutes in Florenz* 16 (1972): 143-52.
27. The Arca of St. Felix, elevated on a raised stepped base so that Mass could be celebrated on it, was erected in 1503-4; see Sartori, "Da San Giacomo a San Felice," pp. 157-73, and Bresciani Alvarez, "L'Architettura e l'arredo," pp. 137-41. The raised altar, which was recently dismantled so that the Altichiero frescoes in the chapel could be better seen, is visible in figure 10. It follows a pattern established with the original Arca of St. Anthony which, as the "Legenda Raimondina" written c.1293 recounts, was elevated on columns and had steps before it so that Mass could be said on it; see Giuseppe Abate, "Le fonti biografiche di S. Antonio V, La 'Vita sancti Antonii' di Fra Pietro Raymondina da San Romano, c. 1293," *Il Santo* 10 (January- August 1970): 3-34.
28. For the authoritative account of the extraordinary devotion inspired by Anthony's relics, see the "Vita prima," the biography written c.1232-34, just a few years after his canonization; the most scholarly annotated edition is by Giuseppe Abate, "Le fonti biografiche di S. Antonio I, La 'Vita Prima' di S. Antonio," *Il Santo* 8 (May-December 1968): 127-226.

devised to accommodate them. First, the bones of St. Anthony were enshrined in the small church of S. Maria Mater Domini to which he had been devoted. Then the large basilica of the Santo was built, incorporating that small church,[29] and St. Anthony's relics were placed in an undecorated sarcophagus on raised columns that was erected before its high altar, so that worshipers could approach the tomb from all sides.[30]

In 1310 the undecorated sarcophagus on columns was transferred from in front of the Santo's high altar to the large transept chapel on the left, which became the Chapel of the Arca of St. Anthony,[31] and was frescoed with scenes of his miracles.[32] The arca was fitted with stairs so that Mass could be said atop it, presumably so that the faithful could visit the relics and hear Mass, separated from the ceremonies that were conducted primarily for the friars at the high altar.

Even this sort of simple shrine – an undecorated sarcophagus in a frescoed chapel – marks a break with Franciscan tradition. The order's emphasis on the life of St. Francis and emulation of his virtuous example meant that it deemphasized devotion to the relics, and potential miracleworking, of any Franciscan saint, including Francis.[33] The

29. Abate, "La 'Vita Prima'," pp. 166-77. The most recent scholarly analysis of the Santo's foundation and construction is Giovanni Lorenzoni, "Cenni per una storia della fondazione della Basilica alla luce dei documenti (con ipotesi interpretative)," in *L'Edificio del Santo di Padova*, pp. 17-30; and Marcello Salvatori, "Costruzione della Basilica dall'origine al secolo XIV," in *L'Edificio*, pp. 31-81. Construction on the new church was well underway by 1238, when there was an active workshop at the site. See the will cited in the document register compiled by Giovanni Lorenzoni in *L'Edificio del Santo di Padova*, p. 197.
30. See Antonio Sartori, "Le Traslazioni del Santo alla luce della storia," *Il Santo* 2 (January-April 1962): 10-11, for the documents pertaining to this first translation of 1263.
31. See Sartori, "Le Traslazioni," p. 13. His account of translations has been challenged by Lorenzoni, who argues that there was an intervening translation of Anthony's relics from before the high altar to the main ambulatory chapel, where they remained until 1350, when they were translated to their present location; see Lorenzoni, "Cenni," pp. 23-30.
32. On the fourteenth-century decoration of the chapel, see Wilk (McHam), "La Decorazione cinquecentesca," pp. 110-12.
33. On the cult of the personality of St. Francis, see Rosalind Brooke, "The Lives of St. Francis of Assisi," in *Latin Biography*, ed. T. A. Dorey (New York: Basic Books, 1967), pp. 177-98. The criteria for sanctification shifted in the early thirteenth century from an emphasis on miracles to an emphasis on a

body of the founder of the order had been transferred from the church of S. Giorgio, where it had worked many miracles, and secretly reburied in an undisclosed location in the newly built S. Francesco, Assisi, which was not discovered until the nineteenth century.[34] None of the other major Franciscan saints – Claire, Elizabeth of Hungary, the five Moroccan martyrs, Louis of Toulouse, Bonaventura, have notably decorated burial places that became significant pilgrimage sites.[35]

In the mid-fifteenth century the overseers of the Santo decided to commission an unprecedentedly grand high altar that honored the basilica's titular saint, Anthony. The inclusion of the Madonna and Child as the altar's central figures accorded with the focus on them in Franciscan

virtuous life; see André Vauchez, *La Sainteté en Occident aux derniers siècles du Moyen Age d'après les procès de canonisations et les documents hagiographiques* (Rome: École Française de Rome, 1981), pp. 56-60. These two references were brought to my attention by Rona Goffen.

34. On Francis's death and burial, see Rosalind B. Brooke, *Early Franciscan Government. Elias to Bonaventure* (Cambridge: Cambridge University Press, 1959), pp. 138-42; and Nicole Hermann-Mascard, *Les Reliques des Saints. Formation coutumière d'un droit* (Paris: Klincksieck, 1975), pp. 9 and 36. The basilica of S. Francesco is, of course, a grand memorial to St. Francis, but it is not notably a healing shrine where pilgrims come to be made well through the saint's intervention. Rather, the elaborate fresco cycles at Assisi indicate the importance of visual imagery in the cult of St. Francis. They were the model for the frequent representations of the saint on portable panels and in frescoes elsewhere that the order used to diffuse the cult of Francis. His veneration was deliberately dissociated from his burial shrine in order to promote its universality; see Rona Goffen, *Spirituality in Conflict. Saint Francis and Giotto's Bardi Chapel* (University Park and London: Pennsylvania State University Press, 1988), pp. 13-26.

Development of the cult of Francis around visual imagery is the salient and influential example of a general practice that began in the thirteenth century. In increasing numbers, the faithful prayed to visual representations of saints, rather than making pilgrimages to their relic shrines. See Vauchez, *La Sainteté*, pp. 519-52.

35. This accords with the general practice described above, note 34, and with the Franciscan Order's primary veneration of Francis. The flourishing cult of the miracle-working relics of St. Anthony and consequent focus on pilgrimage to the Santo is a marked exception not only in Franciscan devotion, but in terms of the broader dissociation of cults from relic shrines. For the cults of these other Franciscans important in the early history of the order, see Engelbert Kirschbaum, *Ikonographie der Heiligen*, ed. Wolfgang Braunfels (Rome, Freiburg, Basel, Vienna: Herder, 1974), 5:423; 6:134; 7:316, 443. Several were not canonized until long after their deaths; and their shrines, if built, were correspondingly late.

devotion and referred to the basilica's construction over the preexisting church of S. Maria Mater Domini. The statue of Anthony was joined by statues of venerated Franciscans and Padua's patron saints because the Santo was both a Franciscan church and the "state church" of Padua. The altar's format and decoration related to the tradition of saints' arcae because the basilica was founded and functioned primarily as the site where St. Anthony's relics were enshrined.

Although the altar thus symbolically alluded to the importance of Anthony's relics, the high altar's monumentality and lavishness emphasized that it, rather than the Chapel of the Arca of St. Anthony, was the formal visual and devotional focus of the basilica. Clearly the earlier high altar had played second fiddle to the altar in the Chapel of the Arca of St. Anthony because the latter housed the relics of the saint; the Donatello high altar was intended to correct that. But even though the Massari replaced the humble fourteenth-century high altar with Donatello's grand conception, they did not translate the relics of the saint back to their earlier location before the high altar. Thus it is clear that they intended to keep the pilgrimage function of the Chapel of the Arca of St. Anthony separate from the high altar.[36]

When we consider that the Massari in the mid-fifteenth century also commissioned an elaborate sculpted choir screen, we can hypothesize that they were attempting to establish an imposing high altar where liturgical functions were conducted for the friars and separate it physically and visually from the adjacent chapel, the pilgrimage center of the basilica.[37] Knowledge of the choir screen, which was later dismantled, is limited; but it seems to have been erected in front of the high

36. Marilyn Aronberg Lavin reminds me that the same sort of use of new decoration to encourage the pattern of pilgrims' movement can be seen contemporaneously at the cathedral of Prato. There Fra Filippo Lippi was commissioned to paint a cycle of Sts. Stephen and John the Baptist around the high altar. The frescoes reminded the faithful that they should move indoors after honoring the relic of the Virgin's girdle to venerate the other saints whose relics were housed inside the cathedral.
37. On the Santo's choir screen, see Bernardo Gonzati, *La Basilica di S. Antonio di Padova* (Padua: Antonio Bianchi, 1852-53), 1:60-72; and Giuseppe Fiocco and Antonio Sartori, "I Cori antichi della chiesa del Santo e i Canozzi-Dell'Abate," *Il Santo* 1 (May-August 1961): 13-65.

altar much like the contemporary screen in the Frari in Venice.[38]

The hordes of pilgrims who visited the Santo in the fifteenth century must have done just what they do today – headed straight to the chapel in the left transept where St. Anthony's relics were enshrined so that they could touch the shrine's exterior and implore the saint's protection, bypassing the high altar. The primary audience for Donatello's great masterpiece must have been the friars, who heard the Mass from the choir stalls around it. Perhaps the laity could have caught glimpses of one side of the altar through the choir screen; they apparently could have seen the other side quite well if they visited the ambulatory chapels where, for example, Anthony's tongue was enshrined.[39]

Later in the fifteenth century, the Massari commissioned a grandiose redecoration of the Chapel of the Arca of St. Anthony, in which monumental fifteen-foot marble reliefs of Anthony's miracles lined the walls around Anthony's arca.[40] The imposing scale and ornateness of the chapel's redecoration seem to have reasserted it as the basilica's devotional and visual focus. Indeed, by the late sixteenth century the Massari were so dissatisfied with the Donatello high altar that they solicited proposals for its replacement.[41] Their motives remain uncertain.[42]

38. Gonzati, *La Basilica*, pp. 67-68.
39. Antonio Sartori, "Di nuovo sulle opere donatelliane al Santo," *Il Santo* 3 (September-December 1963): 349, observed that documents indicate that until 1651 the intercolumniations of the ambulatory were open down to the floor, so that the altar was readily visible.
40. See Wilk (McHam), "La Decorazione cinquecentesca," pp. 109-72.
41. On the replacement altar, see Sartori, *Archivio*, pp. 231-39.
42. See the fifteenth- and early sixteenth-century records of the Massari and visitors to the Santo collected by Sartori, "Donatello e il suo altare," pp. 98-99, in which the Donatello high altar is omitted from the description of the Santo's most notable features. It can be inferred, furthermore, from their sponsorship of monumental white marble reliefs in the redecoration of the Chapel of the Arca of St. Anthony, that the Massari had realized that the smaller-scale, dark patined bronzes of the Donatello altar were difficult to see in the half-light of the Santo. This point was made explicitly in their complaints about the much larger high altar projected by Campagna and Franco at the end of the sixteenth century; see Sartori, *Archivio*, p. 99. The Massari were also very displeased that the tabernacle where the host was reserved on the Donatello altar was very difficult to see so that people irreverently talked loudly when nearby. For the replacement high altar of the late sixteenth century they required that the tabernacle be placed

They thereby initiated a series of transformations that came to obscure Donatello's original design.[43] Thus one of the most beautiful creations of the greatest sculptor of the fifteenth century was soon considered outmoded by those who used it, and they destroyed Donatello's conception although, fortunately, they preserved for us most of the individual components of his masterpiece.

obviously at the front of the altar; see Sartori, "Donatello e il suo altare," pp. 92-95.
43. See Sartori, *Archivio*, pp. 239-44.

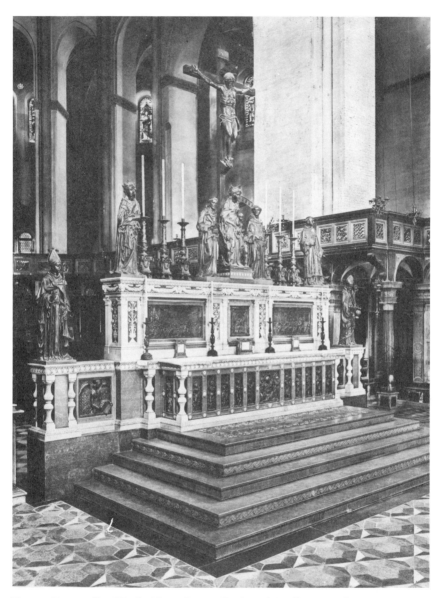

Fig. 1. Donatello, High Altar, Santo, Padua. (Art Resource)

Fig. 2. Donatello, High Altar, Santo, Padua. (Alinari)

Fig. 3. Donatello, Madonna and Child,
High Altar, Padua. (Alinari)

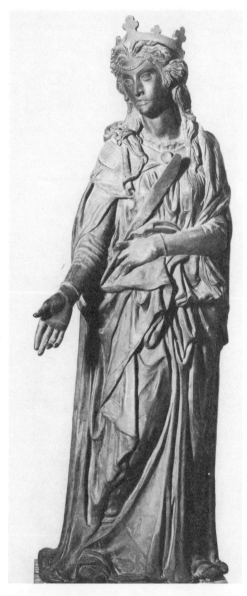

Fig. 4. Donatello, S. Giustina, High Altar, Padua. (Art Resource)

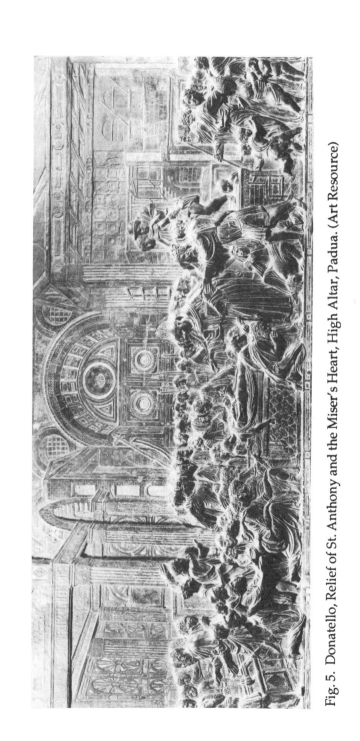

Fig. 5. Donatello, Relief of St. Anthony and the Miser's Heart, High Altar, Padua. (Art Resource)

Fig. 6. Domenico Veneziano, St. Lucy Altarpiece (central panel), Uffizi, Florence. (Art Resource)

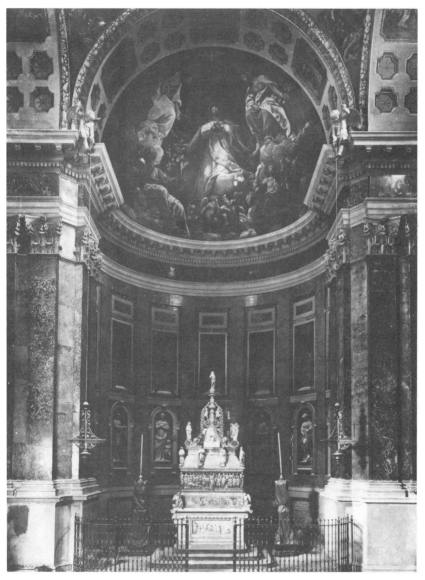

Fig. 7. Nicola Pisano and shop, Arca of St. Dominic, S. Domenico, Bologna.
(Alinari)

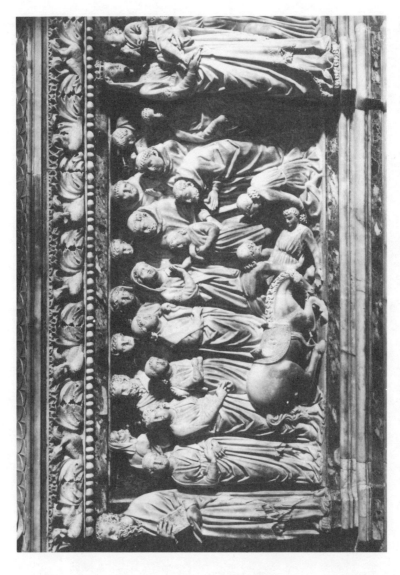

Fig. 8. Relief of a Miracle of St. Dominic, Arca of St. Dominic, S. Domenico, Bologna. (Alinari)

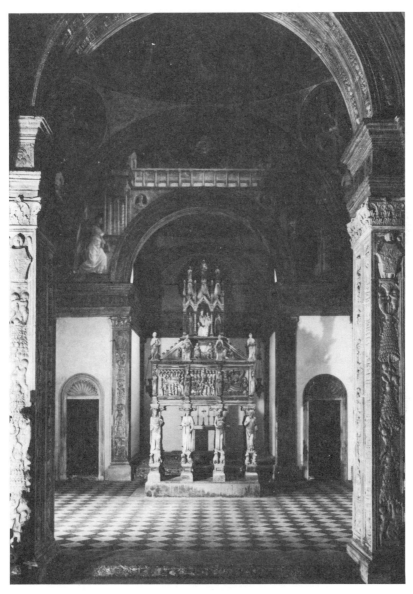

Fig. 9. Arca of St. Peter Martyr, S. Eustorgio, Milan. (Art Resource)

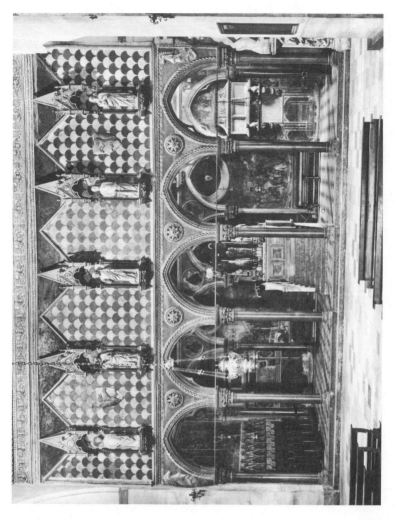

Fig. 10. Chapel of St. Felix showing Arca-altar of Felix, Santo, Padua. (Alinari)

V

Medici Patronage
And the Festival of 1589*

ARTHUR R. BLUMENTHAL

The most important theatrical entertainment ever held during the Renaissance – the festival for the wedding of Ferdinando de' Medici (1549-1609), son of Cosimo, the first grand duke, and his distant cousin, Princess Christine of Lorraine (1565-1636) – took place just over 400 years ago in Florence in April and May of 1589.[1] More blatantly than any previous festival, the occasion was used for political ends: to impress the royalty of Europe with the status of the house of Medici. More events were planned, more lavish theatrical entertainments initiated, more money spent, and more visual and written records were executed than for any Medici wedding before or after.

* This paper is based on a talk given to the Southeast College Art Conference held at Rollins College in Winter Park, Florida, on October 28, 1988. Much of the material comes from the research done for my *Theater Art of the Medici* (Hanover, NH and London: University Press of New England, 1980). The material was gathered in Florence in 1974 and 1975, when I was working on "Giulio Parigi's Stage Designs: Florence and the Early Baroque Spectacle" (Ph.D. diss., Institute of Fine Arts, New York University, 1984; published New York: Garland Press, 1986). Professor Lavin was not only my advisor for the doctorate, but was the one who suggested the topic and guided me to its completion.
1. Detailed records of the preparations for the festival were kept by the majordomo for the Medici, Girolamo Seriacopi. He and others wrote daily notes on the expenses, needs for material, and so forth. See, in the Archivio di Stato, Florence, Archivio de' Magistrati dei Nove..., filza 3679, published in part by Gertrud Bing in an amended version of Aby Warburg's article, "I Costumi teatrali per gli intermezzi del 1589," *Gesammelte Schriften*, vol. 1 (Berlin, 1932), pp. 397-410.

Only a few generations earlier, the Medici were bourgeois bankers with contacts throughout Europe – the Rothschilds of their time. By 1589, France and Spain were both in debt to the Medici, and the pope had granted the Medici grand-ducal status. Still, traces of their too-recent past haunted them. To make it clear that they were truly "noble," they employed every means at their disposal to secure their political position in Renaissance Europe – including using sumptuous theatrical productions to underscore the Medici's independence and proud lineage. Each of the allegories, histories and sculptures of the festival of 1589 refers to this presentation.

The Florentine theatrical festival of April-May 1589 was *truly* sumptuous. Covering a fifteen-day period, it included a triumphal entry, performances by the *commedia dell'arte*, a banquet performance, a fully-staged comedy, a football game, a tilt at the quintain, jousting, and a mock naval battle in the flooded courtyard of the Pitti Palace. In almost every spectacle, the glory of the Medici was touted, their noble ancestry aggrandized, and their historical and political position extravagantly praised.

One of the chief methods for showing the Medici's magnificence to the world was through the festival books – the officially printed *descrizioni* of the events. While serving as souvenirs or printed programs, these publications were also intended for the eyes of the royalty and nobility who were not at the events. Almost all the illustrations in this article come from such *descrizioni*. Incredibly, over eighteen different *descrizioni* of the various aspects of the 1589 *festa* were published.

The decorations for the triumphal entry of Princess Christine into Florence on Sunday, April 30, at ten in the morning, alluded to the Medici connections to France (fig. 1). This allusion most likely was to show Grand Duke Ferdinando de' Medici's worthiness for a French princess – and to demonstrate his dynastic succession. The entry ultimately derived from the Renaissance concept of the ancient Roman triumphal entry.[2] Figure 1 shows "The Ornamental

2. Roy Strong, *Splendor at Court: Renaissance Spectacle and the Theater of Power* (Boston: Houghton Mifflin, 1973), p. 174. Niccolò Gaddi directed the arrangements for the 1589 entry, Pietro Angelio da Barga wrote the

Decoration of the Facade of the Cathedral of Florence,"
designed by Giovanni Antonio Dosio. (The cathedral did not
have a permanent facade, and Dosio proposed this scheme as
permanent.) The Medici-Lorraine coats-of-arms are over the
three principal entrances to the church; two areas were
covered with oil paintings depicting the history of the church
in Florence, and the niches were filled with Tuscan saints.[3]
These decorations served, as did many others, to underline
the grand duke's propagandistic purposes – to show that the
house of Medici was equal to the royal houses of France and
Spain.

After the wedding party left the cathedral, the participants
remounted their horses and proceeded along the back of the
cathedral, through Via Proconsolo (then called Via dei
Bischeri). In the etching by Orazio Scarabelli (act. 1580-1600)
after Taddeo Landini (c.1550-1596) (fig. 2),[4] we see the corner
of the street with statues of the late Charles V and Philip II,
the former and present kings of Spain. The paintings show
"The Retreat of the Turks Routed at Vienna by Charles V"
and "The Battle of Lepanto in 1571." Down the street we see
the Bargello on the left and the Badia monastery on the right,
and straight ahead Piazza San Firenze. Paralleling
Ferdinando's dislike of the Spanish, this ornamentation
glorifying the Spanish monarch is the most modest of all, but
it *does* pay homage to Philip II, whose favor Ferdinando
needed to support his claim to the grand duchy.

The high point of the festivities undoubtedly was the
performance of Girolamo Bargagli's comedy *La Pellegrina*
("The Woman Pilgrim") on May 2 in the Medici Theater in
the Uffizi. Count Giovanni dei Bardi of Vernio, member of

inscriptions, and an army of painters and sculptors executed the decorations.
See also Annamaria Petrioli Tofani, "Gli ingressi trionfali," in *La Scena del
principe*, exhib. cat., Florence, Palazzo Medici Riccardi, March-September 1980
(Florence: Electa, 1980), pp. 343-54.

3. Interestingly, many paintings and sculptures executed for these decorations
still exist. There are six colossal statues of Tuscan saints on view today in the
dome of the cathedral. See James Holderbaum, "Surviving Colossal Sculpture
for the Florentine Wedding Festivities of 1589," public lecture, College Art
Association Conference in St. Louis, 1968.

4. See Vera Daddi Giovannozzi, "Di alcune incisioni dell'Apparato per le
Nozze di Ferdinando de' Medici e Cristina di Lorena," *Rivista d'arte* 22 (1940):
85-100. For a diagram of this print, see Ludovico Zorzi, *Il teatro e la città: Saggi
sulla scena italiana* (Turin: Einaudi, 1977), pp. 103, 209-10 n. 125, fig. 65.

the Florentine association of scholars, musicians and pedants called the Accademia della Crusca, wrote the intermezzi for the comedy (figs. 3-4). The intermezzo[5] was the form of representation that was inserted into a performance between one act and another; gradually it came to supersede the comedy itself, becoming a "spectacle within a spectacle." The intermezzi of 1589 were the most elaborate and advanced in form of the entire Renaissance.

Bernardo Buontalenti (1536-1608) was stage and costume designer for these entertainments, as well as designer for the jousts, tournaments, and naumachiae of the wedding festivities (figs. 5-10). As chief architect to the court, he had constructed Medici palaces, villas, fortresses and gardens, as well as presiding over earlier ducal wedding festivities. A student of, and successor to, Giorgio Vasari (1511-1574), Buontalenti played an important role in Cosimo I's wedding in 1565, for which Vasari had designed sets, costumes, and floats. The influence of Vasari on Buontalenti is apparent in many of these festival designs.

The author of the description of the intermezzi, Bastiano de' Rossi (act. 1585-1605), belonged to the famous Accademia della Crusca. He collaborated with the creator of the intermezzi, Giovanni dei Bardi. It is through De' Rossi that we have an accurate description of these intermezzi, as Bardi would have had us understand them. Jacopo Peri, composer of the first opera, collaborated on the music for these six intermezzi. Ferdinando de' Medici took a great interest in the activities of these humanists; he commissioned Girolamo Bargagli to write *La Pellegrina*. For the theme of the intermezzi, Bardi selected the power of musical harmony, with several allusions to the wedding of Ferdinando and Christine. This theme of universal harmony derives from the Neoplatonic thought then current in Florence,[6] but even here political connotations were included. Bardi saw the theme of

5. In Italian, an intermezzo is also called an *intermedio*, or sometimes *intromessa*, *introdutto*, *tramessa* or *tramezzo*. In French, it is called an *intermède*, in German, a *Zwischenspiel*, and in English, an "interlude" or "entr'acte." John Shearman, in *Mannerism* (Baltimore: Penguin Books, 1967), p. 104, calls the intermezzo "the most comprehensive manifestation of Mannerism."
6. Hélène Leclerc, "Du mythe platonicien, aux fêtes de la Renaissance: 'L'Harmonie du Monde,' Incantation et Symbolisme," *Revue d'histoire du théâtre*, ser. 2, 11 (1952): 106-49.

the harmony of the universe as the model for the government of princes; they were the beneficent powers of order against disorder, harmony against disharmony. The conceits of the intermezzi had the union of Ferdinando and Christine represent not only the return of harmony to earth, but also significant political beliefs.

Our main evidence for the visual aspects of the spectacle comes from Buontalenti's original designs. His settings for the intermezzi to *La Pellegrina* became landmarks in the history of scenography because they were etched and widely dispersed throughout Italy and Europe. As a result, Buontalenti's design for the settings of 1589 played a major role in the development of Italian Baroque scenography, as well as in the evolution of the English masque.[7] By analyzing a number of these prints, our understanding of the character of the spectacle will be greatly enhanced. The first intermezzo setting (fig. 3), surviving in a print after Buontalenti by Agostino Carracci (1557-1602),[8] deals with the thematic content of all six intermezzi: the power of musical harmony in the universe – a not unsubtle reference to the "harmonious" reign of Ferdinando, and, no doubt, to the wish for a "harmonious" union with Christine.

The scene shows a setting of the starry heavens with a cloud in the center on which Mother Necessity sits.[9] Below her are the Three Fates, daughters of Necessity, representing the Past, Present and Future. Necessity turns between her knees the giant diamond spindle joining the two poles of the universe. The center group is surrounded by eight female

7. For the influence of Buontalenti and his successor, Giulio Parigi (1575-1635), on Inigo Jones and his Jacobean masques, see Enrico Rava, "Influssi della scenografia italiana pre-barocca e barocca in Inghilterra," *Antichità viva* 8, 3 (1969): 42-55; and Stephen Orgel and Roy Strong, *Inigo Jones: The Theatre of the Stuart Court*, 2 vols. (Los Angeles: Sotheby Park-Bernet, University of California Press, 1973).

8. Carracci etched and engraved the print after an ink drawing by Andrea Boscoli (c.1560-1607), who in turn had copied an original sketch by Bountalenti. The drawing by Boscoli is in the Uffizi. An excellent study of this print is in Diane DeGrazia Bohlin, *Prints and Related Drawings of the Carracci Family: A Catalogue Raisonné* (Washington, DC: National Gallery of Art, 1979), pp. 266-71, cat. nos. 153-54.

9. This setting, fashioned entirely of clouds, has been likened to Raphael's *Disputà* of 1509. See Carlo E. Rava, "Scenografia tra manierismo e barocco," *Antichità viva* 6, 5 (1967): 16; and Cesare Molinari, *Le Nozze degli dèi: un saggio sul grande spettacolo italiano nel seicento* (Rome: Mario Bulzoni, 1968), p. 27.

personifications of the heavenly bodies – Mercury, the Sun, Jupiter, and Astræa, and the Moon, Venus, Mars, and Saturn. Above, on a higher celestial rung, are the twelve Heroes, representing pairs of the Six Virtues. Sirens on the lower clouds joined in the singing – a madrigal praising Ferdinando and Christine – as the revolving "spheres" moved around the axes of the "universe." Needless to say, almost no one (except Bardi and a few Neoplatonists) understood the symbolism of this arcane intermezzo.

Never before had a non-structured, non-architectural, non-landscape scene been shaped into a perspective stage design. The skillful deployment of the machines and the purposeful arrangement of the singers actually suggest foreshortening without benefit of the usual city square or wooded meadow that had been used till then. The color and weight of the costumes and the very presence of the singers all became part of the stage design. This is perhaps the first extant stage design to depict singers and actors as an integral part of the fantasy. The movement of the cloud machines with their heavy burdens, the lovely singing, the Platonic allusions, the careful references to the harmonious union of the newlyweds – each part combined to become the wondrous whole of the setting.

The print of the setting for the third intermezzo of 1589 (fig. 4), as the one for the first, was etched by Agostino Carracci (after Buontalenti's designs) in 1592, three years after the event.[10] The scene, employing more dramatic conflict than any other, takes place in a forest of Delphi, where a monstrous dragon (called Python) has been threatening the countryside.[11] The huge monster – made of papier-mâché around a wire frame – entered stage center, spewing flames, as the helpless people of Delphi stood terrified on either side. Apollo, flying in from above, came to the rescue. He danced a six-part ballet: first, in scanning the field; then antagonizing the dragon; fighting it in iambic

10. The original drawings by Bountalenti for the scenography of the intermezzi of 1589 are today in the Victoria and Albert Museum. See reproductions in Mario Fabbri, et al., *Il luogo teatrale a Firenze: Brunelleschi, Vasari, Buontalenti, Parigi,* exhib. cat., Florence: Palazzo Medici Riccardi, May 31-October 31, 1975 (Florence: Electa, 1975), pp. 112-14, nos. 8.10-8.20.
11. The story comes from Ovid, *Metamorphoses* I.438ff, and Julius Pollux's account.

rhythm; then fighting it in spondaic rhythm; killing the dragon; and finally dancing a victory dance. Meanwhile, the people of Delphi sang hymns of praise to Apollo. The Neoplatonists held that Apollo, versed in astronomy and music, was precedent to the music of the universe. As the harmony of music purified the passions, purging the soul of spiritual demons, so Apollo purges by his rhythmic dancing the demon of our soul.[12]

Three events took place in the Piazza Santa Croce during the wedding festivities of 1589: the *calcio*, or Florentine soccer game;[13] the animal baiting among the grand duke's zoo animals; and the tilt at the quintain (a joust with a target). The latter is depicted in an etching by Orazio Scarabelli (fig. 5). These events entertained the populace of Florence more than any of the other spectacles, since so few could enter the Uffizi Theater or the Pitti Palace courtyard, beyond the foreign guests, ambassadors, and the Florentine aristocracy.

Like all of the events of 1589, the chivalric spectacle of a tilt at the quintain held political significance for the festival of 1589. The young aristocrats were undoubtedly the ones who participated in this medieval event – one of the few without classical precedents. The etching shows the square with the unfinished facade of the Church of Santa Croce. On the sides are many of the palaces extant today, with Ferdinando and Christine standing on the right in a specially constructed balcony. Pointed umbrellas (for the sun) can be seen on the left side among the spectators. The arena contains numerous teams of three combatants each, dressed as team members in various pseudo-medieval costumes. The event has not yet begun, and the three-man teams are lining up at the right (note one jouster on a camel), as six trumpeters begin to announce the tilt under the grand duke's balcony. The Piazza Santa Croce was used numerous times for Medici festivals, a

12. Leclerc, "Du mythe platonicien," pp. 110-15.
13. There is an oil painting of a *calcio* game in Piazza Santa Croce, erroneously attributed to Raffaello Gualterotti, in the Ringling Museum of Art in Sarasota, Florida. This probably shows the *calcio* of May 1589. See entry by Joyce Nalewajk in *Festivities: Ceremonies and Celebrations in Western Europe 1500-1700*, exhib. cat., Providence, RI: Brown University, Bell Gallery, List Art Building, March 2-25, 1979 (Providence, RI: Brown University Department of Art, 1979), pp. 105-6, no. 63.

tradition that began long before the Medici ruled Florence. Like so many events of 1589, the source for this tilt at the quintain may be found in the joust of 1579, done for the wedding of Francesco de' Medici and Bianca Cappello.

Figure 6 shows an etching after Buontalenti of the "Triumphal Procession of Neptune in a Chariot, and Sea and River Gods."[14] The procession was for the jousting tournament held on the night of May 11, 1589, in the courtyard of the Pitti Palace. The facade of the Pitti Palace can be seen in the print (note the arms of the Medici *palle* over the main entrance to the building) – before the extensions to the building that were done in the early seventeenth century. The chariot of Neptune – probably designed by Buontalenti – is drawn by four horses; the chariot is the last in a cavalcade of marine deities on horseback. Four trumpeters announce the event, and torchbearers light the way. Personifications of the Arno and other Tuscan rivers may be implied; Neptune himself, trident in hand, rides atop the chariot, with small tritons. Grand Duke Ferdinando purposefully selected this event to mirror similar Neptune chariot events for the Medici weddings of 1565 and 1579. His desire to underscore the Medici's development of Livorno as a port no doubt played a role in this.

This etching and the next three (figs. 7-9) all depict elements of the entrance procession for the jousting tournament in the courtyard of the Palazzo Pitti, for the same event of May 11 just described. Buontalenti designed all of these floats and costumes, although the themes of each are somewhat obscure.[15] Before the tournament began, the aristocratic participants rode in on triumphal chariots. The grandest chariot (fig. 7) was drawn by a large dragon.[16] Vincenzo Gonzaga, duke of Mantua, and Don Pietro de' Medici, younger brother of Ferdinando, sat on top of the chariot. These two plumed and armored knights acted as the keepers, or *mantenitori*, of the joust. All the participants

14. This rare print was etched by Epifanio d'Alfiano (act. c.1580-c.1610) after Buontalenti and is in the Anne S. K. Brown Military Collection in Providence.
15. The relationship of these chariot designs by Buontalenti to the chariot designs of Vasari (1565) and Gualterotti (1579) is very strong.
16. There is a drawing in the Victoria and Albert Museum, inventory no. E.1731-1938, from which this print was etched.

entered on these chariots, because the joust used no horses. Like the other chariot floats, this one halted in front of the stand where the grand-ducal couple sat, and the knights paid their respects to the newlyweds with music. The theme of this chariot was infernal; the drivers are winged devils, the front of the chariot is in the form of the mouth of hell, a winged Lucifer decorates the sides, and the wheels have flaming spokes.

The chariot drawn by wolves or foxes contains six plumed and armored knights in a garden-like trellis work (fig. 8). A female figure sits in front; the figure may represent Circe or Venus. Don Virginio de' Medici, nephew of Grand Duke Ferdinando, appeared on one of the last chariots (fig. 9). He sits atop the chariot, dressed as Mars in plumed armor, with scepter in hand, sitting on a ram, symbol of Capricorn. Eight nymphs accompanied Mars aboard the float, decorated with winged hermæ and pictures of Mars' exploits, and drawn by four horses. The god of war was particularly appropriate for the joust, and Don Virginio, too, was particularly appropriate, as the duke of Bracciano, a knight of Malta and valiant warrior, to play the role of Mars. After the jousting had concluded, the barriers for the joust blazed with a pyrotechnical display. Buontalenti – called *"delle Girandole"* (of the pinwheels) because of his supreme mastery of the art of fireworks – undoubtedly designed the display.

An intermission was called, and while the grand-ducal couple and guests dined, the courtyard of the Palazzo Pitti was made ready for a fake naval battle (or naumachia) against the Turks (fig. 10). Just as the ancient Romans had their mock sea fights, so too did the Medici have their naumachiae.[17] The courtyard was flooded about five-feet deep with water. An artificial ceiling to the courtyard was constructed by stretching red cloth over the top (braced by wood); the floor was caulked with pitch to keep the water in.

In the etching, we see a small fortress for the Turks set up over the top of the courtyard fountain. Four small and one very large painting represented battles against the Turks and

17. Although naumachiae had never before taken place in Florence, they were held earlier in northern Europe, for example, at the festivals of the Valois in Brussels in 1582. For more ideas on the naumachia of 1589 in Florence, see Shearman, *Mannerism*, pp. 110-11.

the city of Constantinople, while twelve statues of warriors adorned niches and the terrace above. Special balconies were set up for the hundreds of spectators, and oil lamps lit the arena. It was, by this time, four in the morning. About ten miniature boats are seen here participating in the naval battle between the Turks and Christians – and the latter were, of course, triumphant. In reality, Ferdinando de' Medici was especially interested in building up the Tuscan fleet, and he strongly supported the Tuscan port of Livorno. Thus, the theme of this marine event was particularly appropriate to bring his wedding festival to a close.

The dynastic and imperial implications of these ostentatious festivities were many. Just as the emperors had had such theatrical festivals, so too would the grand dukes of Tuscany have them. Just as the kings of Europe had such celebrations, so too should the grand dukes of Tuscany. Just as the previous two grand dukes, Cosimo I and Francesco, had had elaborate festivities, so too would Ferdinando. After all, the grand duchy was only twenty years old.

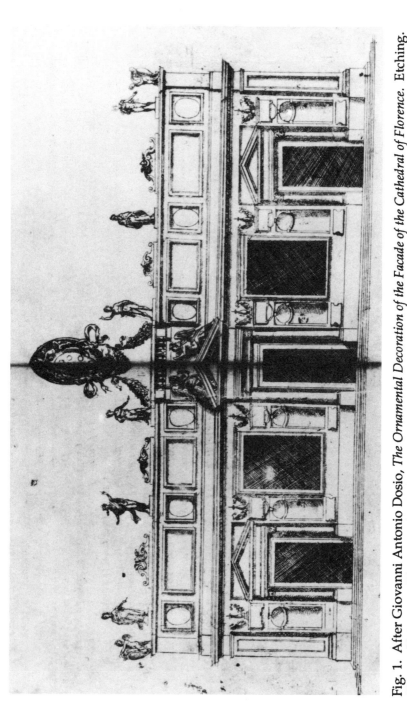

Fig. 1. After Giovanni Antonio Dosio, *The Ornamental Decoration of the Facade of the Cathedral of Florence.* Etching. (Brown University Photographic Laboratory)

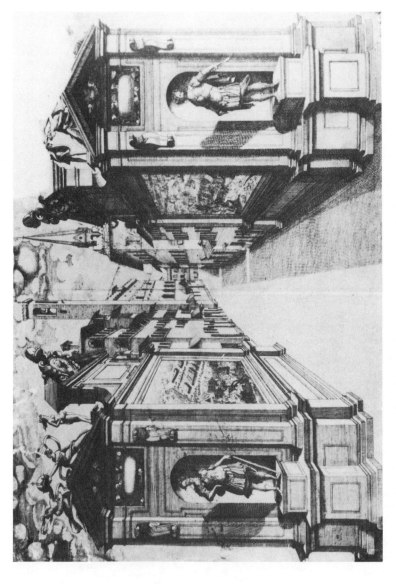

Fig. 2. Orazio Scarabelli, after Taddeo Landini, Street Décor for the Entry of Christine of Lorraine into Florence: View of the Entrance to Via del Proconsolo. Etching (done 1592). (Jeffrey Nintzel)

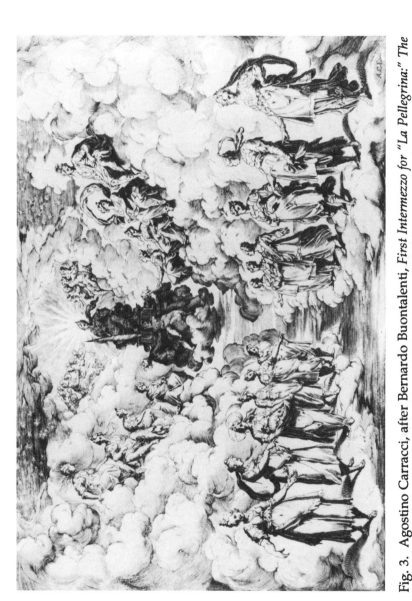

Fig. 3. Agostino Carracci, after Bernardo Buontalenti, *First Intermezzo for "La Pellegrina:" The Harmony of the Spheres*. Etching (done 1592). (Metropolitan Museum of Art)

Fig. 4. Agostino Carracci, after Bernardo Buontalenti, *Third Intermezzo for "La Pellegrina:" Apollo Slaying the Python.* Etching (done 1592). (Fogg Art Museum)

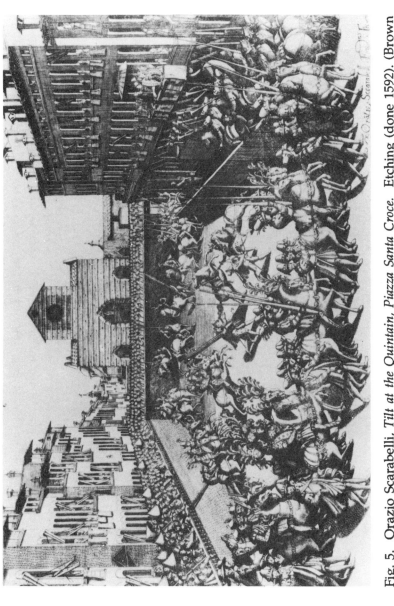

Fig. 5. Orazio Scarabelli, *Tilt at the Quintain, Piazza Santa Croce.* Etching (done 1592). (Brown University Photographic Laboratory)

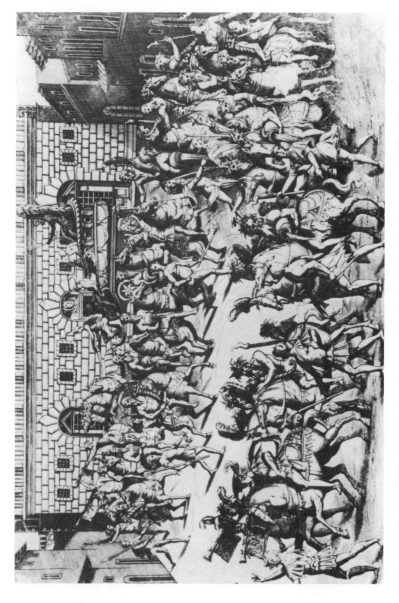

Fig. 6. Epifanio d'Alfiano, after Bernardo Buontalenti, *Triumphal Procession of Neptune in a Chariot and Sea and River Gods*, *before Palazzo Pitti*. Etching (done 1592). (Brown University Photographic Laboratory)

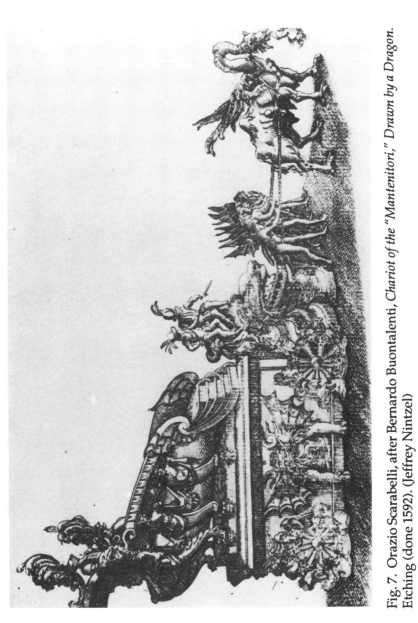

Fig. 7. Orazio Scarabelli, after Bernardo Buontalenti, *Chariot of the "Mantenitori," Drawn by a Dragon.* Etching (done 1592). (Jeffrey Nintzel)

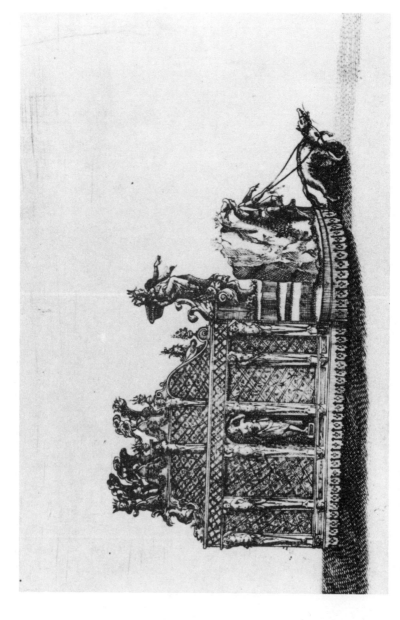

Fig. 8. Orazio Scarabelli, after Bernardo Buontalenti, *Chariot of Circe, Drawn by Wolves.* Etching (done 1592). (Jeffrey Nintzel)

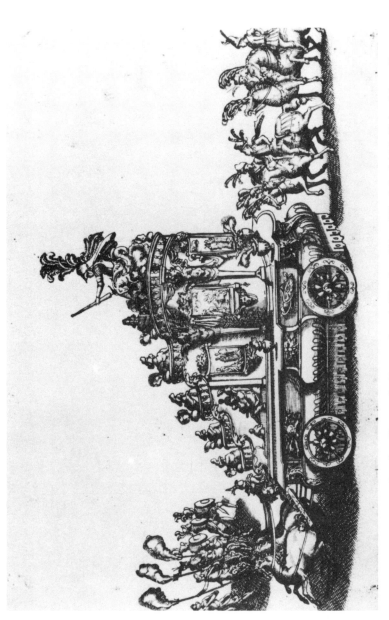

Fig. 9. Orazio Scarabelli, after Bernardo Buontalenti, *Chariot of Don Virginio de' Medici as Mars, Drawn by Four Horses*. Etching (done 1592). (Jeffrey Nintzel)

Fig. 10. Orazio Scarabelli, after Bernardo Buontalenti, *Naumachia in the Courtyard of the Palazzo Pitti*. Etching (done 1592). (Jeffrey Nintzel)

VI

The Vatican Tower of the Winds
And the Architectural Legacy of the
Counter Reformation*

NICOLA COURTRIGHT

In the wake of the Protestant Reformation, the Catholic Church sought to respond to critics within and without its own ranks: the institution that considered itself the sole legitimate church founded by Christ had been shaken to its bedrock and feared its own collapse. Because the church affirmed its traditional doctrines unchanged at the meetings of the Council of Trent, art following the conclusion of the council in 1563 has commonly been regarded as asserting its own orthodoxy, and consequently found doctrinaire, conservative, and intentionally unoriginal.[1] But just as the church of

* This paper is an outgrowth of my "Gregory XIII's Tower of the Winds in the Vatican," (Ph.D. diss., Institute of Fine Arts, New York University, 1990), written under Irving Lavin with Egbert Haverkamp-Begemann. I am deeply indebted not only to Irving Lavin's work on palaces but, above all, to his understanding of unity in the visual arts and its meaning. Further, I am grateful to the discussants at the colloquium for their remarks and would also like to thank James Ackerman, David Coffin, Joseph Connors, Jack Freiberg, Marilyn Aronberg Lavin, and Henry Millon for their observations. At a later stage, Laurie Nussdorfer, John Paoletti, Beth Holman, and John Varriano offered helpful insights and information. Finally, I am happy to acknowledge my debt to David A. Levine, who patiently labored to improve this paper from its inception to its conclusion.
1. Cf. Federico Zeri, *Pittura e Controriforma: L'"arte senza tempo" di Scipione da Gaeta,* 2d ed. (Turin: Giulio Einaudi, 1957). H. Outram Evennett, *The Spirit of the Counter-Reformation,* ed. John Bossy (Cambridge: Cambridge University Press, 1968), discusses the history of modern scholarship on the Counter Reformation; and John O'Malley, "Catholic Reform," in *Reformation Europe: A*

Rome sponsored a variety of deep-seated reforms in the post-Tridentine period, many artists sought a renewal in the arts. In significant ways, their efforts predicted the revolutionary changes of the Baroque period. The subject of this paper is one monument in the Vatican Palace that not only proclaimed itself the symbol of reform but simultaneously created the seventeenth-century concept of "palace" that was to culminate in the palatial retreat of the Sun King at Versailles.

Pope Gregory XIII, best known today for inaugurating the Gregorian calendar, around 1580 commissioned a group of artists to build and decorate a suite of rooms in the Vatican Palace known as the Tower of the Winds.[2] This structure, composed of a rear block of rooms fronted by a lower, projecting loggia and an inset one above, rose so high above a wing of the Vatican's Cortile del Belvedere that it was visible to all of Rome (figs. 1, 2, 3). Gregory's new apartment obliterated one major aspect of Bramante's architecture for Julius II.[3] In the course of enclosing the courtyard in the late 1570s and 1580s, Gregory's architect, Ottaviano Mascarino, built an additional storey on the western corridor to house the Gallery of Geographical Maps, and at its summit he placed the Tower of the Winds. The Flemish artist Matthijs Bril painted a view of the altered wing up to the Tower in the papal apartment (figs. 3, 4).[4] This addition forever destroyed the original effect of monumental perspectival recession realized through architecture, for the corridors, which were to have acted as architectural orthogonals, were now of uneven heights.[5]

Guide to Europe, ed. Steven Ozment (St. Louis: Center for Reformation Research, 1982), pp. 297-319, cites and evaluates recent literature.
2. The basic source for documentation of the Tower of the Winds' construction is James S. Ackerman, *The Cortile del Belvedere* (Vatican City: Biblioteca Apostolica Vaticana, 1954), pp. 102-9. See also Fabrizio Mancinelli and Juan Casanovas, *La Torre dei Venti in Vaticano* (Vatican City: Libreria Editrice Vaticana, 1980). The tower's original appearance has been changed. The openings on the lower loggia were closed in c.1627; Mancinelli and Casanovas, *La Torre*, p. 12.
3. For the reconstruction of Bramante's project, see Ackerman, *Cortile*, pp. 17-40.
4. The fresco is located in the Room of Tobias below the scene representing Tobias and Sarah's wedding night. See Courtright, "Gregory XIII's Tower," p. 474, cat. D-8a.
5. Ackerman, *Cortile*, pp. 106, 121-25.

Although this aspect of Bramante's unique plan was lost, the underlying motivation for the destruction was to revive and reinterpret other important ideas the architect had introduced. As James Ackerman has shown, the cortile, linking the quattrocento villa of Innocent VIII to the body of the Vatican Palace by means of long, arcaded wings, evokes both the circus and the garden with a circus shape, or hippodrome, integral to imperial palace and villa complexes.[6] Mascarino's architecture for the Tower of the Winds augments the tradition of public, ceremonial architecture that informed Bramante's design for the cortile. The location of the Tower of the Winds in the middle of the corridor is analogous to that of the judges' box that Sallustio Peruzzi sketched in his plan of the Circus of Maxentius (fig. 5).[7] The appearance of the tower – an elevated block above the arcaded wing of the cortile – physically resembles boxes surmounting circuses, such as those in Pirro Ligorio's 1561 reconstruction of the Circus of Nero (fig. 6).[8]

The articulation of the Tower of the Winds' upper loggia links it further to the imperial box in a circus. Its form – three openings, an arch crowned by a pediment and flanked by two rectangular bays – is a variation upon a common Renaissance motif, the *Serliana*, that recalls ancient architecture framing the official appearance of the emperor.[9] One forerunner fa-

6. Ackerman, *Cortile*, pp. 125-38. On the relationship of the imperial villa and the circus or hippodrome, see Alfred Frazer, "The Iconography of the Emperor Maxentius' Buildings in Via Appia," *Art Bulletin* 48 (1966): 385-92. On ancient circuses, see John H. Humphrey, *Roman Circuses: Arenas for Chariot Racing* (Berkeley and Los Angeles: University of California Press, 1986).
7. The drawing is preserved in the Gabinetto degli Uffizi, Arch. 691r; Alfonso Bartoli, *I monumenti antichi di Roma nei disegni degli Uffizi di Firenze*, 6 vols. (Rome: C. A. Bontempelli, 1914-1922), 4, pl. 386, fig. 676. See also Romana de Angelis Bertolotti, "Ricerche storiche sulle costruzioni massenziane della Via Appia," in Soprintendenza ai Musei, Gallerie, Monumenti e Scavi, *La residenza imperiale di Massenzio: villa, circo e mausoleo*, exh., Mausoleo e circo di Massenzio, Rome, July – September, 1980 (Rome: Fratelli Palombi, 1980), pp. 62-64.
8. For the sources of Ligorio's reconstruction of ancient circuses, see Donat de Chapeaurouge, "Eine Circus-Rekonstruktion des Pirro Ligorio," *Antike und Abendland* 18 (1973): 89-96. For his map of Rome, see Amato Pietro Frutaz, ed., *Le piante di Roma*, 3 vols. (Rome: Istituto di Studi Romani, 1962), 2, plan 17; 4, pl. 30.
9. Stanislaw Wilinski, "La serliana," *Bollettino del Centro Internazionale di Studi di Architettura Andrea Palladio* 11 (1969): 399-429, an expansion of a 1965 article in the same journal, examines the *Serliana*, its origin, and its meaning in

miliar to contemporary artists is the peristyle of Diocletian's palace at Spalato, where the triple opening frames the entrance to the throne room.[10] As is well known, Bramante's window in the Sala Regia of the Vatican Palace subsequently revived the ancient symbolic association of the appearance motif with the audience hall.[11] The imperial appearance motif, however, is intimately connected to circuses as well. The loge above a circus competition is depicted with the appearance motif in a fifth-century ivory diptych (fig. 7).[12] The motif was employed in the circus box because the imperial ritual of appearance characteristic of throne rooms was repeated in the circus, where the enthroned emperor was publicly acclaimed by his subjects. Ligorio acknowledged the tradition by using the motif in the boxes for his reconstructed Circus of Nero (fig. 6).

Architecture framing the imperial epiphany had sacred connotations understood in the sixteenth century. It was in his ritual of appearance in the late antique circus that the emperor proclaimed his likeness to divinity.[13] Since the impe-

different contexts. Roger J. Crum, "'Cosmos, the World of Cosimo:' The Iconography of the Uffizi Facade," *Art Bulletin* 71 (1989): 241-45, is a recent, useful discussion of the *Serliana* as a traditional appearance motif in relation to the mid-cinquecento Florentine design for the Uffizi.

10. Cf. Karl M. Swoboda, "The Problem of the Iconography of Late Antique and Early Medieval Palaces," *Journal of the Society of Architectural Historians* 20 (1961): 81-83. See now Crum, "Cosmos," p. 241, and nn. 22-23.

11. The architect replaced the existing windows with the one employing the imperial appearance motif by 1507, when stained glass was inserted; Christoph Luitpold Frommel, "Il Palazzo Vaticano sotto Giulio II e Leone X: Strutture e funzioni," in Monumenti, Musei e Gallerie Pontificie, *Raffaello in Vaticano*, exh., Braccio di Carlo Magno, Vatican City, October 16, 1984 – January 16, 1985 (Milan: Electa, 1984), p. 125.

12. The ivory represents the ceremony of dropping the *mappa;* cf. Humphrey, *Roman Circuses*, pp. 79, 153-54. The ivory is a fragment of the diptych of the Lampadii from the first half of the fifth century, in the Museo Civico Cristiano in Brescia; see W. F. *Volbach, Elfenbeinarbeiten der Spätantike und des frühen Mittelalters*, 3d ed. (Mainz: Philipp von Zabern, 1976), pp. 50-51, no. 54. Joseph Connors kindly informed me that the ivory was not known during this period. Other monuments known to contemporaries represent the emperor in his loge above the circus, such as the obelisk base of Theodosius in the hippodrome in Constantinople; cf. Gerda Bruns, *Der Obelisk und seine Basis auf dem Hippodrom zu Konstantinopel* (Istanbul: Universum-Druckerei, 1935).

13. Andreas Alföldi, "Die Ausgestaltung des monarchischen Zeremoniells am römischen Kaiserhofes," *Mitteilungen des Deutschen Archäologischen Instituts, Römische Abteilung* 49 (1934): 81-88. The emperor frequently appeared in the

rial appearance motif had originated in rooms dedicated to the cult of the emperor and continued in Christian ecclesiastical settings, its use in a loge above a circus further emphasized the ruler's sacred character.[14]

In fact, Gregory himself revived the practice of acclamation in a circus. He mimicked the imperial epiphany by receiving pilgrims in the space Bramante had designed, in part, to emulate the ancient circus. The master of ceremonies recorded in his official diary that during the Holy Year of 1575 sponsored by Gregory, the pope habitually greeted groups of pilgrims gathered in the theater of the cortile and blessed them from a window in the corridor.[15] Evidently this practice originated with him; formerly the faithful congregated in the square in front of the basilica of Saint Peter's.[16]

Mascarino designed an architectural setting employing the appearance motif for the cortile that emphasized the tradi-

box containing images of the gods, the *pulvinar;* see Humphrey, *Roman Circuses,* pp. 78-82 and 89.

14. See Fikret K. Yegül, "A Study in Architectural Iconography: *Kaisersaal* and the Imperial Cult," *Art Bulletin* 64 (1982): 7-31. For the continuation of this motif in sacred Christian settings, see now Jack Freiberg, "The Lateran and Clement VIII" (Ph.D. diss., Institute of Fine Arts, New York University, 1988), pp. 208-11. See also Paolo Lino Zovatto, "La pergula paleocristiana del sacello di S. Prosdocimo di Padova e il ritratto del Santo Titolare," *Rivista di archeologia cristiana* 34 (1958): 137-67.

15. According to Franciscus Mucantius, master of ceremonies, in Bibl. Vat., Boncompagni C 5, fols. 275-97, religious societies making pilgrimages to Rome gathered in the theater. Gregory greeted them there often from the middle or upper levels of the corridor, the *"deambulatorio medio"* or *"deambulatorio altiori."*

16. Christoph Luitpold Frommel, "Francesco del Borgo: Architekt Pius' II. und Pauls II.: 1. Der Petersplatz und weitere römische Bauten Pius' II. Piccolomini," *Römisches Jahrbuch für Kunstgeschichte* 20 (1983): 144-52, discusses the history of the ceremony of benediction and of the loggias at Saint Peter's and the Lateran. He points out that Manetti's mid-quattrocento description of Nicholas V's ideal palace unusually connects the *coenaculum* designated for papal appearances with the palace rather than the basilica, thus prefiguring the situation of the Tower of the Winds. See Carroll William Westfall, *In This Most Perfect Paradise: Alberti, Nicholas V, and the Invention of Conscious Urban Planning in Rome, 1447-55* (University Park and London: The Pennsylvania State University Press, 1974), pp. 149-65. For the continuation of the ancient imperial acclamation in the medieval liturgy of *laudes* addressed to kings and popes, see Ernst H. Kantorowicz, *Laudes regiae: A Study in Liturgical Acclamations and Medieval Ruler Worship* (Berkeley and Los Angeles: University of California Press, 1947).

tional associations of Gregory's new practice. The architect
planned a tripartite window for the central bay in the third
storey of the western corridor, where the pope had earlier
appeared to the crowds in the theater below (fig. 8).[17] He
considered two options for the side bays: one rectangular, one
arched. When the window was finally constructed one storey
higher, Mascarino chose round-headed side apertures to
create a triumphal arch.[18] The evidence suggests that he
wished the tower alone to display the classic appearance
motif with rectangular side bays even though a corridor
window had been the actual location of the pope's physical
exhibition to the people. Indeed, the importance of one
particular model for the Tower of the Winds evidently neces-
sitated an isolated, elevated appearance loggia of the classic
type to serve as the prominent symbol of the papacy to all of
Rome.[19]

Certain elements in the Tower of the Winds that depart
from the Roman circus suggest one late antique source. The
Vatican structure differs from the Roman imperial box by
incorporating rooms appropriate to a domicile. The tower is
actually a suite of seven rooms divided among three floors,
not an independent loggia. Another unusual feature is that,
unlike imperial boxes in Renaissance reconstructions of
Roman circuses, the tower is reached by an oval spiral stair
entered from the cortile.[20] These anomalies are found in a
specifically Christian circus, Constantine's hippodrome in

17. The three drawings for this bay, dated after 1580, are in the Accademia
di San Luca, Rome, inv. nos. 2472, 2473, 2474; Paolo Marconi, Angela Cipriani,
and Enrico Valeriani, *I disegni di architettura dell'Archivio storico dell'Accademia
di San Luca* (Rome: DeLuca Editore, 1974), 2:21-22. Cf. Ackerman, *Cortile*, cat.
nos. 54-56; and Jack Wasserman, *Ottaviano Mascarino and his Drawings in the
Accademia Nazionale di San Luca* (Rome: Accademia Nazionale di San Luca,
1966), p. 146, nos. 141-43.
18. Two of the drawings (inv. nos. 2472, 2473) are inscribed "*sotto la Galaria*,"
indicating that they were planned for the third rather than fourth storey
where the bay was finally constructed; see Ackerman, *Cortile*, p. 231, nos. 54,
55.
19. Because of the tower's distance from the cortile, it seems improbable that
it served a practical function as the locus of the pope's actual physical
appearance to the populace. It is more likely that Gregory blessed visitors in
the theater from the window Mascarino built recalling his Holy Year
appearances, although the rather abbreviated diary of the master of
ceremonies does not document this practice.
20. Cf. Courtright, "Gregory XIII's Tower," pp. 68-70.

Constantinople. A Byzantine manuscript known to late sixteenth-century Roman archaeologists, the *Chronicon Paschale*, describes the box Constantine built, the *kathisma*, elevated above the circus in the Roman manner.[21] Constantine also built a palace around the *kathisma*, according to this and other ceremonial accounts.[22] Finally, the Constantinian loggia was reached by a *cochlea*, or spiral stair.[23] This configuration – a spiral stair leading up through a palace to a loggia with the imperial appearance motif above a circus-like space – suggests the Constantinian hippodrome as a model for Gregory's tower more strongly than any other circus or palace known to the sixteenth century.[24]

Recreating the box of the first Christian emperor defined the nature of the pope's authority to reign. Earlier interpretations of palaces help us to understand its significance. The imperial residence began to be considered sacred when

21. *Chronicon Paschale (Corpus scriptorum historiae byzantinae)*, ed. Ludwig Dindorf (Bonn: Weber, 1832), 1:528: "[Constantine] also completed the hippodrome, decorating it with bronze statues and every ornament, building a *kathisma* [for] the royal spectator according to the likeness of the one in Rome." I would like to thank Sarah Morris for her help in translating the passage. Originally compiled in the seventh century, the *Chronicon Paschale* included an annual account of events in Constantinople under Constantine. The eleventh-century manuscript now in the Vatican (Vat. gr. 1941), was bought by a Spanish historian and archivist, Jerome Zurita, in 1551, who made it available to scholars in Rome; Gregorio Andrés, "Historia del ms. Vat. gr. 1941 y sus copias," *Revista de archivos, bibliotecas y museos* 64 (1958): 8-10.
22. *Chronicon Paschale* 1:528, 625. See also Constantin VII Porphyrogénète, *Le Livre des Cérémonies*, ed. Albert Vogt, vol. 1 (Paris: Société d'édition "Les Belles Lettres," 1935), p. 112; and vol. 2 (1939), pp. 113, 144. See Rodolphe Guilland, *Études de topographie de Constantinople byzantine* (Berlin: Akademie-Verlag, 1969), pp. 484-89.
23. *Chronicon Paschale* 1: 528; cf. Guilland, *Études ,*pp. 499-508.
24. An earlier recreation of the Constantinopolitan architectural situation has been suggested for the first papal residence in Rome, the Lateran Palace, by Richard Krautheimer, "Die Decanneacubita in Konstantinopel: Ein kleiner Beitrag zur Frage Rom und Byzanz," *Tortulae: Studien zu altchristlichen und byzantinischen Monumenten (Römische Quartalschrift für christliche Altertumskunde und Kirchengeschichte* 30 (Supplementheft, 1966): 195-99; and in the Lateran's decoration by Hans Belting, "Die beiden Palastaulen Leos III. im Lateran und die Entstehung einer päpstlichen Programmkunst," *Frühmittelalterliche Studien* 12 (1978): 55-83. This evidence, in conjunction with the tower's symbolism, speaks for an iconography of papal palaces in Rome suggesting an unbroken continuity of the papal line.

the emperor's person was declared divine.[25] When
Constantine embraced Christianity, he recalled the relation-
ship to divinity he inherited from his pagan predecessors by
transforming it: he claimed to imitate the Son of God.[26] To
demonstrate the resemblance the emperor appeared before
his people garbed in sparkling raiments reflecting rays of light
as the *sol invictus*, the sun god whose attributes were trans-
posed to Christ when Christianity became the official cult.[27]
After the eighth century, when the Donation of Constantine
was formulated maintaining that the first Christian emperor
had granted imperial rights to the papacy, the papal palace
formally assumed the sacred qualities of the imperial domicile
and was likewise called *sacrum palatium*.[28] The Tower of the
Winds visually states that the intertwined sacred and political
leadership embodied in the person of ancient emperors has a
triumphant and unmistakably Christian purpose.

A remaining element of the Vatican Tower links a focal
point of post-Tridentine reform to the early Christian
emperor. As we know from the manuscript written by the
mathematician and scientist who designed the program,
Egnatio Danti, the name of the structure recalls the homony-
mous monument in Athens.[29] Inspired by the ancient building,

25. S. Viarre, *"Palatium 'Palais',"* *Revue de philologie, de littérature et d'histoire anciennes*, ser. 3, 35 (1961): 241-48; and Irving Lavin, "The House of the Lord: Aspects of the Role of Palace Triclinia in the Architecture of Late Antiquity and the Early Middle Ages," *Art Bulletin* 44 (1962): 16.
26. Cf. Eusebius, *Oration* I, 6.
27. Eusebius, *Life of Constantine*, III, x. See Richard Krautheimer, *Three Christian Capitals: Topography and Politics* (Berkeley, Los Angeles, London: University of California Press, 1983), pp. 62-63.
28. Reinhard Elze, "Das *'sacrum palatium lateranense'* im 10. und 11. Jahrhundert," *Studi Gregoriani* 4 (1952): 27-54; cf. Lavin, "House," p. 14 n. 107.
29. "Anemographia F. Egnatij Dantis O.S.D.: In Anemoscopium Vaticanum Horizontale, ac Verticale instrume[n]tum ostensorem Ventorum," dated January 24, 1581, Bibl. Vat., Vat. lat. 5647, fol. 13v. J. Stein, "La Sala della Meridiana nella Torre dei Venti in Vaticano," *L'Illustrazione Vaticana* 9 (1938): 403-10, summarizes the manuscript and discusses the program of the main room. For the ancient monument, see Joachim von Freeden, OIKIA KYPPHΣTOY: *Studien zum sogenannten Turm der Winde in Athen* (Rome: Giorgio Bretschneider Editore, 1983). Buontalenti's design for the Tribuna in the Uffizi, begun shortly after the Vatican apartment, also recalled the ancient tower. It contained an instrument indicating the direction of the winds in its vault, and its octagonal shape reflected the appearance of the original; cf. Detlef Heikamp, "Zur Geschichte der Uffizien-Tribuna und der Kunstschränke

Danti designed a wind vane for the tower and, mimicking a second feature of the Vatican's predecessor, placed a meridian in the interior to measure time. Danti's instrument charted not the course of the day as the Greek monument's sundials did, however, but the passage of the year. The tower containing the meridian, witness to the year's progress, thus has long been recognized as a tribute to Gregory's renowned reform of Julius Caesar's calendar.[30] Moreover, the calendar reform of 1582 was directed to a religious end consonant with the goals of the Counter Reformation. All contemporary evidence makes clear that the new calendar's primary purpose was to correct the date of Easter, the feast commemorating the fundamental event of Christian faith, Christ's resurrection.[31] The reform explicitly intended to restore Easter to the date determined by the fourth-century Council of Nicaea, convened by Constantine to arrive at a communal celebration of the feast.[32] Eusebius writes that on this occasion the Christian emperor proclaimed Easter the unifying feast of the quarrelling church.[33]

Gregory's reform of the calendar and attendant revival of the ancient Tower of the Winds demonstrated to contemporaries that the pope was the legitimate heir of classical wisdom.[34] The goals of his calendar reform further declare

in Florenz und Deutschland," *Zeitschrift für Kunstgeschichte* 26 (1963): 200-208. I would like to thank Jeffrey Muller for drawing my attention to this room.

30. The instruments are located in the Meridian Room. For the history of the association of the tower with the calendar reform, see Courtright, "Gregory XIII's Tower," pp. 3-5, 51-61. Literature on the Gregorian reform of the calendar includes Ferdinand Kaltenbrunner, "Die Polemik über die Gregorianische Kalender-Reform," *Sitzungsberichte der philosophisch-historischen Classe der Kaiserlichen Akademie der Wissenschaften, Wien* 87 (1877): 485-586; idem, "Beiträge zur Geschichte der Gregorianischen Kalenderreform," *Sitzungsberichte der philosophisch-historischen Classe der Kaiserlichen Akademie der Wissenschaften, Wien* 97 (1880): 7-54; Vittorio Peri, *Due date, un'unica Pasqua: Le origini della moderna disparità liturgica in una trattativa ecumenica tra Roma e Costantinopoli (1582-84)* (Milan: Editrice Vita e Pensiero, 1967); and *Gregorian Reform of the Calendar: Proceedings of the Vatican Conference to Commemorate its 400th Anniversary 1582-1982*, ed. G. V. Coyne, M. A. Hoskin, and O. Pedersen (Vatican City: Specola Vaticana, 1983).

31. See Kaltenbrunner, "Polemik," passim; and idem, "Beiträge," passim.

32. See Kaltenbrunner, "Beiträge," p. 48, for the text of the report of the calendar commission.

33. *Life of Constantine* III, xvii-xviii.

34. In his papal biography, written 1589-97 but only published in the eighteenth century, Johannes Petrus Maffeius placed Gregory in a direct line

him the successor to Constantine, who transformed the ancient *imperium* by joining it with the Christian religion. Like the Christian emperor, Gregory wished to reconcile the divided church and to unify all nations with a single measurement of time eternally celebrating the central promise of Christian faith. The Tower rising over the Vatican symbolized the pope's godlike domination of time and represented in visual terms the early Christian authority that enabled him to do so.

While the tower thus represents the highest aspirations of Gregory's papacy, paradoxically it was also designed to house his most private quarters within the Vatican complex. Far removed from the ceremonial rooms in the old Vatican Palace, the tower served as Gregory's retreat within the Vatican, and thus returned to a second concept of Bramante's for the cortile. By incorporating the earlier papal villa and including gardens in his design, Bramante had instilled the vast space with the classical concept of *otium*, or withdrawal from civilization.[35] Over the course of the sixteenth century the concept of retreat that Bramante conceived for the cortile abated, and the idea of the courtyard as a vast unified theater for public pageantry had gained prominence.[36] The decoration of the six rooms in the rear block of the tower brings the concept of the villa back to the cortile under Gregory. Matthijs Bril painted the walls with landscape friezes and floor-to-ceiling views of the city and countryside like ancient and Renaissance retreats.[37]

with the first calendar reformers, Numa Pompilius and Julius Caesar; *Degli annali di Gregorio XIII, Pontefice Massimo*, 2 vols. (Rome: G. Mainardi, 1742) 1:312. For the date of Maffei's biography, see Pietro Pirri, "Gli annali gregoriani di Gian Pietro Maffei," *Archivum historicum Societatis Iesu* 16 (1947): 56-97.

35. Cf. Ackerman, *Cortile*, p. 132; and David R. Coffin, *The Villa in the Life of Renaissance Rome* (Princeton: Princeton University Press, 1979), pp. 69-87.

36. Cf. Ackerman, *Cortile*, p. 138.

37. A document written shortly after Gregory's death attributes the landscape decoration to Matthijs Bril and not to his better-known brother Paul; Bibl. Vat., Boncompagni D 5, fol. 240v, published in Ludwig von Pastor, *The History of the Popes from the Close of the Middle Ages*, ed. Ralph Francis Kerr, 40 vols. (London: Kegan Paul, Trench, Trubner & Co., 1923-1953), 20:651, app. 11. Because Matthijs' reputation was built on his mastery of topographical landscapes – there are two among the monumental views in the tower – and the decoration was almost certainly completed before Matthijs' death in 1583, there appears to be no reason to attribute any of the paintings to Paul. I am

The private nature of the decoration in the tower seems to contradict the ceremonial symbolism of the architecture. Nevertheless, an architectural configuration joining the pope's public and private personae is directly related to the goals of reform. It is especially appropriate to the residence of a Counter-Reformatory pope that the quarters intended for papal retreat were linked to his symbolic sacred appearance. During the period of church upheaval in the sixteenth century, the pope's private behavior was ever more closely connected with his public function. His human reactions – weeping publicly, for example – were avidly recorded and helped to mold the general perception that emotional response was an essential aspect of reform.[38] The pope not only represented the institution of the church, but was also the model for moral and, it is suggested here, personal, inner reform.[39] Thus, his most private residence became a potent symbol of his public role.

This union of a ruler's public and private domains, expressed in architectural form, is an innovation arising directly out of Counter-Reformatory ideology that becomes the foundation of major seventeenth-century palace design. Soon after the Vatican tower was built, a second version appeared that retained its associations with time, papal ritual, and retreat despite the structure's changed appearance.

deeply grateful to Egbert Haverkamp-Begemann for his contribution to my thinking on these points. Juergen Schulz, "Pinturicchio and the Revival of Antiquity," *Journal of the Warburg and Courtauld Institutes* 25 (1962): 35-55, discusses the relationship of monumental landscapes to antiquity. For Renaissance landscapes in the frieze zone of villas, see A. Richard Turner, *The Vision of Landscape in Renaissance Italy* (Princeton, NJ: Princeton University Press, 1966), pp. 193-212; and for their ancient origins, see Courtright, "Gregory XIII's Tower," pp. 100-108.

38. One example of the pope's public weeping, according to an *avviso*, Bibl. Vat., Urb. lat. 1049, fol. 248v (June 24, 1581), occurred out of tenderness when Cardinal d'Este kissed the pope's feet in front of a large retinue. This practice of reporting papal emotional response continues, for an *avviso* twenty years later describes Clement VIII weeping before the Host; cf. Mark S. Weil, "The Devotion of the Forty Hours and Roman Baroque Illusions," *Journal of the Warburg and Courtauld Institutes* 37 (1974): 222-23.

39. See Frederick J. McGinness, "The Rhetoric of Praise and the New Rome of the Counter Reformation," in *Rome in the Renaissance: The City and the Myth.* Papers of the Thirteenth Annual Conference of the Center for Medieval and Early Renaissance Studies, ed. P. A. Ramsey (Binghamton, NY: Center for Medieval and Early Renaissance Studies, 1982), p. 358.

Around 1584 Mascarino designed another Tower of the Winds for Gregory's magnificent papal villa on the Quirinal Hill, a project that mimicked the cortile that the architect had brought to completion.[40] In the ambitious plan, two wings linked the private quarters of the pope with the ceremonial rooms at the opposite end (fig. 9).[41] The remodeled casino at the north was to receive projecting pavilions flanking a double loggia, the classic form of a Renaissance villa, and the new Tower of the Winds was to surmount it.

In his initial project for the facade of the casino, where no tower appears, Mascarino distinguished the central bay on the upper floor of the double loggia with a balustrade to suggest an appearance loggia (fig. 10).[42] The later tower's design, however, featured its own appearance bay. Its dominant central opening with a half-circular shell, flanked by two narrow rectangular bays, is a subtle reminder of the imperial appearance motif on the Vatican tower (fig. 11).[43] The original Quirinal tower must have precluded the need for a single appearance bay in the *piano nobile*, for Mascarino subsequently extended the balustrade on the loggia across the facade (fig. 12). The tower evidently supplanted the earlier loggia in the casino below because, like its Vatican predecessor, it evoked the papal epiphany.

Like the structure in the Vatican, the Quirinal tower joins the symbol of the divine presence with the papal retreat, so that the sacred numen radiates from the pope's most private living quarters. This connection of the pope's private domain with his public persona is stressed in an emblem from a book dedicated to Gregory XIII (fig. 13).[44] A gloss lauding papal

40. Jack Wasserman, "The Quirinal Palace in Rome," *Art Bulletin* 45 (1963): 205-44, esp. pp. 220-23.
41. Accademia di San Luca, no. 2466; in Marconi et al., *I disegni*, p. 21. See also Wasserman, *Mascarino and His Drawings*, p. 120 n. 111, and fig. 25.
42. Accademia di San Luca, no. 2462; in Marconi et al., *I disegni*, p. 21. Cf. Wasserman, "Quirinal," p. 216 n. 91, fig. 14.
43. Accademia di San Luca, no. 2465; in Marconi et al., *I disegni*, p. 21. Cf. Wasserman, "Quirinal," p. 220 n. 110, and fig. 21. For later changes, see nn. 46-48 below.
44. Principio Fabricius, *Delle allusioni, imprese, et emblemi...di Gregorio XIII* (Rome: Bartolomeo Grassi, 1588), p. 308, no. 204. The representation of the palace embraced by a serpent with its tail in its mouth depends on Horapollo, *Hieroglyphics*, book I, chap. 61, who describes this image as a symbol of a cosmic ruler; cf. Marilyn Aronberg Lavin, "Piero della Francesca's Fresco of

rule over Rome and the world is accompanied by an illustration of the preferred papal retreat, the Quirinal Palace, rather than the Vatican. Because Gregory did not build the wings that would have made the Quirinal a second palace/circus complex, the formal residence of the popes – the Vatican – retained the unique resonance of the venerable Constantinian hippodrome.[45]

During subsequent papacies, as Mascarino's plan for the Quirinal Palace was revived and expanded, the original meaning of the tower was made more explicit.[46] Urban VIII reasserted the symbolism of papal control over time inherent in the Quirinal's Tower of the Winds by building a bell-tower above it (fig. 12).[47] It is tempting to hypothesize that it was also Urban who installed the clock below that made the connection of the tower with time more overt, for the Barberini pope restored the Vatican Tower of the Winds and surely recognized its original link with Gregory's reform of the calendar.[48]

The ideas made visible in the architecture of the papal palaces – the ruler's connection with time and the conflation of the private domicile of the ruler with his symbolic presence – were not limited to papal residences.[49] The artists of Louis

Sigismondo Pandolfo Malatesta Before St. Sigismund: ΘΕΩΙ ΑΘΑΝΑΤΩΙ ΚΑΙ ΤΗΙ ΠΟΛΕΙ," *Art Bulletin* 56 (1974): 362 and n. 83.

45. Death overtook Gregory before he could realize the ambitious plans to make the Quirinal a second Vatican, according to an inscription on the drawing for the expansion (see n. 41 above); cf. Wasserman, "Quirinal," p. 220 n. 111.

46. For Paul V's continuation of Mascarino's ideas, see Wasserman, "Quirinal," pp. 232-38; and Franco Borsi et al., *Il Palazzo del Quirinale*, 2d ed. (Rome: Editalia, 1982), pp. 76-87.

47. Cf. Borsi et al., *Il Palazzo*, p. 108. The print by G. B. Falda was published in the volumes of Pietro Ferrerio's *Palazzi di Roma de' piu celebri architetti* (Rome: Giovanni Giacomo Rossi, n.d.), that appeared after the author's death in 1654. For a discussion of the dating of the prints in this publication, see Laurence Hall Fowler and Elizabeth Baer, eds., *The Fowler Architectural Collection of the Johns Hopkins University Catalogue* (Baltimore, MD: The Evergreen House Foundation, 1961), p. 103.

48. For the Vatican tower's restoration by Urban VIII, see above, n. 2. Maratta designed the mosaic of the Madonna and Child below the clock, still extant today, in 1697; Borsi et al., *Il Palazzo*, p. 262.

49. Borromini's early designs for the Palazzo Pamphili on the Piazza Navona reflect the appearance of and concept behind Gregory's imperial appearance loggia rising above a palace overlooking a circus. Cf. Rudolf Preimesberger, "Pontifex romanus per Aeneam praesignatus: Die Galleria Pamphilij und ihre Fresken," *Römisches Jahrbuch für Kunstgeschichte* 16 (1976):

XIV, the ruler whose ceremonial acts asserted the divine power of kings, employed an artistic vocabulary derived from the only earthly sovereign who could claim a closer relationship to God than he.[50] When Louis decided to expand his palatial retreat at Versailles around 1678, Jules-Hardouin Mansart remodeled the center of the inner court, the Cour de Marbre, by designing a double loggia surmounted by an attic with windows, and by crowning the three storeys with a clock (fig. 14).[51] The double loggia with arched openings in the *piano nobile*, the three square windows on the truncated storey above, and the clock are modifications of the Quirinal's facade as it appeared in the late seventeenth century. Mansart included the remaining element of the Quirinal, the prominent appearance loggia, by means of a projecting balustrade on the *piano nobile*. The clock refers to Louis XIV's domination of time, much as his identification with the sun did.

Further, Mansart joined architectural forms suggesting the public and sacred role of the king to the ruler's ostensibly private quarters. Documents suggest that Louis XIV wanted this courtyard to be more private than the ones leading to it, as it was to be paved with marble and no carriages were to be allowed there.[52] Indeed, like the Quirinal, this area was the site of an older retreat: Louis' father's hunting lodge, preserved and encased by the later architecture.[53] Thus, like

237, and fig. 9. In my "Gregory XIII's Tower," pp. 203-4, I also propose that Bernini drew upon the tower's design in his facade for Santa Bibiana to allude to the church as a *domus ecclesiae*.

50. Cf. Ernst Kantorowicz, "Oriens Augusti – Lever du Roi," *Dumbarton Oaks Papers* 17 (1963): 119-77.

51. See Jean-Claude Le Guillou, "Remarques sur le corps central du château de Versailles a partir du château de Louis XIII," *Gazette des Beaux-Arts*, ser. 6, 87 (1976): 49-60. For the drawing of the new facade, see *Projets pour Versailles: Dessins des Archives Nationales*, exh. Archives Nationales, Hôtel de Soubise, June 1985 – February 1986 (Paris: Archives Nationales, 1985), p. 10 (no. 6), 29. Scholars have previously observed other influences from the Quirinal Palace, most notably in the Escalier des Ambassadeurs; cf. Alfred Marie, *Naissance de Versailles: Le château, les jardins*, 2 vols. (Paris: Éditions Vincent, Fréal, & Cº., 1968), 2:268; and Robert W. Berger, *Versailles: The Château of Louis XIV* (University Park and London: The Pennsylvania State University Press, 1985), p. 36. An intermediary source for the Cour de Marbre that closely followed the Quirinal is Louis LeVau's Hôtel de Lionne; cf. Berger, *Versailles*, p. 26, and fig. 26.

52. See Berger, *Versailles*, p. 9 [M8].

53. Although the wisdom of keeping the modest Petit Château was debated, the final decision to encase it like a shrine with the Enveloppe consisting of

that of the Vatican and Quirinal, Versailles' ceremonial architecture in the courtyard alludes to the ruler's control over time, his sacred epiphany, and the connection of his private domain with his public persona. The imperial vocabulary that the French king habitually adopted assumed the syntax of the popes in the residence of the Sun King in order to suggest Louis' earthly and spiritual supremacy over the church and the universe.[54]

What survived the Counter-Reformatory quest to promulgate a single measurement of time and, simultaneously, a united celebration of faith was the ideal of unity in religious and temporal spheres. The visual symbolism Gregory XIII employed to proclaim the convergence of his private and public personae and, ultimately, the political and spiritual union of the world under his semi-divine leadership found a natural habitat in the palaces of increasingly powerful seventeenth-century princes. It might be said that the papal legacy of unity in the Counter Reformation became the language of absolutism in architecture of royal residences in the following century.[55]

the royal apartments is significant; cf. Berger, *Versailles*, pp. 5-22. The solution for Versailles is comparable to Gregory XIII's remodeling of the old casino at the Quirinal and its subsequent encasement with the corridors, originally planned by Mascarino. See above, n. 41 and fig. 9.

54. While it might be argued, after the declaration of Versailles as the official residence in 1682 and the creation of the Château of Marly, that the royal residence was no longer a retreat, I would maintain that its designers continued purposefully to incorporate villa features in its decoration in a way comparable to the Vatican and Quirinal palaces; that is, they alluded to a "private" realm in what was essentially a public structure. The placement of Louis XIV's bedroom immediately behind Mansart's ceremonial facade in 1701 is the culmination, in my view, of this union of the symbols of rule and the private domain; cf. Guy Walton, *Louis XIV's Versailles* (Chicago: University of Chicago Press, 1986), p. 189. It highlights the peculiar nature of court ceremony in France, where the merger of public and private spheres appears to erase any distinction between them. The visual evidence suggests, however, that a "private" iconography different from that in wholly public spaces, such as the Galerie des Glaces, was employed at Versailles. Perhaps the appearance of a ruler from his private quarters suggested his personal integrity and legitimized his power, as I propose was the case in post-Tridentine Rome. I would like to thank Betsy Rosasco for discussions with me about Versailles.

55. Paolo Prodi, *The Papal Prince: One Body and Two Souls*, trans. Susan Haskins (Cambridge: Cambridge University Press, 1987), reinforces the conclusions I have reached from the visual evidence by suggesting that the political origins of absolutism are to be found in the Counter-Reformatory papal court.

Fig. 1. Tower of the Winds, Vatican Palace. (Servizi Tecnici del Governatorato, Vatican)

Fig. 2. Cortile del Belvedere, Vatican Palace, under Gregory XIII. (Servizi Tecnici del Governatorato, Vatican)

Fig. 3. Matthijs Bril, Tower of the Winds, detail of fresco. Tower of the Winds, Vatican Palace. (Musei Vaticani, Archivio Fotografico)

Fig. 4. Matthijs Bril, western wing of the Cortile del Belvedere, fresco. Tower of the Winds, Vatican Palace. (Musei Vaticani, Archivio Fotografico)

Fig. 6. Pirro Ligorio, Circus of Nero, detail of his 1561 map of ancient Rome. From Graham Smith, *The Casino of Pius IV* (Princeton, NJ: Princeton University Press, 1977), fig. 27.

Fig. 5. Sallustio Peruzzi, plan of the Circus of Maxentius, drawing. Detail. Arch. 691r, Gabinetto degli Uffizi, Florence. From Alfonso Bartoli, *I Monumenti antichi di Roma nei disegni degli Uffizi di Firenze*, vol. 4 (Rome: C. A. Bontempelli, 1919), pl. 386, fig. 676.

Fig. 7. Diptych of the Lampadii. Museo
Civico Cristiano, Brescia. From W. F.
Volbach, *Elfenbernarbeiten der Spätantike
und des frühen Mittelalters* (Mainz: Phil-
ipp von Zabern, 1976), fig. 54.

Fig. 8. Ottaviano Mascarino, drawing for a window in the western corridor of the Cortile del Belvedere. Inv. no. 2474, Accademia di San Luca, Rome. (Guido Guidotti)

Fig. 9. Ottaviano Mascarino, plan for the Quirinal Palace, drawing. Inv. no. 2466, Accademia di San Luca, Rome. (Guido Guidotti)

Fig. 10. Ottaviano Mascarino, elevation of the Casino, Quirinal Palace, drawing. Inv. no. 2462, Accademia di San Luca, Rome. (Guido Guidotti)

Fig. 11. Ottaviano Mascarino, elevation of the Tower of the Winds, Quirinal
Palace, drawing. Inv. no. 2465, Accademia di San Luca, Rome. (Guido
Guidotti)

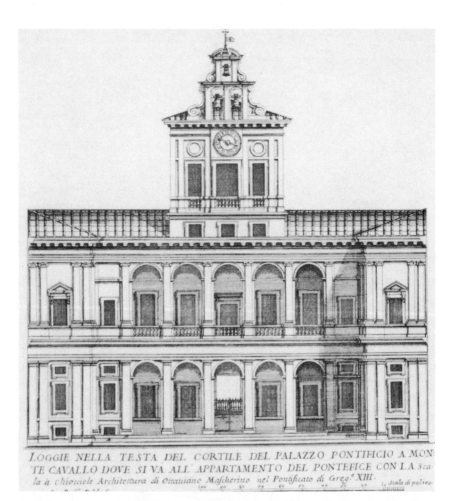

LOGGIE NELLA TESTA DEL CORTILE DEL PALAZZO PONTIFICIO A MON-
TE CAVALLO DOVE SI VA ALL' APPARTAMENTO DEL PONTEFICE CON LA Sca
la à chiocciole Architettura di Ottauiano Mascherino nel Pontificato di Greg.° XIII.

Fig. 12. G.B. Falda, elevation of the Casino, Quirinal Palace, Rome. Detail. From Franco Bozzi, et al., *Il Palazzo del Quirinale*, 2d ed. (Rome: Editalia, 1982), p. 49.

PRINCEPS·REXQ·POTENTISS

Palatium in monte exquilino in Vrbe, quem hodie Caballinum appellãt à Gregor. XIII. ad vsũ Rom. Pont. propter aeris amœnitatem exstructũ fuit. Cui addidim° circũuolutũ Serpentem, quoniam hæc erat imago, formaq́; Principis apud Ægyptios, q̃ subditorum curã æqua lance gerere voluisset.

Princeps in medio Regno, in Vmbilico, vt subditos æqué exaudiat omnes sedem habere debet.

Sol in medio cœlestium orbium cursum peragit, quatuor.n. habet sphæras supra, & tbudé infra.

Mundi Microcosmus Italia, Roma caput est.

Orientales, Occidẽtales, Meridionales, & Septẽtrionales æque pari locorum interuallo ab Vrbe pené dictæ videntur.

CCIIII.

Con ampÿ giri la superba Mole,
 Che'l Regno importa ben fondato, e retto
 Cinge Drago immortal, Signor perfetto,
 Che i Soggetti vgualmente intender vuole.
E quale in mezo à i celesti Orbi il Sole
 Alluma, e scalda con sereno aspetto
 Come à Saturno, à la Sorella il petto,
 Tal Questi à ogn'Alma, che l'honora, e cole.
Del Mondo Italia è vn piccol Mondo, e Roma
 E d'ambi il Capo, oue riluce, e splende
 Con noua Sfera il Pastor santo, e giusto.
Tal che non men può venerar sua Chioma,
 Che del foco diuin gli Animi accende,
 Il Gelato German, che l'Indo adusto.

Fig. 13. Emblem from Principio Fabritius, *Delle allusioni, imprese, et emblemi...di Gregorio XIII* (Rome: Bartolomeo Grassi, 1588), 204:88. (Princeton University Library)

Fig. 14. Jules-Hardouin Mansart, elevation of the palace facade, Cour de Marbre, Versailles. Detail. Inv. no. 36, Archives Nationales, Paris. From *Projets pour Versailles: Dessins des Archives Nationales* (Paris: Archives Nationales, 1985), p. 29.

VII

Drawing and Collaboration
In the Carracci Academy*

GAIL FEIGENBAUM

In the course of preparing a catalog of the works of Lodovico Carracci, I have had the occasion to look at several thousand drawings attributed to the Carracci and their school. This material is scattered all over Europe and America in large and small collections, and most of it is unpublished or cursorily cataloged. Over the years connoisseurs have sorted out the finest drawings and given them individual Carracci names, often lamenting the fact that the profusion of copies and school pieces has clouded our perception of the superb quality of Carracci draftsmanship. In recent years we have come to distinguish the drawing styles of certain members of the academy, Giacomo Cavedone and Pietro Faccini, for example. And although this operation is subject to a great deal of argument back and forth, gradually their works too are being rescued from the vast store of anonymous "sub-Carracci" material.

* The text of this paper is virtually unchanged from the talk I gave at the colloquium. I decided to publish it in its original form – however speculative and provisionary – because so much excellent criticism was offered by my colleagues at the symposium that it could not be taken into account without a substantial expansion of the ideas here presented. Instead, some of the ideas presented at the colloquium have now been taken further in my "Practice in the Carracci Academy," in *The Artist's Workshop, A Symposium,* (March 10-11, 1989), *Studies in the History of Art* (Washington, DC: National Gallery of Art, in press). For their perceptive comments, my particular thanks to Linda Klinger, Craig Hugh Smyth, and William Tronzo. I am especially grateful to Marilyn Lavin for giving Irving Lavin's students the opportunity to bestow upon him this extraordinary birthday present.

Like most people who have studied these drawings, I approached them with certain expectations of how I would behave: how I would separate the authentic from the copy; how I would distinguish one Carracci's draftsmanship from another's; and, of course, how I would unearth some previously unrecognized gems. What I did not expect was to discover that the questions I intended to ask of the material were themselves inadequate. Two facts above all brought this point home to me: first, that there was as much dispute as there was agreement over the attributions of drawings selected out as autograph early Carraccis. Second, after connoisseurs had plucked the best original Carracci drawings out of the boxes, the residue was regarded – intellectually – as dross, of no interest or value whatsoever.

I shall have to be quite brief on the latter problem, namely, what about the chaff left over after the process of winnowing the Carracci wheat – not to mention that of Guido Reni, Cavedone, et cetera? What remains is a wildly disparate mix, much of it consisting of misattributions and of later copies that might shed some light on how the Carracci's art was, in certain times and places, studied as a part of the artist's training. On the other hand, much of the material is also contemporary, including copies as well as odd sheets that may turn out to be by one of the Carracci but for which we now lack *comparanda*. Especially interesting are hundreds of drawings that must have been made by the Incamminati, the members of the Carracci Academy. These works embrace landscapes, caricatures, scores of studies after the model, exercises in the form of games – figures drawn without lifting the pen, or composed entirely of dots or dashes. One finds candid sketches of daily life in the studio and portraits that the pupils seem to have drawn of one another and of visitors. Some of the drawings may be caricatures of paintings – such as a sheet in the Uffizi that may be a spoof of Lodovico's famous lost *Flight into Egypt* with the ass unwilling to debark[1] –

1. Gabinetto disegni e stampe degli Uffizi, inv. 12323 F, pen and ink, 184 x 274 mm. Inscribed on verso: "Di Lod. Carracci." For descriptions of the lost painting see Gail Feigenbaum, "Lodovico Carracci: A Study of his Later Career and a Catalogue of His Paintings," (Ph.D. diss., Princeton University, 1984), pp. 344-46.

not to mention irreverent comments on classical antiquity.[2] We cannot attach names to these drawings, nor even date them with much precision. But however difficult to classify, these "rejects" offer a concrete body of evidence that testifies vividly to the daily activities and training in the Carracci Academy. This "sub-Carracci" material complements the early written accounts, such as that of Malvasia and, if we can find ways to make sense of it, may modify our understanding of actual practice in the academy. This material may not be high art, but it has its own eloquence and usefulness.

Let me cite one example in a pair of drawings, one in the Uffizi (fig. 1), the other in the Victoria and Albert, portraying the same model in the same pose, but from different points of view – clearly from different parts of the same room, and clearly also by two different artists.[3] Both have been attributed, wrongly, to Annibale. In scene VII, *The Shade of Creusa Appears to Aeneas,* of the Virgilian fresco cycle in the Palazzo Fava, an early collaboration by the Carracci, the identical recumbent figure appears, rendered from a steeper angle of vision (fig. 2).[4] As far as I know, whatever drawing may have been used as the *modello* has not survived, but the existence of these other two studies raises certain questions about how drawings were used in the academy. We tend to separate the Carracci's figure drawings done as a preparation for a painting from those made from the model in life-drawing sessions, but is this a real boundary? Should we assume that any drawing used as a *modello* for a painting was necessarily by one of the Carracci, or could a competent study by a pupil serve if it worked out the needed pose? Was the model asked to assume the pose in the life class because the Carracci needed such a figure for the painting upon which they were working? Or might such a drawing have been kept and pulled out later when it was of use? I should also

2. Gabinetto disegni e stampe degli Uffizi, inv. 1312 E, pen and ink 250 x 209 mm. A similar drawing in the Louvre, which omits the defecating figure, may be an autograph sheet by Lodovico.
3. Gabinetto disegni e stampe degli Uffizi, inv. 12399 F, black chalk heightened with white, 263 x 414 mm, retraced and stained. Victoria and Albert Museum, inv. 51298, black chalk.
4. Discussed in Andrea Emiliani, *Bologna 1584*, exh. cat., Pinacoteca Nazionale (Bologna: Nuova Alfa Editoriale, 1984), p. 196.

mention here that this example is one of several that I have collected of life-drawing class poses employed in the early Carracci paintings.

I would like to turn now to questions about autograph Carracci drawings. As anyone who has studied this material knows, the styles of the young Carracci can be exceedingly close.[5] Despite the best efforts of scholars for four centuries, it has often been impossible to tell their works apart: this point applies to both the paintings and the drawings. If two experts agree on an attribution, a third assigns it elsewhere, and back and forth it goes, each scholar arguing confidently for his or her view, and with the most recent opinion usually allowed to rest, for the time being, in lieu of agreement. The situation can acquire an unfortunate tone of parody, as in the case of the Palazzo Magnani frieze depicting the Founding of Rome upon which the Carracci worked together. In this century more than a dozen distinguished scholars have attempted to sort out the various Carracci's particular parts, but no two have offered the same set of conclusions, and none has agreed with Malvasia, who quit his own attempt at making attributions halfway through the fourteen scenes.[6]

5. Both the drawings and the paintings of the Carracci are remarkable for their stylistic diversity. The Carracci advocated the study of an array of different manners as an antidote to the involution of a local tradition that was exhausting itself in its imitation of a limited slate of unsurpassable authorities, especially Michelangelo, for which see Feigenbaum, "Practice in the Carracci Academy." In Vasari's newly written history of art, regional differences in style were organized into a hierarchy of excellence with central Italian painting at the apex. Refusing to accept this narrowing of the artist's choices, the Carracci embraced a multitude of non-Tuscan sources. See Elizabeth Cropper, "Tuscan History and Emilian Style," in *Emilian Painting of the 16th and 17th Centuries, a Symposium* (January 29-10, 1987), *Studies in the History of Art*, (Washington, DC: National Gallery of Art, 1987), pp. 49-62, for a perceptive analysis of this problem. In this context the concept of the "personal" styles of the Carracci can be elusive. They developed in a dialectic with one another's work and, quite self-consciously, with the art of the past. At times the hand of one or the other Carracci is unmistakable. At other times their styles seem to converge, making separation between their hands very difficult.
6. Carlo Cesare Malvasia, *Felsina pittrice*, (Bologna, 1678), 1:392-93; rev. ed. (Bologna: Guidi all'Ancona, 1841), 1:288-90. Hans Tietze, "Annibale Carraccis Galerie im Palazzo Farnese und seine römische Werkstatte," *Jahrbuch der kunsthistorichen Sammlungen des allerhöchsten Kaiserhauses* 26 (1906-7): 58; G. Rouchés, *La Peinture bolognaise a la fin du xvi siècle, Les Carrache*, (Paris: F. Alcan, 1913), p. 127; A. Foratti, *I Carracci nella teoria e nella pratica* (Città di Castello: S. Lapis, 1913), p. 68; Heinrich Bodmer, "Gli Affreschi dei Carracci

Most recently Alessandro Brogi proposed, in a well-argued study, a plausible series of attributions for the frieze.[7] But I have to ask whether his, because most recent, really represents progress toward the resolution of individual responsibility. Perhaps the real problem is the way we have defined the problem.

Only a few drawings for the Magnani frieze have come to light, and among them, especially fortunate, there is one instance where two preliminary sketches survive for the same scene – of Romulus and Remus nursed by the She-Wolf. One study, in the Louvre, is by Annibale; the other in the Cini Foundation, by Lodovico.[8] What conclusions have been drawn from these two sheets? That Annibale painted the landscape in the fresco and Lodovico the wolf and twins; that Annibale painted the whole fresco, deriving the wolf and twins from Lodovico's design; that Lodovico painted the whole scene basing the landscape on Annibale's drawing; that the conception is totally and seamlessly Annibale's and Lodovico's drawing irrelevant; ditto for Lodovico.[9] If we persevere in trying to separate the hands, will the dissection ever yield the "right" answers? However one views the

nel Palazzo Magnani ora Salem a Bologna," *Il Comune di Bologna*, 12:3-20; Francesco Arcangeli, "Sugli inizi dei Carracci," *Paragone* 79 (1956): 45-46; Denis Mahon, *I Carracci, Disegni*, exh. cat. (Bologna: Edizione Alfa, 1956), pp. 47-48, 76-78; Andrea Emiliani in *I Carracci, Dipinti*, exh. cat. (Bologna: Edizione Alfa, 1956), pp. 80-81; Gian Carlo Cavalli, "Carracci, Annibale," in *Encyclopedia universale dell'arte* (Florence, 1958), p. 135; Anna Ottani, *Gli Affreschi dei Carracci in Palazzo Fava* (Bologna: Pàtron, 1966), pp. 73-75; Carlo Volpe, *Il fregio dei Carracci e i dipinti di Palazzo Magnani in Bologna* (Bologna: Credito Romagnolo, 1972); Stephen Ostrow, "Agostino Carracci" (Ph.D. diss., New York University, 1966), p. 197; Andrea Emiliani, ed., Carlo Cesare Malvasia, *Le pitture di Bologna* (Bologna: Edizione Alfa, 1969), pp. 93-94; Donald Posner, *Annibale Carracci. A Study in the Reform of Italian Painting Around 1590* (London: Phaidon, 1971), 1:60 and cat. no. 52; A. W. A. Boschloo, *Visible Reality in Art after the Council of Trent*, 2 vols. (The Hague: Government Publishing Office, 1974), 1:27-28, 43; and 2:221-22 n. 21; and Alessandro Brogi, "Il fregio dei Carracci con 'storie di Romolo e Remo' nel salone di palazzo Magnani," in *Il Credito Romagnolo* (Bologna: Grafis Edizione, 1985), pp. 218-71.
7. Brogi, "Il fregio," pp. 218-71.
8. Anna Ottani Cavina, "Annibale Carracci e la Lupa del Fregio Magnani," in *Les Carrache et les décors profanes: Actes du Colloque organisé par l'École française de Rome* (Rome: École Française de Rome, 1988), argued that the Cini Foundation sheet is by a later hand and derived from the fresco. She kindly informed me of her reservations before I saw the original, but after examining the drawing I found the earlier attribution to Lodovico to be convincing.
9. See note 6 above.

evidence, there is no denying that the fresco can be understood as a collaboration. Malvasia recounts that when asked what was by Annibale, what by Agostino, and where was Lodovico's hand, the Carracci replied: "Ella è de'Carracci, l'abbiam fatta tutti noi."[10] According to Malvasia in the Magnani they worked in such a way that "one artist entered into what the other had begun; one finished what was already half done by another."[11] He added that the Carracci enjoyed this dissimulation of attribution, purposefully confounding outsiders with the resemblances of their manners so as to maintain individual anonymity, wanting praise only for the operation as a whole. They had their reasons for this, as I have discussed elsewhere.[12] The scholarship on the Magnani attests to the Carracci's achievement of perfect confusion.

The same case could also be made for the Jason cycle in the Palazzo Fava, one of their first collaborative decorations, where the lack of consensus on attributions is nearly as complete. The drawings compound the confusion. Scholars are divided between Agostino and Annibale as the author of scene IV, for example, the *Meeting of Jason and Pelias*.[13] The compositional study in the Louvre is usually regarded as Annibale's; although Cavina suggested Lodovico.[14] In the Uffizi is a second drawing (fig. 3), a red chalk figure study, probably for the group at the far right, which Catherine

10. Malvasia, *Felsina pittrice*, 1:287.
11. Ibid.
12. Feigenbaum "Lodovico Carracci," especially pp. 269-73, and "Practice in the Carracci Academy," (in press). See also Cropper, "Tuscan History," pp. 58-59. The only writer to have recognized, albeit in passing, the central importance of collaboration itself was Luigi Spezzaferro, "I Carracci tra naturalismo e classicismo," in *Le Arti a Bologna e in Emilia dal XVI al XVII secolo*, Atti del XXIV Congresso C.I.H.A., 1979, (Bologna: Edizione C.L.U.E.B., 1982), pp. 203-28.
13. Attributions to Annibale are by Denis Mahon, "Afterthoughts on the Carracci Exhibition," *Gazette des Beaux-Arts* 49 (1957): 271; and Ostrow, "Agostino Carracci," pp. 86-89; to Agostino by Arcangeli, "Sugli inizi," p. 21; Ottani, *Gli affreschi*, p. 55; and Emiliani, *Bologna 1584*, pp. 102-3; to Agostino after Annibale's drawing by Boschloo, *Visible Reality*, pp. 25-26; to Agostino and shop after Annibale's drawing by Posner, *Annibale Carracci*, vol. 2, cat. no. 15.
14. For the drawing see Roseline Bacou, *Dessins des Carrache*, exh. cat. (Paris: Musée du Louvre, 1961), no. 23; and Emiliani, *Bologna 1584*, p. 103 for complete bibliography.

Johnston has published as by Annibale.[15] While this attribution has found acceptance, I would like to compare it to a study in the Ashmolean of a sleeping boy (fig. 4), generally regarded as bedrock for Lodovico's early chalk style.[16] I remark on the resemblance between the ribbony contour lines that taper and swell, tending in places to spread out and flatten against the page. Compare the amorphous curves defining the hands in both drawings, to the thick diagonal hatching – sometimes bleeding over the contours – and the manner of layering in patches of shadow upon shadow. In both drawings the shading is fretted where it abruptly meets the light, as in the carried man's thigh, or the sleeping boy's upper arm. Whether or not you are convinced by this comparison, my intention here is to raise, not lower, the level of uncertainty about these attributions. Virtually every study associated with the Jason cycle has been disputed, and yet this simple fact seems to have shaken nobody's confidence but my own in this enterprise of connoisseurship.

In Oslo I recognized a beautiful black chalk drawing (fig. 5) as a study for the horn player, shown in reverse, in the third scene of the Jason cycle (fig. 6). The study is on the verso of the sheet, revealed in a window through the backing paper, which is inscribed Lodovico Carracci, to whom the drawing is attributed.[17] The recto is a pen and wash drawing of the Virgin with the young Christ and Saint John playing with a bird in a landscape (fig. 7). In Stockholm I came upon another unpublished version of this subject (fig. 8), cataloged as by Annibale.[18] It is of slightly smaller dimensions and has a light underdrawing in red chalk. It also differs in showing a string that attaches the bird to the stick in the baby's upraised fist. These features suggest that the Stockholm drawing may have been the model and Oslo the copy, unless we are

15. Gabinetto disegni e stampe degli Uffizi, inv. 12392 F, red chalk. See Catherine Johnston, *Il Seicento e il settecento a Bologna*, (Milan: Fabbri, 1971), p. 82.

16. Oxford, Ashmolean, inv. 171, red chalk, 237 x 223 mm. See Diane DeGrazia, *Correggio and His Legacy*, exh. cat. (Washington, DC: National Gallery of Art, 1984), p. 351, no. 117 for discussion, bibliography, and illustration.

17. Oslo, Nasjonalgalleriet, inv. B.15188 verso, black chalk, 301 x 220 mm. Inscribed in a later hand "Lodovico Caracci." The recto is pen and wash.

18. Stockholm, Nationalmuseum, inv. H. 945/1863, pen and wash over black chalk, 306 x 267 mm.

missing other versions of this composition. But who made these drawings? Is the horn player for the Fava by Lodovico, as the inscription, a notoriously unreliable indicator, claims? It is difficult to find a clinching comparison in either artist's work, although there is little question that it is by one of the Carracci. To make matters worse we cannot always assume recto and verso are by the same hand. As for the pen and wash scenes, the closest comparisons are other disputed drawings, such as the one in Munich, also for the Jason cycle.[19] I would like to introduce a new, although not conclusive, piece of evidence in the form of a pen sketch of *Judith and Holofernes* (fig. 9) that passed recently through the art market, which I believe is an early drawing by Lodovico and which displays stressed, ribbony contours and gently graded washes similar to those of the Stockholm sheet.[20] The splotchy sun-dappled washes of the Oslo sketch are perhaps closer to certain genre drawings by Annibale, but for the moment, the question of attributions is better left open.

The possibility of collaboration in individual works, as opposed to fresco cycles, should also be considered. Although many critics, from Malvasia to Longhi, were convinced that the Carracci worked together on easel paintings, in recent years this view has become extremely unfashionable. One useful case to examine is a painting of *Saint Sebastian* in Leipzig, in my opinion a genuine work by Lodovico, although rejected by Bodmer.[21] A red chalk drawing in the Uffizi (fig. 10) published as by Annibale is clearly related to the Leipzig composition.[22] Evidently the drawing is a preparatory study for the painting. How can this be explained? One possibility is that the attribution to Annibale is mistaken, and this drawing is Lodovico's own study for his painting – the style of draftsmanship, with the soft "attack" of the chalk, the em-

19. Munich inv. 6823, pen and wash, squared with red chalk, 253 x 314 mm. See DeGrazia, *Correggio*, p. 368, no. 125 for discussion, bibliography and illustration.
20. Pen and wash, squared in black chalk, and with stylus, 238 x 390 mm. Kate Ganz, Ltd, London; the drawing has since entered a private collection in California.
21. Heinrich Bodmer, *Lodovico Carracci* (Burg b. Magdeburg: August Hopler, 1939), p. 143. *Saint Sebastian*, Leipzig, Museum der bildenden Künste, inv. 1385, oil on canvas, 62 x 46 cm.
22. Gabinetto disegni e stampe degli Uffizi, inv. 1530 F, red chalk, 398 x 155 mm.

phasis on chiaroscuro above definition of structure, and stringy, cursorily described drapery does not preclude Lodovico's hand. Another explanation is that Lodovico based his painting on a drawing by his cousin.[23] Both possibilities are plausible. On the one hand, there is so much disagreement over the early drawings that any attribution is susceptible to revision. On the other, collaboration was without a doubt the *modus operandi* of the early Carracci Academy. I have cataloged thirteen collaborative projects undertaken before Annibale and Agostino left for Rome. And there is other evidence to suggest that the collaborative attitude may have extended to individual works as well.

To illustrate this point one can turn to another category of drawings, namely a group of compositional sketches by Lodovico for subjects that he himself did not paint but that were painted by his cousins, and at about the same time the drawings were created. According to Malvasia, Annibale and Agostino often turned to Lodovico for inspiration, "il più copioso e ferace in invenzione," for he was able to find twenty ways to vary one idea.[24] There are several bright, free sketches by Lodovico that suggest exactly such fertile *invenzione* for a crucifixion, resurrection, and deposition or pietà – all subjects Annibale painted in the 1580s. And there are other drawings by Lodovico for subjects painted by Agostino, most notably the *Adoration of the Shepherds* altarpiece for the Gessi Chapel, another ensemble to which all

23. After this paper was given, an article appeared by Alessandro Brogi, "Annibale Carracci: un risarcimento," *Paragone* 38 (July 1987): 80-84, publishing a painting that had passed through the London art market under a variety of attributions, including that of Annibale. Brogi argued that the painting (which had since been acquired by Piero Corsini Gallery, New York) was a genuine Annibale and that the Leipzig painting, which Brogi has evidently not seen at firsthand, must consequently be a "copia pedissequa" by another artist (not Lodovico). Having had the opportunity to examine closely both the Leipzig painting and the Corsini picture, I must disagree with Brogi's conclusions. The two versions differ considerably in handling. The Leipzig *Saint Sebastian* does seem to be an autograph work by Lodovico, while the Corsini painting may be by Annibale. I find no objection to the notion that the cousins might copy one another's works, for any number of reasons, be they commercial or as an exercise. The collaborative attitude analyzed here and in Feigenbaum, "Practice in the Carracci Academy," would accommodate such procedure.
24. Malvasia, *Felsina pittrice*, 1:345.

three Carracci contributed.[25] It is worth noting that Malvasia reported of the *Crucifixion* and *Pietà* that Lodovico passed the commissions along to his young cousin, promising to the patron "ogni assistenza e ritocco."[26] If at first glance Annibale's *Pietà* seems to have little except the subject in common with Lodovico's drawings, a closer scrutiny reveals similarities in the Magdalen in the left corner of the painting and in this sheet from Oxford; and in Lodovico's drawing from the Louvre, affinities in the fainting Virgin, the landscape background, and the diagonal orientation of the composition itself.[27] It may be that Annibale assimilated Lodovico's *invenzione* in working out his own, adapting what he needed, and discarding the rest. There seem to be other instances in which the Carracci exchanged drawings for individual works, as in Annibale's *Christ and the Samaritan Woman*.[28]

The connoisseur's question "who made this?" has its own peculiar context in Carracci studies because it is linked to the question "who did this or that *first*?" Ultimately what is at stake here is the authorship of the "reform of painting." Debate over the reform was begun in the seventeenth century, even before Malvasia tangled with Bellori; and it continues, as witness the recent conference on the Farnese Gallery at the French School in Rome.[29] To my mind the best

25. Louvre inv. 7661, pen and wash, 203 x 237 mm.
26. Malvasia, *Felsina pittrice*, 1:267.
27. Christ Church, Oxford, inv. 1356, pen and wash over red chalk, 527 x 295 mm. Louvre inv. 7681, pen and wash over red chalk heightened with white, 298 x 220 mm, (contours possibly strengthened by a later hand).
28. A sketch of this subject in the British Museum, inv. 1858-11-13-34, attributed to Lodovico, establishes the idea for Annibale's composition. The suggestion, made by Donald Posner, was reported in Dwight Miller, "A Drawing by Agostino Carracci for his Christ and the Adulteress," *Master Drawings* 7, 4 (Winter 1969): 412. (My own view is that the drawing is probably by Agostino, which does not, in any case, alter the point about the collaboration.) In the same article Miller showed that Annibale revised Agostino's ideas for his overdoor of *Christ and the Adulteress*, citing a series of drawings that represent "the process of critique and counter critique...[which] must have been a vital part of the studio procedure of the Carracci at this time." This issue is further considered in Feigenbaum, "Practice in the Carracci Academy."
29. The acts have now been published, *Actes du Colloque organisé par l'École française de Rome* (Rome: École Française de Rome, 1988). In particular, the paper of Anton Boschloo considered the critical fortune of Annibale, and concluded by championing the view of Bellori – that Annibale was the

efforts of connoisseurship, especially of the drawings, furnish evidence of the indivisible spirit of the Carracci enterprise in the early years, and the intimacy of their collaboration. Working together the Carracci subordinated their individual propensities to a unity of purpose, and their method of production and of free exchange at every stage ensured that the collective would dominate the personal. Time and again the drawings support the view that the three developed individually in constant reference to the work of the others, and to the simultaneously evolving goals and programs of the collective enterprise. Their talents were complementary rather than duplicative, and it was the rapid interaction among three restlessly analytical, experimental, and inventive artists that produced the "reform of painting." Any one of them working alone would have produced entirely different results.

In conclusion I might add that I am keeping my eyes open for the lost copper (and any related drawings) sold in Malvasia's times to Signor Alessandro Sacchetti, and valued by Pietro da Cortona at 100 *doppie* – that was "da tutti e tre [Carracci] fatta" and given to a nun of San Bernardino who bleached their shirt collars.[30]

supreme Carracci whose reform of painting came to fruition in Rome; his conclusion elicited cheers from the audience.
30. Malvasia, *Felsina pittrice*, 1:332.

Fig. 1. Annibale Carracci, *Figure Study*. Gabinetto disegni e stampe degli Uffizi, Florence. (Soprintendenza alle Gallerie, Florence)

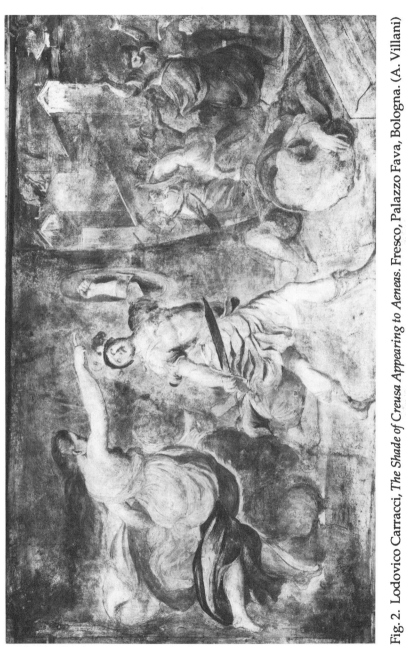

Fig. 2. Lodovico Carracci, *The Shade of Creusa Appearing to Aeneas*. Fresco, Palazzo Fava, Bologna. (A. Villani)

Fig. 3. Annibale Carracci, *A Figure Carrying a Man on his Back*. Gabinetto disegni e stampe degli Uffizi, Florence. (Soprintendenza alle Gallerie, Florence)

Fig. 4. Lodovico Carracci, *Sleeping Boy*. Ashmolean Museum, Oxford.

Fig. 5. Lodovico Carracci, *Young Boy Blowing a Trumpet*. Nasjonalgalleriet, Oslo. (Nasjonalgalleriet)

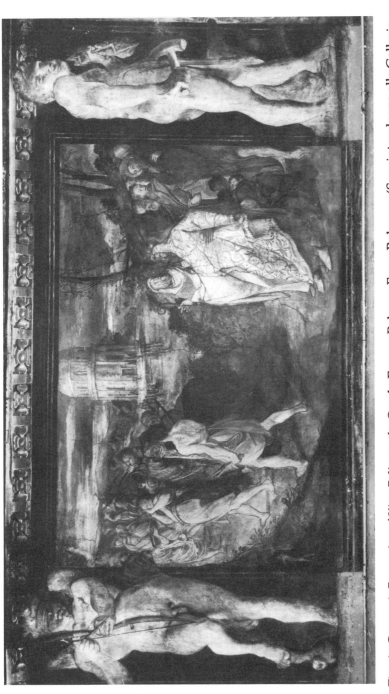

Fig. 6. Carracci, *Procession of King Pelias to the Oracle*. Fresco, Palazzo Fava, Bologna. (Soprintendenza alle Gallerie, Bologna)

Fig. 7. Lodovico Carracci, *The Virgin with Christ and Saint John* (verso).
Nasjonalgalleriet, Oslo. (Nasjonalgalleriet)

Fig. 8. Annibale Carracci, *The Virgin with Christ and Saint John*. The National Swedish Art Museum, Stockholm. (The National Swedish Art Museum)

Fig. 9. Lodovico Carracci, *Judith and Holofernes*. Private collection, California. (Kate Ganz, Ltd.)

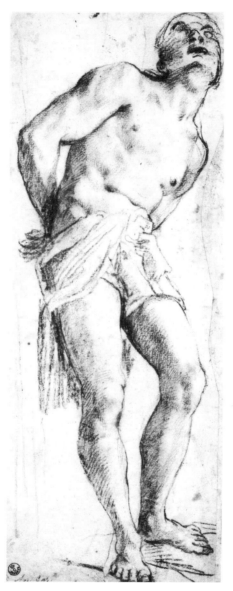

Fig. 10. Annibale Carracci, *Study for a Saint Sebastian.* Gabinetto disegni e stampe degli Uffizi, Florence. (Soprintendenza alle Gallerie, Florence)

VIII

Clement VIII, The Lateran, And Christian Concord·

JACK FREIBERG

Clement VIII (1592-1605) occupied the throne of Peter at a crucial moment in the history of the church. Following a century of religious and political upheaval, his reign was marked by renewed stability. Significant battles with the Turks were won; the schismatic Ruthenian and Coptic churches were reunited with Rome; and Henry IV, king of France, returned to the fold – all by 1595. In 1598 Ferrara was reabsorbed into the papal states and the two great Christian powers, France and Spain, were reconciled.[1] As harbingers of a new age of Catholic hegemony and peace, these events were commemorated in medals, inscriptions, and engravings. Among the expressions of public celebration, two are especially resonant. On the Capitoline Hill, set above the main entrance to the Palazzo del Senatore, a large inscription records Clement's *fasti* on the very site that had witnessed the triumphal processions of the Roman emperors. A widely-disseminated engraving visualizes the same deeds, arranged

* In developing the material presented here I have benefited from the comments offered by the discussants at the *IL60 Colloquium*: Irving Lavin, George Bauer, Michael Conforti, John Coolidge, and John Beldon Scott. I am also indebted to Godelieve Denhaene, Cheryl Sowder, William Tronzo, and Shelley Zuraw for their kind assistance.
1. Ludwig von Pastor, *The History of the Popes from the Close of the Middle Ages*, trans. Ralph Francis Kerr, et al., 5th ed., 40 vols. (London: Kegan Paul, Trench, Trubner & Co., 1923-1953), 23:100-46, 209-13, 265-86; 24:125-40, 256-57, 382-99.

in heraldic pairs to frame the papal portrait (fig. 1).[2] The temporal and spiritual victories are grouped to the right and left, respectively, while at the top the spiritual reconciliation of the temporal lord Henry IV bridges the two sides. Reference is thus made to the pope's masterful exercise of his prerogatives in both spheres to attain Christian concord, the fundamental goal of his reign announced at the outset by his choice of name.

The most complex and wide-ranging expression of Clement's vision took shape at San Giovanni in Laterano where, in anticipation of the Holy Year of 1600, he initiated a comprehensive restructuring of the church. As will be seen, the special history of the Lateran provided an appropriate context for the particular emphases of his pontificate which, in a symbolic sense, culminated with the great tercentennial Holy Year. Traditionally, pilgrims visit Rome during Holy Years to gain the extraordinary indulgence made available by the pope only at that time.[3] The Holy Year is a literal enactment of Christian concord when the faithful come together in the head city of Christendom to be reconciled with God. With peace now secured throughout Europe, more pilgrims were able to undertake this journey in 1600 than had been possible in the past. Once again Rome fulfilled its providential role as the center of the Christian world and the focus for the reconciliation of all the faithful. The carefully orchestrated program for the Clementine Holy Year was centered at the Lateran, the first church built by Constantine and the pope's seat as bishop of Rome. Honored as "Mother and Head of all the Churches of Rome and of the World," the Lateran is the visible sign of triumphant Christianity.

Pilgrims arriving at the Lateran from the densely-populated Campus Martius would enter the church not from the portico to the east, which gives onto the nave, but

2. The inscription was installed in February 1598; see J. A. F. Orbaan, *Documenti sul barocco in Roma*, Miscellanea della R. Società Romana di Storia Patria 6 (Rome: Società Romana di Storia Patria, 1920), p. 462 n. 2. The text is published in Vincenzo Forcella, *Iscrizioni delle chiese e d'altri edificii di Roma dal secolo XI fino ai giorni nostri*, 14 vols. (Rome: Tipografia delle Scienze, Matematiche e Fisiche, 1869-1884), 1:48, no. 104. For the engraving, see Dorothee Kühn-Hattenhauer, "Das grafische Oeuvre des Francesco Villamenas," (Ph.D. diss., Berlin, Freie Universität, 1979), p. 102.
3. Pastor, *Popes*, 24:269-80.

through the north transept, for it is there that the principal roads from the city terminate. In the 1580s Sixtus V expanded the system of streets to facilitate the approach, and he transformed the piazza fronting the transept to reflect its importance. These works created a coherent axis that still links the city with its cathedral. The Clementine project extended this axis into the Lateran itself by unifying the entire transept as an architectural and decorative ensemble (executed 1597-1600). The inner entrance facade was outfitted with an organ, the side walls were decorated with frescoes and polychrome marble revetment, and directly opposite the entrance where it would be seen upon entering, a monumental altar dedicated to the Eucharist was raised. Thus, a significant area of the Lateran was realigned to face the city.[4]

The focus of this new space, the grand altar of the sacrament, is well known to students of the Roman Baroque (fig. 2). Irving Lavin was the first to recognize its significance in connection with Bernini's design for the crossing of Saint Peter's.[5] There, as at the Lateran, the sacred area around the altar is unified and defined as the site of a dramatic action where the viewer becomes an active participant in the ongoing process of redemption. A crucial factor occasioning these formal and psychological innovations was the extraordinary sanctity possessed by these sites, derived from their associations with Constantine and with the Holy City, Jerusalem.

While each component of the Clementine transept functions as a tangible metaphor for the new age of concord, this

4. I have studied the Clementine renovations in my "The Lateran and Clement VIII" (Ph.D. diss., Institute of Fine Arts, New York University, 1988). An index of the relevant documents is provided by Anna Maria Corbo, ed., *Fonti per la storia artistica al tempo di Clemente VIII*, Ministero per i Beni Culturali e Ambientali, pubblicazioni degli archivi di stato 85 (Rome: Fratelli Palombi, 1975).
5. Irving Lavin, *Bernini and the Crossing of Saint Peter's*, The Archaeological Institute of America and the College Art Association, Monographs on Archaeology and the Fine Arts 17 (New York: New York University Press, 1968), pp. 16-18, 28-37, 39; Irving Lavin, *Bernini and the Unity of the Visual Arts*, 2 vols. (New York, London: Oxford University Press, 1980), text vol., pp. 20-21, 102-3; and idem, "Bernini's Baldachin: Considering a Reconsideration," *Römisches Jahrbuch für Kunstgeschichte* 21 (1984): 408-9. See Lavin, *Unity*, pp. 87, 89-90, 125-26, for the further influence of the Lateran altar on Bernini's Cornaro chapel.

idea is most clearly and succinctly expressed in the altar, and especially in its monumental ciborium where the pope's name appears emblazoned in bronze letters against a blue ground. The ciborium is the work of Pier Paolo Olivieri, sculptor and architect, who had a prior association with Giacomo della Porta, architect in charge of the structural renovations at the Lateran under Clement VIII. The sources are silent concerning della Porta's possible role in the design of the ciborium, but that it was appreciated as an extraordinary creation is made clear by one of the participants in the fresco decoration, Giovanni Baglione, who claimed "che a riguardarlo induce stupore."[6]

Conceived as a classical, pedimented aedicula supported on four columns of the Composite order, the ciborium rises some forty feet above the pavement of the church to define a chapel-like space where the Divine Office is celebrated. Repeating the basic form of the outer structure, a secondary aedicula shelters the altar and the tabernacle where the Eucharist is reserved (fig. 3). Earlier altar ciboria were relatively simple, either placed directly against the wall or free-standing. At the Lateran these types are combined. The central pair of columns are shifted forward to carry the pediment and those at the sides are stepped back to support the entablature; where it meets the transept walls, the entablature is extended to embrace them, supported by pilasters. The ciborium is thus firmly anchored into its context, gripping the lateral walls and forcefully projecting into the path of the worshiper. The traditional altar ciborium is here reinterpreted as a monumental entrance portico.

Certain details of the structure recall Giacomo della Porta's facade of the Gesù, in particular, the double aedicula arrangement of the lower zone and the dynamic movement of

6. Olivieri's responsibility for the ciborium is recorded by Giovanni Baglione, *Le nove chiese di Roma...Nelle quali si contengono le historie, pitture, scolture, & architetture di esse* (Rome: Andrea Fei, 1639), pp. 111-12, 114; and idem, *Le vite de' pittori scultori et architetti dal pontificato di Gregorio XIII. del 1572 in fino à tempi di Papa Urbano Ottavo nel 1642* (Rome: Andrea Fei, 1642), p. 76. The quotation appears in the *Vite*, p. 60. Baglione, *Nove chiese*, p. 111, named Giacomo della Porta as the architect in charge (repeated by others). Avvisi of 1601 and 1602 confirm his role; see Orbaan, *Documenti*, p. 47n; and Ermete Rossi, "Roma ignorata," *Roma* 13 (1935): 34. For Olivieri's association with della Porta, see Howard Hibbard, "The Early History of Sant'Andrea della Valle," *Art Bulletin* 43 (December 1961): 295-96.

the entablature, which extends outward from the central portal (fig. 4). At the Lateran, the type was developed in the third dimension, perhaps influenced by an unexecuted design for Saint Peter's where the entire facade is conceived as a free-standing columned portico (fig. 5).[7] This latter work, thought to reflect Michelangelo's intention, provides the closest parallel in Renaissance architecture to the Lateran ciborium. Given della Porta's affiliation with Michelangelo on the one hand, and his association with Olivieri on the other, it is probable that he was responsible for the adaptation at the Lateran of this revolutionary concept. The wall treatment of the Gesù and the free-standing pedimented portico of the Saint Peter's design are combined in the Clementine ciborium to produce a new architectural form defined by visual clarity and dramatic emphasis on the center, distinctive features of the nascent Baroque style.

The portico-like shape of the ciborium constitutes only one aspect of its reinterpretation of traditional forms. Another is its material: both the columns and the pediment they support are formed of gilded bronze. The pediment, the column bases, and three capitals are creations of the Clementine period, but all four shafts and one capital are of early Imperial date. The existence at the Lateran of these columns – the sole monumental remains of ancient bronze architecture – is first recorded in the eleventh century, but the reference is a casual one and it is probable that they had been there for some time, perhaps from the foundation of the church. Although the true origin of the columns is unknown, from the later Middle Ages they were associated with the great victories of the Roman past and with the triumph of Christianity under Constantine. According to one explanation, they were cast using the bronze prows of the Egyptian naval fleet vanquished by Augustus at Actium, the battle that marked the end of civil war and the

7. For the facade of the Gesù, see James Ackerman and Wolfgang Lotz, "Vignoliana," *Essays in Memory of Karl Lehmann*, ed. Lucy Freeman Sandler, *Marsyas*, Supplementary vol. 1 (Locust Valley, N.Y.: J. J. Augustin, 1964), pp. 18-22. Concerning the facade of Saint Peter's, see James Ackerman, *The Architecture of Michelangelo*, 2 vols. (London: A. Zwemmer Ltd., 1964), cat. vol., pp. 105-7; and Christof Thoenes, "Bemerkungen zur St. Peter-Fassade Michelangelos," *Munuscula discipulorum. Kunsthistorische Studien Hans Kauffmann zum 70. Geburtstag, 1966*, eds. Tilmann Buddensieg and Matthias Winner (Berlin: Bruno Hessling, 1968), pp. 331-41.

beginning of the *pax Romana*. The second legend, which received papal sanction in 1291, asserted that they had formed part of Solomon's Temple at Jerusalem and were transferred to Rome by Titus following the conquest of the Holy City. In both traditions, Constantine was credited with donating the columns to the Lateran. Their sanctity and their link to Constantine was amplified by the notion that these noble shafts functioned as reliquaries, containing earth from the site of Christ's death in Jerusalem, which had been brought to Rome by the empress Helena. They were said to be responsible for working miracles.[8]

It is against this background that the formal innovations of the Lateran ciborium are best considered. Concerning the Temple at Jerusalem, in the literary tradition its principal gates were identified as having been constructed with bronze elements. All of these gates were situated to the east, at the main entrance into the Temple precinct, and in each case they were associated with events that imparted to them an especially sacred character. The Corinthian Gate opened of its own accord to signal the fall of the Holy City during the siege of Titus. The Beautiful Gate (Porta Preciosa) was the site of the first miracle of the apostles, the healing of the lame man by Peter. Finally, the portico built by Solomon was said to have been embellished with a bronze column, and it was there that he knelt to pray when dedicating the Temple; at that time God appeared in a numinous cloud to take possession of the sanctuary.[9] This portico is mentioned in the New Testament as the place where the Christians would congregate and where Christ first publicly revealed his

8.　On the columns and their legendary origins, see Ursula Nilgen, "Das Fastigium in der Basilica Constantiniana und vier Bronzesäulen des Lateran," *Römische Quartalschrift* 72 (1977): 18-27. For their miraculous power, see below n. 10, repeated by Sebastiano Fabrini, *Dichiarazione del giubileo dell'anno santo...* (Rome: B. Bonfadino, 1600), p. 131 ("appresso le quali colonne si sono fatti per virtù divina molti miracoli").
9.　On the Corinthian Gate, see Josephus *Jewish War* 5.201, 6.293-96. Petrus Comestor (d. c.1179) claimed that the Beautiful Gate included bronze doors, "Historia scholastica," in J. P. Migne, ed., *Patrologiae cursus completus...series latina*, 221 vols. (Paris: Garnier Fratres, 1844-1855), 198:1361. The same author associated Solomon's Portico with a bronze column (col. 1593); cf. 2 Chronicles 6:13. The Corinthian and the Beautiful Gates were assimilated by Cesare Baronio, *Annales ecclesiastici...*, ed. Antonio Pagi, 19 vols. (Lucca: Typis Leonardi Venturini, 1738-1746), 1:201-8, year 34, nos. 250-68, esp. no. 257.

divinity (John 10:23). An early sixteenth-century inventory of the Lateran's relics actually specifies the "Porticus Salomonis" as the original location of the bronze columns that were incorporated into the Clementine ciborium.[10]

Relevant as much for its name as for its form is another entrance to the Temple, called the Royal Portico by the first-century Jewish historian Josephus. Claiming that it was "more noteworthy than any under the sun," he described its multitude of columns as being arranged in four rows, thus forming three aisles, with the central one being higher and wider than the sides. Somewhat ambiguous is the additional statement that the front of the wall was cut all around with architraves having columns built into it. This text evidently influenced certain Renaissance depictions of the Temple, such as the late fifteenth-century engraving reproduced here (fig. 6).[11]

The physical presence of the bronze columns at the Lateran, with their tangible reference to Solomon's Temple and its gates, surely contributed to the idea of developing the ciborium of Clement VIII's sacrament altar as an entrance portico. It is equally probable that aspects of the architecture were adapted from Josephus' description of the Royal Portico and those visualizations of the Temple that depended upon it. The underlying thought was to identify the Eucharist as the fulfillment of the Old Testament promise of human salvation, a valid idea for every Christian altar, but one that carries a particular meaning at the Lateran. In addition to the bronze columns, the church claimed to possess other relics from the Temple: the tablets of the Law, the rods of Aaron and Moses, and most significant because of their proto-eucharistic meaning, the Ark of the Covenant and the golden urn filled with manna.[12] At the sides of Clement's ciborium-portico, statues

10. The relic list is dated to the reign of Leo X (1513-21) by Philippe Lauer, *Le palais de Latran. Étude historique et archéologique* (Paris: Ernest Leroux, 1911), p. 297 ("Quatuor Columnae ex Metallo deauratae, quae erant in Porticu Salomonis quas Titus et Vespasianus a Judeis ex Hierusalem asportari jusserunt, una cum Reliquiis, et rebus mirabilibus hic annotatis.").
11. Josephus *Jewish Antiquities* 15.411-16. The architecture represented in our figure 6 derives from one of the scenes designed by Antonio Pollaiuolo for the vestments used in the baptistery of Florence; see Leopold D. Eittlinger, *Antonio and Piero Pollaiuolo* (Oxford: Phaidon, 1978), pp. 156-59, cat. no. 26.
12. The presence of the Hebrew cult objects at the Lateran was first stated c.1140-43 by Benedict, Canon of Saint Peter's, in his *Liber politicus*. See Paul

of Hebrew priests turn toward the sacrament at the altar to acknowledge the fulfillment of the Old Testament antetypes of the Eucharist. They recall the presence of the Temple's relics within the church and, along with the ciborium itself, document the Lateran's claim to be the true successor to the Jewish sanctuary and the locus of Christian redemption.

Complementing the reference to the Temple at Jerusalem is the parallel legend that associated the bronze columns with Augustus. The universal peace that Augustus achieved and the fact that his reign was graced by the birth of Christ made him a quasi-sacred personage who was inextricably linked to the dream of a Christian Golden Age. It is therefore significant that a series of coins (sestertii) issued by Augustus' adopted son and successor, Tiberius, includes the image of a temple whose characteristic features – the projected pedimented pronaos, the lateral extensions of the rear wall articulated with niches and columns, and the profusion of figures above the pediment – also define the Lateran altar (fig. 7).[13] Even the activation of the sculptures set to either side of the temple's steps foreshadows the later arrangement. Given the conventions common to medallic art, comparison with a medal of Clement VIII depicting the Lateran altar underscores the similarities (fig. 8).[14]

Fabre and Louis Duchesne, eds., *Le Liber censuum de l'église romaine,* Bibliothèque des Écoles Françaises d'Athènes et de Rome, 2d ser., 3 vols. (Paris: Albert Fontemoing, 1905-1952), 2:166-67, 170 nn. 4-6. See also the *Descriptio lateranensis ecclesiae* of John the Deacon (before 1181), in Roberto Valentini and Giuseppe Zucchetti, eds., *Codice topografico della città di Roma,* R. Istituto Storico Italiano per il Medio Evo, Fonti per la storia d'Italia, 4 vols. (Rome: Tipografia del Senato, 1940-1953), 3:335-37, 341-42. These relics were listed in the official inventory compiled by Pope Nicholas IV in 1291, which includes the columns as well; see Lauer, *Latran,* p. 292, fig. 109, and Forcella, *Iscrizioni,* 8:14-15, nos. 15-16.
13. The reverse appears on sestertii of Tiberius issued in 34-37 CE (obverse: no portrait, inscribed in center S. C. and around the border TI. CAESAR. DIVI. AVG. F. AVGVST. P. M. TR. POT. XXXVI, also XXXVII, XXXIIX); see Harold Mattingly, *Coins of the Roman Empire in the British Museum.* Vol. 1, *Augustus to Vitellius* (London: Oxford University Press, 1923), pp. cxxxviii n. 4, 137-39, nos. 116, 132-34; and A. Banti and L. Simonetti, *Corpus nummorum romanorum,* 18 vols. (Florence: A. Banti and L. Simonetti, 1972-1979), 9:233-36, nos. 382-84 (with many examples illustrated).
14. For the Clementine medal, see Harald Küthmann, et al., *Bauten Roms auf Münzen und Medaillen,* exhib. cat. (Munich: Egon Beckenbauer, 1973), p. 194, cat. no. 314; Lavin, *Unity,* p. 125 n. 2; and Lavin, "Baldachin," p. 408, figs. 3, 4.

In the sixteenth century, when the study of ancient coins was being pursued with remarkable intensity and precision, the Tiberian coin was drawn, engraved, and copied (fig. 9).[15] It was a well-known image, yet one that held a certain mystery: the obverse legend records Tiberius' imperial titulature, but the temple represented on the reverse is not identified. Those scholars of the day engaged in the study of Roman coins would have known from the literary sources that Tiberius was principally associated with three sacred structures. Two of these, the temples of Castor and of Concord, he rebuilt or restored during the reign of Augustus. It was the third temple, dedicated to the Deified Augustus, that was most often linked to the image on the coin.[16] One

It is possible that Michelangelo's design for the facade of Saint Peter's was also indebted to the temple represented on the Tiberian coin.

15. Around the middle of the sixteenth century Sallustio Peruzzi drew the coin on a sheet now in the Uffizi, no. UA 683v. See Ian Campbell, "Reconstructions of Roman Temples Made in Italy Between 1450 and 1600," (Ph.D. diss., Oxford University, 1984), p. 126, fig. 21. The first published image of the coin I know is Enea Vico, *Le imagini con tutti i riversi trovati et le vite de gli imperatori tratte dalle medaglie et dalle historiae de gli antichi. Libro primo* (Venice, 1548), second plate following p. 3v. See also Vico, *Omnium Caesarum verissimae imagines ex antiquis numismatis desumptae* (Venice: P. Manutius, 1554), pl. C.I, no. 7. A more precise rendering of the coin appears in Johannes Sambucus, *Emblemata cum aliquot nummis antiqui operis...* (Antwerp: Plantin, 1564), p. 236 (our fig. 9). In none of these cases is the temple identified. For other reproductions, see the following note.

16. The literary sources are cited in Samuel Ball Platner and Thomas Ashby, *A Topographical Dictionary of Ancient Rome* (London: Oxford University Press, 1929), pp. 62-65 (Deified Augustus), 102-5 (Castor), 138-40 (Concord). Two versions of the reverse and one obverse were published by Hubert Goltzius, *Caesar Augustus sive Historiae imperatorum caesarumque romanorum ex antiquis numismatibus restitutae liber secundus...* (Bruges: Hubertum Goltzium, 1574), pl. LXXXI (caption to the entire plate: "Divi Augusti Divaeque Iuliae Augustae Divinitas, statuae sacrae, Templa, ac Carpentum"). While one of the reverses reflects an authentic example, albeit embellished, the other repeats a sixteenth-century copy; cf. the ones referred to below. Goltzius' volume was republished with a commentary by Ludovicus Nonnius, *Commentarius in nomismata Imp. Iuli. Augusti. et Tiberi. Huberto Goltzio scalptore...* (Antwerp: Iacobum Bieum, 1620), (Augustus), pl. 80, p. 98; an elaborated version of the reverse appears in the section on Tiberius, pl. 8, p. 34; in both cases the temple is identified with Augustus. The same association is made by Alexander Donati, *Roma vetus ac recens utriusque aedificiis ad eruditam cognitionem expositis...* (Rome: Manelphi Manelphij, 1639), p. 157 (illustrated on p. 177); Francesco Angeloni, *La historia augusta da Giulio Cesare insino à Costantino il Magno. Illustrata con la verità delle antiche medaglie...* (Rome: Andrea Fei, 1641), p. 22 (illustrated); and Famiano Nardini, *Roma antica...* (Rome: Per il Falco [Ottavio Falconieri], 1665), pp. 397-98 (illustrated).

Renaissance copy even incorporated a new obverse bearing a portrait and the legend DIVVS AVGVSTVS P(ATER) P(ATRIAE) (fig. 10).[17]

In the entire corpus of ancient coinage the Tiberian sestertii are unique for representing a temple facade with extended pronaos, an architectural form unusual enough to be discussed by Vitruvius in a separate category.[18] Among the few temples that existed with this feature in Rome, the most prominent and spectacular was the one dedicated to Concord, located near the Arch of Septimius Severus on the northeast slope of the Capitoline Hill. Originally constructed in the second century BCE to celebrate peace between the plebeians and patricians, it was rebuilt by Tiberius during the reign of Augustus. The lavish materials employed, the refined ornament, and the masterpieces of Greek art that were displayed there made this temple a showpiece of Augustan Rome.[19] In fact, its original political significance was assimilated to the imperial family and to Augustus in particular: Tiberius dedicated the new structure to the Augustan Concord, *Aedes Concordiae Augustae*.[20]

17. Heinrich Dressel, *Die römischen Medaillone des Münzkabinetts der Staatlichen Museen zu Berlin*, ed. Kurt Regling, 2 vols. (Dublin-Zurich: Weidmann, 1973), text vol., p. 437, no. 3 (no. 2 is identical); no. 6 is another Renaissance variation with a portrait of Tiberius, profile left, inscribed TI CAESAR AVGVSTI F IMPERATOR V; illustrated in Banti and Simonetti, *Corpus* 9:237.
18. Vitruvius *De re architectura* 4.8.4. On the plan, see Marisa Conticello de' Spagnolis, *Il Tempio dei Dioscuri nel Circo Flaminio*, Soprintendenza Archeologica di Roma, Lavori e Studi di Archeologia 4 (Rome: De Luca, 1984), pp. 34-37.
19. For the Temple of Concord, see Paul Zanker, *Forum Romanum. Die Neugestaltung durch Augustus*, Monumenta artis antiquae 5 (Tübingen: Ernst Wasmuth, 1972), pp. 19-23; and Carlo Gasparri, *Aedes Concordiae Augustae*, I monumenti romani 8 (Rome: Istituto di Studi Romani, 1979). The literary sources assert that the second-century BCE temple was preceded by one of the fourth century BCE, but this has been disputed; see Zanker, *Forum*, p. 20; and Lawrence Richardson, Jr., "Concordia and Concordia Augusta: Rome and Pompeii," *La parola del passato* 33 (1978): 260-72. See also German Hafner, "Aedes Concordiae et Basilica Opimia," *Archäologischer Anzeiger* 98, 4 (1984): 591-96. Concerning the decoration of the temple, see Giovanni Becatti, "Opere d'arte greca nella Roma di Tiberio," *Archeologia classica* 25-26 (1973-74): 30-42. In our context, it is relevant that in the late fourth century BCE an "Aedicula Concordia" was constructed of bronze in the vicinity of the later Temple of Concord; see Livy 9.46.1-6; Pliny the Elder *Natural History* 33.6.19.
20. Suetonius *Tiberius* 20, and Dio Cassius *Roman History* 56.25.1, record that Tiberius dedicated the temple in his own name and that of his deceased

Excavations conducted in the Forum in the early nine-
teenth century uncovered the podium of the Temple of
Concord. It was only when the unusual plan became known
that the Tiberian coin could be linked unequivocally with this
temple.[21] Nevertheless, in 1695 the same identification was
proposed, perhaps for the first time in published form.[22] It is
possible, however, that this association had already been
made in the sixteenth century. A consideration of the sculp-
tural decoration represented on the coin would have assisted
in the correct identification, for the three embracing figures
located above the apex of the pediment translate concord as a
spiritual state into physical terms.[23] In any case, Augustus
was so closely identified with concord as a political ideal that
in the Renaissance both the temples of Concord and of the
Deified Augustus would have carried similar meaning, the
ultimate significance of which from a Christian viewpoint
was the coincidence of the Augustan age with the birth of
Christ. This constellation of ideas helps to explain why the
architectural features of the Lateran ciborium recall the
image on the ancient coin.

brother, Drusus. The new *dies natalis* of the temple was January 16, the day on
which Augustus received his cognomen in 27 BCE, understood as the date the
Republic was restored; see Pierre Gros, *Aurea templa. Recherches sur
l'architecture religieuse de Rome à l'époque d'Auguste*, Bibliothèque des Écoles
Françaises d'Athènes et de Rome 231 (Rome: École Française de Rome, 1976),
pp. 32-34.
21. For these excavations, see Carlo Fea, "Sul vero tempio della Dea
Concordia, ultimamente scoperto," *Notizie del giorno* 31 (August 7, 1817): 1-3; 32
(August 14, 1817): 1-2; 33 (August 21, 1817): 2-4; republished with additions in
Fea, *Varietà di notizie economiche fisiche antiquaire...* (Rome: F. Bourlié, 1820),
pp. 88-119. See now, Ronald T. Ridley, "The Monuments of the Roman Forum:
The Struggle for Identity," *Xenia* 17 (1989): 75-76.
22. Jean Foy-Vaillant, *Selectiora numismata in aere maximi moduli e museo
illustrissimi D. D. Francisci de Camps...* (Paris: A. Dezallier, 1695), pp. 5-6
(illustrated). The coin reproduced is a sixteenth-century copy, incorporating a
portrait of Tiberius and a legend dated to his fifth term as imperator (9-11
CE); cf. the example cited above, n. 17. This date led the author to the correct
identification of the temple since Dio Cassius placed its dedication in 10 CE.
Foy-Vaillant's argument was developed by Lorenz Berger, *Thesaurus
Brandenburgicus selectus sive Gemmarum et numismatum Graecorum in
cimeliarchio electorali Brandenburgico...* (Cologne: Ulricus Liebpert, 1696), pp. 87-
89.
23. The figures that decorate the pediment are discussed by Becatti, "Opere,"
p. 37; and Zanker, *Forum*, p. 22. They may have suggested a pagan equivalent
to the Christian Trinity.

The formal sources here proposed for the Lateran ciborium are linked to the legendary origins of the bronze columns – to Jerusalem and Solomon on the one hand, and to Rome and Augustus on the other. In a larger sense, they reflect the Lateran's own unique position in Christian history that was established when Constantine founded the church as the first permanent, legally sanctioned place of Christian worship. In this context, one additional source for the ciborium must be discussed.

Among the regal gifts that Constantine donated to the Lateran was a structure whose form and decoration is recorded in the compendium of popes' lives, the *Liber pontificalis*. Apparently it was free-standing, it occupied a central position within the church, and it was made of silver. The sculptural decoration, also of silver, included life-size statues that centered on two depictions of Christ, as earthly judge surrounded by the apostles and as divine king flanked by angels. Perhaps the most revealing element of the description is the name that was applied to the whole – "fastigium" – which in architectural nomenclature signifies pediment.[24] Originally a symbol of divinity that was used to define the entrances to ancient temples, the pediment became an essential aspect of the fully-developed imperial ceremonial, denoting the place where the emperor would appear in majesty. Constantine's gift to the Lateran in effect transferred the dignity of imperial presentation to Christ and his court, an idea that was especially resonant at the royal Lateran church. Its significance in the context of Clement VIII's sacrament altar is underscored by the fact that in the late sixteenth century Constantine's fastigium was thought to have been an altar ciborium.[25] One of the defining elements

24. Louis Duchesne, ed., *Le Liber pontificalis...*, Bibliothèque des Écoles Françaises d'Athènes et de Rome, 2d ser. 3, 2 vols. (Paris: Ernest Thorin, 1886-1892), 1:179. Nilgen, "Fastigium," pp. 1-31, argues that Constantine's fastigium functioned as an altar ciborium and that the bronze columns served as its original supports; for another interpretation, see Molly Teasdale Smith, "The Lateran *Fastigium*: A Gift of Constantine the Great," *Rivista di archeologia cristiana* 46, 1-2 (1979): 149-75.
25. The identification was made by Cardinal Giulio Antonio Santori when discussing the collection of imperial coins discovered in the foundations of the old Lateran palace during its demolition under Sixtus V. One of these coins pertained to the emperor Valentinian III (425-455) who restored Constantine's fastigium after it was plundered by the Goths (Duchesne, *Liber pontificalis,*

of the Clementine altar – the projected pediment – recalls this lost Constantinian model. Indeed, it is precisely this architectural feature that would have recommended the visual sources discussed above where the pediment assumes an unusual prominence.

The three models I have proposed for the Clementine ciborium not only explicate its unusual form but suggest the conceptual framework that governed its creation. References to the Old Dispensation and to the pagan Roman past, which are combined in the form and material substance of the structure, function as a metaphor of Christian concord. Jerusalem is assimilated to Rome and the *Ecclesia ex circumcisione* is brought into harmony with the *Ecclesia ex gentibus*. The expression of these themes at the Lateran was surely due to the fact that this historic conjunction between the Jews and the Gentiles was first institutionalized in that very place and by Constantine himself. It was Constantine and the Lateran church that fulfilled the promise of unity held by the Old Testament and pagan antetypes.

By way of confirmation, I turn to the last link in this chain of evidence, one that can be understood as having provided the prospectus for the entire Clementine program. I refer to an inscription that purports to be Constantinian in date. The text claims that in gratitude to the emperor for extending the Republic to the entire world, the Senate and the Roman People restored the Temple of Concord, ruined by age, to a more splendid and improved appearance (fig. 11). In truth, no such inscription existed. It is a hybrid creation, composed of two independent texts that are known from numerous copies beginning with the late eighth-century *Einsiedeln Itinerary*.[26] One inscription apparently decorated the base of a statue of Constantine ("In Basi Constantini"). The other

1:233); see G. Cugoni, "Autobiografia di Monsignor G. Antonio Santori, Cadinale di S. Severina," *Archivio della Società Romana di Storia Patria* 13 (1890): 179 ("nissuno imperatore dopo il Magno Costantino havea fabricato in S. Giovanni Laterano, eccetto Valentiniano terzo, che fe'sopra l'altare il ciborio d'argento").

26. *Corpus inscriptionum latinarum*, VI: *Inscriptiones urbis Romae latinae* (Berlin: Georgium Reimerum, 1876), nos. 89, 1141; Gerold Walser, ed. and trans., *Die Einsiedler Inschriftensammlung und der Pilgerführer durch Rom (Codex Einsidlensis 326)...*, *Historia*, Supplementary vol. 53 (Stuttgart: Franz Steiner, 1987), pp. 35, 37, 91-92, 94-95.

recorded a restoration of the Temple of Concord and was seen by the copyist on the Capitoline Hill ("In Capitolio"). These two inscriptions were elided in the early sixteenth century, and the location of this new entity was recast as the Lateran church, *basi* being understood as an abbreviation for "basilica."[27] The final step in the transformation is represented by the engraving of 1598 reproduced here where the hybrid text is validated by appearing on an ancient statue base; at the top of the sheet this spurious object is located "in basilica Laterana." It is unlikely that the process by which the two inscriptions were brought together and linked to the Lateran was simply due to misconception; rather, it appears to be a purposeful manipulation that associates Constantine, the unity of the Roman world, and the Temple of Concord with Rome's cathedral.

Similar ideas stand behind the conception of Clement VIII's sacrament altar. Solomon's Temple at Jerusalem, the Augustan temple in Rome, and Constantine's fastigium provided the three fundamental themes. Their visual assimilation in the Lateran ciborium reflects a process of imaginative recreation of these sacred monuments. More significantly, the formal and intellectual cohesiveness that underlies the structure is itself a tangible manifestation of concord. The fact that this monument was created for the Lateran to honor the Eucharist equates the church's own unique position in Christian history with the primary expression of Christian unity, the sacrament. These ideas parallel and complement Clement VIII's achievement in restoring the Christian nation to its ideal state, and they place him in direct line of descent from those preeminent models of sacred kingship – Solomon, Augustus, and Constantine.

27. Both inscriptions were published by Iacobus Mazochius, *Epigrammata antiquae Urbis* (Rome: Iacobi Mazocchii, 1521), p. XXXIIIr, surrounded by a common floral border and located "In Basilica Lateranensi."

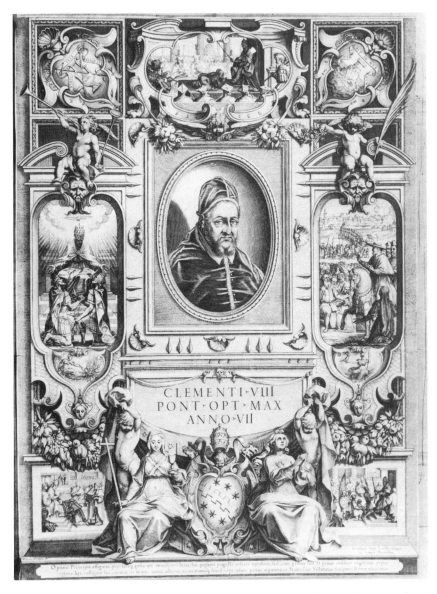

Fig. 1. Mario Arconio and Francesco Villamena, *The deeds of Clement VIII*, dated 1599. (Warburg Institute)

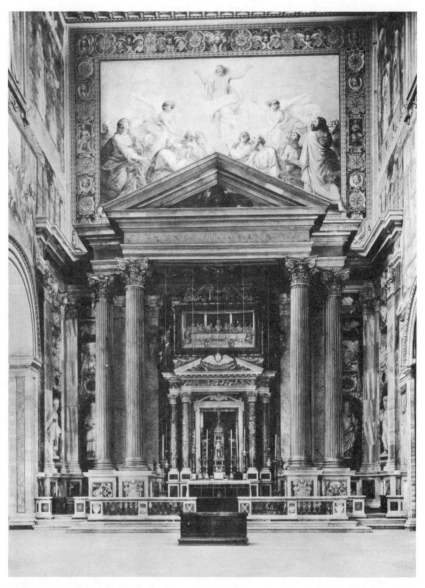

Fig. 2. Pier Paolo Olivieri, et al., Sacrament altar. San Giovanni in Laterano. (Anderson)

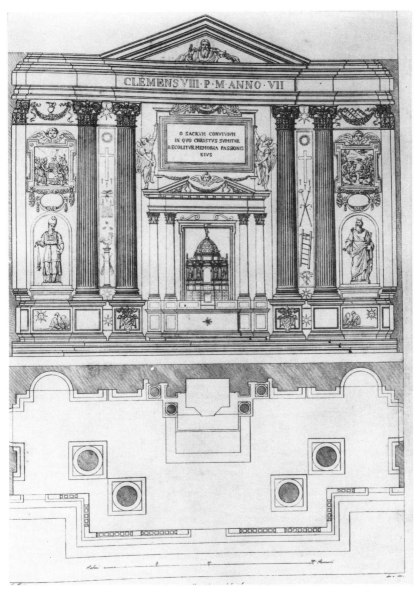

Fig. 3. Plan and elevation of the Lateran sacrament altar. Giacomo Fontana, *Raccolta delle migliori chiese di Roma e suburbane...* 4 vols. in 2 (Rome: Giacomo Fontana, 1855), 3, pl. IX.

Fig. 4. Giacomo della Porta, Il Gesù, facade. (The Conway Library, Cour-
tauld Institute of Art)

Fig. 5. Cesare Nebbia, et al., *Ideal view of Saint Peter's*. Detail. Salone Sistino, Vatican palace. (Alinari)

Fig. 6. Francesco Rosselli, *Presentation of Christ in the Temple*. London, British Museum. (Courtesy of the Trustees of the British Museum)

Fig. 7. Sestertius of Tiberius representing the Temple of Concord. (Fototeca Unione)

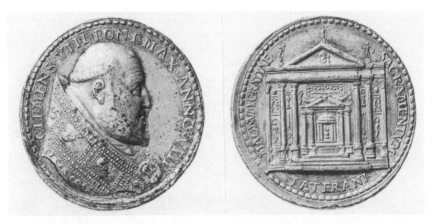

Fig. 8. Medal of Clement VIII commemorating the Lateran sacrament altar, dated 1599. Munich, Staatlichen Münzsammlung. (Museum)

Fig. 9. Sestertius of Tiberius. Joannes Sambucus, *Emblemata cum aliquot nummis antiqui operis...* (Antwerp: Plantin, 1564), p. 236.

Fig. 10. Sixteenth-century variation of the Tiberian sestertius. Berlin, Staatlichen Museen, Münzkabinett. (From a cast supplied by the Museum.)

Fig. 11. Recreation of a statue base honoring Constantine. Jean Jacques Boissard, *IIII. pars Antiquitatum romanarum sive II. tomus Inscriptionum & monumentorum, quae Romae in saxis & marmoribus visuntur...* (Frankfurt: Theodor de Bry, 1598), pl. 143.

IX

Lelio Pasqualini,
A Late Sixteenth-Century
Antiquarian*

ALEXANDRA HERZ

Many scholars of the sixteenth and seventeenth centuries, such as Pirro Ligorio, Onofrio Panvinio, Fulvio Orsini, Pompeo Ugonio, Filippo de Winghe, and Antonio Bosio, are well known to us.[1] It is strange therefore that a scholar and

* I am exceedingly grateful to John W. O'Malley, S.J. for his reading of an earlier draft of this paper, and for his translations from the Latin. For other translations from the Latin I owe thanks as well to Joseph Alchermes.
1. For Pirro Ligorio (c.1510-1583) see especially David R. Coffin, "Pirro Ligorio and Decoration of the Late Sixteenth Century at Ferrara," *Art Bulletin* 37 (September 1955): 167-85; idem, *The Villa d'Este at Tivoli* (Princeton: Princeton University Press, 1960), pp. 92-97; idem, "Pirro Ligorio on the Nobility of the Arts," *Journal of the Warburg and Courtauld Institutes* 27 (1964): 191-210; and Graham Smith, *The Casino of Pius IV* (Princeton: Princeton University Press, 1977), pp. 20-25, 29-30, 55-63. For Onofrio Panvinio (1530-1568) see Davide A. Perini, *Onofrio Panvinio e le sue opere* (Rome: Tip. Poliglotta della S. C. de prop. fide, 1899); Pietro Fremiotti, *La riforma cattolica del secolo decimosesto e gli studi di archeologia cristiana* (Rome, 1926), pp. 26-41; for Fulvio Orsini (1529-1600) see Pierre de Nolhac, *La bibliothèque de Fulvio Orsini* (Paris: Bouillon and Vieweg, 1887); for Pompeo Ugonio (died c.1614) see Fremiotti, *La riforma cattolica*, pp. 74-76; and Carlo Cecchelli, *Il cenacolo filippino e l'archeologia cristiana* (Rome: Istituto di studi romani, 1938), pp. 18-20; for Filippo de Winghe (1550-1592) see Godefridus J. Hoogewerff, "Philips van Winghe," *Mededelingen van het Nederlandsch Historisch Instituut te Rome* 7 (1927): 59-82; and Fremiotti, *La riforma cattolica*, pp. 70-71. For Antonio Bosio (1575-1629) see Orazio M. Premoli, *Lo scopritore della Roma sotterranea* (Monza, 1919). For many of these scholars and others, see also Ingo Herklotz, "Historia Sacra und Mittelalterliche Kunst während der Zweiten Hälfte des 16. Jahrhunderts in Rom," *Baronio e l'arte. Atti del Convegno Internazionale di Studi, Sora*, Oct. 1984,

antiquarian who may have been among the best has disappeared completely from history. Lelio Pasqualini (1549-1611) was a canon at S. Maria Maggiore and a collector with a special love for early Christian antiquities who enjoyed an extraordinary reputation during his lifetime. Responsible for giving such scholars as Cesare Baronio and Nicolas-Claude Fabri de Peiresc some idea of early Christian life and art, he seems to have exerted considerable influence in other ways as well. I will try to fill the gap in this article, giving surviving vital statistics about Pasqualini and surviving information about his collection, writings, and impact on other scholars.

Contemporaries gave Pasqualini the highest ratings. Cardinal Cesare Baronio (1538-1607), who discussed and illustrated forty-nine of Pasqualini's coins in his *Annales ecclesiastici,* mentioned him several times, always in the warmest terms. Thus, "along with antiquity," Pasqualini offered Baronio "all honesty, so that he is not liable to the slightest suspicion of decit." Pasqualini again is "our dear friend...very close to us on account of friendship and shared scholarship," and "...in the collection of R. D. Lelio Pasqualini, canon of S. Maria Maggiore, of whom I avail myself most familiarly, on account of the pleasantness of his manners, and for his knowledge...."[2]

Giuseppe Castiglione of Ancona, a distinguished philologist and jurist, and a member of this circle of friends and scholars, wrote the only life of Fulvio Orsini that may be considered contemporary. According to Castiglione, there was in Rome a collector who was even more adept than

ed. Romeo de Maio, et al. (Sora: Centro di Studi Sorani "V. Patriarca," 1985), pp. 22-74.
2. Extat ipsum quidem in Archivo rerum antiquarum
mei pernecessarii viri diserti, Lelii Pasqualini
Canonici S. Mariae Majoris: praesefert namque
omnem cum antiquitate sinceritatem, ut nec
levissimae suspicioni subjaceat imposturae ...

Reddimus hic tibi ipsum exemplar ex aurei nummi, prototypo quem accepimus a nostro Lelio Pasqualino nobis amicitiae & rei litterariae usu conjunctissimo.

...apud R. D. Laelium Pasqualinum Canonicum S. Mariae Majoris, quo ob morum suavitatem atque peritiam familiarissime utor ...

Annales ecclesiastici (Lucca: Leonardi Venturini, 1738-1759, hereafter AE) 8:245; ibid., 322, Par. V; 4:492, Par. VII, respectively.

Orsini: though Orsini was "incurring great expense" by adding ancient statues, bronze tablets, coins, incised gems, and signet rings to his collection, he was nevertheless bested by "the most illustrious Laelius Pasqualinus," who could distinguish better than Orsini, by familiarity and skill, what was genuine from false. Pasqualini also knew better the "relative commonness or rareness of these things."[3]

In 1600/1601 the French humanist Nicolas-Claude Fabri de Peiresc (1580-1637) was in Rome. There he met, among many others, Lelio Pasqualini. After his departure, Peiresc corresponded with Pasqualini until the end of the latter's life; although Peiresc wrote to enormous numbers of scholars and others throughout Europe until he himself died, his letters to Pasqualini were said to have been the longest.[4] "A sincere admiration," Rizza notes, "tied him to the aged Pasqualini, whose splendid collection of antiquities was one of the most complete and best organized that he had ever seen."[5] Around 1609 Peiresc prepared a list for a young compatriot, who was about to leave on a trip to Italy, of all the important people to visit in various cities there. Lelio Pasqualini heads the list of

3. Castiglione continues that Lelio Pasqualini "having made his brother's son Pompeo his heir, on his death left his collection to this most deserving and erudite nephew...:"

> Maximos quidem sumptus in coemendis vetustioribus signis, simulacrisque marmoreis, tabulisque aereis, numismatis, gemmis insculptis, annulis signatoriis faciebat (Ursinus): quo tamen in studio superabatur, qua discernendi vera a confictis usu et peritia, qua numera et raritate earum rerum incomparabili a viro clarissimo Laelio Pasqualino qui Pompeio optime merito eruditissimo fratris filio haeredi instituto Thesaurum antiquitatis moriens reliquit, canoni catu S. Mariae Maioris eidem prius resignato.

De Nolhac, *La bibliothèque*, p. 34. See ibid., n. 1, on Castiglione, whose biography of Orsini was not published until 1657.
4. Pierre Gassendi, *The Mirrour of True Nobility & Gentility. Being the Life of the Renowned Nicolaus Claudius Fabricius Lord of Peiresk, Senator of the Parliament at Aix*, trans. W. Rand (London: H. Moseley, 1657), p. 121.
5. Cecilia Rizza, *Peiresc e l'Italia* (Turin: Giappichelli, 1965), p. 16. Nicolas-Claude Fabri de Peiresc was one of the most learned of the scholars and collectors of the seventeenth century. He had a tremendous influence on the linguistic and philological studies of his day; see Francis W. Gravit, *The Peiresc Papers* (Ann Arbor: University of Michigan Press, 1951), p. 1; and Gassendi, *Mirrour*, passim.

important people in Rome.[6] Having settled permanently in Aix in 1623, Peiresc surrounded himself with a large and very fine library. On the walls of his study were life-size portraits of his closest scholar-friends, including such worthies as Pope Urban VIII, Francesco Barberini, and Lelio Pasqualini.[7] After Pasqualini's death in 1611, Peiresc wrote to his nephew Pompeo asking for a copy of whatever eulogy had been delivered on that occasion, saying that it would be included in a history of the era then being composed in France.[8] As will be shown presently, Peiresc received more than friendship from Pasqualini, who also played a crucial role in the formation of the French humanist's methodology.

Lelio Pasqualini seems to have been in contact with nearly all of the major scholars of his time. He corresponded with many, and others seem to have been aware of specific objects in his extensive collection. He wrote frequently to Federico Borromeo in Milan, eventually finding in Rome a medal depicting Pope Gregory VII that Borromeo had requested. In 1608 Giuseppe Franchi painted a portrait of Gregory VII after this medal for Borromeo's collection.[9]

We know that Cesare Baronio visited Pasqualini's collection, and that Peiresc's close friend Lorenzo Pignoria (1571-1631) did as well. In fact, it was through Peiresc's efforts, Pignoria wrote, that "also at Rome, I was admitted to the rich Treasurie of that gallant man, Laelius Pascalinus, out of which I was furnished with coins, Gemmes, Seales; all rare."[10] Another contemporary scholar-antiquarian, Jean l'Heureux (or Joannes Macarius) mentions an important

6. Rizza, *Peiresc*, p. 25. The list of important men in Rome continues with Girolamo Aleandro, Lorenzo Pignoria, Abate Antonio Persio, Cav. Oratio della Valle, "il sig. Vincenzo pittore," Ludovico Compagno, and Francesco Morone.
7. Ibid., p. 31; and Pieter J. J. van Thiel, "La collection de portraits réunie par Peiresc a propos d'un portrait de Jean Barclay conservé a Amsterdam," *Gazette des Beaux-Arts* 65 (1965): 341-52. Peiresc's collection of portraits was destroyed at the beginning of the French Revolution; see Joseph F. Michaud, *Biographie universelle ancienne et moderne*, 45 vols. (Paris: Delagrave, 1870-1873), 32:378.
8. Rizza, *Peiresc*, pp. 57-58.
9. Pamela M. Jones, "Federico Borromeo's Pinacoteca Ambrosiana" (Ph.D. diss., Brown University, 1985), Catalog, p. 35, no. 144. According to Professor Jones, whom I thank for her help, Pasqualini was clearly one of Borromeo's many agents.
10. Gassendi, *Mirrour*, pp. 61-62.

devotional medal owned by Pasqualini; it is likely that l'Heureux knew the medal from the collection itself.[11] In 1592 Dionysius Octavius Sada published his Italian translation of the *Dialoghi...intorno alle medaglie, inscrittioni, et altre antichità*. In his introduction, Sada explains that he added illustrations to the few originals. He was aided in this by Fulvio Orsini, Giovaen Vincenzo della Porta, Alfonso Ciacconio, and Lelio Pasqualini, who supplied medals that Sada's own collection lacked.[12] Therefore Sada certainly knew of Pasqualini's collection, and the three other collaborators probably did as well.

In the nineteenth century, the Italian archeologist Giovanni Battista de Rossi (1822-1894) knew of Pasqualini's collection and thought very highly indeed of the collector's expertise. De Rossi describes him as "un sì esperto numismatico," "espertissimo in numismatica," and as one who "aveva l'occhio tanto esercitato nelle monete romane e bizantine."[13] Throughout the twentieth century, writers have referred to Pasqualini through earlier scholars, or have mentioned him briefly, but none seem to have realized his importance.[14]

11. *Hagioglypta, sive picturae et sculpturae sacrae antiquiores praesertim quae Romae reperiuntur explicatae a Joanne l'Heureux*, ed. Raphael Garrucci (Paris: J. A. Toulouse, 1856), p. 78.
12. Dionysius Octavius Sada is mentioned by Gassendi, *Mirrour*, p. 28, as among the important men Peiresc met in Rome, along with the cardinals Baronio and Bellarmino, Jacobo Sirmondo, Fulvio Orsini, Paulo Gualdo, and others unknown today.
13. Giovanni B. de Rossi, "Le medaglie di devozione dei primi sei o sette secoli della chiesa," *Bullettino di archeologia cristiana* 7, 3-4 (1869): 33-45, 49-64. In the eighteenth century, G. Fontanini said:

> Eadem aetate, post Fulvium Ursinum, illustres floruerunt Laeulis Paschalinus, Franciscus Gualdus, Ludovicus Compagnis et Martius Milesius, Christianorum cimeliis et symbolis perquirendis mirifice intenti.

> In the same period, in addition to Fulvius Orsinus, the illustrious Laelius Paschalinus, Franciscus Gualdus, Ludovicus Compagnius and Martius Milesius were marvelously intent on researching the treasures and symbols of the Christians.

Fremiotti, *La riforma cattolica*, p. 70. But, Fremiotti adds (ibid.), the work of these scholars cannot be traced.
14. As de Nolhac quoting Castiglione, *La bibliothèque*, p. 34; Fremiotti quoting Fontanini, n. 13 above; Rizza, *Peiresc*, especially pp. 16, 18, 23-25, 31, 56-58, 276. According to Rizza, *Peiresc*, p. 56 n. 46, the only information surviving on

ALEXANDRA HERZ

While it may never be possible to reconstruct it in its entirety, it is possible to get some idea of the contents of Pasqualini's collection. Cesare Baronio, as noted above, discussed and illustrated no fewer than forty-nine coins from Pasqualini's collection throughout his *Annales ecclesiastici*. A number of these were pagan, but most were minted under Christian rulers (fig. 1).[15] A devotional medallion in Pasqualini's collection, showing on one side a bust of Christ and on the other the Adoration of the Magi, was well-known in the sixteenth and seventeenth centuries and to G. B. de Rossi in the nineteenth (fig. 2).[16] Practically unknown, by contrast, is a bronze slave's tag that Lorenzo Pignoria saw in Pasqualini's collection. Centuries later de Rossi used it to show the extremely early date of the church of S. Clemente in Rome.[17] According to de Rossi, on one side of the tag were the words:

Pasqualini is that given by Gassendi, *Mirrour*, pp. 27-28, 121, and 164, and one statement by Jean-Jacques Bouchard in his *Monumentum Romanum Nicolao Claudio Fabricio Perescio, senatori Aquensi doctrinae virtutisque causa factum* (Rome: Typis Vaticanis, 1638), p. 7; Bouchard speaks there of Pasqualini and Orsini as "viros in colligendis colendisque antiquitatum reliquijs diligentissimos et maxime industrios." Cyriac K. Pullapilly, *Caesar Baronius, Counter-Reformation Historian* (Notre Dame: University of Notre Dame Press, 1975), p. 161 noted that Baronio used one of Pasqualini's coins in his *Annales ecclesiastici*. See also Jones, "Borromeo's Pinacoteca," Catalog, p. 35, no. 144; Steven F. Ostrow, "The Tomb of Cardinal Francisco de Toledo at S. Maria Maggiore: A New Work by Giacomo della Porta and Egidio della Riviera," *Ricerche di Storia dell'arte* 21 (1983): 86-96, especially p. 88, and n. 24; and Alexandra Herz, "Cardinal Cesare Baronio's Restoration of SS. Nereo ed Achilleo and S. Cesareo de'Appia, *Art Bulletin* 70 (December 1988): 590-620, especially pp. 614 n. 155, and 616.
15. AE 1:679, 751; AE 2:34, 39, 72, 85, 105, 125, 148, 428, 429, 455, 456, 560; AE 3:420, 438, 510; AE 4:2, 156, 183, 237-238, 300, 321, 491; AE 5:51, 159, 451 (two coins); AE 6:207, 313; AE 7:69, 226-227; AE 8:45-47, 147-148, 167-168, 196, 245, 248, 249, 322, 330; AE 9:206, 376, 494, 529; AE 11:232-233 (three coins).
16. It was described by l'Heureux, *Hagioglypta*, p. 78, and discussed at length by de Rossi, "Le medaglie," pp. 37-38. De Rossi notes that Pasqualini owned several devotional medals, considering this one, now lost, of particular importance (ibid., pp. 52-54).
17. Lorenzo Pignoria, *De servis, et eorum apud veteres ministerijs, commentarius* (Augsburg: Pinus, 1613), p. 21; Giovanni B. de Rossi, "Origine de la basilique de S. Clément," *Bulletin d'archéologie chrétienne* 1, 4 (1863): 25-31, especially p. 26. The tag dates to the time of Constantine, and was reused.

TENE ME Q
VIA FVG . ET REB
OCA ME VICTOR
I . ACOLIT
O A DOMIN
ICV CLEM
ENTIS

(*"tene me quia fugi et reboca me Victori acolito a dominicu Clementis,"* that is, "Stop me, for I have escaped and report me to Victor, acolyte of the church of Clement"). On the other side were the words "FVG EVP / LOGIO EX . / PRF . VRB" (*"fugi Euplogio ex praefecto urbis,"* that is, "I have escaped from the house of Euplogius, formerly Prefect of Rome.") The tag, which was attached to an iron collar placed around the fugitive slave's neck, also showed the monogram of Christ on the first side and on the other some initials, the chi rho within a wreath, and a palm branch.[18]

An early Christian monument once in Lelio Pasqualini's collection that survives today is the funerary epitaph of Flavia Iovina, who died in 367 CE (fig. 3). The stone is recorded as having been seen in or near S. Martino ai Monti in Rome around 1585-1590. From there it went directly into Pasqualini's collection, where Baronio saw and studied it, later illustrating it in Volume IV of his *Annales ecclesiastici*.[19] The monument eventually went to the Vatican Museums, where it can be seen today.[20]

In spite of his admitted expertise, Pasqualini occasionally allowed himself to be fooled, and like the blind following the blind, others fell after him. This was the case with one of the canon's most spectacular possessions, a life-size bronze crown of realistically depicted laurel leaves and berries, with an oval plaque bearing the chi rho in its center. Though now easily recognized by experts as a counterfeit, many in Pasqualini's

18. De Rossi, "S. Clément," p. 25.
19. Rome: Typographia Vaticana, 1593, p. 195.
20. On this monument, now Vatican Museums 1614, see Rodolfo A. Lanciani, "Il codice barberiniano XXX, 89, contenente frammenti di una descrizione di Roma del secolo XVI," *Archivio della Società Romana di Storia Patria* 6, 3-4 (1883): 479; *Inscriptiones christianae urbis Romae septimo saeculo antiquiores*, n.s. 1, ed. Angelus Silvagni (Rome: Befani, 1922), no. 1614; Herz, "Cardinal Baronio's Restoration," p. 616.

time were taken in by it, including Baronio, who discussed it at length and illustrated it in the *Annales ecclesiastici*.[21]

Like many other antiquarians of his era and earlier, Lelio Pasqualini seems to have maintained a "paper museum" consisting of copies of inscriptions he made as he explored the ancient sites of Rome.[22] To Pasqualini's diligence we owe the survival today of an important funerary epitaph:

MIRAE INNOCENTIAE . ADQ . EXIMIAE
BONITATIS . HIC . REQVIESCIT . LEOPARDVS
LECTOR . DE . PVDENTIANA . QVI . VIXIT
ANN. XXIIII . DEF . VIII . KAL . DEC.
RICOMEDE . ET . CLEARCO . CON.[23]

De Rossi, who found copies of Pasqualini's copy around 1867, says that we do not know where he saw the epitaph, which then disappeared or was destroyed. De Rossi, who was able to use the inscription to show the early date of S. Pudenziana, adds that Pasqualini then seems to have attached no importance to it, nor does he seem to have told Baronio about it, as he had other ancient monuments.[24]

Surprisingly, in light of how thoroughly Pasqualini and all his effects disappeared, a twelve-page, fully illustrated treatise by him survives. The study is very hard to find as it appears at the end of the *Dialoghi...intorno alle medaglie, inscrittioni, et altre antichità* translated by Sada,[25] mentioned

21. Georg Daltrop, formerly curator at the Vatican Museums, kindly informed me that the crown was false. Verbal communication, June 1984. See AE 4:492, par. VII: *De Corona Nomine Christi aucta*.

22. See Giacomo Bosio, *La trionfante e gloriosa croce* (Rome: Alfonso Ciacone, 1610), pp. 709-11; Giuseppe Ferretto, *Note storico-bibliografiche di archeologia cristiana* (Vatican City: Tipografia Poliglotta Vaticana, 1942), pp. 99, 102-3.

23. "Here rests Leopardus, lector at S. Pudentiana, a man of marvelous innocence and great goodness. He lived twenty-four years, and died on the eighth Kalends of December, under the consuls Recomedis and Clercus."

24. Giovanni B. de Rossi, "I monumenti del secolo quarto spettanti alla chiesa di S. Pudenziana," *Bullettino di archeologia cristiana* 5, 4 (1867): 49-60. Leopardo, "lector de Pudentiana," died in the year 384 CE, which was also Pope Damasus' last year. The inscription is the most ancient recollection of S. Pudenziana surviving, de Rossi says ("S. Pudenziana," p. 51).

25. The complete title is: *Dialoghi di Don Antonio Agostini Arcivescovo di Tarracona intorno alle medaglie, inscrittioni et altre antichità tradotti di lingua Spagnuola in Italiana da Dionigi Ottaviano Sada & dal medesimo accresciuti con diverse annotationi, & illustrati con disegni di molte medaglie e d'altre figure* (The *Dialogues of Don Antonio Agostini, Archbishop of Tarragona, on Medals,*

above. In a brief introduction Sada explains that he had heard of a very beautiful coin of Constantine in Lelio Pasqualini's collection. Sada says he felt that the medallion had to be included somehow. The owner courteously provided the coin, together with a discourse that he had written about it, which Sada put at the end, because the book was already entirely printed.[26]

Following the style of the *Dialoghi* themselves, Pasqualini's treatise is written in the form of a discussion between three amateurs named "A," "B," and "C" – the last is Pasqualini himself. The discussion begins with a coin showing the emperor Constantine in profile on its recto, and on the verso the Labarum topped by Christ's monogram, and impaling a serpent. The Labarum is flanked by the words "SPES PUBLICA." "B" asks why the emperor is crowned with laurel, giving Pasqualini an opportunity to discuss when and on what occasions Constantine wore laurel crowns and diadems. "C," answering objections raised by "A," continues that one can find the laurel crown with Christ's monogram in the center carved in marble, and he illustrates the marble epitaph of Flavia Iovina (fig. 3) also in his collection. The same motif of crowns with cross or monogram in the center also appears on coins, Pasqualini adds, proving his point with two drawings of coins; he can also show a "beautiful ancient crown of metal, large, that I keep among my most treasured things, which is all of laurel leaves, with its berries reproduced realistically, and it has in the center a button with the seal of the same form of the name of Christ,"[27] and here

Inscriptions, and Other Antiquities, Translated from the Spanish Language into Italian by Dionigi Ottaviano Sada, and by the Same Enlarged with Diverse Annotations, and Illustrated with Drawings of Many Medals and Other Figures) (Rome: G. Faciotto, 1592).

26. "Havendo Io havuta notitia di una Medaglia di Costantino, molto bella, & che molto fa à proposito delle cose, che di lui si raccontano in questa opera, hò giudicato, che non si dovesse lasciar di metterla in moda niuno; la qual Medaglia si ritrova nello studio del Signor Lelio Pasqualino, & da lui n'è stata cortesemente conceduta, insieme con un discorso, che egli vi hà fatto, il quale hò meso qui nel fine, poiche era già stampato tutto il libro: Et si dee porre nel primo Dialogo, à carte 18. dopo le parole: 'Et noi ce ne passeremo per hora à trattare della nostra materia.'" Sada, *Dialoghi*, p. 1.

27. "Et io vi posso mostrar una bellissima Corona antica, di metallo, grande, che io tengo fra le mie cose più care, laqual è tutta di foglie d'alloro, con sue bacche ritratte al naturale; & ha nel mezzo un bottone col Sigillo della medesimo nota del nome di Christo" (Pasqualini, in Sada, *Dialoghi*, p. 2v).

the author gives an illustration of the so-called ancient crown discussed above.

"C" next discusses the reverse of the Constantinian coin with which he began, showing the Labarum impaling a serpent. Here "C" describes what Constantine actually saw in his famous vision, as opposed to the Labarum, or standard, that the emperor then had his craftsmen make. "C" explains that for the ancient pagans, the word "cross" was very general, used "for every sort of invention made for torment- ing and killing men." Because of this diversity, Constantine had to describe carefully the cross that appeared to him in the sky. "B," saying that all this makes him more confused than convinced, counters with the opinion of Onofrio Panvinio. "C" agrees that Panvinio was both learned and prolific, but dealing with ancient medals is more difficult than one might think. Here "C" (that is, Lelio Pasqualini) gives some idea of his methodology, to which we will return presently.

After more discussion of banners and crosses, "C" goes on to discuss the skill of the craftsmen who designed and engraved the coins, showing through several illustrations that they could depict many minute elements in a tiny space with perfect clarity. Pasqualini bolsters his points throughout by citing ancient and contemporary authorities, including Cassiodorus, Tertullian, Suetonius, Pliny, Virgil, Eusebius, Nicephorus, Zonaras, Prudentius, Seneca, Terence, Sozomenus, S. Gregory Nazianzenus, Pomponio Leto, and Onofrio Panvinio. Pasqualini is perfectly capable, however, of criticizing or disagreeing with these authorities when necessary.

Lelio Pasqualini's total disappearance from history, moreover, is not due to the complete loss of relevant docu- ments. The archives of S. Maria Maggiore and the city of Rome provide vital statistics about the canon from which others can be inferred. We know that he was born in 1549 (probably in Bologna),[28] that he became a canon at S. Maria

28. The date of Pasqualini's birth can be determined from his epitaph: D. O. M. / Lelio Pasqualino / Hujus Basilicae Canonico / Religionis cultu / Et morum elegantia / Praesentibus colendo / Antiquitatis notitia cum / Antiquis comparande / Obiit an. Dom. MDCXI / Etatis suae LXII / Pompejus Pasqualinus / Patruo optime merito / Posuit. ("God be praised. Pompeius Pasqualinus has established this monument for his uncle of great merit, Laelius Pasqualinus, a canon of this basilica, a man worthy of the veneration of his contemporaries

Maggiore on 16 August 1572, after the resignation of Giovanni Francesco Pasqualini, a relative,[29] and resigned from the canonicate himself in favor of his nephew Pompeo Pasqualini on 1 August 1610.[30] He made out his last will on 27 July 1611[31] and died on 13 August of that year.[32] He was buried two days later in S. Maria Maggiore.[33]

Like his patron, Giovanni Francesco Pasqualini, Lelio is described in the documents as papal *familiaris* (the pope was Gregory XIII when Lelio became a canon at S. Maria Maggiore in 1572), meaning that he was a member of the pope's inner circle or one of his closer staff members. Lelio remained prominent to the end of his life: executors of his will were Julius Monterensius, governor of Rome, Marcantonius Ianus, *familiaris* of Paul V, and the pope's secretary. Unfortunately, the will tells us nothing about Pasqualini's collection. From it we learn that Lelio had a brother, Francesco, and three sisters, Constantia, Ottavia

for his devout life and cultivated tastes, a man comparable to the ancients in his knowledge of antiquity. He died in the year of our Lord 1611, in the sixty-second year of his age.") See Giuseppe Bianchini, *Historia Basilicae Liberianae Mariae Maioris*, 1764 (10 volumes in manuscript), 4:241. Pasqualini's tomb was moved to make way for the Pauline Chapel, and the inscription destroyed or lost. Paolo de Angelis, *Basiliae S. Mariae Maioris de Urbe a Liberio Papa I usque ad Paulum V Pont. Max.* (Rome: B. Zannetti, 1621), 12:47-48 calls Lelio and his nephew Pompeo "Bononiensis."
29. Bianchini, *Historia Basilicae*, p. 240; and Archivio Capitolare di S. Maria Maggiore (hereafter ACSMM), *Atti capitolari 1556-1577*, fol. 94r, Die xvi Aug. MDLXXII, "Rev. D. Lelius Pasqualinus adeptus est possessem," and ACSMM, *Instrumenta*, XVI, fols. 109v-111r. Lelio Pasqualini was responsible for building the tomb of his relative and patron Johannes Franciscus Pasqualinus. See Bianchini, *Historia Basilicae*, p. 231. This tomb and its inscription were also destroyed. Giovanni Francesco Pasqualini became a canon at S. Maria Maggiore on 29 January 1560 (ibid.). I am very grateful to Father Jean Coste, formerly Archivist at S. Maria Maggiore, for his help in finding and deciphering relevant documents mentioned here and in note 31.
30. ACSMM, *Atti capitolari 1596-1610*, fol. 119r, "R. D. Io. Bapta. Tedallinus Diaconalis ordinis optavit locum presbyterale vacantem per resignationem R. D. Lalii Pasqualini ad favorem R. D. Pompeij Pasqualini fratris filii."
31. Archivio di Stato, Roma (hereafter ASR), *Fondo Notaii Cancellieri del Tribunale dell' A. C. Testamenti*, XXXV, fols. 576r-579v, and 581v. The will is dated 27 July 1611 and was opened on 14 August 1611, the day after Pasqualini died.
32. Ibid., fol. 576r.
33. Bianchini, *Historia Basilicae*, p. 240; and ACSMM, *Libro dei morti, 1611-1804*, fol. 2r: "Adi 15 d'Agosto 1611 fu sepolto il corpo del R. Sig. Lelio Pasqualino gia canonico di nostra chiesa parrochia di Sto. Biagio accanto le scale d'Araceli."

and Dianone (the latter two were nuns in S. Maria Nuova, in Bologna). Francesco had one son, Pompeo, in Rome, and two more sons and two daughters who lived in Bologna. The will designates Pompeo as heir of all Lelio's goods in Rome, and the Bolognese nephews as heirs of all his goods in Bologna.[34]

In the materials mentioned above enough survives so that we have some idea also of Lelio Pasqualini's methodology as scholar and collector, important because the canon had considerable influence on contemporaries, and on much younger scholars who would later become important, such as Peiresc.[35] In fact, it is in Pasqualini's letters to Peiresc that we learn how he became involved in collecting, how he thought it should be done, and what it meant to him. The canon described his experiences for his young friend: "I began to collect some ancient things for the pure amusement of my studies, without any other object; but as happens from our unending desire to know...I found myself in brief having put together so many things it occurred to me that I could make a systematic study of them, and this done, my own pleasure still did not satisfy me unless it was communicated, which, as you know, is a defect of human nature...."[36] Like Pasqualini, Peiresc remained throughout his life dissatisfied if he could not tell others about his work.

But Pasqualini taught his famous pupil something of even greater value – the importance of direct investigation, of documented research. He writes to Peiresc: "if study of them sufficed to enable one to deal with ancient things, it would be madness, if not also superfluous, to gather so many things and spend so much money on antiquities," while, on the other hand, "there is too great a difference between learning a thing from writers, and seeing the thing itself."[37] In his

34. ASR, *Fondo Notaii Cancellieri del Tribunale dell' A. C. Testamenti*, fols. 576r-579v.
35. On Peiresc, see notes 4 and 5 above.
36. "Io cominciai a raccogliere alcune cose antiche per puro spasso dei studi miei senz' altro oggetto: ma come avviene di questo nostro desiderio di sapere che non ha mai fine...mi trovai in breve haver messo insieme tante cose che entrai in pensiero di poterne far studio regolato; et fatto questo ancora, non contento del mio particolare piacere; se non era comunicato, com'ella sa che è difetto della natura humana...." Unpublished letter by Pasqualini to Peiresc, 3 June 1608, Rizza, *Peiresc*, p. 57 n. 48.
37. "...se per poter trattare delle cose antiche bastasse lo studio, sarebbe pazzia, non che cosa superflua, il radunar tante cose et spender tanti danari in

discourse of 1592 in the *Dialoghi...intorno alle medaglie*, Pasqualini elaborates on what the expert numismatist should know. An entire and universal knowledge of history, Latin and Greek, is not enough, he says. One also needs a varied knowledge of almost all the arts and sciences, and "above all to have seen, even possessed and handled...an infinite number of medals, and observed minutely everything, and with utmost circumspection and diligence...."[38] That the pupil, Peiresc, took these lessons seriously seems proven by his requests for firsthand information, his search for documents and testimony, and his repetition of observations made by Galileo. Because of this training, Peiresc could later cross disciplines with impunity.[39]

Though, as we have seen, he occasionally made mistakes, contemporary testimony that Lelio Pasqualini bested even such a scholar as Fulvio Orsini can easily be believed. In his insistence on direct observation, that is, on the empirical method, and his ability to question authority, Pasqualini even surpassed his good friend, Cesare Baronio.[40] Such a scholar deserves better than to be completely forgotten by history itself.

anticaglie...è troppo gran differenza dall' imparare una cosa dalli scrittori, o veder la cosa stessa" (ibid.).

38. "& sopra tutto di haver veduto, anzi havuto, & maneggiato...infinite Medaglie, & osservatovi minutamente ogni cosa, & con somma circospettione, & diligenza...," Pasqualini, in Sada, *Dialoghi*, p. 5r.

39. Rizza, *Peiresc*, pp. 276-77.

40. Baronio all too often could not bring himself to question authority; see Pullapilly, *Baronius*, especially pp. 163-64, also 146-47, 167-71.

Fig. 1. Coins from the collection of Lelio Pasqualini (top: Flaccilla, wife of Theodosius I, 379-386 CE, bottom: Eudocia, wife of Theodosius II, 423-c.450 CE, from Cesare Baronio, *Annales ecclesiastici* (Rome: Typographia Vaticana, 1595), 6:255. (Biblioteca Apostolica Vaticana)

Fig. 2. Devotional medal of c.450-550 CE, once in the collection of Lelio Pasqualini, *Bullettino di archeologia cristiana* 7, 3 (1869): 44, no. 5. (Harvard Libraries)

Fig. 3. Funerary epitaph of Fl. Iovina, 367 CE, once in the collection of Lelio Pasqualini, now in the Vatican Museum. (Vatican Museums)

X

The Bentvueghels: "Bande Académique"*

DAVID A. LEVINE

In his classic study of academies of art, Nikolaus Pevsner took no account of the Roman Bent, the society of Dutch and Flemish painters active in Rome from about 1623 to 1720.[1] That this group, whose members called themselves Bentvueghels, is still excluded from consideration in the context of academies seems reasonable enough. Investigations by G. J. Hoogewerff demonstrated long ago that the Bent shared neither the values nor the ambitions of early academies of art in Florence and Rome.[2] As far as we know,

* I would like to express my special debt to Irving Lavin. As my dissertation supervisor, Lavin led me to explore the notion that Pieter van Laer and his associates in Rome possessed a coherent theory of art informed by irony and paradox, an idea that provoked my study of academies and guided my reasoning here. I am also deeply grateful to Nicola Courtright and to the commentators at the IL60 Colloquium for their insightful criticisms. The J. P. Getty Trust; Princeton University; the Institute for Advanced Study, Princeton; and Southern Connecticut State University generously supported my research.
1. Nikolaus Pevsner, *Academies of Art Past and Present* (Rpt. ed., New York: Da Capo Press, 1973). Pevsner mentioned the group, known also as the Schildersbent, only in passing, calling it a "popular club" (p. 65). The terms used to designate the society and its members are discussed below.
2. G. J. Hoogewerff, *De Bentvueghels* (The Hague: Martinus Nijhoff, 1952), consolidates the essential information from the author's numerous earlier articles on the subject. On the Bentvueghels generally, see also Didier Bodart, *Les Peintres des Pays-Bas méridionaux et de la principauté de Liège à Rome au XVIIème siècle*, 2 vols. (Brussels: Institut Historique Belge de Rome, 1970), 1:98-112; and Thomas Kren, "Chi non vuol Baccho: Roeland van Laer's Burlesque Painting about Dutch Artists in Rome," *Simiolus* 11 (1981): 63-80. On early academies of art, see, in addition to Pevsner: Charles Dempsey, "Some

DAVID A. LEVINE

they had no written bylaws or official hierarchy. They offered no curriculum, held no scholarly lectures, sponsored no competitions or exhibitions. Moreover, unlike early artists' academies, the Bent did not endeavor to raise the social status of its members. Indeed, the activities of this group were thought by Italian chroniclers to demean both the painters who took part in them and the art of painting as a whole.[3]

Particularly offensive to the Italians were the Bent's so-called "baptisms," festive induction rituals performed to welcome new members into the society. According to the artists Joachim von Sandrart and Cornelis de Bruyn, who were initiated as Bentvueghels in 1628 and 1675 respectively, these ceremonies began with the staging of witty tableaux vivants by various members of the group.[4] Mythologies and allegories were evidently the preferred subjects of these quasi-theatrical performances. The tableau described by Sandrart portrayed a gathering on Mount Olympus with Bent members playing the roles of Apollo and the Muses, whereas one depicted in a print after Domenicus van Wijnen (fig. 1), a Bentvueghel in the 1680s, represents an obscene comedy in which a nude Bacchus takes center stage.[5] Bacchic

Observations on the Education of Artists in Florence and Bologna During the Later Sixteenth Century," *Art Bulletin* 62 (1980): 552-69; Zygmunt Ważbiński, *L'Accademia Medicea del disegno a Firenze nel Cinquecento: Idea e istituzione*, 2 vols. (Florence: Leo S. Olschki, 1987); and now, Anton W. A. Boschloo, et al., eds., *Academies of Art Between Renaissance and Romanticism*, Leids Kunsthistorisch Jaarboek 5-6, 1986-87 (The Hague: SDU Uitgeverij, 1989).
3. For negative assessments of the Bentvueghels, see Jakob Hess, ed., *Die Künstlerbiographien von Giovanni Battista Passeri*, Römische Forschungen der Bibliotheca Hertziana 11 (Leipzig: Heinrich Keller, 1934), p. 73; and S. Rosa, "La Pittura," ll. 661-66, in G. A. Cesareo, ed., *Poesie e lettere edite e inedite di Salvator Rosa*, 2 vols. (Naples: Tipografia della Regia Università, 1892), 1:248.
4. Joachim von Sandrart, *Teutsche Academie der edlen Bau-, und Mahlerey-Künste*, ed. A. R. Peltzer (Munich: G. Hirth, 1925), pp. 27-28; and Cornelis de Bruyn, *Reizen van Cornelis de Bruyn door de vermaardste deelen van Klein Asia...* (Delft: Henrik van Krooneveld, 1698), pp. 5-6. Sandrart was one of the few non-Netherlandish artists to be installed as a group member. On the Bent baptism, see G. J. Hoogewerff, "Bentvogels te Rome en hun feesten," *Mededeelingen van het Nederlandsch Historische Instituut te Rome* 2 (1922): 223-48, in addition to the studies cited in n. 2 above.
5. On the engraving by Van Wijnen, see Jan Willem Salomonson, "Dominicus van Wijnen: Een fantast, doordraaier en schilder van visionaire taferelen, werkend aan het eind van de zeventiende eeuw," *Kunst en antiek Revue* 9, 4 (1983): 34-35; and idem, "Dominicus van Wijnen: Ein interessanter 'Einzelgänger' unter

imagery also dominates the scene staged in an anonymous painting of a Bent initiation (fig. 2) today in the Rijksmuseum.[6] The prominence of Bacchus in these productions is no accident; other evidence suggests that the god of wine was the virtual patron saint of the group.

Against this background, a mock priest called the *Veldpaap* would address the inductee, explaining to him certain precepts of painting and the inviolable statutes of the society. Upon agreeing to uphold the traditions of the Bent, the inductee or *Novitio,* as he was called, would then be crowned with a laurel wreath and pronounced a member of the society to the cheers of his compatriots.[7]

The new Bentvueghel was also assigned a pseudonym by which he was thereafter addressed by his fellows. This alias often poked fun at some odd physical trait or abnormality; for example, Jan Asselijn's claw-like hand earned him the Bent name *Crabbetje,* while Pieter van Laer was called *il Bamboccio* because his long legs and awkward movements made him look like a big ugly doll or puppet. It was also fashionable to endow the initiates with the names of classical gods and heroes, such as Bacchus, Cupid, Hector, Meleager, Cephalus, Pyramus, Orpheus, and so on.[8]

When the investiture was completed, the entire company would partake of a festive meal lasting long into the night.[9]

den niederländischen Malern des späten 17. Jahrhunderts," *Niederdeutsche Beiträge zur Kunstgeschichte* 24 (1985): 140-41.

6. Amsterdam, Rijksmuseum, no. A4672. See P. J. J. van Thiel et al., *All the Paintings in the Rijksmuseum in Amsterdam* (Amsterdam: Rijksmuseum, 1976), p. 910 (as Netherlands school c.1660); and Kren, "Baccho," pp. 71-72. A Bacchic tableau vivant is also featured in a canvas by Roeland van Laer in the Museo di Roma thought to represent a Bent baptism. For an analysis of this work, see Kren, "Baccho," passim.

7. De Bruyn, *Reizen,* p. 5. According to De Bruyn's account, the *Novitio* also received a document *(Bendbrief)* signed by all the attending members of the ceremony. This moment of the ritual is depicted in a second engraving after Van Wijnen. See Salomonson, "Van Wijnen" (1985), pp. 140, fig. 27; and 141.

8. For lists of Bent members and their aliases, see Hoogewerff, *Bentvueghels,* pp. 131-47; and Arnold Houbraken, *De Groote Schouburgh der nederlantsche konstschilders en schilderessen,* ed. P. T. A. Swillens, 3 vols. (Maastricht: Leiter-Nypels, 1943-1953), 3:361-65. On the meanings of Van Laer's nickname, see David A. Levine, "The Art of the Bamboccianti" (Ph.D. diss., Princeton University, 1984), pp. 4, 34-36.

9. This is a conservative estimate of the duration of the meal based upon the accounts of Sandrart and De Bruyn. Hess, *Passeri,* p. 73, reported that the feasting "durava il meno 24 hore continue, senza mai levarsi da tavola...."

This event, at which wine was consumed by the barrel, was represented in another print after Van Wijnen (fig. 3).[10] Then the group would march down the Via Nomentana to the little church of Santa Costanza, once popularly known as the Temple of Bacchus.[11] Inside the church the Bentvueghels prayed before the porphyry sarcophagus of the Empress Constantia now in the Vatican (fig. 4), an object they evidently imagined to be Bacchus' tomb.[12] The artists commemorated their visits to the mausoleum by scratching their signatures onto the walls of niches flanking the recess where the sarcophagus had once stood. Many of these inscriptions are still visible today.[13]

Gluttony, drunkenness, worshipping Bacchus, satirizing the clergy and religious ritual: the Bentvueghels were guilty of all these sins. It is thus easy to understand why scholars have never considered the society of *oltramontani* in the same light as the sober Accademia del Disegno and Accademia di San Luca. But as much as the ribald activities of the Bent distinguish the Dutch organization from contemporary academies of art, they show it to be related to another type of academy: the private literary academy as it had existed in Italy and elsewhere in the fifteenth and sixteenth centuries. Indeed, many of the salient features of the Bent initiation

10. Salomonson, "Van Wijnen," (1983), pp. 34-35; and Salomonson, "Van Wijnen," (1985), p. 140.
11. On the Mausoleum of Santa Costanza and its identification as the Temple of Bacchus, see H. Stern, "Les Mosaïques de l'église de Sainte-Constance à Rome," *Dumbarton Oaks Papers* 12 (1958): 157-218; and Hoogewerff, *Bentvueghels*, pp. 104-5. The march to the Temple of Bacchus seems to have become part of the initiation ritual only after about 1648-49, the dates of the earliest Bentvueghel signatures found at the shrine (Bodart, *Peintres*, p. 109). There can be no doubt, however, that the Bent was dedicated to Bacchus from its very inception. An anonymous drawing in the Museum Boymans-van Beuningen, Rotterdam (Anon. Neth. 17th C. no. 8E), believed to be one of the earliest documents of the Bent's activities, represents a nude Bacchus seated on a wine keg surrounded by portraits of group members, one of whom bends toward the wine-god in obeisance (Hoogewerff, *Bentvueghels*, pl. 20).
12. On the sarcophagus of Constantia, see Friedrich Wilhelm Deichmann, *Repertorium der christlich-antiken Sarkophage*, vol. 1 (Wiesbaden: Franz Steiner, 1967), pp. 108-10; and Stern, "Mosaïques," p. 164.
13. The signatures were discussed by Hoogewerff, *Bentvueghels*, pp. 113-15. An updated and corrected list is published in H. van de Schoor, "Bentvueghel Signatures in Santa Costanza in Rome," *Mededelingen van het Nederlands Instituut te Rome* 38, n.s. 3 (1976): 77-86.

ceremony were foreshadowed by activities performed by groups of learned writers and other intellectuals.

It is often overlooked that humor, wit, and ironic self-mockery were fundamental *modi operandi* of the Renaissance literary academy.[14] Such spirit is advertised by the capricious and ridiculous names often chosen by these groups: Addormentati, Apatisti, Insensati, Incolti, Immaturi, and Rozzi, to name but a few.[15] In the seicento, specialized academies were formed whose sole purpose was to promote Socratic irony. The Mammagnuccoli of Florence, for example, were permitted to speak only gibberish at meetings, a policy designed to demonstrate their ostensible simplemind-edness.[16] In the preceding centuries, even those academies whose activities were primarily serious encouraged laughter and wit. The stated purpose of the Umidi of Florence, founded in 1540, was to foster the Tuscan language, but the earliest members of this academy, described by one scholar as "spiriti faceti e bizzari, sempre in vena di scherzi," habitually punctuated the society's formal proceedings with practical jokes and other forms of ribald entertainment.[17] The

14. On literary academies generally, see Eric W. Cochrane, *Tradition and Enlightenment in the Tuscan Academies (1690-1800)* (Chicago: University of Chicago Press, 1961), pp. 1-35 (esp. chapter 1: "From the Cinquecento to the Settecento"); Michele Maylender, *Storia delle accademie d'Italia,* 5 vols. (Bologna: L. Cappelli, 1926-1930); Pevsner, *Academies,* pp. 1-24; A. Quondam, "L'accademia," in Alberto Asor Rosa, ed., *Letteratura italiana,* 9 vols. (Turin: Giulio Einaudi, 1982), 1:823-98; and Girolamo Tiraboschi, *Storia della letteratura italiana,* 9 vols. (Milan: Società Tipografica de' Classici Italiani, 1822-1826), 7:203-95, 8:65-93.

15. These names might be translated as the Sleepers, Apathetic Ones, Senseless, Uncultivated, Immature, and Uncouth. Tiraboschi, *Storia,* 7:203-4; and Pevsner, *Academies,* p. 13, comment on the odd nicknames of the academies. For the paradoxical idea that academies chose humble and defective names "nobile effetti partorire," see Girolamo Aleandro, *Sopra l'impresa de gli accademici humoristi discorso* (Rome: Giacomo Mascardi, 1611), pp. 38-39.

16. Antonio Belloni, *Il Seicento,* Storia letteraria d'Italia (Milan: Francesco Vallardi, 1929), p. 31.

17. See Detlef Heikamp, "Rapporti fra accademici ed artisti nella Firenze del '500," *Il Vasari* 15 (1957): 140; and Leatrice Mendelsohn, *Paragoni: Benedetto Varchi's 'Due lezzioni' and Cinquecento Art Theory* (Ann Arbor, MI: U.M.I. Research Press, 1982), p. 25. Even after it was reorganized as the Accademia Fiorentina at the direction of Cosimo I, this group was characterized by a "spirito d'ingegno arguto, e leggiardo." See *Rime piacevoli del Berni, Casa, Mauro, Dolce, et d'altri autori...,* vol. 1 (Venice: Francesco Baba, 1627), p. A9v. As is well known, Bronzino, Michelangelo, Cellini, Francesco da Sangallo and Bandinelli, as well as other Italian artists, were members of this academy.

DAVID A. LEVINE

Accademia della Crusca also pursued philological studies, publishing the first edition of its dictionary in 1612. At its charter in 1582, however, the group gave indication of far less pedantic concerns, voicing as its one fixed rule that "only the hilarious element in literature was to be cultivated."[18] Even the august Accademia Platonica may have embraced the academic custom of accepting comic expression as a companion to serious discourse: the group's regular meeting place was decorated with a large painting in which the laughing philosopher Democritus was emphasized no less than his tearful counterpart Heraclitus.[19]

In addition to anticipating the Bent's general outlook, literary academies engaged in many of the facetious practices that later occupied the artists' group. For example, it was customary since the fifteenth century for academicians to be addressed in their societies by nicknames that, like many Bentvueghel aliases, had a bizarre and mocking aspect. Consider for example the academic appellations of members of the Umidi: l'Umoroso, il Gelato, il Frigido, il Lasca, to name but a few.[20] Even the most serious academies, such as the Notti Vaticane, whose members included Carlo Borromeo, Ugo Boncompagni, and Francesco Gonzaga, followed the practice of using comic nicknames.[21] In some societies, the Roman Academy of Pomponio Leto, for example, members were known by Greek and Roman pseudonyms, a practice directly imitated by the Bentvueghels.[22]

Holding long, merry banquets was also a standard practice of literary academies later adopted by the Bent. This

18. Pevsner, *Academies*, p. 15. Only in 1591 was it resolved that the aim of the group should be to codify the Italian language.
19. See Edgar Wind, *Pagan Mysteries in the Renaissance* (New York: W. W. Norton, 1968), pp. 48, 49n., with bibliography; August Buck, "Die humanistischen Akademien in Italien," in Fritz Hartmann and Rudolf Vierhaus, eds., *Der Akademiengedanke im 17. und 18. Jahrhundert*, Wolfenbütteler Forschungen 3 (Bremen: Jacobi Verlag, 1977), p. 14; and A. Blankert, "Heraclitus en Democritus bij Marsilio Ficino," *Simiolus* 1 (1966-67): 128-35.
20. See Maylender, *Storia*, 5:366.
21. Tiraboschi, *Storia*, 7:216-18. On the group in general, see Luigi Berra, *L'accademia delle Notti Vaticane fondata da San Carlo Borromeo* (Rome: Max Bretschneider, 1915). S. Carlo's alias was *il Caos*.
22. See I. Carini, "La 'Difesa' di Pomponio Leto," in *Nozze Cian-Sappa Flandinet...* (Bergamo: Istituto Italiano d'Arti Grafiche, 1894), p. 158; and Maylender, *Storia*, 4:323.

tradition, which originated at the Platonic academy in Athens, was first revived in Renaissance Florence by Marsilio Ficino and his friends.[23] By the sixteenth century the banquet became a regular feature of academic life, serving as an occasion for witty presentations by members of the group. Rather than staging tableaux vivants at their feasts, the academicians would often entertain their colleagues by reciting paradoxical encomia and other ironic literary compositions. At the Roman academy of Claudio Tolommei (L'Accademia della Virtù), for example, members were required to recite a poem in praise of some ridiculous item brought to the banquet table.[24] It was here that Annibale Caro delivered his "Diceria de'nasi," an encomium lauding the huge nose of co-academician Gianfrancesco Leoni. This custom continued well into the seventeenth century. At the Florentine Accademia dei Percossi, a society famed for its sumptuous banquets of many excellent courses, the toothless Francesco Maria Agli declaimed in praise of the lowly meatball *(polpette)*, presumably the only dish he was able to chew.[25]

Among the most famous banquets were those of the Vignaiuoli, an academy of poets founded in Rome after the Sack. Like the Bentvueghels, this group made a ritual of wine-drinking at their feasts, claiming that wine helped them to achieve the poetic furor essential to creativity.[26] Nor were they the only literary academy to kneel at the feet of Bacchus. An early seventeenth-century Paduan group known as the Padrani were also said to be sworn to Bacchus no less than to

23. Arnaldo della Torre, *Storia dell'Accademia Platonica di Firenze* (Florence: G. Carnesecchi, 1902), pp. 813-15, cited by Erwin Panofsky, *Renaissance and Renascences in Western Art* (New York: Harper & Row, 1972), p. 173.
24. See Annibal Caro, *De le lettere familiari* (Venice: Bernardo Giunti, 1581), 1:10-11 (letter to Varchi of March 1533), cited by Tiraboschi, *Storia*, 7:214.
25. Filippo Baldinucci, *Notizie dei professori del disegno da Cimabue in qua....*, vol. 5 (Florence: V. Batelli, 1847), p. 454; cited by Maylender, *Storia*, 4:264. Comic discourses *(cicalate)* were also made on a regular basis at the Accademia della Crusca (see Belloni, *Seicento*, p. 31).
26. Tiraboschi, *Storia*, 7:213, cites a letter of 1531 describing one of these banquets at which "altro vino non fu bevuto, che quello della vigna del Pontano fatto venire da Napoli a posta; il quale ebbe in se tanto del vigore poetico, che tutti ci riscaldò non in vederlo, ma in gustarlo, et in beverne oltre a sette e otto volte per uno, et tal vi fu, che arrivò al numero delle Muse."

DAVID A. LEVINE

Apollo and the Muses.[27] Lomazzo's Accademia di Val di Bregno also engaged in Bacchic rites, even developing a hermetic language for use in academic publications and meetings that was based largely upon the dialect of local vineyard workers who were hailed by the academicians as descendants of Bacchus.[28]

It was even common for academies to parody the clergy in a manner later repeated by the Bentvueghels. The tradition evidently began in the early fifteenth century when the title "Pontifex Maximus" was applied to Pomponio Leto at the academy that bears his name. Leto's co-academician Platina was called "Padre Santissimo," while other members wore clerical garb and were addressed as "Sacerdotes Romanae Academiae."[29] This tradition was evidently carried on into the sixteenth century. The members of the Accademia della Virtù, for example, liked to speak of themselves as Padri.[30] Facetious clerical titles prefixed the pseudonyms of other academicians of the period as well.[31]

27. Belloni, *Seicento*, p. 31. On the Padrani generally, see Carlo de Dottori, *L'asino* (Venice: Combi, 1652), canto V, stanzas 51-58; and Natale Busetto, *Carlo de' Dottori* (Città di Castello: S. Lapi, 1902), pp. 79, 88, 91.
28. On this academy see Maylender, *Storia*, 5:421-22; Francesco Cherubini, *Vocabolario Milanese-Italiano*, 5 vols. (Milan: Regia Stamperia, 1839-1856), 2:83; James Lynch, "Lomazzo and the Accademia della Valle di Bregno," *Art Bulletin* 68 (1966): 210-11; and Roberto Paolo Ciardi, ed., *G. P. Lomazzo, Scritti sulle Arte*, 2 vols. (Florence: Centro Di, 1973), 1:xvi-xix, lxxxvi. As Lynch reported, the group pretended that it had been founded by Bacchus, who was believed to have inhabited the Val di Bregno. The seal of the academy designed by Annibale Fontana depicted Bacchus transported on a chariot drawn by tigers, beneath which was the motto *Bacco inspiratori*. Lomazzo's *Rabisch dra Academiglia dor Compà Zavargna, Nabad dra Vall d'Bregn, ed tucch i sù fidigl soghit, con rà ricenciglia dra Valada* (Milan: Gottardo Ponzio, 1589), a treatise written in the academy's own dialect to commemorate Lomazzo's coronation as head of the group, begins with a prolog in honor of Bacchus.
29. Maylender, *Storia*, 4:322-23; cited by Panofsky, *Renaissance*, p. 173. Members of this academy also anticipated the Bentvueghels in the custom of inscribing their aliases on the walls of their sacred precincts. Giovanni Battista de Rossi, *La Roma sotterranea cristiana*, vol. 1 (Rome: Cromo-Litografia Pontificia, 1864), p. 3, documents the discovery of the names of members of the Accademia Romana in the catacombs where the group habitually met. The walls of the Accademia Platonica were scrawled with epigrams or mottos (see Buck, "Akademien," p. 14).
30. Tiraboschi, *Storia*, 7:214.
31. For example, Mazzuoli, one of the founders of the Umidi, was called Padre Stradino (Maylender, *Storia*, 5:366). Although no academies to my knowledge baptized their initiates like the Bentvueghels, some societies

214

Even the word *"Bentvueghels"* may allude to the relationship between the Dutch painters' society and academies. The term, which has been translated as "birds of a flock," clearly gives expression to the group's fraternal ambitions.[32] In addition to designating a simple brotherhood, however, the root *bent* or *bende* could denote a more serious kind of organization. Vondel, for example, used the term *bende* to describe a group of theologians to which the humanist Melanchthon belonged.[33] Moreover, the word *vueghel* (bird) in this context may allude to a paradigmatic academic institution. In the introduction to his treatise on the history of academies first published in 1639, Giovanni Battista Alberti cited the ancient Alexandrian "Museum" founded by Ptolemy Soter as one of the principal models for later academies.[34] Paraphrasing Athenaeus of Naucratis, Alberti reported that the philosophers constituting this society were mockingly called *"uccelli"* by contemporaries because they were kept like rare birds in sumptuous quarters. The Museum, he explained further, amounted to nothing less than an *"uccelliera delle Muse."*[35] Following Alberti's lead, later writers sometimes

parodied other aspects of church liturgy in their ceremonies. See Ciardi, *Lomazzo*, p. xvi n. 33, on the Accademia di Bregno and the Accademia degli Occulti in Brescia.

32. Hoogewerff, *Bentvueghels*, p. 157. The term was no doubt coined by members of the society. The phrase "Bent. Vueghels" appears on a drawing by Jan Asselijn in the Berlin Kupferstichkabinett, S.M.P.K., inv. no. 144, probably dating from 1635-42. See Albert Blankert, *Nederlandse 17e eeuwse italianiserende landschapschilders*, 2d ed. (Soest-Holland: Davaco, 1979), pp. 142-44; and Anne Charlotte Steland-Stief, *Jan Asselijn nach 1610 bis 1652* (Amsterdam: Van Gendt, 1971), p. 16. De Bruyn, *Reizen*, p. 5, described members of the group as "Bendvogels."

33. J. van Lennep, ed., *De Werken van Vondel*, vol. 4 (Amsterdam: Gebroeders Binger, 1858), p. 683: "Dat de Hyeligen, van dit leven verlost, voor de Kercke bidden, bestemt Melanchthon, ja oock Perkensius en andered van de selve Bende." The term *bent* was applied in the nineteenth century to the Dutch academy Nil Volentibus Arduum, a practice that may have began much earlier. For the relevant citations, see the *Woordenboek der nederlandsche taal* (The Hague: Martinus Nijhoff, 1898), 2, 1:1786.

34. Giovanni Battista Alberti, *Discorso dell'origine delle accademie publiche, e private, e sopra l'impresa de gli affidati di pavia* (Genoa: Gio. Maria Farroni, 1639), p. 9.

35. Ibid., p. 10. Athenaeus *Deipnosophistae*, trans. Charles Burton (London: W. Heinemann, Loeb Classical Library, 1927), I. 22d, pp. 98-99, reported that "Timon of Philius, the satirist, calls the Museum a bird-cage, by way of ridiculing the philosophers who got their living there because they are fed

described modern academies as aviaries. Antonio Palomino, for example, referred to the famous academy of Francesco Pacheco as "a gilded cage of art," presumably in order to signal its kinship to the Alexandrian society.[36] Thus from the beginning, the Bentvueghels may well have been alluding to this tradition, identifying themselves with the academicians of the Alexandrian Museum.[37]

My aim here is not to challenge the old idea, first put forth by Hoogewerff, that the Bent's infamous rituals were construed in deliberate parody of the pompous ceremonies of the Order of the Golden Fleece, although I see little evidence for this view.[38] Nor do I disallow that the society and its activities were stimulated in part by certain types of native Dutch organizations, such as the *rederijkerskamers*, an idea that has yet to be adequately explored.[39] I do wish to suggest,

like the choicest birds in a coop: 'Many there be that batten in populous Egypt, well-propped pedants who quarrel without end in the Muses' bird-cage.'"

36. Antonio Palomino de Castro y Velasco, *El museo pictórico y escala óptica* (Madrid: M. Aguilar, 1947), p. 892: "Era la casa de Pacheco cárcel dorada del arte, academia, y escuela de los mayores ingenios de Sevilla."

37. I can find no reason to suppose that the term *bentvueghel* contains the bawdy sexual meanings sometimes associated with the image of birds and bird cages. On this theme in seventeenth-century Dutch art, see E. de Jongh, "Erotica in vogelperspectief: De dubbelzinnigheid van een reeks 17de eeuwse genrevorstellingen," *Simiolus* 3 (1968-69): 22-74.

38. Hoogewerff, *Bentvueghels*, p. 102. On the ceremonies of the Order of the Golden Fleece, see Charles Terlinden, "Coup d'oeil sur l'histoire de l'ordre illustre de la Toison d'Or," in *La Toison d'or: Cinq siècles d'art de d'histoire*, exh. cat. (Bruges: Musée Communal des Beaux-Arts, 1962), pp. 19-33; and H. Kervyn de Lettenhove, *La Toison d'Or: Notes sur l'institution et l'histoire de l'ordre...* (Brussels: G. van Oest, 1907).

39. On the contrary, the *rederijkers* probably provided an important model for Bentvueghel customs. Drinking was a central activity at *rederijker* meetings, especially during the seventeenth century, and *rederijker* verses are replete with praises of wine and Bacchus. These Northern groups also customarily staged tableaux vivants that may have inspired the informal productions initiating Bent investitures. See Kren, p. 73; Albert Heppner, "The Popular Theatre of the Rederijkers in the Work of Jan Steen and His Contemporaries," *Journal of the Warburg and Courtauld Institutes* 1 (1940): 38-40; and George R. Kernodle, *From Art to Theater: Form and Convention in the Renaissance* (Chicago: University of Chicago Press, 1944), pp. 52-76, 111-29. Moreover, the Bent's custom of holding welcoming banquets may derive as much from Netherlandish tradition as from the academic practices described above (see the comments of Sandrart, *Teutsche Academie*, p. 27, quoted in n. 40 below).

Although the question is beyond the scope of this paper, further evidence suggests that the Bentvueghels attempted to merge social customs, artistic practices, and theoretical notions brought with them from the North with

however, that one major impetus for the Bent's behavior was the tradition of the literary academy, and that the Bentvueghels imagined themselves to be continuing along the path blazed by their intellectual confreres. What would better explain Sandrart's surprising testimony that his own Bent baptism featured "reasoned discourses, undertaken by French and Italians, as well as by Germans and Netherlanders, each in his own tongue?"[40] Even if such multilingual disquisitions did not actually occur, the mere mention in this context of an activity associated primarily with groups of intellectuals suggests that the author recognized the Bent's kinship to literary academies. The same perception probably also lies behind Jean Baptiste Descamps' identification of the Bent as "la Bande Académique" in his mid-eighteenth-century compendium of artists' biographies, *La Vie des peintres*. The author may well have been signaling the group's proximity to societies of *letterati* (rather than, as has been assumed, misinterpreting the Bent as a conventional artist's academy).[41]

What, then, is the significance of this insight for the history of art? Hoogewerff believed that the Bent had only two aims: to provide its members with sufficient opportunities to make merry, and to take measures for mutual support in times of need.[42] If the Bentvueghels were consciously imitating literary academies, however, it seems probable that the fellowship had, in addition, a more elevated purpose. Indeed, I would like to suggest that the group's most significant raison d'être was to advocate an artistic program, or theory of art.

those they discovered in Italy for purposes similar to those informing their art. I plan to address this issue in a future study.

40. The entire passage reads, "Allhier beflisse Er sich ungesäumt, mit allen denen, die in der Mahlereykunst und Bildhauerey fürtrefflich waren, eine recht vertrauliche Kundschaft zu machen, um dadurch zu seinem vorgesetzen Zweck desto bässer zu gelangen. Zu diesem seinem Fürhaben ware Ihm beförderlich die daselbst auf Niederländische Manier übliche Willkomms-Mahlzeit: worzu Er alle fürnehme Künstlere, (deren Anzahl sich damals auf 40 erstrecket) selbst in Person eingeladen, auch mit vernünftigen Discursen, sowohl die Französische und Italiänische, als die Teutsche und Niederländische, jeden in seiner eigenen Sprache unterhalten" (Sandrart, *Teutsche Academie*, p. 27).

41. Jean Baptiste Descamps, *La Vie des peintres flamands, allemands et hollandois.....*, 4 vols (Paris: C. A. Jombert, 1753-1764), 2:401-2, 3:401-2. Cf. Bodart, *Peintres*, p. 102.

42. Hoogewerff, *Bentvueghels*, p. 42. Also see Bodart, *Peintres*, pp. 100-101.

Such a program is already intimated in one of the earliest documents we possess concerning the activities of the group: a remarkable pen and wash drawing attributed to Pieter van Laer representing drunken Bentvueghels carousing in a tavern in Rome (fig. 5).[43] As I have argued elsewhere, this work may well allude ironically to the question of artistic inspiration: the crude sketches on the rear wall of the inn seem to refer to an old notion that inspired artists vented themselves by drawing on walls, whereas the manifest drunkenness of the figures recalls the doctrine that artistic creativity was stimulated by Bacchus. The sheet parodies certain representations of "real" academies of art, pictures that also show men seated around tables in candle-lit interiors framed by art on the walls. Those works – Agostino Veneziano's print depicting Bandinelli's so-called Academy of Rome (fig. 6) is a good example – express an idea fundamental to the conventional art academy, namely that painting and sculpture could be learned by following a set of standard procedures. The drawing evidently suggests that the Bent was promoting an opposing view, that true art was of divine or mystical origin and could therefore never be reduced to a series of confining rules. And since, according to venerable doctrines then current, divine truths could be probed best through indirect means, the society's guiding principle came to be the glorification of irony, paradox and wit.

In view of the current proposal, the notion that the Bent served as a counter-academy dedicated to fostering an inspirational theory of creativity takes on additional weight. We saw above that Bent members could justify their odd ritual by pointing to its source in an unassailable humanistic tradition. They might have justified their attitudes about the making of art on the same basis. Indeed, it could be argued that the program espoused by the society of Netherlanders

43. Berlin, Kupferstichkabinett, S.M.P.K., inv. no. 5239. See David A. Levine, "Pieter van Laer's *Artists' Tavern:* An Ironic Commentary on Art," in Henning Bock and Thomas W. Gaehtgens, eds., *Holländische Genremalerei im 17. Jahrhundert: Symposium Berlin 1984,* Jahrbuch Preussischer Kulturbesitz 4 (Berlin: Gebr. Mann Verlag, 1987), pp. 169-91. Suggestions made to me by Irving Lavin during a Princeton graduate seminar determined my basic approach to this drawing and led me to the specific points of interpretation outlined below.

was, paradoxically, more authentically academic than that of conventional academies of art. After all, the idea that irony, paradox, and wit stimulated creative activity was promoted in literary societies long before it was taken up by the Bent.[44] In carrying forth that notion, the Bentvueghels were thus once again imitating an academic model. No program sponsored by conventional artist's academies could boast more erudite origins. In fact, academic art-pedagogy, with its emphasis on repetitious copying, might well have struck members of the Bent as a low, mechanical process in contrast to their truly humanistic approach.

To what extent is such a counter-theory reflected in the art of the Bentvueghels? The work of Pieter van Laer provides at least a partial answer to this question. One of the Bent's most colorful and controversial members, *il Bamboccio* specialized in painting *bambocciate*, little works representing various ignoble subjects related to life in and around contemporary Rome. These pictures may appear at first glance to be nothing more than simple, realistic scenes. A closer look reveals, however, that they are actually highly contrived, syncretistic images that parody canonical works of art.[45] *Bambocciate* joke upon the classical tradition of painting and orthodox art theory. They also challenge conventional wisdom, drawing attention to hidden truths through the action of ironies and paradoxes inherent in their structure. When so construed, Van Laer's art seems remarkably consonant with Bentvueghel ideology. A re-examination of the work of other Bentvueghels is now needed to see how that art corresponds to the society's ironic program.

44. This notion evidently lay behind the academicians' espousal of light-hearted behavior. For some suggestive observations on this point, see Cochrane, *Tradition,* p. 27.
45. David A. Levine, "The Roman Limekilns of the Bamboccianti," *Art Bulletin* 70 (1988): 569-89, in addition to the studies cited in notes 8 and 43 above.

Fig. 1. M. Pool after Dominicus van Wijnen, Bentvueghel Induction Ceremony. Rijksprentenkabinet, Amsterdam. (Rijksmuseum-Stichting, Amsterdam)

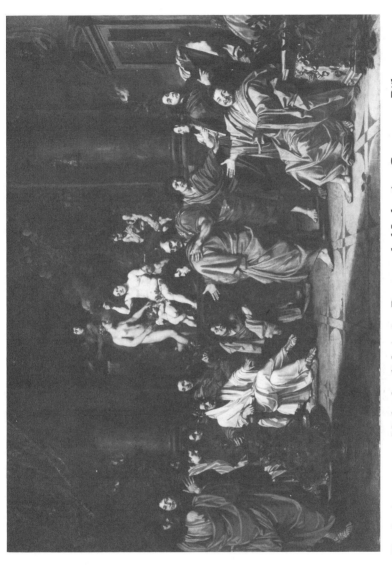

Fig. 2. Anonymous Netherlandish Artist, Bentvueghel Induction Ceremony. Rijksmuseum, Amsterdam. (Rijksmuseum-Stichting, Amsterdam)

Fig. 3. M. Pool after Dominicus van Wijnen, Bentvueghel Feast. Rijksprentenkabinet, Amsterdam. (Rijksmuseum-Stichting, Amsterdam)

Fig. 4. Porphyry sarcophagus of Constantia, Rome, Vatican Museums.
(Musei Vaticani Archivio Fotografico)

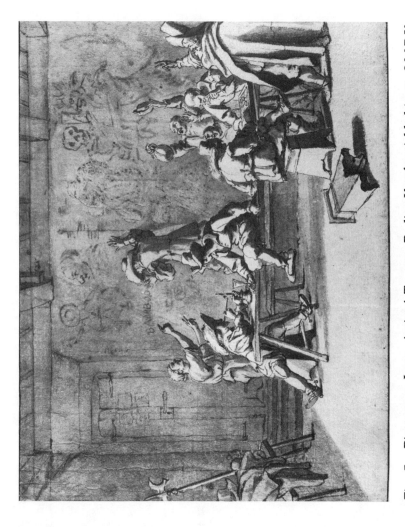

Fig. 5. Pieter van Laer, Artists' Tavern, Berlin, Kupferstichkabinett, S.M.P.K. (Museum)

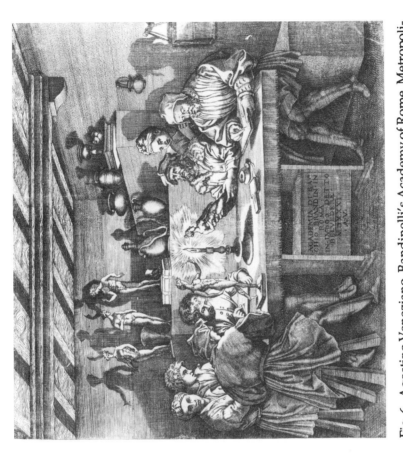

Fig. 6. Agostino Veneziano, Bandinelli's Academy of Rome. Metropolitan Museum of Art. (Purchase, The Elisha Whittelsey Collection, The Elisha Whittelsey Fund, 1949)

XI

The King, the Poet, and the Nation: A French Sixteenth-Century Relief And the Pléiade*

MICHAEL P. MEZZATESTA

An exquisitely carved, anonymous, and unpublished alabaster relief, presently on loan to the Duke University Museum of Art, is clearly sixteenth-century French in origin (fig.1).[1] Its relationship to the ideas of a group of poets at the court of Henri II known as the Pléiade is the subject of this paper. I hope to show that this relief presents a complicated and subtle set of allusions involving issues of politics and metaphysics in the world of French poetry in the 1550s. My aim is to trace the sources and meaning of these ideas as they are expressed in the various elements of the relief and to clarify their underlying relationship.

Before proceeding, a brief word is in order concerning the relief's authorship and style. That the artist is unknown is not surprising in light of the uncertainties that plague the study of French sixteenth-century sculpture. One need only consider the famous marble *Diana* of Anet in the Louvre, a statue attributed to every major French sculptor of the period,

* This essay originated as a project with Olga Raggio. I would like to thank her, as well as Marilyn Lavin, for her expert editorial suggestions and Michael Hall for making the relief available for an extended period of study.
1. The relief measures 14.5 x 19.25 inches and is part of the collection of Mr. Michael Hall, New York. It is in excellent condition with the exception of some minor losses on the staff of Mercury's caduceus and a modern break along an old crack.

to sense the problems associated with French Renaissance sculpture.[2]

Interestingly enough, it is the *Diana* of Anet, or more precisely its base, that provides an initial clue to the relief's stylistic origin. The group was originally part of a fountain of Diana, erected at the Chateau of Anet for Diane de Poitiers, and known in its original form through several drawings (fig. 2).[3] The large basin with scrolling ends, straight top, and sloping base flanked by dolphins is repeated in the relief, albeit in a stylized form with the ends of the basin considerably enlarged. Even more direct are the links with sculptures in the chateau itself. The pose of Mercury and the putto in the lower left appear to derive directly from one of two vault angels in the tribune of the chapel at Anet (figs. 1, 3).[4] There are, moreover, strong resemblances in terms of body type, physiognomy, and the use of swirling, decorative drapery. Although the sculptures of the chapel are undocumented, the consecration of the chapel in 1553 provides a terminus post quem.[5] A number of stylistic factors seem to indicate a date between 1553 and the 1560s.[6] As we will see, the iconology narrows the period to the late 1550s.

The program of the relief, like the composition, is focused on the central elements – Jupiter and the globe. Flanked by his eagle, Jupiter holds a scepter in his right hand and an open book in his left, the latter an extremely unusual attribute

2. For a review of the history of this work, see Naomi Miller, *French Renaissance Fountains* (New York: Garland Publishing, 1977), pp. 156-74.
3. The form and setting of the fountain of Diana are discussed by Miller, *Fountains*, pp. 158-61.
4. The figures on the vault are undocumented. Of the nine vault reliefs, seven have been attributed to Germain Pilon by Thomas Gaehtgens, while of those remaining, two pairs of standing putti that are perhaps the closest stylistically to the Anet angels, he leaves unattributed. See Thomas W. Gaehtgens, "Zum fruhen und reifen work de Germain Pilon" (Ph.D. diss., University of Bonn, 1967), pp. 64-66.
5. Maürice Roy, *Artistes et Monuments de la Renaissance en France*, 2 vols. (Paris: Société de l'histoire de l'art Français, 1929), 1:295.
6. Further stylistic aspects in the figure of Jupiter find a parallel in what may be Primataccio's sole surviving painting, the *Ulysses and Penelope*, at the Toledo Museum of Art, a work datable to around 1560. See Sylvie Béguin, Bertrand Jestaz, and Jacques Thirion, *L'École de Fontainebleau* (Paris: Musées nationaux, 1972), no. 141 and fig. 30; and W. McAllister Johnson, "Nicolo dell'Abbate's *Eros and Psyche*," *Bulletin of the Detroit Institute of Arts* 35, 2 (1966): 30.

for the king of gods. Three streams emerge from openings in his rustic "throne" and disappear behind the upper rim of the globe. They reappear as five jets of water at the top of the fountain's obelisk. While formally related to the Fountain of Diana at Anet, this fountain displays several unusual features. The base is composed of two dolphins that flank an architectural support decorated with a dolphin entwined around a trident. The upper basin, balanced on a ball-like support, is decorated with two dolphins and two masks that spew water at the bases of a palm and pine tree. The crowning element of the fountain is an obelisk, again carried by a ball, from whose apex shoot the five jets of water. A diverse array of flowers and trees, all distinctly characterized, surround the fountain. The entire scene is contained within the convex globe.

The composition is made up of six seemingly heterogeneous elements disposed on two superimposed tiers; there are three elements on each tier, with an overall central focus. There is almost no spatial recession, and the elements read on the surface as non-narrative and emblematic, to be understood separately but seen as interrelated and signifying a larger whole. Explication of these elements must be considered in relation to French sixteenth century allegorical traditions – decorations devised for triumphal entries, prints, medals, and the poetry of the Pléiade. Only in this context is their meaning clarified along with the part each plays in the highly articulated program.

Jupiter's placement above a globe and fountain had an immediate antecedent in the monumental decorations devised for the Fontaine de Ponceau on the occasion of Henri II's triumphal entry into Paris in 1549.[7] Located at the fountain's summit was a statue of Jupiter holding a thunderbolt and scepter, standing on a globe, and surrounded by three allegorical figures representing the Fortunes of the king, the nobility, and the people (fig. 5).[8] Jupiter, of course, was to be

7. An illustrated account of the entry was published the same year; see *C'est l'ordre qui a esté tenu à la nouvelle et joyeuse entrée, que très hault, très excellent, et très puissant prince, le Roy très chréstien Henri deuzième...à faicte en sa bonne ville et cité de Paris...le sesième jour de juin* (Paris: I. Roffet, 1549).
8. The Fortune of the king was gold, that of the nobility, silver, and that of the people, lead: *C'est l'ordre*, fols. 4v-5r.

understood as Henri II, a mythological association developed widely during his reign. The program thus celebrated Henri II's predominance over the terrestrial sphere – for he is set above the globe – and, as an accompanying inscription recorded, his supremacy over cosmic forces, symbolized by his scepter.[9] Similarly, Jupiter's scepter and his placement above the globe in the relief may also signal his dual dominion. But this globe is not decorated with ships, as is the sphere on the Fontaine de Ponceau, but with a fountain, trees, and flowers. Moreover, the water flowing from the "throne" to the fountain below connects Jupiter even closer to the pastoral world beneath him. The allegorical content here differs from its prototype.

We begin with the water flowing from the throne. Water, in the form of springs and fountains, has long been a poetic device signalling inspiration. The poets of the Pléiade adopted and developed this ancient topos, perhaps none more fully than Pierre Ronsard. In his first *Eclogues*, Ronsard distinguished two types of fountains, the rustic spring flowing from a rocky source and the architectural fountain.[10]

Whether a stream flowing from real rocks, as in *Les Eclogues*, a formal architectural fountain as in the "Fontaine d'Helene" or the meandering brook of the "Fontaine Bellerie," the concept of poetic inspiration is the unifying theme.[11] The image of the architectural fountain employed in this context appeared on the frontispiece of the 1545 Paris edition of the *Iliad* (fig. 6). Here Homer stands at the top of the fountain of poetry, while below poets gather to drink

9. *C'est l'ordre*, fols. 4v-5r. This dual dominion of the French kings is expressed on the reverse of a medal of François I dated 1515 that shows two globes, one celestial and one terrestrial, beneath a crown with the motto: VNVS NON SVFFICIT ORBIS (A single world does not suffice). For this medal, see Mark Jones, ed., *A Catalogue of the French Medals in the British Museum, 1402-1610*, 1 vol. to date (London: British Museum, 1982), 1:220, no. 217. The same reverse and legend were employed on a jeton of François II dated 1547, for which see Victor E. Graham and W. McAllister Johnson, *Estienne Jodelle, Le Recueil des inscriptions 1558: A Literary and Iconographical Exegesis* (Toronto: University of Toronto Press, 1972), fig. 32.
10. Eclogue I, 1.7-12. For the collected work of Ronsard, see *Les Oeuvres de Pierre de Ronsard, Texte de 1587*, intro. and notes by Isidore Silver, 8 vols. (Chicago: University of Chicago Press, 1966). For Eclogue I, see 5:13-51.
11. *Les Oeuvres de Pierre de Ronsard*, "Fontaine d'Helene," 2:304-9; "Fontaine Bellerie," 3.2.9, 139-40; 3.3.7, 206.

from the basin or to catch the water flowing to the ground in three streams.[12]

Water inevitably evoked the Boetian springs on Mount Helicon, Pindus, or Parnassus, conveying the notion of inspiration as a divine gift.[13] In this case, the location of the watery source in the rustic throne of Jupiter marks the god as the origin of inspiration. This is not surprising when we recall that the poets of the Pléiade hailed Jupiter as Father of the Muses and the ultimate source of all spiritual energy.[14]

The placement of the fountain in a lush landscape provides another poetic parallel. A fountain located at the center of a garden was generally understood as the symbolic heart of a terrestrial paradise.[15] The setting in the relief, however, is less a formal garden than the idyllic landscape, the place where poetic inspiration occurs. In imitation of Theocritus and Virgil, the poets of the Pléiade adopted the beautiful, natural, shaded site as the locus of inspiration. Works, such as Ronsard's "Fontaine Bellerie," combine the evocation of nature with the antique arcadian sentiment toward the creation of a perfect landscape of "perpetual spring."

This poetic topos helps to explain the lush vegetation surrounding the fountain. It is a combination of the *locus amoenus* – the shaded, natural site composed of several trees, a meadow, spring and flowers – and the ideal or "mixed

12. *Les Dix Premiers Livres de l'Iliade d'Homer, Prince des Poètes: Traduictz en vers François par M. Hugoes Salel,* (Paris: I. Loys, 1545). Water flowing from real rocks as a source of inspiration was seen in an engraving showing "The Good Architect" in Philibert de L'Orme, *Le premier tome de l'architecture* (Paris: Frederic Morel, 1567), p. 238. The image is reproduced in Elizabeth B. MacDougall and Naomi Miller, *Fons Sapientiae – Garden Fountains in Illustrated Books: Sixteenth-Eighteenth Centuries* (Washington, DC: Dumbarton Oaks, 1977), p. 51.
13. Clements has pointed out that these springs were repeatedly invoked by the members of the Pléiade as sources of poetic inspiration. See Robert J. Clements, *Critical Theory and Practice of the Pléiade* (Cambridge, MA: Harvard University Press, 1949), p. 217.
14. See T. C. Cave, "Ronsard's Mythological Universe," in T. C. Cave, ed., *Ronsard the Poet* (London: Methuen, 1973), pp. 187-88.
15. Miller, *French Renaissance Fountains,* p. 287. See also the fountain found at the center of a garden in the frontispiece of Jean Ruel's 1536 *De Natura Stirpium,* a compilation of Greek and Latin writers on botany. Here the fountain may be seen as a symbol of the fecundity and diversity of nature. See Miller, *French Renaissance Fountains,* p. 287, fig. 184.

231

forest," a grove with many kinds of trees.[16] Thus this sylvan glade is an ideal world, one where peace and poetry reign. The message is reinforced by the globe itself, for the circle or sphere was an expression of the Platonic notion of perfection and, by extension, of the world it contains.[17]

In this context, the significance of Jupiter's book is clear: it may be understood as an attribute of poetry.[18] His role as Father of the Muses and his close association with the very source of poetic inspiration indicate the literary facet of his character. Henri's dominion, however, goes beyond an abstract world of poetry, for, in its largest sense, the globe at his feet may be understood as an emblem of his temporal supremacy. Henri II, at the chateaux of Ecouen and Anet, the Louvre, and in the triumphal entries of Rouen and Paris, utilized the sphere as an emblem expressing his global ambitions.[19] In the late 1540s and early 1550s, the king waged an active campaign to be named Charles V's successor as Holy Roman Emperor. Thus the globe becomes an attribute of Henry's dream of a universal monarchy under French control.[20]

Besides his central placement over the globe, the king's supremacy is also expressed in the form of the fountain within the sphere (fig. 7). The most salient feature there is the obelisk, a very unusual element for the centerpiece of a

16. Ernst Curtius, *European Literature and the Latin Middle Ages* (New York: Pantheon, 1967), pp. 194-210.
17. D. E. Wilson, *Ronsard, Poet of Nature* (Manchester: Manchester University Press, 1961), pp. 77-85.
18. The book was a familiar attribute of poetry. It appears later in Ripa's description of poetry, "La sinistra tenga un libro." See Guy de Tervarent, *Attributs et symboles dans l'art profane 1450-1600* (Geneva: Droz, 1958), p. 149. More broadly, the book symbolized "letters" in the popular Renaissance debate concerning arms vs. letters, a concept applied to the French monarchs in the *ex utroque Caesar* emblem; see Graham and McAllister Johnson in *Jodelle-Le Recueil*, pp. 29-31.
19. See Volkner Hoffmann, "*Donec Totum Impleat Orbem*, Symbolisme Imperial au Temps de Henri II," *Bulletin de la Société de l'Histoire de l'Art Français* (1978): 29-42.
20. In relation to the Louvre, see Volkner Hoffmann, "Le Louvre de Henri II: un palais imperial," *Bulletin de la Société de l'Histoire de l'Art Français* (1982): 7-15.

fountain at this time.[21] As components of royal entries, however, obelisks were quite popular.[22] One was erected in Lyons for Henri's 1548 entry and a second for his Paris entry the following year. The Paris obelisk was especially impressive, for it stood over seventy feet high, was carried on the back of a rhinoceros, and was topped by a figure of France as Bellona standing on a golden globe (fig. 8).[23] The superimposition of elements forecast the arrangement on the relief; and although the obelisk is not topped by a globe, it is carried by one. It is not surmounted by an allegorical figure of France, but by five jets of water. On the other hand, these streams may embody the same concept symbolizing France through its five rivers. Moreover, the idea may find its source in Goujon's five nymphs on the *Fontaine des Innocents* (1547-49).[24]

The *Fontaine des Innocents* provides another parallel for an extremely significant motif on our relief. One of the attic reliefs and all three keystones are decorated with a dolphin wrapped around a trident: those on the keystones are flanked in the spandrals with victories presenting laurel crowns (fig. 9). This device is certainly an emblem of Henri II, stressing – appropriately enough for the setting – his maritime dominion.[25] The appearance of this emblem on the fountain in the

21. The only sixteenth-century French example of an obelisk fountain known to the writer is Du Cerceau's design in the Morgan Library volume dated c.1572. See Miller, *French Renaissance Fountains*, p. 308, fig. 139.
22. See the classic study of William S. Heckscher, "Bernini's Elephant and Obelisk," *Art Bulletin* 29 (1947): 155-82, who (p. 177) quotes Ripa's suggestion that obelisks should be erected in honor of the "chiara e alta gloria de i Prencipi...."
23. The face of the obelisk was decorated with hieroglyphs expressing the wish of Parisians that Force and Vigilance should guard the realm and celebrating the king as victor over his enemies. A French inscription dedicated the "sacred obelisk" to his royal majesty, Josèphe Chartrou, *Les entrées solennelles et triumphales à la Renaissance, 1484-1551* (Paris: Les Presses Universitaires de France, 1928), pp. 112-15.
24. The Somme, the Seine, the Loire, the Garonne, and the Rhone. See Naomi Miller, "French Renaissance Fountains," (Ph.D. diss., Institute of Fine Arts, New York University, 1966), p. 231, in which she suggests that the five nymphs on the *Fontaine des Innocents* may be seen as the five rivers of France. However, in her published edition of the dissertation she abandoned this suggestion, proposing a wide range of possibilities without accepting any. See Miller, *French Renaissance Fountains*, pp. 127-29.
25. It seems clear that the project was executed after the accession of Henri and thus the appearance of the dolphin would not allude to his earlier status

relief, in conjunction with the obelisk and five jets of water, equates it with the king and, through the king, the nation. The embodiment of Henri II and of France thus stands at the center of the globe as a source of inspiration and sustenance to the entire world.

This idea is extended in the image of the temple, set on the same rocky escarpment as the throne, at the upper right of the composition (fig. 10). The temple appeared in French art in a number of roles. Ronsard embraced it as a symbol of virtuous effort in his "Hymne de la Philosophie" where the goddess of virtue inhabits a temple at the summit of a mountainous escarpment rewarding those men courageous enough to attempt to reach her.[26]

Ronsard and other members of the Pléiade never offered a precise description of the temple but contemporary festival decorations do provide counterpoints. For Henri's 1548 Lyons entry, the arch of honor and virtue was crowned by a circular temple of honor and virtue dedicated to the king. Similarly, Charles IX's Lyons entry of 1564 contained, "un temple des Vertus, fondé sur un roc, et sostenu de dix pilasters, basti en forme ronde et sphérique."[27]

The circle, by tradition considered the most perfect of forms, was the only fitting shape for an edifice dedicated to virtue. The poets of the Pléiade placed tremendous importance on virtue and, more directly, equated virtue with poetry itself.[28] To Ronsard, "poetry was virtue by its origins and its mission, by its tradition and by its role. The Pléiade who taught this concept, renewed this lost tradition."[29] In this

as dauphin. The maritime nature of Henri's iconography has yet to be fully explored. Its importance is revealed in Niccolo della Casa's 1547 portrait print of the king, in which his martial prowess in stressed by the aquatic mythological figures battling on his armor. See *The School of Fontainebleau. An Exhibition of Paintings, Drawings, Engravings, Etchings and Sculpture 1530-1619*, exh. cat., Fort Worth Art Center, 15 September - 24 October, 1965 (Austin, TX: University of Texas, 1965), p. 51 n. 48, illus.

26. "Hymne de la Philosophie," vv. 191-210, for which see Albert Py, *Ronsard Hymnes* (Geneva: Droz, 1978), pp. 163-72. The topos has its origins in Greco-Latin poetry. See Henri Franchet, *Le poète et son oeuvre d'après Ronsard* (Geneva: Slatkine Reprints, 1969), pp. 103-8.

27. Both are discussed by Franchet, *Le poète*, p. 108. See also Roy Strong, *Splendour at Court* (Boston and London: Houghton Mifflin, 1973), p. 64, fig. 55 for an illustration of the Lyons arch.

28. See Franchet, *Le poète*, especially chapter 2, "La Vertu," pp. 43-113.

29. Franchet, *Le poète*, p. 69.

light we may interpret the temple perched on its rocky promontory as representing the Temple of Virtue and, by extension, the Temple of Poetry. As we will see below, its relationship to the cityscape in the background supports this interpretation.

The program continues at the upper left where a figure of Mercury is shown in flight, facing Jupiter, who meets his gaze and points toward him with the index finger of his right hand. Here Mercury is not only the traditional messenger but also represents the god of eloquence and the arts.[30] Indeed, he was viewed in this way by Ronsard in a poem of 1550, "A Mercure," where the god is addressed in language normally reserved for Apollo and the Muses.[31] So he is represented here, harmoniously supporting Jupiter, working in the interest of poetry.

Recalling now that the figure of Jupiter/Henri II is identified as the ruler of cosmic forces by his scepter and placement above the globe,[32] we enter into another level of interpretation. At least three of the surrounding elements have astrological meaning. Mercury himself is, of course, the astrological constellation. The embracing nudes below him represent the heavenly twins, the Gemini, a zodiacal attribute of the god and one of the constellations in Mercury's two houses. Similarly, the centaur represents Sagittarius, a constellation in the house of Jupiter and astral attribute of the god.[33]

These astrological signs suggest the influence of the stars on the world of poetry. Ronsard dealt with the theme in two early poems, the "Hymne des Astres," and the "Hymne des

30. Isadore Silver, *Ronsard and the Hellenic Renaissance in France* (Chicago: University of Chicago Press, 1961), pp. 264-66.
31. "A Mercure," ll. 1-6, 37-48. In Ronsard's poem "La Lyre" (1569) Mercury is closely associated with the arts of poetry and music; and in his *Discours ou Dialogue entre les Muses deslogées et Ronsard*, it is Mercury who leads the offended Muses from France where, under the reign of Henri III, their worship had fallen on evil days. See Silver, *Hellenic Renaissance*, p. 267.
32. See above n. 7. It is interesting to note that the head of the scepter is a pomegranate, alluding perhaps to the unity and prosperity of the people of the realm under the leadership of the king as well as to the notion of the oneness of the universe. See Tervarent, *Attributs et Symboles*, pp. 204-5; and J. E. Cirlot, *A Dictionary of Symbols*, (New York: Philosophical Library, 1983), p. 261.
33. Tervarent, *Attributs et Symboles*, pp. 198, 331, (Chiron).

Estoiles," in which the crucial role of the stars in the
formation of the poet was expressed.[34] The poets of the
Pléiade complained to or thanked the stars and considered
them responsible for fortune, good or ill, and above all for
inspiration.[35] It is against this background that Gemini and
Sagittarius relate to the program. The former is the
constellation under which a poet is most likely to be born
since it is the constellation in the house of Mercury, patron of
poetry. Sagittarius' presence as an attribute of Jupiter is also
necessary, for it is only with the proper patronage, protection,
inspiration, and beneficent rule that a poet can flourish. Thus
the zodiacal signs express cosmologically the salubrious
influence of their respective deities and assert the astral role
in the inspiration and formation of the poet, a role orches-
trated by Jupiter.

The emphasis placed on Jupiter and his relationship to
poetry finds a connection with the "politics of poetry" in
France during the 1550s. Henri II's accession in 1547 wit-
nessed a struggle in intellectual circles for the leadership of
French poetry, one openly joined with the appearance of two
books that mark a watershed in the history of French liter-
ature: Joachim du Bellay's *Deffence et Illustration de la Langues
Françoyse* (1549) and Ronsard's *Quatre Premiers Livres des Odes*
(1550). These works severely criticized the older verse tradi-
tions while presenting the program of a new generation for
the renewal of French poetry. They rejected the immediate
past in favor of the poets of ancient Rome and Greece.[36]

The Pléiade was not solely concerned with the aesthetic
ideals of poetry. Its members asserted a purpose far nobler
than mere delectation. To write poetry was to enrich the

34. The "Hymne des Astres," dedicated to Mellin de Saint-Gelays, whose
1546 *Advertissement sur les judgements d'astrologie* advanced a strong argument
for the role of astrology, is Ronsard's most important statement on the
relationship of astrology and poetic theory. See Clements, *Critical Theory*, p.
222. For the complete text, see Py, *Hymnes*, pp. 215-24.
35. Clements, *Critical Theory*, p. 222.
36. K. R. W. Jones, *Pierre de Ronsard* (New York: Twayne, 1970), pp. 17-21. For
the development of French humanism, see Werner Gundersheimer, *French
Humanism 1470-1600* (London: Macmillan, 1969). François I was generally
referred to as "*père des arts et lettres;*" see Graham and McAllister Johnson,
Jodelle-Le Recueil, p. 144. His death, and the accession of his less learned son,
provided the opportunity to influence the development of French poetry and
lay claim to the spoils of royal patronage.

cultural heritage of the nation, bringing honor to France by the creation of a respected school of national poetry, one able to rival any other past or present.[37] Poetry was patriotic: it celebrated the virtues of the king, immortalized the heroic deeds of France's greatest men, and assured the glory of the nation. Without the poet, the country would be doomed to oblivion.[38]

Ronsard developed these ideas in his poems of the 1550s, defining the role of poetry, the poet's function, and the nature of poetic inspiration. His is a complex system, rich in allusions and diverse in its poetic and mythological sources. The poetic universe of Ronsard and the Pléiade is far from being a comprehensive cosmography, but its underlying unity is apparent; and it is within this universe that the relief seems to be located.

If Ronsard's system could be reduced to its bare essentials one might present an ever-expanding sequence of relationships beginning with the king and poet and proceeding to the nation, the world, and finally the universe. As noted above, the poet's role was fundamental in his ability to celebrate the great and to reveal higher truths. Yet the poet was not an independent entity – he required sustenance and, above all, inspiration. A dominant concern of the Pléiade was an analysis of the conditions necessary for the poet's creation, especially the role of art versus nature. Although the relative importance of learning and study, as opposed to the innate poetic gift, was never completely resolved, Ronsard believed firmly in the decisiveness of divine inspiration.[39]

That position, I believe, is expressed in the relief. The waters flowing from the rocks evoke, as we have seen, the Boetian springs of poetic inspiration. Here, however, the water is linked directly to its ultimate source – Jupiter, Father of the Muses, the force binding all things together.[40] Similarly, it is the favorable conjunction of the constellations Gemini and Sagittarius, propitiously arranged by Jupiter, that

37. Francis M. Higman, "Ronsard's Political and Polemical Poetry," in *Ronsard The Poet*, ed. Terence Cave (London: Methuen, 1973), p. 243.
38. Ibid.
39. Clements, *Critical Theory*, p. 221.
40. On the concept of the "chain of Jupiter," the unifying force of Ronsard's poetic universe, see Cave, "Ronsard's Mythological Universe," p. 194.

likewise assures the optimum conditions for the formation of the poet.

But the poet did not live by inspiration alone. He required patronage, particularly the king's, in order to accomplish his greatest tasks. Royal support would assure the benefits of the muses for the nation, a notion repeatedly advanced in Ronsard's poems of the early 1550s.[41] In fact, the Pléiade hoped for the establishment of a new golden age under Henri II, one in which the arts would flourish as the nation enjoyed peace and security under the king's benevolent rule.[42] This concept is embodied in the fountain, symbol of the king as France and umbilicus of an idyllic world. Here poetry, inspired by the monarch and flourishing under his patronage and peaceful rule, glorifies the king and nation, assuring their fame and immortality, just as the waters flowing from the mascerons nourish the palm and pine trees – themselves symbols of fame and immortality.[43]

However, poetry was not merely an instrument of royal panegyric. Ronsard's *Hymnes* of 1555 – fifteen long poems on serious subjects – demonstrated that poetry was a philosophical activity through which the secrets of the universe might be revealed.[44] This idea may be expressed in the cityscape at the upper right (fig. 10). The city is approached via the Temple of Poetry. After "passing through," one mounts a

41. For a discussion of this point, see Higman, "Political and Polemical," pp. 241-85. Ronsard continually sought Henry's support for his epic poem *La Françiade* and was greatly disappointed by the king's failure to provide the necessary funds. See Charles Dedegan, "Henri II, La Françiade et Les Hymnes de 1555-1556," *Bibliothèque d'Humanisme et de Renaissance* 9 (1947): 114-28; and Henri Chamard, *Histoire de la Pléiade*, 4 vols. (Paris: H. Didier, 1961), 3:97-103.
42. Cave, "Ronsard's Mythological Universe," pp. 187-90, 204. The notion of a new golden age is basic to French political panegyrics. See Elizabeth Armstrong, *Ronsard and the Age of Gold* (London: Cambridge University Press, 1968), pp. 7-9; and the articles by V. L. Saulnier, "L'Entrée de Henri II à Paris et la Révolution Poétique de 1550;" and Frances A. Yates, "Poètes et artistes dans les Entrées de Charles IX et de sa Reine à Paris en 1571," both in Jean Jacquot, ed., *Les Fêtes de la Renaissance*, 3 vols. (Paris: Éditions du Centre National de la Recherche Scientifique, 1956), 1:31-59, 61-84.
43. Palm and pine trees are symbols of fame and immortality respectively. See Tervarent, *Attributs et Symboles*, p. 296; J. C. Cooper, *An Illustrated Encyclopedia of Traditional Symbols* (London: Thames and Hudson, 1978), pp. 125, 131; and Edouard Urech, *Dictionnaire des Symboles Chrétiens* (Neuchatol: Delachaux & Niestlé, 1972), pp. 138, 151.
44. T. Cave, "Ronsard's Mythological Universe," pp. 194-97.

flight of stairs to a rusticated, pyramidal "gatehouse" providing access to the inner precincts. Temple and gatehouse are topped by globes,[45] emblems of Henri II, lord of the temple and the city. Within are ruins reminiscent of ancient buildings, the crenelated walls of a medieval edifice, two obelisks, and at the top of a wooded hill, two steepled churches – one at the upper left, the other at the upper right. These elements would appear to be more than the decorative cityscape found in the backgrounds of many prints, paintings, and reliefs of the period. It is tempting to assume that the temple and cityscape refer to the centrality of poetry and role of the city in the Pléiade's poetic universe.[46]

Ronsard believed poetry to be a key with which the secrets of the world might be unlocked, a fact perhaps alluded to in the relief as one must "pass through" the temple in order to reach the city. Poetry, and its glorification of the hero, sought to spur men to rival the virtues and deeds of the ancients and, in so doing, to construct a life of harmony and unity consistent with the ideals of the ancient city.[47] For Ronsard, the city was less a locale or mode of political organization than a metaphor for the individual's being and relationship to king and God.[48] The city, not surprisingly, belonged to the king, himself a figure endowed with an almost magical power and a source of life for all the people.[49] The seminal role of the king and the import of the ancient world is conveyed through the pair of obelisks – symbols of princely glory – and the ruins both ancient and medieval, above, and on, which a new society is formed.

Two contemporary, steepled structures, located at the uppermost left and right of the hill in figure 10, allude to religion's essential role in the city. The king might be a symbol of order to the diverse elements of his state; but the city also required an internal cohesion, one provided by religion. Unlike St. Augustine's heavenly and earthly spheres,

45. On the globe as an emblem of Henri II, see above pp. 228-29.
46. The concept of the city in Ronsard's poetry is discussed at length in a masterful analysis by Daniel Ménager, *Ronsard Le Roi, le Poète et les Hommes* (Geneva: Droz, 1979), pp. 131-45. The following analysis is indebted to his work.
47. Ibid., p. 3.
48. Ibid., pp. 135-36.
49. Ibid., pp. 146-61.

reflecting the influence of church and state on the political and spiritual lives of individuals, there was for Ronsard but one force on earth: the king. He was, on earth, consubstantial to God in heaven.[50]

In sum, the cityscape may reflect Ronsard's social and political ideal of the city inspired by the ancient world, ruled by the divine king, and united by religion toward a goal of social and spiritual harmony. It is nothing less than the ideal of a new golden age, a political and religious dream expressing the deepest desires for a world of order and unity, one in which the gods favored the poet, who in turn celebrated and perpetuated the peace and prosperity of France's new golden age under Henri II.[51]

There is no documentary evidence that helps to establish either the patron or original location of the relief. If the date and interpretation advanced here are correct, however, one should consider the possible role of Charles de Guise, Cardinal de Lorraine (1524-1574), a man of extraordinary wealth, culture, and influence. As a trusted adviser to Henri II, he and his brother François de Guise (1519-1562) – hero of the battles of Calais and Metz – exerted tremendous power at court. A man of learning, Charles was also an active patron of the arts and letters. This combination of influence, wealth and erudition made the cardinal a natural favorite of the poets; and he was instrumental in obtaining many of them pensions. Among his admirers were Rabelais and Ronsard; and it is not unusual that more than anyone else, the poets of the Pléiade sought his protection.[52] Du Bellay dedicated several odes to his virtue, as did Jodelle;[53] but above all, it was Ronsard who praised the cardinal, likening him to

50. Ibid., p. 158. This idea may be restated by the presence of a statue placed at the pinnacle of the entrance to the church at the upper right. This nude male figure, seen in profile, stands with its left arm behind its back in a gesture reminiscent of the Farnese Hercules. The allusion may be to the king as Hercules. The kings of France were said to be descended from the ancient hero. On this theme, as well as the tradition of the Gallic Hercules, see Graham and McAllister Johnson, *Jodelle-Le Recueil*, pp. 150-51.
51. The notion of an *aurea aetas* was developed from the Lyons entry of 1548. See Graham and McAllister Johnson, *Jodelle-Le Recueil*, p. 29.
52. Chamard, *Histoire de la Pléiade*, 2:279.
53. Ibid., nn. 2, 3.

Mercury in his "Hymne de Henri II" of 1555 and in the 1559 hymn dedicated to the cardinal.[54]

This assimilation of Charles to Mercury was in keeping with Ronsard's mythological universe.[55] The association, however, was not unprecedented. Charles' father, Claude de Lorraine, had the insignias of Mercury and Mars placed on exterior walls of his Chateau du Grand Jardin when built in 1546 to indicate the high destinies awaiting his sons Charles and François.[56] At the Chateau de Tanlay, residence of the Coligny-Chatillon family, the cardinal is shown as Mercury, along with the king as Jupiter and other members of the court in the guise of gods and goddesses, in a fresco by a follower of Primaticcio. The program is said to have been provided by Ronsard.[57]

The possibility thus arises that Mercury in the relief may refer to the Cardinal de Lorraine. His role as patron of the arts and his wide erudition qualified him for the title, as did his personal relationship to the poets of the Pléiade. If the identification is correct, the relief may have been commissioned by the cardinal for one of his residences. This suggestion can only be advanced tentatively, but it is important to recall that between 1553 and 1560 Charles constructed an immense chateau outside of Paris at Meudon called La Grotte.[58] Set high on a hill above the Seine, La Grotte de Meudon was a series of arcaded terraces dominated at the highest level by a central building with a monumental staircase. Two lower buildings flanked it on either side. The galleries were lavishly decorated, as Vasari reported, with illusionistic wall painting, enamels, coral, majolica, and stucco work. Primaticcio, Domenico del Barbiere, Jean Le Reux, Maitre Ponce, and Niccolo Del l'Abbate are recorded as

54. For a list of the works Ronsard dedicated to Charles, see Claude Binet, *La vie de Pierre Ronsard* (Geneva: Droz, 1969), p. 145.
55. The key figures of Henri's court were all equated, at one time or other, with the Olympian deities. Charles' brother enjoyed a similar apotheosis as Mars. See Chamard, *Histoire de la Pléiade*, pp. 277-78.
56. Guy Demerson, *La Mythologie classique dans l'oeuvre lyrique de la Pléiade* (Geneva: Droz, 1972), p. 553 n. 72.
57. J. Seznec, *The Survival of the Pagan Gods* (Princeton, NJ: Princeton University Press, 1972), pp. 33-35.
58. Paul Biver, *Histoire du Chateau de Meudon* (Paris: Presses Universitaires de France, 1923).

working there.[59] Vasari's praise for the decoration "infinite e varie" was echoed by Ronsard in a poem of 1559 that celebrated the chateau on the occasion of the marriage of Henri II's daughter to Charles, Duc de Lorraine.[60]

Ronsard's pastoral chant celebrated Meudon and its grotto as the home of the muses. In fact, the grottos at Meudon were conceived as sanctuaries or dwelling of various mythological figures. The inscription over the portal of La Grotte de Meudon consecrated them AUX MUSES DE HENRI II.[61] It is tempting to assume that this relief – dedicated to Henri II as Father of the Muses and inspirer of poetry – formed part of that elaborate iconographical decorative scheme. Considering the poetic content of the relief and Ronsard's relationship to the Cardinal de Lorraine, it is possible that Ronsard or another member of the Pléiade supplied the program.[62] If so, this relief would be a surviving fragment from Meudon and one of the earliest examples of a poet of the Pléiade providing a program for an artistic project.

59. The chateau at Meudon is discussed in some detail by Miller, *French Renaissance Fountains*, pp. 251-54.
60. Ibid., p. 252.
61. Ibid., p. 253.
62. The relationship of the poets of the Pléiade to the visual arts has generated considerable debate. The traditional view that Ronsard's artistic interest was minimal may have to be reconsidered in light of recent research. See, for example, Gunter Irmscher, "Pierre de Ronsards 'Sinope:' Ein goldtauschierte Eisenkassette im Kunstgewerbemuseum der Stadt Koln," *Wallraf-Richartz Jahrbuch* 41 (1979-80): 143-57.

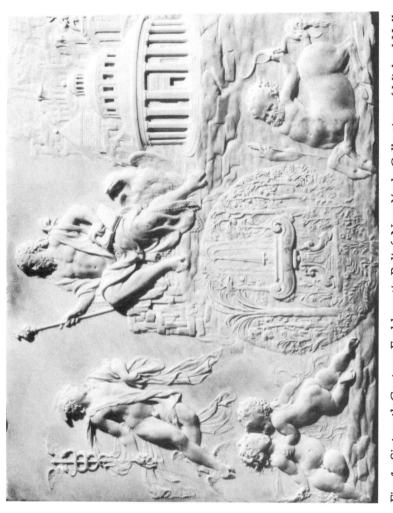

Fig. 1. Sixteenth Century Emblematic Relief. New York, Collection of Michael Hall. (Author)

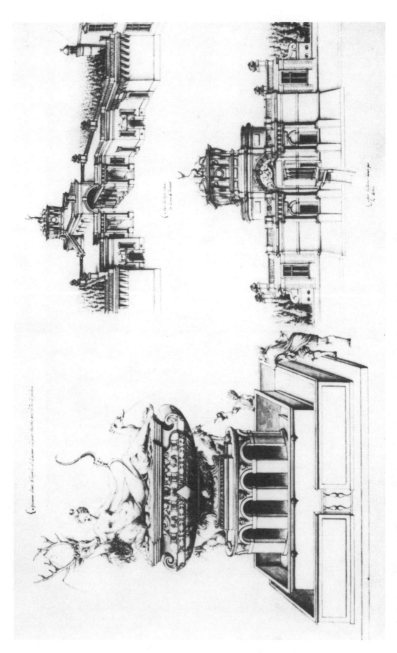

Fig. 2. DuCerceau, Drawing of the Fountain of Diana at the Chateau at Anet (detail). (The British Museum)

Fig. 3. Anonymous, Angel from the tribune vault of the Anet Chapel, Anet.
(Bulloz)

Fig. 4. Detail of Figure 1.

Fig. 5. Engraving of the Fontaine de Ponceau erected for Henri II's triumphal entry into Paris, 1549. (Author)

Fig. 6. Frontispiece to 1545 Paris edition of the *Iliad*. (Author)

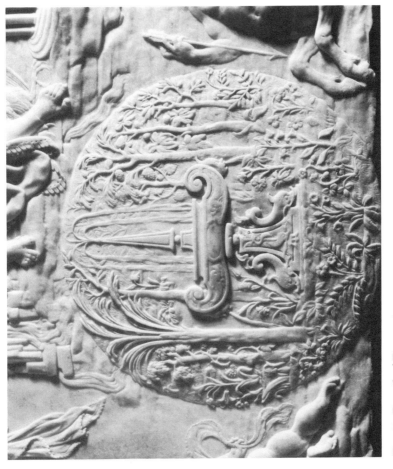

Fig. 7. Detail of Figure 1.

Fig. 8. Engraving of Rhinoceros obelisk erected for Henri II's 1548 Lyons entry. (Author)

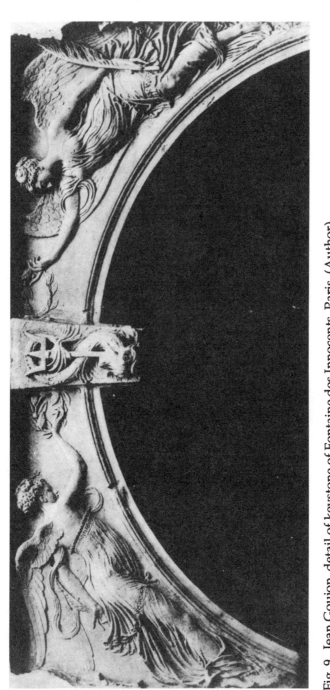

Fig. 9. Jean Goujon, detail of keystone of Fontaine des Innocents, Paris. (Author)

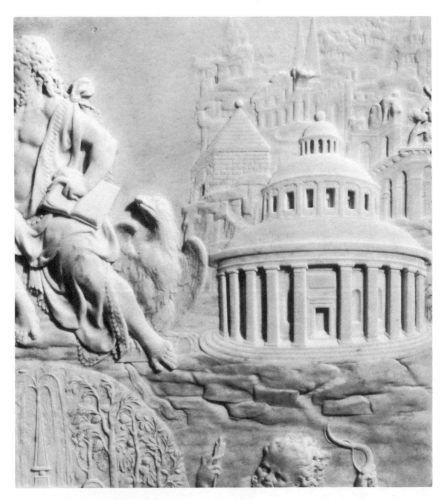

Fig. 10. Detail of Figure 1.

XII

Marble Revetment in Late Sixteenth-Century Roman Chapels

STEVEN F. OSTROW

In his *Bernini and the Unity of the Visual Arts*, Irving Lavin analyzed the rich polychrome encrustation in the apse of S. Maria in Via Lata, a project undertaken by Bernini in 1636 and finished by 1643. Lavin underscored the innovative way in which Bernini employed colored marbles – that is, reinforcing the structural organization and clarifying the architectural system – by contrasting it to Francesco da Volterra's Caetani Chapel in S. Pudenziana (1590-1603). There the polychrome revetment is applied as if to undermine the structural integrity of the architecture in terms of support and implied weight. Lavin further pointed out that the type of marble decoration in the Caetani Chapel flourished in the latter part of the sixteenth century in Rome; and he remarked, more generally, that the subject of polychrome marble chapels "is greatly in need of a special study."[1]

That brief but suggestive remark has served, in part, as the impetus for this paper. I am concerned with the phenomenon of colored-marble chapels of the late sixteenth century in Rome – chapels in which polychrome marble revetment covers the walls from pavement to cornice.[2] Specifically, I am

1. Irving Lavin, *Bernini and the Unity of the Visual Arts*, 2 vols. (New York and London: Oxford University Press, 1980), 1:50-53, and 2: plates 2 and 3, for color illustrations of the Caetani Chapel and apse of S. Maria in Via Lata.
2. This paper derives, in part, from a portion of my "The Sistine Chapel at S. Maria Maggiore: Sixtus V and the Art of the Counter Reformation" (Ph.D. diss., Princeton University, 1987). Since I plan to publish this material in greater detail, and with specific discussion of the design character of late

interested in the associative meaning of this form of decoration and in exploring its iconographic and historical implications. I shall propose that marble revetment was not employed at this time merely for decorative effects. Rather, I shall argue that the colored-marble chapel was conceived and meant to be read on two levels: as an evocation of early Christian architecture and as an image of the celestial paradise. I take as my focus one of the most important examples of its kind – the Sistine Chapel in S. Maria Maggiore, erected between 1585 and 1590 by Domenico Fontana as a reliquary and mortuary chapel for Pope Sixtus V (figs. 1, 2).

In the Sistine Chapel variegated marble panels outlined in white frames adorn every wall surface not occupied by frescoes, statue niches, or tombs. Mottled and speckled panels of *africano* with inlays of *giallo antico* and *bianco e nero antico* are set below each of the six statue niches; and pilasters are divided horizontally into panels ornamented with intarsias of *porta santa, verde antico, rosso antico, broccatello,* and other colored marbles. Pilaster strips and the areas flanking the tombs are covered with panels of *porta santa, breccia,* and alabaster.[3] Here, as in the slightly later Caetani Chapel, the Aldobrandini Chapel in S. Maria sopra Minerva, the Salviati Chapel in S. Gregorio Magno, and numerous other examples from this period, the application of colored marble panels, many inlaid with intarsias, subverts the structural system. Supporting elements seem to merge into the wall, and everywhere the emphasis is on the surface; walls and architectural framework "dissolve," as Lavin observes, "in a coloristic interplay."[4]

sixteenth-century revetment, notes and references are here kept to a minimum. Andrew Morrogh, "Vasari and Coloured Stones," in *Giorgio Vasari tra decorazione ambientale e storiografia artistica,* ed. Gian Carlo Garfagnini (Florence: Leo S. Olschki, 1985), p. 310, first used the designation "colored-marble chapel."
3. All of the colored marbles employed in the chapel are itemized (with measurements and costs) in Archivio Segreto Vaticano, Archivum Arcis, Armadio B. 7, "Libro di tutta la spesa fatta da N. S. Sisto V nella Capella del Presepio in S.ta M.ria Maggiore," fols. 50r-67r. For an extremely valuable discussion of marble types, with excellent plates, see Raniero Gnoli, *Marmora Romana* (Rome: Edizioni dell' Elefante, 1971).
4. Lavin, *Bernini,* p. 25, whose remark concerns the analogous use of polychromy in the Cappella Caetani in S. Pudenziana. It should be noted that in the Salviati Chapel the marble cladding is feigned in fresco.

Art-historical scholarship has paid relatively scant attention to this kind of marble decoration, concerning itself primarily with formal qualities. Leo Bruhns was one of the first to address the phenomenon, with an analysis entirely formalist in nature. Paolo Portoghesi likened the revetment in the Sistina to damask church hangings; and Antonio Muñoz saw Fontana's use of colored marbles as "anticipating the resounding symphonies...of the baroque."[5] Rudolf Wittkower provided more insightful observations. He warned that this decoration should not be explained "simply as the 'baroque' love for swagger and magnificence." He pointed out that much of the colored marble in the Sistina was taken from ancient Roman buildings, thereby forming "an important part of Sixtus V's counter-reformatory programme of systematically transforming pagan into Christian Rome."[6]

What Wittkower did not note, however, was that many of the marbles were taken from early Christian and medieval buildings as well, such as the Lateran Palace and the adjacent fifth-century Oratory of the Holy Cross. Thus, one can add that Sixtus also transformed early and medieval Christian Rome into the modern Christian city.[7] Most recently, Howard Hibbard asserted that "the almost garish polychromy of the Cappella Sistina probably reflects late sixteenth-century Roman culture more accurately [than other chapels]. A rich patron almost invariably decorated his chapel richly."[8]

There is no question that marble revetment, a luxurious and costly form of decoration, was appropriate to a papal

5. Leo Bruhns, *Die Kunst der Stadt Rom* (Vienna: A. Schroll, 1951), pp. 575-76; Paolo Portoghesi, *Roma barocca*, rev. ed. (Rome and Bari: Editori Laterza, 1978), p. 83; Antonio Muñoz, *Domenico Fontana architetto 1543-1607* (Rome and Gubbio: Cremonese, 1944), pp. 94-95.
6. Rudolf Wittkower, *Art and Architecture in Italy 1600-1750*, The Pelican History of Art, 3d, rev. ed. (Harmondsworth and Baltimore, MD: Penguin Books, 1973), pp. 29-30.
7. See especially Rodolfo Lanciani, *Storia degli scavi di Roma e notizie intorno le collezioni romane di antichità*, 4 vols. (Rome: E. Loescher, 1902-1912), 4:164-67; Ludwig von Pastor, *The History of the Popes from the Close of the Middle Ages*, vol. 22 (London: Kegan Paul, Trench, Trubner and Co., 1937), pp. 237-38, 269-73; G. Nicolosi, "Intorno a Papa Sisto V e la distruzione del Settizonio," *L'Illustrazione Vaticana* 11, 9 (1938): 369-72.
8. Howard Hibbard, *Carlo Maderno and Roman Architecture 1580-1630* (University Park, PA and London: Zwemmer, 1971), p. 28.

chapel in which the pope desired to display his wealth and grandeur. As an analogue, in fact, we may cite the Cappella de' Principi in Florence (fig. 3), as initially conceived by Vasari and carried out by Don Giovanni de' Medici, Buontalenti, and others from 1604 on. Here, according to Vasari's own description, the richly adorned marble interior was "worthy of the power and greatness" of the Medici who were to be buried within its confines.[9] So too can the polychrome marble decoration be seen as related to the reliquary function of the Sistine Chapel. As Alexandra Herz noted, the Sistina may be viewed as a colossal reliquary turned inside out, richly encrusted with precious stones.[10] As such, it may be compared with the late fifteenth-century marble-veneered Cappella del Perdono in the Ducal Palace in Urbino, erected to house the most sacred relics in the possession of the dukes (fig. 4), and to the richly encrusted Cappella del Santo in S. Antonio, Padua, containing the relics of St. Anthony.[11] But beyond these two ways of viewing the revetment, how else might this peculiar form of decoration be understood? One method of arriving at an answer, I believe, is to consider late sixteenth-century revetment in relation to the long and continuous tradition of marble encrustation.

The ancient Romans were the first to use colored marbles to sheath the inside of their buildings. The Pantheon is among the few surviving and best-known examples.[12]

9. Giorgio Vasari, *Le Vite de' più eccellenti pittori, scultori et architettori,* ed. Gaetano Milanesi, vol. 7 (Florence: G. C. Sansoni, 1906), p. 712, quoted in Morrogh, "Coloured Stones," p. 315.
10. Alexandra Herz, "The Sistine and Pauline Tombs. Documents of the Counter Reformation," *Storia dell' arte* 43 (1981): 242.
11. On the Cappella del Perdono, variously dated from 1475 to c.1495 and attributed to Piero della Francesca, Bramante, and others, see Pasquale Rotondi, *Il Palazzo Ducale di Urbino* (Urbino: Istituto statale d'arte per il libro, 1950), pp. 357-67. Sarah Blake McHam, "Miraculous Bones and their Impact on Italian Renaissance Church Architecture," paper delivered at the Seventy-seventh Annual Meeting of the College Art Association, San Francisco, CA., February 1989, pp. 4-5, writes: "the profusion of colored marbles...of the 16th-century redecoration [of the chapel of St. Anthony] signal by their richness that this is a reliquary chapel...."
12. See Emerson H. Swift, *Roman Sources of Christian Art* (New York: Columbia University Press, 1951); Hetty Joyce, *The Decoration of Walls, Ceilings, and Floors in the Second and Third Centuries A.D.* (Rome: Giorgio Bretschneider, 1981); and William L. MacDonald, *The Pantheon – Design, Meaning, and Progeny* (London: A, Lane, 1976), esp. p. 37.

Constantine helped spread this mode of decoration to the Holy Land and to Constantinople, where it was used extensively in church interiors. Marble cladding, generally consisting of large slabs and small areas of *opus sectile*, then became a regular feature of Byzantine churches – for example the Euphrasian Basilica in Poreč, San Vitale in Ravenna, San Marco in Venice, and Hagia Sophia in Istanbul. These marble-encrusted churches were praised by contemporary viewers for their magnificence; more significant for an understanding of meaning, however, is the fact that the revetted interiors were interpreted anagogically, as reflections of God's power and capable of bringing one closer to God.[13] In describing Hagia Sophia, for example, Procopius, after marvelling at the beauty of the colored marbles, wrote: "Whenever one goes in this church to pray, one understands immediately that this work has been fashioned not by human power or skill, but by the influence of God. And so the visitor's mind is lifted up to God...."[14]

In Italy the pagan tradition of marble revetment was taken over and reinterpreted in early Christian church interiors. In several of Constantine's buildings, including the Lateran Basilica and its adjacent baptistry and Oratory of the Holy Cross, in S. Costanza, and in SS. Cosma e Damiano (figs. 5-7), to name just a few, the walls and pilasters were sheathed with marble revetment divided into framed tiers and panels, with inlaid geometric designs in *opus sectile*.[15] Later, in the medieval period, three separate trends emerge: the first is the so-called *Inkrustationstil* of the Tuscan Romanesque, exemplified by San Miniato, which is essentially bichrome; the second is Cosmati-work which, as far as I know, was never applied to entire wall surfaces; and the

13. Eusebius, *Vita Constantini*, as quoted in Cyril Mango, *The Art of the Byzantine Empire 312-1453* (Englewood Cliffs, NJ: Prentice-Hall, 1972), p. 13; Swift, *Roman Sources*, p. 131. See also the sixth-century description of Hagia Sophia by Paulus Silentiarius in Mango, *Byzantine Empire*, pp. 85-86; and Ann Terry, "The Opus Sectile in the Eufrasius Cathedral at Poreč," *Dumbarton Oaks Papers* 40 (1986): 147-64.
14. Procopius, *De aedificiis*, as quoted in Mango, *Byzantine Empire*, p. 76.
15. Each of these early Christian buildings has a vast literature; for a general discussion of early Christian marble revetment, see Giovanni Battista Giovenale, *Il Battistero Lateranense* (Rome: Pontificio istituto di archeologia cristiana, 1929), pp. 128-39; and Carlo Cecchelli, *Vita di Roma nel Medio Evo*, vol. 1 (Rome: Fratelli Palombi, 1951), pp. 663-90.

third is fictive marble cladding rendered in fresco, as in Giotto's Arena Chapel in Padua and in the sacristy of S. Croce in Florence, carried out by Taddeo Gaddi and his shop.[16]

Fictive marble revetment, generally confined to the basement level of the walls, became a common feature of chapel decoration in central Italy in the fifteenth century. The practice of sheathing entire wall surfaces with actual marble, on the other hand, reemerged in Venice as early as the 1430s in the Mascoli Chapel in San Marco. There, in Pietro Lombardo's S. Maria dei Miracoli, and in numerous other examples, large panels of colored marble adorn the walls in direct imitation of Byzantine models.[17]

It was not until the early sixteenth century – with Raphael's Chigi Chapel in S. Maria del Popolo – that the walls of a Roman chapel were wholly covered with marble revetment. In this case, the point was to emulate ancient Roman architecture, specifically the Pantheon.[18] Consequently, as in its model, and quite unlike early Christian buildings, the walls between the pilasters are revetted with marble panels; and the pilasters, as structural members, remain unclad. The Chigi Chapel, however, had no immediate followers in Rome. In fact, it was not until the last quarter of the sixteenth century that polychrome marble revetment

16. See Adolf Behne, *Der Inkrustationsstil in Toscana* (Berlin: Ebering, 1912); and Fritz Rupp, *Inkrustationstil der romanischen Baukunst zu Florenz* (Strassburg: J. H. E. Heitz, 1912). On Cosmati-work, see Edward Hutton, *The Cosmati: The Roman Marble Workers of the XIIth and XIIIth Centuries* (London: Routledge and Keegan Paul, 1950); and Dorothy Glass, *Studies on Cosmatesque Pavements* (Oxford: British Archaeological Reports), 1980. On trecento fictive-marble cladding, see Theodor Hetzer, *Giotto, Grundlegung der neuzeitlichen Kunst* (Stuttgart: Urachhaus/KNO, 1981), pp. 176-77; and Eve Borsook, *The Mural Painters of Tuscany from Cimabue to Andrea del Sarto*, 2d ed. (Oxford: Clarendon Press, 1980), passim and figs. 5-9, 52-55.
17. Ferdinando Forlati, *La Basilica di San Marco attraverso i suoi restauri* (Triest: LINT, 1975), pp. 117-19, figs. 16-17; John McAndrew, *Venetian Architecture of the Early Renaissance* (Cambridge, MA: MIT Press, 1980), pp. 9-42, 47-50, 150-81; Ralph Lieberman, *Renaissance Architecture in Venice 1450-1540* (New York: Abbeville Press, 1982), pp. 14-21, text to plates 29-30, 50-52.
18. The fundamental study of the Chigi Chapel is that of John Shearman, "The Chigi Chapel in S. Maria del Popolo," *Journal of the Warburg and Courtauld Institutes* 24 (1961): 129-60, which unfortunately omits any discussion of the marble revetment. See Lavin, *Bernini*, 1:30, on Raphael's use of colored marbles. On Raphael's drawings of the Pantheon, see Stefano Ray, *Rafaello architetto* (Rome: Laterza, 1974), p. 272 and figs. 132-35.

again became a prominent feature of chapel decoration in the papal capital. The initiative was largely Giacomo della Porta's – in his Cappella Gregoriana in St. Peter's, where the use of marble encrustation was resumed, but in a programatic way that was entirely new.

In della Porta's chapel, begun in 1573, all surfaces – walls and pilasters alike – are covered with marble (fig. 8). Walls are revetted with framed rectangular panels, and pilasters are edged with white marble frames and encrusted with designs in *opus sectile*. Unlike Raphael's Pantheon-like application of marbles that reinforced the structural integrity of the architectural framework, in the Gregoriana the more ornate revetment subverts the structural system, creating an effect of a thin, substanceless veneer.[19]

There can be little doubt that the all-over application of marble revetment in the Sistine Chapel in S. Maria Maggiore depended on Domenico Fontana's careful study of della Porta's Cappella Gregoriana. The Gregoriana was, after all, an important conceptual model for the Cappella Sistina in plan, general design, and decorative scheme. In the Sistina, however, there is an increase in the variety and brightness of the colored marbles, and the *opus sectile* inlays are more numerous and complex. Moreover, whereas the inlays in the Gregoriana are purely decorative, those in the Sistina are symbolic; they represent the *monti*, star and cross – the emblem of Sixtus V's papacy and the symbol of Christian triumph that he placed on all his monuments.

The encrustation seen in the Gregoriana, Sistina, and other related Roman chapels must be understood as part of the continuous tradition of revetment sketched above. At the same time it is apparent that late sixteenth-century Roman colored-marble chapels look decidedly different from all their immediate predecessors. In fact, the only parallel that I can find to the revetment in these chapels is the polychrome sheathing of early Christian churches. While differences exist, their similarities cannot be ignored. In both groups of

19. On the Cappella Gregoriana, see Lanciani, *Storia degli scavi*, 4:54-59; Pastor, *History of the Popes*, 20:567-73; Herbert Siebenhüner, "Umrisse zur Geschichte der Ausstattung von St. Peter in Rom von Paul III. bis Paul V. (1547-1606)," in *Festschrift für Hans Sedlmayr* (Munich: Verlag C. H. Beck, 1962), pp. 259-83.

monuments we find all surfaces covered with an a-tectonic application of marbles. Walls are divided horizontally and vertically by cornices and pilasters, each section covered by a marble panel. In both, *opus sectile* designs are used extensively. We might compare, for example, the *opus sectile* emblems on the pilasters of the Sistina with the inlaid emblems that adorn the walls of S. Sabina, a church to which Sixtus V gave much attention (fig. 9). The overall organization of wall surfaces in the Sistine Chapel also makes a striking comparison with the interior of the fifth-century Oratory of the Holy Cross (as recorded in Antonio Lafréry's engraving of 1568), the marbles from which were reused for the Sistina's revetment.[20]

For lack of documentary evidence, it is difficult to prove that Giacomo della Porta, Domenico Fontana, and other late sixteenth-century architects turned to early Christian churches as models for their chapels. But there is good reason to believe that this is precisely what took place. The foremost trend in post-Tridentine Rome was what has come to be called the Early Christian Revival. Largely under the direction of the Oratory of San Filippo Neri, and such individuals as Cesare Baronio, Onofrio Panvinio, Pompeo Ugonio, Antonio Bosio, and Alfonso Ciacconio (Chacon), the early church – the golden age of Christianity – was embraced as a model worthy of emulation. Early Christian devotional practices, such as visiting the *Sette Chiese*, were revived and, following the accidental discovery in 1578 of a catacomb on the Via Salaria, an intensive study of the physical remains of the primitive church was begun.[21] The venerable churches of

20. On Sixtus V's restoration of S. Sabina, see F. Darsy, *Santa Sabina*, Le chiese di Roma illustrate, no. 63-64, ed. Carlo Galassi Paluzzi (Rome: Edizioni "Roma," Marietti, 1961), pp. 38-39. On the Oratory of the Holy Cross, see Richard Krautheimer, "The Architecture of Sixtus III: A Fifth-Century Renascence?," in *Studies in Early Christian, Medieval, and Renaissance Art*, ed. and trans. A. Frazer et al. (New York and London: New York University Press, 1969), pp. 182, 193 n. 11. For reproductions of Lafréry's engraving, along with other Renaissance drawings of the oratory, see Giuseppe Zander, "Le invenzioni architettoniche di Giovanni Battista Montano Milanese (1534-1621)," *Quaderni dell' Istituto di Storia dell' Architettura* 49-50 (1962): 15, fig. 79.

21. On the broad subjects of the Early Christian Revival and early Christian archaeology in the last quarter of the sixteenth century, see Pietro Fremiotti, *La riforma cattolica del secolo decimosesto e gli studi di archeologia cristiana* (Rome: Pustet, 1926); Richard Krautheimer, "A Christian Triumph in 1597," in *Essays*

Rome, particularly the early Christian basilicas and titular churches, were looked upon as hidden treasures, *tesori nascosti*, to borrow from the title of a contemporary ecclesiastical guidebook; they were considered to be historical documents of the paleochristian past, worthy of preservation, embellishment, and emulation.

One feature of this early Christian renascence, as Eric Hubala and Howard Hibbard have shown, was the revival of paleochristian architectural forms – the loculus, certain types of altar tabernacles, and the sunken confessio, such as the one in the center of the Sistine Chapel.[22] Moreover, in his renovations of SS. Nereo ed Achilleo and S. Cesareo, Cesare Baronio created cycles of decoration that emulated the pictorial form and iconography of the early church.[23] Paleochristian mosaics also began to be studied and restored and, doubtless with the intention of recapturing the early Christian splendor of Old St. Peter's, Gregory XIII adorned the pendentives, cupola, and lunettes of the Cappella Gregoriana with mosaics, instead of the more traditional frescoes.[24]

in the History of Art Presented to Rudolf Wittkower, ed. D. Fraser, H. Hibbard and M. J. Lewine, 2 vols. (London: Phaidon, 1967), 2:174-78; Gisella Wataghin Cantino, "Roma sotterranea: Appunti sulle origini dell' archeologia cristiana," *Ricerche di Storia dell'arte* 10 (1980): 5-14; Alessandro Zuccari "La politica culturale dell' Oratorio romano nella seconda metà del Cinquecento," *Storia dell' Arte* 41 (1981): 77-112; idem, *Arte e committenza nella Roma di Caravaggio* (Turin: ERI Edizioni RAI, 1984); Ingo Herklotz, "'Historia sacra' und mittelalteriche Kunst während der zweiten Hälfte des 16. Jahrhunderts in Rom," in *Baronio e l'arte,* ed. Romeo de Maio et al. (Sora: Centro di Studi Sorani, 1985), pp. 21-74.

22. Hibbard, *Carlo Maderno,* pp. 19, 40, 60, 66, 73; Erich Hubala, "Roma sotterranea barocca," *Das Münster* 18 (1965): 157-70.

23. Alessandro Zuccari, "La politica culturale dell' Oratorio Romano nelle imprese artistiche promosse da Cesare Baronio," *Storia dell' Arte* 42 (1981): 171-93; idem, *Arte e committenza,* pp. 51-88; idem, "Restauro e filologia baroniani," in *Baronio e l'arte,* pp. 489-510; Alexandra Herz, "Cardinal Cesare Baronio's Restoration of SS. Nereo ed Achilleo and S. Cesareo de' Appia," *Art Bulletin* 70 (1988): 590-620.

24. On the study of early Christian mosaics and on the revival of the medium as one aspect of the Early Christian Revival, see Stephan Waetzoldt, *Die Kopien des 17. Jahrhunderts nach Mosaiken und Wandmalereien in Rom,* 2 vols. (Vienna and Munich: Schroll-Verlag, 1964); Giovanni Previtali, "Le prime interpretazioni figurate dai 'primitivi,'" *Paragone* 11, 121 (1960): 20-23. On the use of mosaics in the Gregoriana, see Miles L. Chappell and Chandler W. Kirwin, "A Petrine Triumph: The Decoration of the Navi Piccole in San Pietro under Clement VIII," *Storia dell' Arte* 21 (1974): 127; Frank DiFederico, *The*

Early Christian revetment was also the focus of considerable study. Careful visual records were made of the marble cladding in the form of pen and watercolor drawings by architects and historians of the church.[25] And in their ecclesiastical guidebooks to Rome, Pompeo Ugonio, Onofrio Panvinio, and others frequently singled out the marble encrustation in early Christian churches as being particularly noteworthy, and they described the paleochristian revetment with the very same language used for the revetment in the Gregoriana and Sistina. Even Cesare Baronio, in his *Annales ecclesiastici*, discussed the marble encrustation of floors and walls of early Christian churches as being worthy models for emulation.[26]

It is against this backdrop, I believe, that the revetment of late sixteenth-century chapels should be viewed – as sharing a common language and spirit with the decorations of the early church, and as one facet of the Early Christian Revival in Rome. This revival should not necessarily be thought of in terms of explicit quotations; indeed neither the Cappella Sistina nor the Cappella Gregoriana is a copy of an early Christian church. Rather, the revival was achieved by means of employing a mode of decoration that communicated particular associations with the past. It was a creation *all'antica;* but for specific ideological and spiritual reasons the Christian antique served as the model. This evocation of early Christian decoration should be seen, I think, as reflecting a neo-medieval attitude toward copying (an attitude that permeated Counter-Reformation thought) as defined by Richard Krautheimer, whereby the newer monument represents a copy of or an allusion to the older one through a "selective reshuffling of elements shared with the model" and crossed

Mosaics of Saint Peter's (University Park, PA and London: The Pennsylvania State University Press, 1983), pp. 5-6.

25. For example, Cecchelli *Vita di Roma*, 1:686, cites drawings by Ugonio and Ciaconio of the revetment in S. Andrea in Catabarbara, formerly the Basilica of Junius Bassus; and Otfried Deubner, "Expolitio: Inkrustation und Wandmalerei," *Mitteilungen des deutschen Archäologischen Instituts. Römische Abteilung* 54 (1939): fig. 9, reproduces a late Renaissance drawing of the revetment in S. Costanza. The polychrome marble revetment in the Lateran Baptistry is recorded in a late sixteenth-century watercolor drawing, Biblioteca Vaticana Apostolica, Barb. lat. 4333, fol. 69v.

26. On Baronio's discussion of marble encrustation, see Herz, "Baronio's Restoration," p. 605.

with new features.[27] The luxurious decoration of late sixteenth-century colored-marble chapels may best be understood as an evocation of the general visual appearance of early Christian churches. The Sistine and related chapels become, then, recreations in a modern idiom of early Christian monuments.

*

Turning now to the second level of meaning, I take as my starting point a statement by Wittkower. In reference to the Sistina's marble revetment, he wrote: "By placing this sumptuous spectacle before the eyes of the faithful, Sixtus fulfilled the neo-medieval demand, voiced by men like [Johannes] Molanus, that the church, the image of heaven on earth, ought to be decorated with the most precious treasures in existence."[28] Indeed, the rich marbles, applied to all surfaces, present a kaleidoscopic display of color that imbues the chapel with a decidedly unearthly character, transforming it into a sacred domain, not of this world.

The metaphorical interpretation of the physical church as an image of the celestial paradise was, of course, a topos of medieval thought; and as Meyer Schapiro has stated, "the church aspired to be a model of the divine palace, the heavenly Jerusalem, which medieval poets saw as an architecture of gold and jewels."[29] It is in this light that Durandus speaks of the church in his *Rationale divinorum officiorum;* and Hugh of St. Victor, in the *Mystical Mirror of the Church,* poetically articulates this idea, stating "the material church...signifieth the Holy...Church, which is builded in the heavens of living stones."[30] Similarly, in the eighth-century

27. Krautheimer first formulated this concept of a "copy" in "Introduction to an 'Iconography of Medieval Architecture,'" *Journal of the Warburg and Courtauld Institutes* 5 (1942): 1-33. I quote from idem, "Success and Failure in Late Antique Church Planning," in *Age of Spirituality: A Symposium*, ed. K. Weitzmann (New York: The Metropolitan Museum of Art in conjunction with Princeton University Press, 1980), pp. 134-35 .
28. Wittkower, *Art and Architecture in Italy*, p. 30.
29. Meyer Schapiro, "On the Aesthetic Attitude in Romanesque Art," in *Art and Thought: Issued in Honour of Dr. Ananda K. Coomaraswamy on the Occasion of his 70th Birthday*, ed. K. Bharatha Iyer (London: Luzac and Company, 1947), p. 141.
30. Guglielmus Duranti (William Durandus), *The Symbolism of Churches and Church Ornaments: A Translation of the First Book of the Rationale Divinorum*

Historia mystagogica, attributed to Germanus I, we read: "the church is a heaven on earth wherein the heavenly God dwells and walks."[31] In his well-known treatise, *De diversis artibus,* Theophilus, describing the church, writes: "having illuminated the vaults or the walls with diverse works and diverse colours, thou has in a manner shown forth to the beholders a vision of God's paradise...."[32] This topos was still widely held in the sixteenth century, as is made clear in Molanus' statement and by the statements of other ecclesiastical writers. One of the most explicit affirmations of this idea was voiced by Alberto Pio da Carpi in a treatise published in 1531. He argued that the physical church must imitate the celestial Jerusalem, as described in Revelations, and that the material richness of the church is, in itself, a manifestation of God. Churches should be splendidly decorated, he states, with precious materials and, in words reminiscent of Procopius' remarks on Hagia Sophia, he declares that the magnificence and richness of the decoration ignite our spirits as we contemplate paradise.[33]

I wish to suggest that the Sistine Chapel with its walls sheathed in colored marbles was meant to be read, almost literally, as an image of the celestial paradise. That it was both conceived and understood in this way is testified to, I further believe, by recorded reactions to it and to its similarly encrusted pendant on the other side of the nave, the Pauline Chapel (fig. 10).

In 1646 the learned English traveller, John Raymond, visited the Sistine and Pauline Chapels. Of them, he wrote: "The two emulous Chappells of Paulus quintus and Sixtus V, for the variety and preciousnesse of the stone, imitate the

Officiorum, ed. and trans. with an intro. essay by J. M. Neale and B. Webb (Leeds: T. W. Green, 1843), pp. 17, 198. A portion of Hugh of St. Victor's text appears as a supplement to that of Durandus (pp. 197-209). See also Laurence H. Stookey, "The Gothic Cathedral as the Heavenly Jerusalem: Liturgical and Theological Sources," *Gesta* 8 (1969): 35-41.

31. Quoted in Mango, *Byzantine Empire,* pp. 141-42.

32. I follow the translation in G. G. Coulton, *Life in the Middle Ages,* 2d ed., reissued, 4 vols. in 2 (Cambridge: University Press, 1967), 4:195; cf. Theophilus, *The Various Arts (De Diversis Artibus),* trans. with intro. and notes by C. R. Dodwell (London: Thomas Nelson and Sons, 1961), p. 63.

33. Alberto Pio da Carpi, *Tres et viginti libri in locos lucubrationum D. Erasmi* (Paris: Jodocus Badius, 1531), as cited in Giuseppe Scavizzi, "La teologia cattolica e le immagini durante il XVI secolo," *Storia dell' Arte* 21 (1974): 183, 186.

famous San Lorenzo of Florence."[34] Raymond, of course, was referring to the Cappella de' Principi, and his description of its interior is quite remarkable: it is "so glorious," he writes, "that whosoever enters, will even imagine himselfe in some place above terrestriall. 'Tis wholly overlaid with fine Pollisht stone."[35] The dazzling display of marbles was clearly the impetus for Raymond's comparison; and in their similarity to the Cappella de' Principi, the Sistine and Pauline chapels represented to him an unearthly realm.

Two orations delivered in the Pauline Chapel in 1613 also express this paradisiacal association and elucidate why Raymond interpreted the colored-marble chapels in the way he did. Pompeo Brunelli, in the first oration, states simply: "I have seen that the Pope [Paul V] has made a paradise on the Esquiline, which, for as much as it is possible, corresponds to that celestial Paradise."[36] And in the second oration, a certain Monsignor Castello goes even further:

...and who observes the marbles, the porphyrys, the jaspers, the golds, the silvers, the crystals, the colors... of this place, will easily be reminded of that which St. John speaks in the Apocalypse when he describes the City of Paradise – "and the city was pure gold, like unto clear glass, clear as crystal; the building of the wall of it was of jasper, (and) of all manner of precious stones."[37]

On the basis of these reactions, it is apparent that the colorful and precious encrustation of the walls of the Sistine

34. John Raymond, *An Itinerary Contayning A Voyage Made through Italy in the yeare 1646, and 1647* (London: H. Mosely, 1648), p. 82. Raymond was not aware that the Sistine Chapel predates the Cappella de' Principi by more than a decade.
35. Raymond, *Itinerary*, p. 40.
36. Pompeo Brunelli, *Oratione in Lode Della Beatissima Vergine Maria* (Rome: Tipografia Camera Apostolica, 1613), p. 2: "Perciòche dopo d'haver io veduto, che l'istesso Pontefice Massimo ha fatto nell' Esquilino un Paradiso, il quale, per quanto è possibile, ha corrispondenza con quel Paradiso celeste...."
37. Archivio Capitolare di S. Maria Maggiore, Fondo Cappella Borghese, Misc. III, fasc. 11, no. 52, "Ragionamento Fatto dal M. R. P. Castello sopra le due Capelle in S.ta Maria maggiore...Alli 3 di Febraro 1613," unpaginated: "e chi osserva i marmi, i porfidi, i diaspri, gli ori, gli argenti, i cristalli, i colori...di questo luoco facil[mente] si raccordarà di quello che dice San Giovanni nell' Apocalissi quando descrive la Città del Paradiso[:] aurum mundum simile vitro mundo tanquam cristallum structura muri ex lapide jaspide, ex ommi lapide pretioso." Castello conflates Rev. 21:18-19 and 21:11.

Chapel, like that in the Pauline Chapel, gave visual expression to the long-standing idea of the church as an image of paradise. By evoking the city of paradise as described in John's Revelations, the chapels were seen as visual embodiments of heaven on earth.

The colored-marble chapel that came into being in Rome at the end of the sixteenth century was a unique expression of Counter-Reformation thought. More than simply a rich and costly form of decoration appropriate to the patron, and more than endowing the chapel with the character of a reliquary, I propose, the particular type of marble revetment of this period was considerably richer in its implications. It at once revived and emulated a specifically early Christian form of decoration – a model ideally suited to the larger ambitions of spiritual and physical renewal of the post-Tridentine church – and, simultaneously, it made manifest the time-honored reading of the church as an image of the celestial paradise.

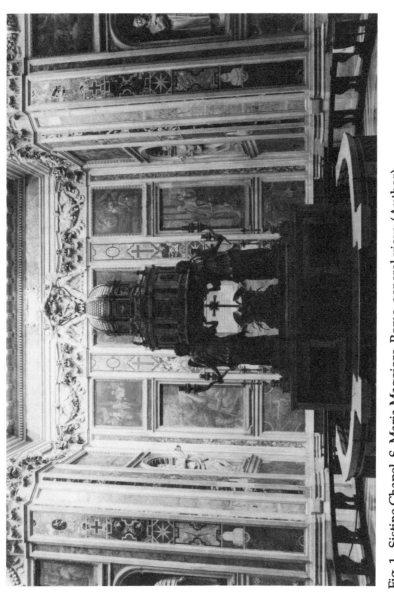

Fig. 1. Sistine Chapel, S. Maria Maggiore, Rome, general view. (Author)

Fig. 2. Sistine Chapel, S. Maria Maggiore, Rome, detail. (Author)

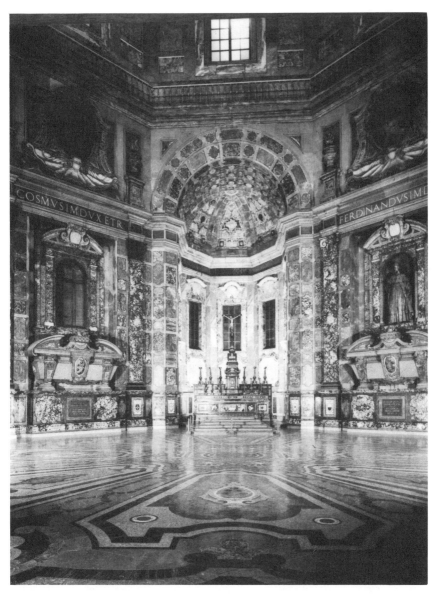

Fig. 3. Cappella de' Principi, San Lorenzo, Florence, general view. (Author)

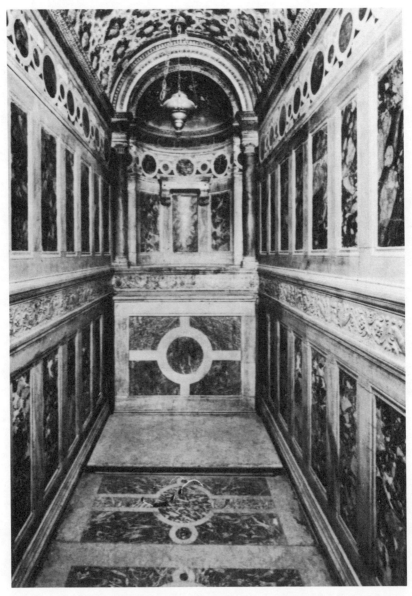

Fig. 4. Cappella del Perdono, Ducal Palace, Urbino, general view.
(Author)

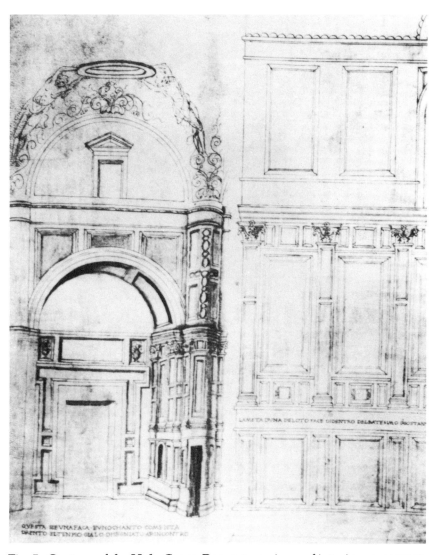

Fig. 5. Oratory of the Holy Cross, Rome, two views of interior revetment, drawing by Giuliano da Sangallo, Vatican Library, Barb. lat. 4424. (Vatican Library)

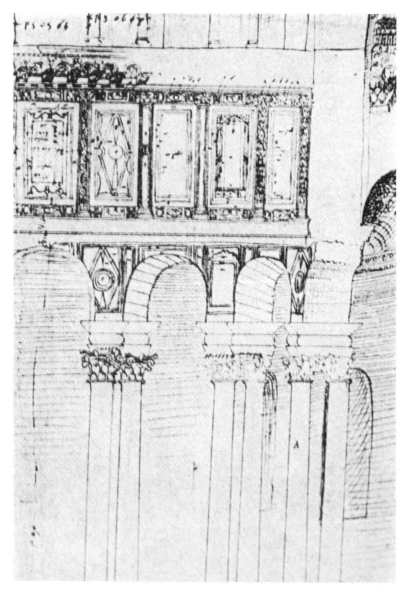

Fig. 6. S. Costanza, Rome, interior revetment, sixteenth-century drawing, detail. From E. H. Swift, *Roman Sources of Christian Art* (New York: Columbia University Press, 1951), pl. XXV.

Fig. 7. SS. Cosma e Damiano, Rome, interior revetment, drawing by Pirro Ligorio, Vatican Library, Vat. lat. 3439. Detail. (Vatican Library)

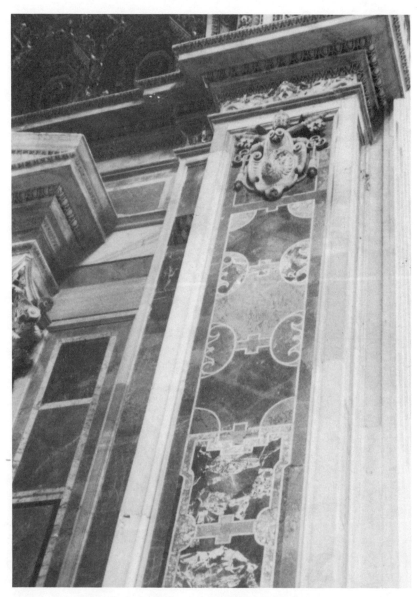

Fig. 8. Cappella Gregoriana, St. Peter's, Rome, section of wall and pilaster with marble revetment. (Author)

Fig. 9. S. Sabina, Rome, *opus sectile* emblems of nave. (Author)

Fig. 10. Pauline Chapel, S. Maria Maggiore, Rome, general view. (Author)

Contributors

ARTHUR R. BLUMENTHAL received his doctorate from the Institute of Fine Arts, New York University, in 1984. He is the Director of the Cornell Fine Arts Museum, Rollins College.

JOHN R. CLARKE received his doctorate from Yale University in 1973. He is Professor of the History of Art at the University of Texas at Austin.

NICOLA COURTRIGHT received her doctorate from the Institute of Fine Arts, New York University, in 1990. She is currently Assistant Professor of Art History at Amherst College.

GAIL FEIGENBAUM received her doctorate from Princeton University in 1984. She is Curator of Academic Programs at the National Gallery of Art in Washington, DC.

JACK FREIBERG received his doctorate from the Institute of Fine Arts, New York University, in 1988. He is currently on the faculty of the University of Notre Dame program in Rome, Italy.

ALEXANDRA HERZ received her doctorate from the Institute of Fine Arts, New York University, in 1974. She is an independent scholar in Boston, MA.

EDITH W. KIRSCH received her doctorate from Princeton University in 1981. She is Associate Professor of Art History at The Colorado College, Colorado Springs.

DAVID A. LEVINE received his doctorate from Princeton University in 1984. He is Associate Professor of Art History at Southern Connecticut State University in New Haven.

SARAH BLAKE MCHAM received her doctorate from the Institute of Fine Arts, New York University, in 1976. She is Associate Professor and currently Chair of Art History at Rutgers University, New Brunswick.

277

MICHAEL P. MEZZATESTA received his doctorate from the Institute of Fine Arts, New York University, in 1980. He is Director of the Duke University Museum of Art.

STEVEN F. OSTROW received his doctorate from Princeton University in 1987. He is Assistant Professor of Art History at Vassar College.

MARIE SPIRO received her doctorate from the Institute of Fine Arts, New York University, in 1975. She is Associate Professor of Art History at the University of Maryland at College Park.

INDEX

279

This Book Was Completed on March 12, 1990
at Italica Press, New York, New York and
Was Set in Palatino. It Was Printed on
60 lb Glatfelter Natural Paper with a
Smyth-Sewn, Case Binding by
McNaughton & Gunn
Ann Arbor, MI
U. S. A.

* *

*